Picturing New York

GLORIA DEÁK

PICTURING

THE CITY FROM ITS BEGINNINGS TO THE PRESENT

COLUMBIA UNIVERSITY PRESS NEW YORK

NEW YORK

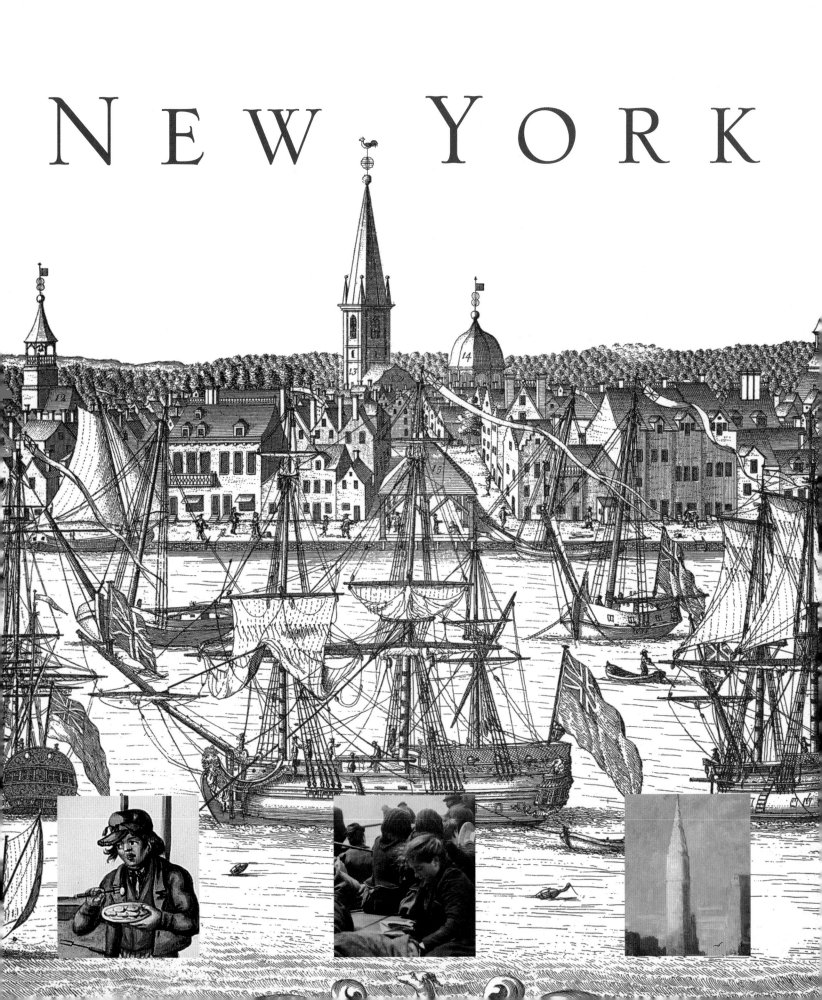

The Press gratefully acknowledges assistance from Furthermore, the publication program of the J. M. Kaplan Fund, toward the costs of publishing this book.

Columbia University Press
Publishers Since 1893
New York Chichester, West Sussex

Library of Congress Cataloging-in-Publication Data
Deák, Gloria
 Picturing New York : the city from its beginnings to the present /
 Gloria Deák
 p. cm.
 Includes bibliographical references (p.) and index.
 ISBN 0-231-10728-5 (acid-free paper)
 1. New York (N.Y.)—History. 2. New York (N.Y.)—History—Pictorial
 works. I. Title.

 F128.3 .D38 2000
 974.7'1—dc21
 99-054832

To István, Éva and Tom
the three delights of my life

Contents

PREFACE

The City of New York needs scant introduction. Who has not heard of this brash New World seaport that vaunts its narcissism and makes a constant celebrity of itself in prose, in song, and on the worldwide news? Nicknamed Gotham by Washington Irving, it is fondly celebrated in the poetry of Walt Whitman, who tramped its motley neighborhoods and "Saw many I loved in the street or ferry-boat . . . / Yet never told them a word."

From the time of its shy debut as a scruffy, Atlantic trading post—at first under Dutch, then longer under English colonial rule—the future Gotham moved steadily to the forefront of the international stage. As a fledgling seventeenth-century seaport, it took advantage of its geography, as well as of the multitude of talents that continually poured onto its shores, to amass wealth and stature in the ensuing 375 years. When it left behind the seafaring splendor of its Victorian decades, it pursued other commercial directions that continued to expand its power. Often this was achieved through ruthless and exploitative means; just as often it was achieved through accumulated daring and imagination. Always, its choice positioning by Neptune played a role.

New York defies any single attempt to take its measure. Here is an unquestionably unique metropolis that continually fascinates and infuriates, provoking renewed interpretations of its past. Permanent residents, the many who pour into the city day after day, onlookers from afar, and those who perilously attempt to chart its peregrinations, all register a host of different responses to the city's dynamism. Personalities as diverse as Alexis de Tocqueville, Frances Trollope, Fanny Kemble, Mark Twain, Sarah Bernhardt, Leon Trotsky, Fernand Léger, and W. H. Auden, who strode the city's streets and contributed to its history, penned views that animate the pages of this book. A persistent response we hear on the part of residents and travelers alike is that of New York as a magnetic, disorderly Elysium. It has prompted some who visit to take their tally of the city in a permanent state of indignation, waxing as censoriously observant as did Charles Dickens on his first visit in 1842. Others are like William Makepeace Thackeray: his capitulation to the charms of the city a decade later was complete. Two weeks after returning home, Thackeray was still refusing to adjust his watch from Manhattan to London time.

In preparing *Picturing New York*, I modestly join a staggering roster of chroniclers who have peered into the city's past before me: from Washington Irving in 1809 to the team of Burrows and Wallace whose last flourish of quills

in 1999 has produced volume one of their magisterial *Gotham*. My own chronicle follows no particular model from the past. Nor have I, as Washington Irving confessed, seasoned my account "with profound speculations like Thucydides, sweetened it with the graces of sentiment like Tacitus, and infused into the whole the dignity, the grandeur, and the magnificence of Livy." No, I have included no digressions or flights of fancy he did. What I offer is a factual overview of New York City's history from the days of discovery to the new millennium. True, the historical sails of the erstwhile seaport have here been outrageously trimmed; this is by no means an exhaustive account. My aim has been twofold: to trace the European origins of the city's development and to offer highlights of the city's history that profile the turning points in her rise to greatness. As the formative centuries were the seventeenth, eighteenth, and nineteenth, less emphasis is placed on the century that has just come to a close. Throughout I have attempted to answer the beguiling question, Was New York unique from the beginning?

I have chosen illustrations to lend yet another dimension to the historical events that carry the story forward. We see a Renaissance and a modern version of the New World discovery; a map identifying New York with its first European name of *Angoulême*; Charles II deep in conversation with his admiralty secretary Samuel Pepys plotting the takeover of New Amsterdam; the Duke of York, after whom the city was named, as a chubby eight-year-old and as a most royal adult; a section of the palisaded wall that gave Wall Street its name; an enemy flotilla approaching Staten Island in 1776; Edgar Allan Poe's crushing critique of Margaret Fuller's feminist tract; Bartleby the Scrivener intensely wielding a feathered nib; a city gala in 1860 for the Prince of Wales; wasp-waisted women playing tennis in Prospect Park; an engineer's sketch of the Queensboro Bridge; the disheartening sight of a breadline following the stock market crash of 1929; Sarah Bernhardt on her fourth New York City tour; and a sketch of the irrepressible Truman Capote by the equally irrepressible Andy Warhol. The illustrations stream from a variety of sources to augment the text.

In an effort to endow so wide-ranging a coverage with welcome pauses, my writing has proceeded along fourteen themes, or vignettes. Each vignette can be read independently; each traces the theme in a chronological path from beginnings to the year 2000. What will become immediately evident to the reader is that this historical rendering is a selective one, as is true of the illustrations. While it is based on the latest scholarship, on primary documents, and on the reports of eminent travelers, the scope and direction of the book are of my own fashioning. My fervent hope is that the selections I have made, subjective though they are, will go far in gratifying the appetite for an enduring portrait of New York at the dawn of a new millennium.

ACKNOWLEDGMENTS

As an initial step in conceiving this book four years ago, I enrolled in a course on the history of New York City at Columbia University, conducted by Professor Kenneth T. Jackson. It was a rewarding introductory move. To my great delight, desk space was subsequently assigned to me in the legendary Frederick Lewis Allen Room of the New York Public Library, where I had access to the Library's peerless collection of primary and printed materials bearing on the city's history There I began a journey through innumerable volumes, accumulated endless notes, worked up a furor scribendi, and became indebted to scholars whom I shall never meet but whose pioneering work fed my imagination.

A number of colleagues read the chapters as they emerged in rough draft, acting as beacons all along the way. To all five—Ella Milbank Foshay, Edwin T. Burrows, Sanford Malter, Thomas Bender, and Nancy Finlay—I owe my first resounding round of thanks.

Many others to whom I turned for advice, information, an opinion, or a smile of encouragement were invariably accommodating. Listing them alphabetically cannot indicate the scope or variety of their individual help but allows me to express gratitude: to Catherine Dabney, Lewis Dabney, Paula Baxter, David Berreby, David Combs, John Demaray, E. Christian Filstrup, Augusta Foshay-Rothfeld, Wayne Furman, Serge Gavronsky, Karen Gissony, Bartholomew Hargitay, Steven Jaffe, Edith Ham Jonas, Zoe Kaplan, Stanley Kruger, Geraldine Malter, Comfort Myers, Richard Newman, Rodney Phillips, Jan Ramirez, Michael Rothfeld Michael Seidel, Diane Serrano, Elisabeth Sifton, Lloyd Ultan, Helga Windhager, Bonnie Yochelson, Vera Zalaznick, and Sheldon Zalaznick. A supporting hand came from Sandra Angulo who, as a work-study student at Columbia, took on detective work, scoured the diary of Samuel Pepys, made outlines, and monitored the unruly endnotes.

Choosing and ordering more than 150 images was a project unto itself, and here I am grateful to institutions as well as individuals: to Robert Rainwater, curator of the Spencer Collection of the New York Public Library; to Roberta Waddell, Elizabeth Wyckoff, Margaret Glover, and Ramirez Suarez of the Library's Print Room; to the entire staff of the Library's Art and Architecture Division as well as to the staffs of the Library's Periodicals Division and the local History Room; to Alice Hudson, chief of the Library's Map Collection and her staff; to Nicole Wells of the New-York Historical Society; to Laszlo Clements of the British Museum; to Jill Frisch of the New Yorker magazine;

Contents

to Renee Coppola of the Museum of Modern Art; to Hollis Taggart, Vivian Ballaudy, and Cynthia Siebels of the Hollis Taggart Galleries; to Sherrill Robertson of the Los Angeles County Museum; to Donald Cresswell and Christopher Lane of the Philadelphia Print Shop; to Ulrik Stiller of the Rijksmuseum in Amsterdam; to Steven Jaffe of the South Street Seaport Museum; to Yasmin Zerhouin of Columbia Spectator, and finally to Susan Sheehan of the lively Susan Sheehan Gallery.

A majority of the illustrations was garnered from the collections of the Museum of the City of New York. There, the help and professionalism of Eileen Kennedy Morales and Peter Simmons went far in facilitating my research.

A special salute goes to John Dennis Moore, erstwhile director of Columbia University Press, for his abiding interest in the progress of my book.

Additional salutes go to artist Thomas Wesley Peck for his rendering of two original drawings and to artist Elizabeth Petschek for following exacting guidelines in the execution of a pen and ink drawing.

A small army at Columbia University Press went into action when I submitted my manuscript. I accumulated debts of gratitude there, above all, to my wise editor Jennifer Crewe. I additionally thank Leslie Bialler, Anne Gibbons, Liz Hartman, Martha Hostetter, Anne McCoy, Melissane Scheld, Helena Schwarz, and Katherine Williams. I especially salute the inspired work of Linda Secondari, CUP's creative director.

Throughout the course of the project, there were always three enduring allies to cheer me on: my husband, my daughter, and my son-in-law. To them, I dedicate this work.

Gloria Deák
New York
March 1, 2000

Map of
THE BOROUGHS
of
GREATER NEW YORK
in the Year 2000

N
W E
S

Henry Hudson Br.
Broadway Br.
George Washington Bridge
University Hts. Br.
Harlem R.
Washington Br.
Bronx
Madison Ave. Br.
3rd Ave. Br.
East River
Throgs Neck Bridge
Bronx-Whitestone Bridge
Manhattan
Triborough Bridge
Hudson River
Queensboro Bridge
Queens
Lincoln Tunnel
Queens-Midtown Tunnel
Holland Tunnel
Manhattan Bridge
Williamsburg Bridge
Brooklyn Bridge
Brooklyn-Battery Tunnel
Newark Bay
Upper New York Bay
N. Channel Bridge
Brooklyn
(KINGS)
The Narrows
Staten Island
(RICHMOND)
Verrazano-Narrows Bridge
Jamaica Bay
Lower New York Bay
Cross Bay Veterans Memorial Bridge
Rockaway Inlet
Marine Parkway Bridge

Long Island Sound

Atlantic Ocean

Miles
0 1 2 3 4 5
Kilometeres
0 1 2 3 4 5

map by Claudia Carlson

New York City

Picturing New York

CHAPTER ONE

A MULTIPLE BIRTH

The European Discovery and Naming of Manhattan:
Angoulême, New Amsterdam, New York, New Orange, and Forever After, New York

"Nowadays countries are always being discovered that were never in the old geography books," sighed Sir Thomas More as he prepared the introductory pages, in the year 1516, to his *Utopia.* Sir Thomas and his sixteenth-century contemporaries were baffled by reports trickling in to Europe of hitherto undetected lands and populations sharing their planet. Tidings of a New World proved startling. How was it possible that such lands and their peoples had remained so long hidden from view? Why were they unmentioned in the Scriptures and the classical texts? Did they spring into existence at the sight of explorers seeking a passage to the Orient? How would Europe adjust to this sudden reconfiguration of its once seemingly fixed and ordained universe? With long-held cosmographic beliefs suddenly shattered, neither geographers nor pundits of the Renaissance had answers. Followers of Columbus who were daring a crossing of the Atlantic, then known as the Ocean Sea, could only report on their discoveries without fitting them into a coherent geography. Not until more than a century after publication of More's *Utopia* would people realize there was no direct sea route westward from European ports to the coast of Asia. Large land masses, with lively populations, loomed as obstacles at every turn.

In 1524 Giovanni da Verrazzano set out in high hopes that his would be the ship to make it to the Orient. Sailing under the banner of Francis I of France, the ship successfully weathered the furies of the Ocean Sea and ventured several landfalls along the North American coast. Midway in his New World encounter, Verrazzano dropped anchor in the accommodating waters of New York's bay where he was warmly greeted by the local natives. Following his spirited report of this reception, a legend gathered force that he was the first European to touch the shores of Manhattan. This may well be so. A frailty of data surrounds the Ocean Sea crossings made in the Middle Ages by Irishmen, Vikings, and Bristol seamen, while Verrazzano offers solid documentation of a landing in the waters of the then-uncharted New York location.

Precisely where navigators of earlier centuries anchored is not known. Prevailing winds favored Ocean Sea crossings that ventured toward the Newfoundland area or Caribbean ports. By 1507, when the noted German cosmographer Martin Waldseemüller set about making his famous New World map based on findings that were brought back to the Continent, the New York coastal area was in total eclipse. It would emerge on a world chart only in the

third decade of that century, following Verrazzano's return to France. For this reason the Florentine navigator's report makes for an exhilarating start in any launching of the city's history. His detailed chronicle contributed to the wonder registered by Europeans with each disclosure of a New World landing. Dictated to a scribe for presentation to the French monarch on Verrazzano's return home, his account not only establishes the exact geographic position of the New York area he surveyed but also introduces the native population. "We saw many people on shore making various signs of affection as they motioned us to them," reported the Renaissance explorer to his patron, "and I saw a magnificent deed, as Your Majesty will hear." What His Majesty learned was of the hospitality of the natives that was extended to a shipload of Europeans who had landed weary and bewildered in a strange new continent.

Verrazzano's voyage of discovery began on January 17, 1524, when he set out in great secrecy from Europe to locate a passage to the Indies, a term then in use for the eastern stretches of Asia. Included in that broad term were the fabled lands of Cathay (China), Cipangu (Japan), Burma, India, Indonesia, and the Moluccas. Fifty days out of France, at the helm of his three-masted carrack the *Dauphine,* Verrazzano sighted the coast of an unmapped North American region. Beginning at a latitude of thirty-four degrees, he made seven landings along the coast, dropping anchor in accommodating harbors from the Carolinas northward. It was on April 17, 1524, that Verrazzano sighted the waters of New York bay. Making careful note of his findings, he offered, in a language fresh and direct, the first prose portraits of the region's inhabitants:

> We entered only with the small boat in the said river and saw the land much populated. The people were like the others, dressed with the feathers of birds of various colors, and they came towards us joyfully, uttering very great exclamations of admiration, showing us where we could land with the boat more safely. We approached the land about half a league by the same river which made a beautiful lake of a circuit of about three leagues.
>
> They [the Indians] came in thirty of their little barges on this lake, going from one side to the other, and there were innumerable people passing now from one part of the shore, now to the other, in order to see us.

Along with the notes he kept in his diary, Verrazzano made sketches of this historical encounter. Had the diary not been lost following the navigator's report to the French king, his jottings would have constituted the first graphic images of the New York scene to circulate in Europe. At the time, no tradition had been established of assigning a trained artist to a ship's complement on voyages of discovery. Four decades later, the French did so when they sent an expeditionary force to Florida. The resulting drawings by the recording artist circulated widely as engravings and fascinated all of Europe with their visual depictions of a strange New World. So scarce and prized were these images that they were often ascribed indiscriminately by mapmakers and chroniclers to varying regions of the newly discovered continents.

CHRISTOPHORVS COLVMBVS LIGVR *terroribus Oceani superatis alterius pęne Orbis regiones à se inventas Hispanis regibus addixit. An. salutis* ꝏ.VIIID.

FIGURE 1.1 *New World Discovery, 1492.*
"Nowadays countries are always being
discovered that were never in the old
geography books," sighs Sir Thomas More
in the 1516 preface to his *Utopia.* Like his
contemporaries, Sir Thomas found the
discovery of a New World baffling. In this
Renaissance projection, Columbus braves
the real and mythological terrors of the
Atlantic seas.

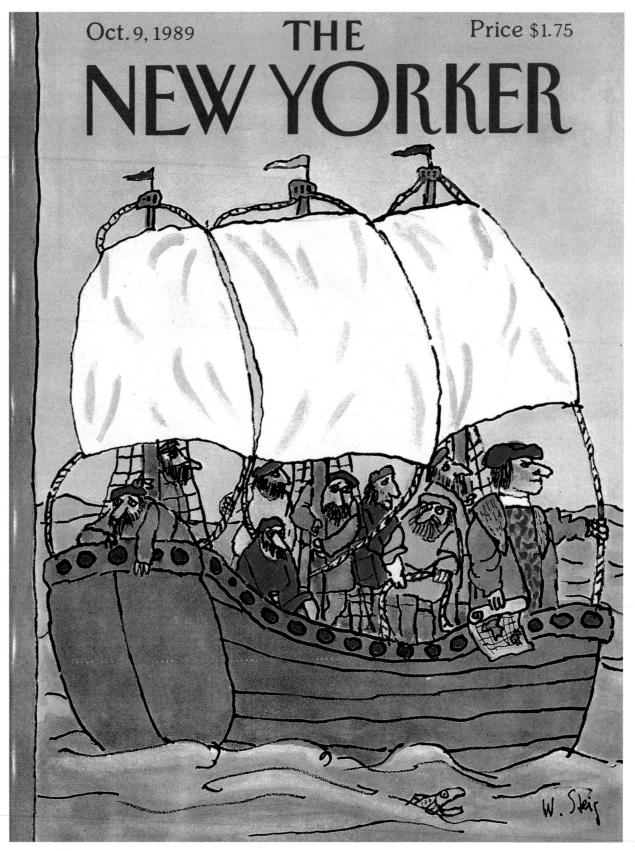

Courtesy of THE NEW YORKER

FIGURE 1.2 *Crossing the Ocean Sea, 1492.* The expansion of the universe led by Columbus's path-breaking journey has teased the imagination of artists ever since. In a modern projection of the New World's discovery by artist William Steig, mythological terrors no longer abound. Here, the weary members of the explorer's European crew struggle to maintain a heroic stance.

Verrazzano had little notion of the extent of his amazing discovery as he returned the greetings of the Manhattan natives in 1524. Like Columbus, Vespucci, and others before him who had weathered the treacherous Ocean Sea in their small ships, he was convinced the coastal regions he encountered were but negligible interruptions on the westward route to the Indies. His *Dauphine* was expected to return laden with the fabled riches of Cathay that had been so vividly described in the earlier chronicles of Sir John Mandeville and Marco Polo, both of whom wrote in heightened prose about the unsurpassed wealth of the East. Sir John assured his readers that life in the Indies was lived in the utter sumptuousness of silks, jewels, and palaces, while Marco Polo described how precious pearls were in such great abundance in Cipangu that each of that country's dead was buried with a luminous pearl in his mouth. Descriptions of this kind draped in fantasy left an indelible impression on the minds of early navigators, from Columbus onward, who dared the seas in their quest.

Verrazzano had entered a harbor of astounding size and accommodation, yet it was bereft of trading ships. Marco Polo had reported that as many as five thousand ships could be seen at once on one of Cathay's rivers. The figure was an outlandish exaggeration but it successfully conjured up visions of a fabulous trading world in which Europe was anxious to play a role. So, too, did Sir John stir up seafaring fantasies when he claimed he saw a fleet of ships as white as snow designed with great interior halls. Nothing remotely approaching these descriptions greeted Verrazzano in Manhattan's harbor. All was wilderness and quiet, with forests sloping to the very edge of the shores on all sides and small canoes gliding about. Still, the Florentine navigator was convinced he had found an opening to the China seas farther south when he sighted Pamlico Sound across the Outer Banks of North Carolina; only a narrow isthmus, he believed, barred the way. He was profoundly wrong.

Before Verrazzano made for home, he gave Manhattan its first European name, Angoulême. It paid tribute to his patron, Francis I, who was the son of Charles of Angoulême. The explorer further honored the French royal family by declaring that "the bay formed by this land [of Angoulême] we called Santa Margarita after the name of your sister, who surpasses all other matrons in modesty and intellect." French claims to the area proved fleeting, as did the two names. The city that was to be shaped in the next century by other European hands was to be left with virtually no trace of its original French birth, beyond the indelible inscription of its French name on world maps. As geographers were quick to snap up whatever data were brought back to Europe by Francis I's emissary, the name Angoulême was incorporated into engraved charts of the sixteenth century, together with Verrazzano's false Pamlico isthmus leading to Cathay. A woodcut map of 1540, conceived by the cosmographer Sebastian Münster, depicts a Renaissance ship of discovery and charts Verrazzano's findings; it ventures the location of Cipangu as well. That cluster of much-sought-after Japanese islands is seen optimistically closer to the American continent than to Asia, supported by a sixteenth-century belief that the world was two-thirds of its actual circumference.

The Naming of Manhattan

FIGURE 1.4 *Die Neuwen Inseln (The New World), ca. 1540.*
More of South than of North America was known in 1540 but by that date the bay of New York had been cited by Giovanni da Verrazzano. A New World map records the first European name, Angoulême, given to Manhattan Island by the Florentine navigator. Verrazzano's principal mission had been to locate a passage to the "Indies."

FIGURE 1.3 *Francis I and His Sister, Marguerite, 1500.*
Angoulême was the name of the domain of the powerful French monarch Francis I, who is shown with his sister, Marguerite, a lady renowned for her intellectual refinement. It was Francis I who commissioned the Florentine Giovanni da Verrazzano to make a voyage of exploration in 1524, leading to the navigator's discovery of New York.

The Englishman Henry Hudson was, like Verrazzano, searching for a passage to Cathay when his ship the *Half Moon* entered New York bay in the opening decade of the following century. He was not the first to spy the river soon to be named after him, for Verrazzano had attempted to enter its waters eighty-five years earlier but was turned back by unfavorable winds. Other explorers are known to have dropped anchor here later in the sixteenth century and charted the region on world maps. Esteban Gomez, a Portuguese mariner who had sailed the New World seas with Magellan and who sighted the river in 1525 during his explorations for the Spanish crown, named it Rio de San Antonio. Still, it was for Hudson to claim he was the first European to demonstrate the extent and importance of the river after sailing the *Half Moon,* in September 1609, all the way up from the harbor to a point near Albany.

Because Hudson's 1609 trip was his third voyage to the New World, he had a certain familiarity with the coast of North America. He knew firsthand that the upper reaches of the continent were blocked by ice in winter, a condition not forgotten by his crew who were loath to spend time in the frigid conditions of high latitudes. The English voyager believed fervently that, along that coast, near a forty-degree latitude, was a navigational opening offering a northwest passage to China. His friend Captain John Smith, at that very moment making a settlement in Virginia, had provided him with a map as an aid in this quest, leading Hudson to the bay of New York. Since this was a latitude more congenial to the crew, they urged their captain southward. On Hudson's first beholding the broad river that drained into Manhattan's bay, he

The Naming of Manhattan

was certain it was the sought-after waterway to the Indies. But after marking the increasingly shallow soundings taken by his crew and noting the diminishing salinity of the water when they proceeded north toward its source, he understood that the river offered no passage out to China. Faring no better than Verrazzano, Hudson realized on this third hazardous trip to the far side of the Ocean Sea that he had lost one of the great gambles of his seafaring career: finding a westward route to the riches of Cathay had become an obsession with him. There seemed to be nothing sensational to report to the Dutch East India Company in Amsterdam, which had financed the *Half Moon's* voyage of discovery.

Before setting his compass for the return journey, Hudson did some trading with the natives of the region. One of his officers on the *Half Moon,* Robert Juet, who kept the ship's log, reported in his entry for September 11, 1609, that the "people of the Countrey came aboord of us, making shew of love, and gave us Tabacco and Indian Wheat, and departed for the night; but we durst not trust them." He continued his note of caution toward the natives in the next day's entry where he remarked that "there came eight and twenty Canoes full of men, women, and children to betray us. They brought with them Oysters and Beanes, whereof wee bought some. They have great Tabacco pipes of yellow Copper, and Pots of Earth to dresse their meate in."

Hudson apparently made no attempt to name the region he explored. His log-keeping officer had borrowed Columbus's term of "Indian" to qualify the kind of wheat the crew accepted from the natives. The entry for October 2, 1609, is significant, however, for there we find the first mention of the name Manhattan: "We saw a very good piece of ground: and hard by it there was a Cliffe, that looked of the colour of a white greene, as though it were either Copper or Silver Myne: and I thinke it be one of them, by the trees that grow upon it. For they be all burned, and the other places are as greene as grasse; it is on that side of the river that is called Manna-hatta." Hudson evidently wished to perpetuate the Indian name, meaning "island of the hills." It appeared, in variant spellings, on the elaborate Velasco map of the New World prepared two years later. That chart of 1611 was commissioned in England by Don Alonso de Velasco, Spanish ambassador to London, for the eyes of the powerful monarch of Spain.

The natives of Mannahatta, known as the Manates as well as by several other identifications belonging to the wider family of Algonkians, appeared willing to accept cloth, beads, knives, and trinkets from the crew of the *Half Moon* in return for their beaver skins, thereby fostering an exchange. This early bit of New World commerce was immediately recognized by Dutch merchants back in Amsterdam as the basis for a brisk fur trade; the pelts they were getting from Russia were costly. Hudson's trip was nonetheless deemed a failure by the East India Company in Amsterdam despite suggestions in the *Half Moon's* report that the region abounded in copper or silver. Still, Dutch interest in the area was not snuffed out by dissatisfaction with the English naviga-

tor. More ships were subsequently dispatched across the Ocean Sea under the banner of the newly formed Dutch West India Company (DWI).

Initially, the DWI was not concerned with establishing a permanent colony along the Atlantic coast; it aimed primarily to set up a North American outpost where a profitable barter in furs could be conducted with the natives. But as traders began to frequent the port visited by Verrazzano and Hudson, the place called *Mannahatta* slowly took on a European countenance. By 1624, with Manhattan still clothed in forest green, the first traders began to arrive and, in that same year, the skins of four thousand beavers and seven hundred otters were shipped to Holland. This amazing sequel to Hudson's Manhattan visit was something of which the English navigator would never learn. He had long since come to a disastrous end at sea at the hands of a mutinous crew.

With the Dutch in the throes of Europeanizing the small island of Manhattan and its adjoining areas, what was to be the fate of the native population? Dutch attitudes toward just this question were somewhat ambiguous: they were fraught with moral considerations yet overlaid with an insatiable appetite for new trading possibilities. Instructions were given to Hudson River traders by the DWI in Amsterdam to find suitable places for farming that were "abandoned or unoccupied." If there were not sufficient of these, settlers were warned against taking possession of occupied territories "by craft or fraud, lest we call down the wrath of God on our unrighteous beginnings." Possession was to be arranged either in return for trading goods or by means of an amicable agreement. It was a commendable start.

Appointed the first director-general of a trading colony now swelled to a populace of two hundred Europeans in 1626, Peter Minuit opted for a "righteous" beginning. In that year, he summoned the local Manates chiefs to a council regarding the permanent descent of an outside population in their midst. From the chiefs, he acquired Manhattan Island for goods valued at sixty guilders, an amount exceeding the twenty-four-dollar value of popular legend. The bargain weighed heavily in favor of the Dutch since the Indians had no notion whatsoever of real estate: land existed to be shared like the sun and the sea. But Dutch entrepreneurship allowed no dawdling in pushing ahead with trading possibilities. Trade, not colonization, had been the primary reason for the formation of the Dutch West India Company and for the subsequent Dutch presence in the area of Manhattan. And to hallow that presence, Manhattan received its first seventeenth-century European name: Nieuw Amsterdam. Originally assigned to the protective fort built at the southern end of Manhattan, the name eventually stood for all the island. For the wider province of Dutch holdings on the North American coast, the term Nieuw Netherland was assigned.

The Dutch settlement that now assembled itself around the protective fort in southern Manhattan clung tenaciously to its European ways of life, despite a paucity of numbers and accommodations of the most primitive sort. An ad-

NEU AMSTERDAM

Cum Privilegio Ordinum Hollandiæ et West-Frisiæ

mittedly shabby affair, the settlement consisted of small houses made of wood and hovels of bark crowded together for protection. Over the next three decades, the diminutive village would model itself on the look and trappings of a traditional Dutch town. To serve the unloading of barges, a canal was dug that led from the harbor northward right into the colony's midst. A countinghouse materialized, as did a windmill, a brewery, a horse mill, a shed for boatbuilding, a tavern, and a stone church. By the 1640s there was even a gabled inn on the east shore to accommodate the now frequent comings and goings of merchants both from abroad and from nearby colonies.

In this little patch of the New World, the tempo soon picked up. A good part of the bustle emanated from the busy harbor, which served as a staging area for Dutch travelers going home from their ports in South America to Holland and for English ships trading between New England and Virginia. From the start there was an undeniably lusty atmosphere, compounded of practices imported from Amsterdam, a kind of frontier abandon, and a headiness engendered by the speculation of trade. Eighteen languages were reported to be heard among the settlers who practiced an array of religions grudgingly tolerated by the die-hard Calvinists among DWI officials. A general tendency of "treating with good Liquor Liberally" prompted the Dutch settler Nicasius de Sille to observe in the 1650s that "they all drink here, from the moment they are able to lick a spoon." He also remarked with evident satisfaction that, owing to the bounty of the land, "one can live here and forget *Patria*. Beer is brewed here as good as in Holland of barley and wheat." Lawlessness, drunkenness, and poverty picked up, too, as well as bloody skirmishes that often marred contact with the local population. Both a prison and a house for the poor were operating by 1653, by which time the hot-headed Peter Stuyvesant had been administering the colony as director-general for some six years.

During Stuyvesant's tenure, a local government of *schout* (prosecutor), *burgomasters* (local officials), and *schepens* (sheriffs) prevailed. So did a so-called bench of justice, modeled "after the laudable customs of the city of Amsterdam, which gave her name to this first commenced town." The powers of the bench resided in the examination and determination by sentence or arbitration of the civil cases submitted before it. A score of duties assigned to local officials were largely overshadowed by the need to defend the colony. Along the east-west line of today's Wall Street, local officials arranged for the settlers to join in erecting a fortifying wall from river to river to ward off any hostile advances, whether by natives or by the English. The latter were solidly entrenched in colonies to the north, south, and parts of nearby Long Island, fuming at what they considered the illegal presence of the Dutch. Local burgomasters also arranged the establishment of a night watch "to stand guard in full squads over night" at designated places, including the city tavern, which also acted as a city hall. This was the beginning of the "Rattle Watch," or night police. Those assigned to the watch were not to report for duty drunk, to be insolent, or to commit nuisances in making the rounds. They were to collect

FIGURE 1.5 *View of New Amsterdam, ca. 1643.* The Dutch gave a second European name to Manhattan in 1624, Nieuw Amsterdam. Originally assigned only to the fort built at the southern end of the New World colony, it was to endure as Manhattan's identification for forty years of Dutch rule. The name is seen in the banderole of the engraving; fanciful figures fill the foreground.

The Naming of Manhattan

FIGURE 1.6 *King Charles II with the Diarist Samuel Pepys, ca. 1663.*
Seventeenth-century rivalry between the Dutch and the English for overseas possessions is vividly recorded in the famed diary of Samuel Pepys, secretary to the admiralty. "The Dutch are with twenty-two sail of ships of war," Pepys noted peevishly on August 27, 1664, "at which we are alarmed." He need not have been.

fifteen stivers, the equivalent of thirty cents, from each household monthly for the support of the watch.

The Dutch were not successful in safeguarding their city despite the barricade they erected and the somewhat naive preparations they made against an assault by a major power. Nor were the entreaties of the population to Holland heeded. Local council members had warned the Amsterdam authorities that the "country has arrived to that state that if it be not now assisted it will not need any aid hereafter because the English will wholly absorb it. . . . It will lose even the name New Netherland and no Dutchman will have anything to say there." The English had long had their eye on Manhattan. As far back as 1623, they had begun a series of diplomatic attacks on the Dutch title to New Netherland, which they sustained for a number of decades. Their possession of colonies to the north and south of the New Netherland settlement gave them the right, they believed, to claim uninterrupted possession of that part of the Atlantic coast.

Although England and Holland were at peace in 1664, relations between the two countries were decidedly mettlesome. At the core of the squabbling was a battle for marine hegemony on the high seas both in the Old World and the New. England was on the cusp of her rise as a sea power and saw the Netherlands as an unwanted rival. Annexing the fledgling New Amsterdam colony as a prize was only a minor consideration, as reflected in the 1664 diary entries of Samuel Pepys, then secretary to the admiralty. "Great talk of the Dutch proclaiming themselves, in India, Lords of the Southern Seas, and deny traffick there to all ships but their own . . . which makes our merchants mad," he noted on February ninth. The recorded talks of the admiralty secretary with King Charles II, as well as with his brother the Duke of York and court officials, map the rising tide in the English battle to diminish the marine glory of her European neighbor. "All the news this day is," Pepys noted on August twenty-seventh, "that the Dutch are with twenty-two sail of ships of war cruising up and down about Ostend; at which we are alarmed." It proved to be not the sort of alarm to crimp English trading ambitions. The upshot was that King Charles II—declaring the Dutch to be usurpers in the New World—ordered four warships to cross the Atlantic and take possession of Manhattan Island that very summer.

His Majesty's forces met with little resistance on the part of the Dutch: not a shot was fired in the New World colony. Because of poor defenses and a food shortage, and because, as the Dutch had said, the city's founders in Amsterdam had neglected and forgotten them, the colonists were not able to put up resistance. Besides, the surrounding English colonies had been enjoined to support the mother country. Governor Winthrop of Connecticut wrote rather sympathetically to Stuyvesant, just as the English prepared to invade, that

I thought fitt to give you this friendly advertisemet, That I undersand his Ma^ties [Majesty's] comand concerning this businesse is urgent: and yt although he hath sent over very considerable forces exceedingly well fitted w^th all necessaries for warre w^th

such Ingineers, & other expedients for the forcing the strongest fortifications, yet hath also given them order to require assistance of all his Ma^ties Colones, & subjects in New England and hath directed his particular commands in his Royall letters to our Colonies.

Stuyvesant heroically attempted to hold out, replying passionately to the supplications of his townspeople for a peaceful surrender that "I had much rather be carried out dead!"

Ultimately, the British envoy accepted Stuyvesant's proposal for a treaty of surrender in order, as the Dutch governor said, to prevent the effusion of blood and to improve the good of the inhabitants. At eight o'clock on the morning of August 27, 1664, the articles of surrender were arranged by the joint Dutch and English commissioners at Stuyvesant's own farm, the Bowery. Writing later to the "Illustrious, High and Mighty Lords" in Holland with regard to the circumstances of the surrender, the feisty governor concluded his account "praying that God will temper this loss with other more notable successes and prosper your government."

Soon after the takeover, the conquerors were demanding an oath of allegiance to the British king. The Dutch, who had been promised the "liberty of their Consciences in Divine Worship" and the right to "Enjoy their owne Customes," were horrified. Objections and squabbles ensued, but there was little the vanquished could do. Dutch officials, including the *schout, burgomasters,* and *schepens* had no choice but to take the oath, and they even approved a letter to be sent to the Duke of York, who had been granted the New World territory by his brother King Charles II. In their letter they declared themselves fortunate that the duke had provided them "with so gentle, wise and intelligent a gentleman" for governor as Colonel Richard Nicolls. They were confident that "under the wings of this valiant gentleman," the former Dutch city would "bloom and grow like the Cedar on Lebanon." In honor of the thirty-one-year-old Duke of York, later to be crowned King James II, New Amsterdam was henceforth named New York. "Now begins New Netherland to lose its name," exulted an English chronicler of these events, "for His Majesty . . . [has] appointed collonel Nicholls Governour who [has] chang'd the Names of some of the Principal places." The city had already begun to build a historic past.

With the installation of Colonel Richard Nicolls as the first royal governor, the British would have more than a century to leave their stamp on the newly named colony. Nicolls revoked the Dutch "fforme and Ceremony of Government . . . under the name of . . . Sc[h]out, Burgomasters, & Schepens" for a "Mayor Alderman & Sherriffe," the time-honored officialdom of British municipal government. The new colonial hold on Manhattan got off to a shaky start, however. Hostilities between England and the Netherlands flared up again with a renewal of war in 1672. During a temporary absence in the summer of 1673 of the second governor, Colonel Richard Lovelace, a Dutch

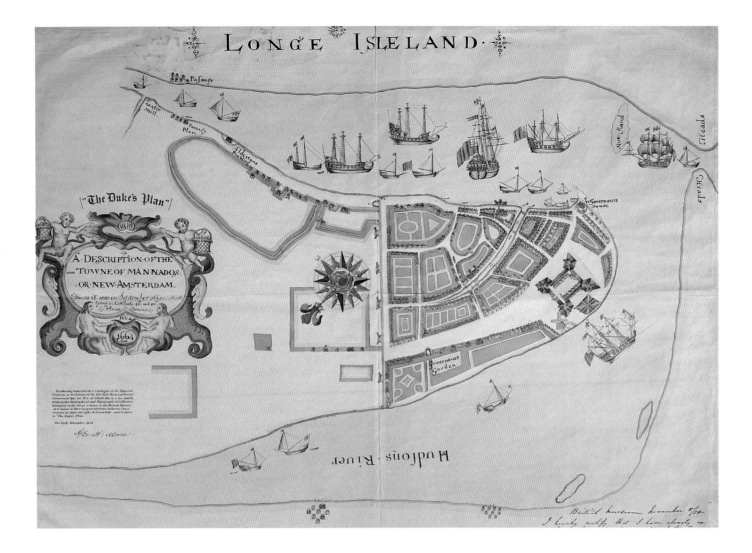

FIGURE 1.7
The Duke's Plan of Manhattan, 1661–4.
Following the British takover of Manhattan
in 1664, the colonial outpost acquired its
third European name *New York*. It was a
tribute to the thirty-one-year-old James,
Duke of York, who had been awarded the
overseas territory by his brother King
Charles II. The Duke of York closely
administered his new domain but never
visited it.

The City of New Orange, 1673, as then sketched.

the Fort & Church, _ B. Governor's house & the dock _ C. the Canal in Broad St. _ D. Rondeel or Battery _ E. Stadt-huys _ F. Gate & Wall on Wall S.

FIGURE 1.8 *Map of New Orange, 1673.*
During a temporary absence of the
English governor, a Dutch fleet appeared
in Manhattan's harbor and successfully
reclaimed the overseas territory. Thereupon,
the former Dutch colony received its fourth
European name, *New Orange.* It was to last
for less than a year, when the English were
once more triumphant as colonial rulers.

fleet appeared in Manhattan's harbor, successfully reclaiming the colony. For the fourth time, the colonial city was baptized with yet another European name: New Orange. A report sent back to Holland proudly announced the capture of "this entire Province of New Netherland, consisting of three cities and thirty villages." Anthony Colve was made Dutch administrator, and the city government of New Orange reverted to the system of *schout, burgomasters,* and *schepens.*

This glorious triumph of the Dutch was, in turn, short lived. In a further reshuffling of colonial sovereignty, New Netherland was restored to England nine months later by the Treaty of Westminster and Sir Edmund Andros installed as English governor. "I cannot delay giving you this Early Acampt [*sic*] of my having in the Behalf of his Ma^tie Received Saturday Last, this Place and dependences, from the Dutch," wrote Andros exultantly to the governor of Connecticut, "not doubting of yo^r Satisfaction in the Newes." Once again, the island was to be known by its former name of New York.

A campaign to attract settlers was begun within six years of the English resumption of power. Daniel Denton, an Englishman who had bought from the Indians a tract of land in the area of today's borough of Queens, was enjoined to promote immigration. He went about it with gusto. His booklet of 1670, describing the boundless attractions of the New York region, is couched in the kind of compelling prose familiar in the tales of Marco Polo and equally familiar in the hyperbole of modern advertising. Addressed to an English audience, it discourses on the topography of the region, on Dutch-English coexistence, on agricultural pursuits in the outlying areas of Manhattan, on the steady trading with the Indians, and on the infinite resources of land and sea. He waxes ecstatic about the region's abundance of fruits:

> The fruits natural [to the area] are Mulberries, Posimons, Grapes great and small, Huckelberries, Cramberries, Plums of several sorts, Rosberries and Strawberries, of which last is such abundance in June, that the Fields and Woods are died red: Which the Countrey-people perceiving, instantly arm themselves with bottles of Wine, Cream, and Sugar and in stead of a Coat of Male, every one takes a Female upon his Horse behind him, and so rushing violently into the fields, never leave till they disrob'd them of their red colours.

The voluble Denton unabashedly promotes Manhattan and the "places thereunto adjoining" as no less than a long-lost Eden. "I may say, and say truly, that if there be any terrestrial happiness to be had by people of all ranks . . . it must certainly be here."

Clearly, the New York area was nowhere near the paradise Denton depicted. Daily life in the settled areas of southern Manhattan was marred by muddy, unpaved streets, by the presence of hogs running in every direction, and by the offensive stench that came from the canal dug along the present-day Broad Street when the water dried up. Dissatisfaction with many in the new line of governors sent by the Crown led to a nasty rebellion in 1689; pesky trade re-

*ain Henry Hudson discovered this Country An: 1609 and sold it to y'r Hollanders & Letters Patents being granted to some Merch:ts by y'e States ...y was settled An: 1614 call'd New Netherland. But J. Samuel Argal Governour of Virginia gave them disturbance ere they were warm in their Quarters hav... ...applieation to King James he permitted them to build some Cottages for the Entertainment of Shipping that came for Water under which umbrage they Towns and fortifie them and upon expectation of a Governour from Amsterdam, they refuse to pay the accustomed Tribute & declare themselves and the Amsterdam sold Proprieters which being complain'd of by King Charles to his Embassador to y'e State at the Hague, they by Publick Instrument declare ...who is a private undertaking of some Merchants at Amsterdam, then Complysant being granted by King Charles for Selling Colonies to the Southward, & ...for disorard of them, they declare themselves willing to depart and leave all they had, upon condition of the payment of give but the trouble in England soon ...eaking out they receed from their first proposals and begin to strengthen themselves by all possible means. Thus affairs stood till after y'e Restauration ...g Charles y'e 2. who being inform'd of his Right resolved to Seize on it and accordingly it was recovered by J'r Robert (for those of the Inhabitants y'e remained.

A South Prospect of y'e Flourishing City of N...

1. The Fort. 2. The Chappel in the Fort. 3. The Secretaries Office. 4. The Great Dock with a bridge over it. 5. The Ruins of White Hall built by Governour Duncan. 6. Part of Nutten I...

FIGURE 1.9 *A South Prospect of New York (detail), ca. 1717.*
English printmakers grandly projected New York as a colonial seaport steadily gaining prominence on the New World side of the Atlantic. Crowded with telling details, the panorama was painstakingly prepared by the artist William Burgis and sent to London to be engraved on four sheets of copper in glorification of England's expanding empire.

...k in the Province of New York in America.

... Lower Market 9. The Crane 10. The Great Fish Market. 11. The City Arms supported by Peace. 12. The Dutch Church. 13 The English Church. 14 The City Hall. 15 The Exchange

P. Harris

taking Oath of fidelity to the King of England, the other being Liberty to remove with all their Effects. Now begins New Netherland to loose its name, His Majesty having conferred by Patent upon his Royal Highness all acquisitions made upon Foreigners. His Royal Highness appointed Collonel Nicholls Governour he, chang'd the Name of some of the Principal places and concluded a League, between ye Inhabitants & ye Indians, & in ye Year 1675 upon conclusion of War with the Dutch they had surrender made over to them by the Treaty as an Equivalent for new York. The Province of new York is divided into 10 Counties, the City one then, Albany, Ulster, Dutches, Orange, Kings, Queens, Suffolk, Chester, and Richmond, ye City of new York is builded on a point of Land, & under ye late having a Corporation on a West part, & on ye Lat. 41. 40 Long 74. 20 In a good Air. The Province abounds with all Necessary of Life and hath a Governour Council & General Assembly the City hath a Mayor, Aldermen & Sheriff, & is under the Regulation of the English Laws, and Customs. The Trade of ye City in a few Years is become almost Universal, her Merchants having extended their Commerce to most ports of ye known World. The Harbour is capa of Ships of ye greatest burthens, & very secure lying 12 miles from ye Sea, having great convenience of Building of Ships & vast Quantities of fine Timber in ye adjacent W...

FIGURE 1.10 *A New Map of the West Indies, 1741.*
The English recapture of New York had closed the gap in that country's territorial claims along the Atlantic between New England and the southern colonies. Emboldened by their permanent victory over Dutch possessions in the New World, the English grandly renamed the northern Atlantic seaboard *Sea of the British Empire.*

strictions, imposed by a mother country ever watchful over her own trade, threatened to undermine the city's potential as a profit-making seaport. Still, it was during the century of English rule that the substructure of a metropolis took shape. A merchants' exchange, a fire department, a press, a theater, a college, a library, and an organized union for workers came into being. So did an opposition newspaper that did not reflect the Royalist view. These and a host of equally important innovations pointed to Manhattan's irreversible bid for a cosmopolitan destiny. Nor was there a change in the noticeably lusty tone of the place during this era of English sovereignty. Observations penned in 1695 by the Reverend John Miller are unsparing in this regard. Appointed "Chaplain of the two Companies of foot in the Colony of Newyorke," the Reverend Miller laid the lash on heavily in describing what he considered the colony's dissolute environment during his three-year residency:

> The number of the inhabitants in this Province are about 3000 families whereof almost one halfe are naturally Dutch a great part English and the rest French which how they are seated & what number of families of each Nation what Churches, meeting houses Ministers or pretended Ministers there are in each County may be best discerned by the table here inserted. As to their Religion they are very miuch divided. few of them intelligent & sincere but the most part ignorant & conceited, fickle & regardless. As to their wealth & disposition thereto ye Dutch are rich & sparing, the English neither very rich nor too great husbands, the French are poor and therefore forced to be penurious. As to their way of trade & dealing they are all generally cunning and crafty but many of them not so just to their words as they should be.

Gaiety, dissipation, and a certain peccancy continued to be durable features of the lively seaport during the seventeenth century and most of the eighteenth. "The people of New York," observed Alexander Hamilton, a visiting Scottish physician, "are seemingly civil and courteous. To drink stoutly with the Hungarian Club, who are all bumper men, is the readiest way for a stranger to recommend himself, and a set among them are very fond of making a stranger drunk. To talk bawdy and have a knack at punning passes among them for good sterling wit. Gouvernor Clinton himself is a jolly toaper." The story presents itself in terms of a feisty colony moving inexorably forward in shipping and trade, with a population expanding to well over twenty thousand by mid-eighteenth century.

Physical expansion of the city was another story. It had been abruptly curtailed under the Duke of York when separate royal counties were made of the area adjoining the island of Manhattan. They were given the solidly English names of Albany, Chester, Dutchess, Kings, Orange, Queens, Richmond, Suffolk, and Ulster, all of them resonating with links to the British aristocracy. Then, in a gesture that could have been crippling, the duke awarded the west bank of the Hudson to a core of English settlers who promptly called the territory *New Jersey*. It was surely odd that New York was not awarded claim to the two shores of a river that gave the city its unique

The Naming of Manhattan

FIGURE I.11 *The First President Taking the Oath of Office, 1789.*
Post-Revolutionary New York embarked on a spirited course to show that, while it retained its colonial name, its rise as an independent polity would be spectacular. It became the first capital of the new republic where statuesque George Washington, that minuscule figure on the balcony, solemnly took his oath of office as first president.

character. New Jersey tried, but never managed, to develop a competing port. Even at this early date, as the colonial authorities were shortly to report, the prosperity of New York was gaining fast ground: "Trade of this City in a few Years is become almost Universal, her Merchants having extended their Commerce to most parts of Ye known World. The Harbour is capable of Ships of ye greatest burthens, & very secure lying 12 miles from ye Sea, having great convenience of Building of Ships, & vast Quantities of fine Timber in the adjacent Woods." It was all true.

In 1717, while not really ready for it, colonial New York was lined up with the seaports of Boston, Philadelphia, and Charleston in a quartet of engravings designed to show off the flourishing commerce in their harbors. Crowded with architectural detail, the oversized panoramas were painstakingly prepared by resident artists and then sent to England to be professionally engraved. Each of the four-foot copperplate panoramas attested to the pride of England in what was clearly seen as the ever-expanding prosperity of its New World possessions. Each panorama looms as a buoyant specimen of eighteenth-century topographic art. An extensive caption accompanying the New York engraving offers a brief history of the city in which the English navigator Henry Hudson is given credit for having "discovered this Country [of New York], anno 1609, and sold it to ye Hollanders."

Manhattan was, in reality, not as imposing in population or wealth as the other three ports honored by the eighteenth-century quartet of engravings. Indeed, the Boston caption concedes that the Massachusetts city is "Mistress of North America." Competition would be keen for New York to overtake the New England city as well as to bypass Philadelphia and Charleston in population and prosperity. But New York's potential for greatness was already palpable; it would be realized despite a long, interruptive pause caused by the battle for disengagement from the mother country. In 1776 a somewhat reluctant New York joined her colonial counterparts in waging a prolonged war for independence from the British Crown. In so doing, it became an enemy base with all the attendant horrors of confiscated quarters, disease, cold, crowding, scarcity of food, and skyrocketing prices. Captured patriots were herded into filthy jails or rotting prison ships lined up in the East River, while major battles were fought on its soil and the nascent metropolis laid in ruins. At war's end, a hard-won victory gave New York yet another birth though not another name: it became an independent, *American* city.

Post-Revolutionary New York subsequently embarked on a long and spirited venture to show that, while it retained its colonial name, its resurgence as an independent polity over the next two centuries would be spectacular. The rise to eminence would be cultural as well as commercial, with the population steadily expanding from a count of 33,131 taken in the first census of 1790. It was then already being said that the city "was every day growing into symmetry, elegance and beauty," as claimed by the *Daily Advertiser* of November 23, 1790. Inevitably, there was a move to burst the boundaries of the narrow geographic profile imposed on it by the Duke of York. The city managed

THE EUROPEAN DISCOVERY

CHAPTER TWO

A MULTIRELIGIOUS DESTINY

The Early Establishment of Religious Pluralism in Churches and Schools

Churches

Wicked! Irreligious! thundered the Reverend John Miller, appalled by the libertine practices of New Yorkers that he witnessed during his Anglican chaplaincy at the close of the seventeenth century. Piety, it seems, did not hang heavy in the air of the New World settlement during either Dutch or English times. Colonists who crossed the Atlantic to test their fortunes in the promising newness of Manhattan were almost immediately caught up in the lusty, frontier atmosphere of the place where the focus was on the propagation of trade, not faith. That, according to the Reverend Miller, was exactly the problem. Not only were traders cunning and crafty in his view but he found that "in most people of what Sect or party soever they p'tend to be, their eternall interests are their least concerne." Yet those who settled here were likely to have been reared abroad in the tradition of churchgoing for the salvation of their souls.

Merchants of the Dutch West India Company had brought with them European attitudes toward religion, symbolized in the rites of the Reformed Dutch Church. They envisioned their colonial settlement of the early 1600s as an extension of the Calvinist state that prevailed at home. Though Calvinists were by no means in the majority in Holland, the Reformed Dutch Church was indisputably the privileged denomination. For most of the population, churchgoing was an integral part of Dutch life and had taken on particular significance for Calvinists: the Dutch Republic and Calvinism were honorably intertwined in a struggle to throw off the yoke of hated Catholic Spain.

Instructions from Amsterdam to the successive directors of the Manhattan settlement made clear that only the Reformed Dutch Church would enjoy official recognition. Colonial administrators were accordingly enjoined to promote Calvinist worship, short of embarking on the kind of religious crusade to suppress heresies desired by the church's *predikanten* (preachers) who were particularly zealous. Erecting a proper church building was given high priority, though a want of materials and labor in the primitive settlement delayed this for some time. Fears by foreign settlers that the Dutch would create a theocracy in this corner of the New World never took hold, for almost immediately, ecclesiastical affairs assumed a direction other than that envisioned by the Dutch West India Company.

FIGURE 2.1 *Portrait of the Syndics of the Drapers' Guild by Rembrandt, 1662.* The Dutch practice in Holland of "hidden churches" fostered religious pluralism in the colony of New Amsterdam, though none but Calvinist ministers were licensed to hold services. Two prominent Dutchmen who conducted unlicensed Catholic rituals behind closed doors in Amsterdam form part of Rembrandt's famous group of merchants.

By the 1640s, as the tiny Manhattan settlement grew in numbers and in ethnic diversity, so did the chorus of tongues. The fact that eighteen languages were purportedly heard among those making their way in and out of Manhattan's harbor meant a profusion of faiths as well. Among the colonial dwellers, then numbering not quite three hundred, were Calvinists, Puritans, Lutherans, Mennonites, and Jews, all of them anxious to maintain their own covenants of faith in the wilderness and seeking the tolerance, if not the blessing, of the Dutch authorities. It soon became evident to the latter that their Reformed Church, which had begun receiving its congregation in the only accommodation available—a loft above the horse mill near the colony's fort—could never claim a monopoly on the word of God. Even when a stone church was built in the southeast corner of the fort compound, it was a shabby affair that hardly radiated a sense of ecclesiastical authority. A visiting patroon pronounced it unworthy to serve as a shining beacon of Calvinist doctrine.

The religious pluralism that flourished in the struggling Manhattan settlement grew out of practical considerations. It took its direction from the mother country where religious tolerance, never officially espoused in the seventeenth century, nonetheless prevailed. The problem peculiar to the colony was that attracting traders proved to be difficult enough without imposing religious restrictions. A group of French-speaking Protestants from southern Holland known as Walloons, who had been among the earliest lured to the New World by the Dutch, would have looked askance at any attempt by the company to insist on the official or exclusive standing of the Dutch Reformed Church. They themselves were followers of a group that had fled to Holland from French religious persecution, subsequent to the Saint Bartholomew's Day massacre of 1572. But the exclusive standing of the Reformed Dutch Church was exactly what the *predikanten* would have wished; it was over their protesting voices that a de facto tolerance reigned in their New World colony. With each wave of settlers to Manhattan's shores, the aversion to heterodoxy was newly aired by the *predikanten* but, in the long run, the West India Company deemed it more practicable, in the exercise of its commercial interests, to allow the practices of other faiths. An accommodation was sought so as not to make the colony a locus of religious squabbles.

In Holland, the ingenious way that allowance had been made for dissenters was through a benign policy of so-called connivance. This was the practice of turning a blind eye to the existence of *schuilkerken,* or "hidden churches." Originally developed in the city of Amsterdam by the unpopular minority Catholics, *schuilkerken* were rooms converted to places of worship on the ground floor or in attics of private homes. The artist Jan Vermeer, a chronicler of Dutch life in the seventeenth century, was obliged to attend services in this way when he converted to Catholicism following his marriage in 1653. In no time the practice was taken up by other religious congregations. While some of the concealed "churches" occupying several floors were too elaborate to escape public detection, a tacit sufferance prevailed. It could scarcely be otherwise. Many of the city's powerful, mercantile contributors to Holland's golden age were nonad-

herents of the Reformed Church. Mercantilism spelled Holland's well-being, and the exigencies of mercantilism embraced all faiths. In one of his familiar group paintings, Rembrandt immortalized two prominent merchant-Catholics who were known to conduct *schuilkerken* in their homes.

Hidden churches were not at all to the liking of the irascible Peter Stuyvesant when he came on board as director-general of New Amsterdam in 1647. Together with the resident *predikant* named Johannes Megapolensis, he constantly jousted with his Amsterdam superiors when their focus on trade liberalized their religious views. Both Stuyvesant and Megapolensis would have liked to rout all the "servants of Baal" making their way to Manhattan, their proclaimed fear being that a tolerance of heterodoxy would channel the nascent colony into a disorderly haven for heretics and fanatics.

Separate boatloads of Lutherans, Jews, and Quakers arrived during the course of Stuyvesant's tenure. With the collaboration of Megapolensis, the director-general railed against their entry in his reports to Amsterdam. When the Lutherans petitioned Stuyvesant for the right to public worship, he slapped a fine on what he called their "unqualified preachers" and threw some of the offenders in jail. In the summer of 1654 Jews began to arrive, planning to trade; they were viewed by Megapolensis as "godless rascals." Most were descendants of Sephardim from Spain who had been displaced to Portugal in the time of Columbus and who then moved to the Netherlands. A group of them had gone to Brazil when the Dutch held control in the city of Recife, but when that control was lost they were exiled and looked to New Amsterdam for a fresh start. On their arrival, Megapolensis fired off a protest to Amsterdam. "For as we have here Papists, Mennonites and Lutherans among the Dutch; also many Puritans or Independents, and many Atheists and various other servants of Baal . . . it would create a still further confusion if the obstinate and immovable Jews came to settle here." He accordingly sought permission to forbid all Jews to "infest New Netherland." Word came from Amsterdam that there was land enough for all and besides, Megapolensis was reminded, many Jews were principal shareholders in the Dutch West India Company.

Of all the undesired sectarians, the Quakers were seen as the ultimate scourge visited on the colony. In 1657 a boatload of Quakers arrived who were members of a new and radical English sect. They were unbound to the Bible or to an established church, and when their ship docked in Manhattan's harbor, their leader felt no compulsion to doff his hat deferentially on meeting the authorities. Stuyvesant, who could abide neither their costume nor their public manifestations, and who characterized the sect as nothing less than "a new unheard of abominable heresy," issued strict ordinances against receiving or harboring them.

When the Amsterdam authorities were supplicated by Stuyvesant and Megapolensis to make a ruling unfavorable to all the so-called heretics as they sought preaching licenses for their ministers, the answer was unswerving each time a petition was freshly submitted: Lutherans, Jews, and Quakers were to be allowed to practice their faiths "peacefully and quietly in their own houses." Such a de-

cision was characteristic of Dutch West India Company members who invariably attempted to finesse their anxieties and accordingly sought a policy of religious toleration that had to be discreetly, rather than openly, declared. Their solution for working out the problem of religious diversity was the one known to them of *oogluiking* and *conniventie,* that is, of blinking and conniving. Explicit instructions were given to Stuyvesant to "shut your eyes, at least not force people's consciences, but allow everyone to have his own belief, as long as he behaves quietly and legally." Pluralism, the West India Company directors knew, was the key to the swelling of the colonial population, which in turn swelled the possibilities of trade.

Religious tolerance was largely furthered by the English, when they arrived in the colony in 1664 as victors, accompanied by the repeated admonition to successive royal governors that the various sects "give noe disturbance to ye publick peace, nor doe molest or disquiet others in ye free exercise of their religion." Sir Edmund Andros, one of the earliest of the royal governors and the first to make his way grandly about the colony in a horse-drawn coach, reported that there were then "abt 20 churches or Meeting places" but lamented the lack of clerical leadership. "If good Ministers could be had to goe theither [it] might doe well and gaine much upon those people," he added. Thomas Dongan, who served for eight years as British governor of New York from 1682, tabulated the various denominations that existed in his domain: "Here bee not many of the Church of England, few Roman Catholicks; abundance of Quaker preachers men and Women especially; Singing Quakers; Ranting Quakers; Sabbatarians; Antisabbatarians; Some Anabaptists some Independents, some Jews, in short of all sorts of opinions there are some, and the most part, of none at all."

Himself a professed Catholic born in Ireland, Dongan was concerned, as had been Andros, that there were not enough ministers representing this cluster of religions. He reported the problem to the Crown, commenting that, because New Yorkers were "generaly of a turbulent disposition," a lack of licensed ecclesiastics made matters rather untidy. This engendered a further problem, raised earlier by Andros. "Ministers have been so scarce & Religions many," he declared, "that noe acct cann be given of Childrens births or Christenings." Local sheriffs were accordingly deputized to make lists of the christenings, marriages, and burials that had taken place in their provinces in the previous seven years, giving sheriffs almost as much moral as legal monitoring to do. Ministers in good standing, it seems, were reluctant to leave their well-established parishes in Europe for risky conditions in the New World. An absence of concerted moral authority made matters more difficult for the colonial governor, whose subjects were not distinguished for their piety. Dongan was swift to punish excessive mischief in his domain yet he was shy of calling New Yorkers *wicked* as would the Reverend Miller in 1695. The flaming denunciation by that offended churchman reflected the conspicuously secular tone of the New York settlement, which set it apart from other seventeenth-century colonies that had come into being along the East Coast.

CAPT. T. WEBB
preaching in the barracks in N. York

During Dongan's governorship in the 1680s, scarcely any of the practicing faiths could boast a proper house of worship in which they could take pride. The little stone church that had been built in the fort in 1643 was being shared by English and Dutch congregations, but it was no longer adequate. Most other religions could not claim even that modest accommodation since they were still being practiced in rooms set aside for the purpose. Those that did, however, could expect a benign nod from the government. On a petition from the Lutherans to have their church and parsonage exempted from taxes, Dongan and the council agreed that this should be granted as it had been to the "Dutch and ffrench Ministers." With regard to the Church of England, Dongan viewed the lack of an appropriate edifice particularly regrettable and beseeched his London superiors to take note: "The Great Church which serves both the English and the Dutch is within the Fort which is found to bee very inconvenient; therefore I desire that there may bee an order for their building another, ground being layd out for that purpose, and they wanting not money in Store where with all to build it."

The prod from the governor proved effective. Not long after, the first Trinity Church building came into being at the commanding location of Wall Street and Broadway where services were first held in the spring of 1698. Built of brick, the graceful steeple of the church was to dominate Manhattan's skyline for more than a century. Farther south on Broadway, the Lutherans built their own church but it was dwarfed by the more pretentious Anglican meetinghouse. Only Trinity seemed to merit comment by Thomas Pownall, a colonial secretary in the 1750s, who remarked that the two churches on the west side of Broadway "are the Lutheran Church & the English Church called Trinity Church a very large plain brick Building, but within as spacious commodious & handsome a Place of Worship as I ever saw belonging to a private Parish." And no wonder. Following the erection of Trinity, constant touches of elegance were added. An organ had been especially ordered and, after its arrival in 1740, it was voted "that the Organ pipes be gilded with gold Leaf in such manner as the [Church] Committee shall think proper." In a further effort to please the aesthetic tastes of the congregation, it was deemed that, in the decorative motifs on the pillars supporting the galleries, "there be a Crown and Cherub alternately instead of all Cherubs."

During Pownall's tenure, a small number of the motley congregations in the colony began to claim a church of their own. Modest though they were, the designs of the churches invariably followed European models with conspicuous spires that pointed skyward clamoring for the attention of God. Very often the only identifiable features in eighteenth-century topographical renderings of Manhattan were the church towers. It was a time when clergymen officiating at these churches served not only as the emancipators of troubled souls but also as the thinkers and theologians of their day. Their moral authority was undisputed since the hubris of science had not yet displaced the hubris of religion. Meanwhile the various professions of faith increased with the population, which stood at nearly thirty thousand in 1770.

FIGURE 2.2 *The Preaching of Methodism, 1768.* With the installation of English rule in 1664, various religious practices were licensed. New York was to become a leading center of Methodism following the building of the first Methodist church at 44 John Street in 1768. Here the British officer Captain Thomas Webb, an ardent Methodist follower, preaches in local army barracks.

Churches and Schools

FIGURE 2.3 *Trinity Church, ca. 1790.*
From the time it was formed in 1697, Trinity Church at Broadway and Wall Street numbered among its Anglican parishioners the city's most distinguished residents. It also dug its roots deep into the Manhattan scene with lucrative property holdings and the naming of a whole loop of streets that reverberate today with its church history.

From the beginning of its history, Trinity numbered among its parishioners the city's most distinguished residents, some of whose descendants still worship there. It also dug its roots deep into the Manhattan scene with the naming of a whole loop of streets that reverberate with its church history. Church and Chapel Streets take the lead with Vesey and Barclay following; the latter were named after Trinity's first two rectors. Varick, Morris, Bayard, Lispenard, White, Reade, Delancy, Duane, and Harrison are more streets with Trinity connections. Trinity's financial status was made secure beyond measure when Queen Anne gave the young parish a generous tract of land in 1705: as the years wore on, its property holdings became exceedingly lucrative.

Trinity generously shared its largesse with other churches by giving sizable doses of seed money in a move to create a network of schools and charitable institutions. It was the prime mover in creating a college to serve Manhattan, named King's College. The Anglican church eventually became the parent of seven subsidiary chapels, which included some of the largest and most beautiful church structures in New York. Saint Paul's Chapel, built in 1766 in Georgian style at Broadway and Fulton Street, is one of them: it is the American equivalent of Saint Martin's-in-the-Fields in London.

Patrick M'Robert, a well-to-do Scotsman visiting Manhattan just before the outbreak of the Revolutionary War, agreed that some of the religious buildings could make a claim for elegance. New Yorkers, he reported, "have three English churches, three Presbyterian, two Dutch Lutheran, two Dutch Calvinists, all neat and well finished buildings, besides a French, an Anabaptist, a Methodist, a Quaker meeting, a Moravian church, and a Jews synagogue." Within two years of his visit, a number of these structures met an unhappy fate in the opening years of the Revolution either through the exigencies of military occupation or at the hands of a disastrous fire in 1776 that consumed a third of the city. Trinity Church was reduced to a shell by the fire; what we see today is its third, not second, architectural incarnation. The Middle Dutch Church, a substantial building opened in 1729 on Nassau Street, suffered the indignity of being used both as a riding school and as a prison by British forces billeted in Manhattan.

M'Robert does not include a Catholic church in his tabulation for the simple reason that there was none at the time. Although some Catholic families had managed to settle in New York during Dongan's administration, subsequent Protestant governors sent by the Crown made clear their hostility to what was called papism. Oppressive laws were passed whereby no Catholic clergyman was given permission to officiate in the city. Not until after the Revolution was the first Catholic church erected at the corner of Barclay and Church Streets and named Saint Peter's. When it was rebuilt in 1840, it surprisingly eschewed Gothic motifs for a pagan flavor, offering itself as the city's finest example of a temple church. Its impressive Ionic columns beneath the pediment reflect the fact that the Greek-revival style of architecture was then all the rage. Saint Peter's may have been the inspiration for the Village Presby-

J.R. BRADY
Architect.

A.J.DAVIS. del.
Imbert's Litho.

בהכנ דקק בני ישורון תקפה לפק

The Synagogue of the Congregation B'nai Jeshuruen..... New York, A.M. 5587.

FIGURE 2.4 (facing page) *Synagogue of B'nai Jeshurun, 1830.*
Synagogues and churches built in the early nineteenth century
often followed classical motifs in architecture. A Greek temple
motif commands the edifice of the synagogue of the congrega-
tion B'nai Jeshurun, located on the east side of Lafayette Street,
south of Howard.

FIGURE 2.5 (above) *Saint Thomas Church, ca. 1835.*
Erected at the northwest corner of Broadway and Houston
Streets in 1824, Saint Thomas Episcopal Church attracted a
fashionable congregation. When the church moved to its present
site on Fifth Avenue at Fifty-third Street, a procession of its
elegant parishioners sparked the idea of the now-traditional
Easter parade along Fifth Avenue.

FIGURE 2.6

The Beecher Trial in Brooklyn, 1875.
One of the notable churches of the
nineteenth century was the Plymouth
(Congregational) Church in Brooklyn.
There Henry Ward Beecher used his
eloquence to expound his liberal views on
abolition, temperance, woman's suffrage, and
the theory of evolution. His court trial on
charges of adultery caused a sensation.

terian Church, another splendid temple church on West Thirteenth Street, modeled after the Theseum in Greece. A fair number of temples were built in lower Manhattan in the 1840s, identifiable today by their columned facades and imposing pediments.

Throughout the nineteenth century, the flowering of churches kept pace with other construction and with a population growth due mostly to successive waves of immigration. The churches slowly dotted the moral landscape of the city in coveted or inconspicuous locations, at once a part of their busy neighborhoods and proud of being able to offer an abrupt change of pace inside their hushed portals. For these churches, designers borrowed from every conceivable style of European architecture. Many gems among them remain: Saint Mark's-in-the-Bowery on East Tenth Street is particularly noticed by passers-by; its Georgian-inspired central structure dates from the eighteenth century as opposed to the nineteenth-century additions of tower, portico, and steeple. Other nineteenth-century places of worship are not as conspicuous or as well-known as Saint Mark's and rely on the transient attention given them by walking tour guides who rescue them from oblivion. They are "hidden" churches, laments the architecture critic Ada Louise Huxtable, using the term in a departure from the earlier Dutch adaptation of it. Some of those she singles out are the Church of the Transfiguration on Mott Street, the Bialystokes Synagogue on Willett Street, Saint Luke's Chapel on Hudson Street, and two on Henry Street: Saint Augustine's Chapel and the Sea and Land Church. All of them, boasting a distinct Georgian-Gothic charm, "are buildings of simplicity, quality, and tremendous pathos," Huxtable writes, "for in spite of their excellence they are little known, and they obviously exist on the thin edge of salvation, maintained tenuously by limited and elusive funds."

When Saint Mark's was crowned with a steeple in 1828, more than one hundred churches were in existence. Peter Neilson, visiting from Glasgow, reckoned that in 1826 "the 103rd place of worship was erected within the city so that there is no want of visible religion in this quarter." The reckoning was meant only for Manhattan; across the East River, Brooklyn was quietly gaining its own reputation as "the borough of churches," with its first church dating from the year 1666. Brooklyn's church buildings, uneclipsed by a modernskyscrapers, maintain the kind of ecclesiastical identity that was earlier so common a feature of the landscape. A bird's-eye view from nearly any point in Brooklyn today underscores the large number of churches and their distinct presence in the borough's skyline. One of the most fashionable churches in the nineteenth century was the Plymouth (Congregational) Church where Henry Ward Beecher used his eloquence to expound his liberal views on abolition, temperance, woman's suffrage, and Darwin's theory of evolution. Beecher contributed a colorful chapter to Brooklyn's church history when he became the defendant in a sensational trial where he was charged with adultery. He was eventually acquitted.

Churches, church practices, and churchgoing in New York, and elsewhere in the expanding new republic, prompted Count Alexis de Tocqueville to

Church spires and steeples, including that of handsome Saint Mark's at Tenth Street and Second Avenue, dominated the city's skyline for two and a half centuries. Dating from 1799, St. Mark's was built over Peter Stuyvesant's property, where it continues to lend its name to a thriving street in the East Village known as Saint Marks' Place.

characterize Americans as a deeply religious people and as genuinely pious. Striding the streets of Manhattan on a visit from France in 1831, the count's observations on religious practices had little in common with those earlier expressed by the offended John Miller. "Sunday is vigorously observed," noted Tocqueville and held that, unlike his native France where the spirit of religion and the spirit of freedom proceeded in opposite paths, here "they were intimately united." No single religion, among the many faiths being professed, was allowed ascendancy, he observed. "I did not meet a single individual, of the clergy or the laity, who was not of the same opinion on this point," the visiting Frenchman reported in his chronicle.

Tocqueville did not otherwise find Manhattan physically appealing; quite the contrary. "One sees neither domes, nor bell towers, nor great edifices," he announced, "with the result that one has the constant impression of being in a suburb." He did not, of course, see the third incarnation of Trinity Church which would open in 1846 but, then, neither Manhattan's handsome city hall nor elegant Grace Church already in place had managed to excite him. He should have made a return visit. Manhattan's spectacular churches—Saint Patrick's Cathedral, Saint Bartholomew's Church, Riverside Church, and the Cathedral of Saint John the Divine—were actually conceived during the century of the Frenchman's visit but, so ambitious were the architectural concepts, they took decades to build.

"We'll need plenty of time and plenty of money," was the crisp assessment of the architect James Renwick when the decision was boldly made by Archbishop John Hughes in 1850 to use the newly acquired Fiftieth Street property as the site for a cathedral. By this midcentury point, the number of churches of all faiths and synagogues hovered around a total of 250, matched with a population of half a million. That figure now included the fresh arrival of nearly 120,000 Catholic immigrants from Ireland. Up to this time, Catholics were in the minority and looked upon as outsiders in what was a predominately Protestant city. Prejudice against them increased during the course of the century with the dramatic rise of Catholic believers coming from Germany, Italy, and Poland. The grandiose plans of the archbishop were considered daring, if not a folly, both as to location (so far out of town) and as to size. The diarist George Templeton Strong remarked sarcastically in an 1856 entry that the plans called for a structure that would "probably be a combination of Cologne Cathedral and the Crystal Palace." But the undaunted Catholic prelate was well aware of how powerful an instrument a cathedral would be in effecting Catholic integration. Saint Patrick's was the first of the four colossal structures that would eventually rise in the midst of Manhattan's streets to assure New Yorkers of the intercession of the Almighty on their behalf. Charles Dickens, making his second visit to the city in 1876, was witness to its construction. It led him to the hostile reflection that the "Irish element is acquiring such enormous influence in New York city, that when I think of it, and see the large Roman Catholic cathedral rising there, it seems unfair to stigmatise as 'American' other monstrous things that one also sees."

Just two blocks east of Saint Patrick's, the imposing edifice of Saint Bartholomew's Episcopal Church, conceived by Bertram Grosvenor Goodhue, opened in 1918. Tocqueville would have found the dome he was looking for in its grandiose Byzantine design. Facing Park Avenue, Saint Bart's, in its medieval garb, stands serenely indifferent to the steel and glass world surrounding it. In 1980, millions of dollars were offered by a real estate developer for some of its untrammeled air space, but the Landmarks Commission stepped in with a veto. Much farther uptown is the Riverside Church, an ambitious Gothic-revival house of worship financed by John D. Rockefeller, which identifies itself as interdenominational, interracial, and international. Rising majestically on the banks of the Hudson River near 120th Street, it began as a small Baptist congregation in 1841, but since opening its cathedral doors in 1930, it has spread wide its spiritual wings. Its very first minister, Harry Emerson Fosdick, attracted a following well beyond the confines of the city. To the distinguished French visitor clamoring for domes and bell towers, Riverside offers something unquestionably stunning: it boasts a carillon of seventy-four bells, the first in history to achieve a compass of five octaves.

Ten blocks south of Riverside Church on Amsterdam Avenue lies the sprawling twelve-acre complex of the Episcopal Cathedral of Saint John the Divine, the last of the quartet of colossal churches to be built in Manhattan. Saint John's set out deliberately to overshadow the other three with its combined Byzantine and early French-Gothic motifs, designed on a grand cruciform scale. It occupies a commanding site that served as the stormy Harlem Heights battlefield during the Revolution. But so grand was the design that the structure remains unfinished to this day. Still, Saint John's accommodates twenty-five hundred worshipers and is host to pulpit speakers of world renown. It is home to a peacock that struts on the spacious grounds, to a tightrope walker in residence, and to a daily procession of the homeless, all of whom were welcomed by the energetic James Parks Morton, dean of the cathedral for a quarter century until his retirement in 1996.

It is noteworthy that both the Riverside Church and Saint John's, which opened their doors in the twentieth century, reverted to medieval and Renaissance forms that once represented a rigid church establishmentarianism. Yet the two churches espouse an ecumenism that steers wide of any sectarian ascendancy. Like many other parishes in Manhattan and the outer boroughs, large or not so large, they have adopted a tone of cultural benevolence in their ecumenism that appeals as much to secular as to spiritual yearnings, not only among their own steady congregations but also among sizable crowds attracted to the concerts, lectures, and "star" appearances staged within their portals. New Yorkers of all creeds are invited from time to time to dance like whirling dervishes under the vast dome of Saint John's during evenings devoted to honoring Sufi Muslim church practices.

The twentieth-century growth of the Muslim population in the city is responsible for the sight of another monumental dome. It rises, like Saint Bart's,

against the eastern skyline of Manhattan and is of recent vintage. The dome caps the house of worship belonging to the Islamic Center of New York, located at Ninety-sixth Street and Third Avenue. Complete with detached minaret, the mosque embodies both traditional and modern elements as designed by the firm of Skidmore, Owings, and Merrill. When it opened in 1992, it took its place as the grandest of sixty mosques existing in the city, the most humble of which can be found in basements, storefronts, or abandoned factories. By that year, the city's Muslim population had jumped to half a million.

Black Muslims, who represent a sizable component of the Muslim population—perhaps 35 percent—had long since brought to the public's attention some notable Muslim preachers who fused spiritual stirrings with political militancy. Because churches remain African Americans' strongest institutions, agents of the church acquire strong followings, with frequent, biblical-sounding calls for racial freedom. Elijah Muhammad, leader of the Nation of Islam, or Black Muslim movement, exercised a strong hold on Muslim congregations in decades leading to the 1990s through a reading of the Islamic scriptures fused with revelations of his own. Malcolm X, also gifted with charismatic oratory, was a disciple of Elijah Muhammad but broke with his mentor a short while before his assassination in a Harlem ballroom in 1965. Not only Black Muslim houses of worship but conventional black Baptist and Methodist churches serve as centers of community influence and power.

Would the God-fearing governor of the early Dutch colony be inclined to equate this expanded religious pluralism flourishing on the eve of the twenty-first century with expanded godliness? Not likely. Stuyvesant would probably commend the fact that vast numbers of New Yorkers identify with a religious belief, though not necessarily a faith requiring traditional worship. In this regard, the growing secularization of religion marking the final decades of the twentieth century would not have escaped him. The governor would more likely be amazed to learn that the heightened plurality of faiths in the city has sparked no religious disorder of conspicuous magnitude. To be sure, localized disturbances have occurred since his governing days, such as the Orange Riots of the 1870s and black-Jewish scuffles in twentieth-century Brooklyn, but none compares with the damage of the Leisler Rebellion staged during the English colonial era. That confrontation of 1687 between two factions, Protestants and so-called Papists, went well beyond a religious dispute to threaten the very foundations of New York's government. Nothing of so dramatic a dimension has transpired ever since.

Schools

Schooling in the seventeenth-century years of colonial rule in Manhattan was based on the European tradition of shared responsibility for education between church and state. Over the ensuing centuries, the church has been an

active partner in shaping school patterns basic to the city's instructional system in all five boroughs. Some of New York City's most prestigious schools, as well as several universities, owe their birth to ministerial initiatives.

The Dutch rulers of New Amsterdam gave the matter of schooling serious thought inasmuch as they tied education to the inculcation of morality and to the propagation of the Calvinist faith. It did not follow, nonetheless, that teachers and classrooms enjoyed high priority in the doling out of the colony's meager funds. "The bowl has been going round a long time for the purpose of erecting a common school and it has been built with words, but as yet the first stone is not laid," wailed New Amsterdam's councilmen in seeking action from Holland in 1649. It was then some ten years after the arrival of the first teacher, Adam Roelentsen, who began his work under makeshift conditions and who unhappily proved wanting in his morality.

The seafaring town of nearly eight hundred was enjoying the comforts of seventeen tap-houses but no lasting uplift at the font of learning. A schoolhouse was desperately needed to regularize elementary schooling, and a worthy schoolmaster was just as urgently required to act as role model for the school-age population. "He should not only know how to read, write and cipher," insisted the colony's minister, "but should also be a man of pious life, and decent habits . . . and set a holy example to the children." Some of the teachers who were eventually licensed in Dutch times kept school in rented rooms or in their own lodgings; others were privately employed by families of means. Peter Stuyvesant proposed that teaching be conducted in the kitchen of the prosecuting officer "or else some other place inspected by the church wardens." He saw the classroom more as a vehicle of discipline than of learning. A schoolhouse was never built.

English rulers who took over from the Dutch in 1664, and named the fledgling town New York, faced a variety of tongues and religions in the colony, as would be true of the city forever after. Largely for this reason, education could never be brought under rigid regularization. During English rule, right up to the outbreak of the Revolutionary War, the Dutch continued to form a sizable component of the heterogenous population, and it was they who set up the first independent school for boys, which functions to this day. Established in 1687 on Beaver Street, it was named the Collegiate School, and it severed its ties with the Reformed Protestant Dutch Church only in the twentieth century. So-called charity schools, formed in this Georgian period, were largely organized by the Society for the Propagation of the Gospel, which was essentially Anglican, as well as by the Dutch Reformed congregations and by the Jewish community. Wealthy pupils went to privately organized schools or were tutored at home; the poor and middle class could attend the charity schools but, in truth, most children had a haphazard education or none at all.

As part of the apprenticeship to a trade, youngsters in eighteenth-century colonial days could acquire the rudiments of learning at the hands of a master. He was customarily obliged to provide them with "sufficient meat

drinke Apparell Lodging and washing fitting for a Apprentice . . . [for] seaven years . . . and to Instruct and teach his said Apprentice in seaven years to read and write English." The middle class tended to keep away from the charity schools for fear of being identified with pauperism. Nonetheless, an enlightened feature of these schools was that they were generally open to enrollment by girls as well as boys. An eighteenth-century school that opened for the poor of the Presbyterian congregation functions to this day on a coeducational level as the privately run Alexander Robertson primary school on Manhattan's Upper West Side. It is still tied to the Scottish Presbyterian Church, appoints a minister as the headmaster, and traditionally engages the playing of bagpipes at special events.

And what of higher education in the eighteenth century? That very question provoked William Smith Jr., a resident lawyer, to wondering in 1752 why "this Province should have been near a whole Century, in the Hands of a civilized and enlightened People; and yet, not one public Seminary of Learning planted in it." Smith himself had received a Yale degree; two years later he would realize his yearning for a "public Seminary" when King's College was launched under royal charter with an Anglican president. The fact that King's opened with eight students in the vestry room of Trinity Church underscored its close connection with ecclesiastical authority. The church looked forward to the graduation of young men who would enroll in the ministry. King's was to suffer initially from insufficient enrollment because of a want of good lower schools that could feed into the college's freshmen registration. Wealthy families had become accustomed to looking to New England or to schools abroad for the education of their sons. In 1764 Columbia Grammar School was finally established to serve the higher institution. It had been vigorously promoted by Samuel Johnson, first president of King's College, who believed in a thorough grammatical training for the young. Herman Melville would one day be a student there.

Young men enrolled as freshmen at King's made their way to an imposing building at the corner of Murray and Church Streets where, between classes, they could loll about on grassy hills sloping down to the river. This excellent placement of the three-story edifice, about 150 yards from the banks of the Hudson, did not escape the notice of the well-educated Scottish visitor Patrick M'Robert. He declared that the college made a handsome appearance "on one of the finest situations perhaps of any college in the world. Here are taught divinity, mathematicks, the practice and theory of medicine, chymistry, surgery, and materia medica." M'Robert did not overlook the fact that the approach to the college from the east "is thro' one of the streets where the most noted prostitutes live . . . certainly a temptation to the youth that have occasion to pass so often that way." As one way of deterring undue lingering in this seductive quarter, King's College students were required to wear gowns; any undergraduate discovered "going without his Academical Habit, by Day or by Night; in public or in private" was threatened with dismissal. During these pre-Revolutionary years, the college graduated a fairly high percentage of

FIGURE 2.8 *King's College, ca. 1763.*
King's College (now Columbia University)
opened to students in 1754 under royal
charter with an Anglican president. Located
on Murray Street, its first building had a
fine view of the Hudson as well as scandal-
ous proximity to a whorehouse. Tricorn-
hatted students loiter beneath a palm tree,
a fanciful touch added by the artist.

Loyalists. Among the distinguished alumni who were ranged on the side of the patriots were John Jay, Robert B. Livingston, Gouverneur Morris, Egbert Benson, and Alexander Hamilton. At war's end, their alma mater received a name befitting the triumphant new republic: Columbia College.

DeWitt Clinton, one of the early graduates of newly named Columbia, who was largely responsible for the success of the Erie Canal, believed passionately in the importance of schooling not only in fostering moral rectitude but also in propagating a democratic government. As New York City's mayor during the presidencies of Thomas Jefferson and James Madison, and later as state governor, he promoted educational measures as tirelessly as he promoted the building of the canal. "Let it be our ambition," he announced to an audience in 1809, "to dispense to the obscure, the poor, the humble, the friendless, and the distressed, the power of rising to usefulness and acquiring distinction." Under his patronage, the Free School Society was formed that year as a vehicle for the creation of nondenominational schools that would reach out to working-class children. Opening its first classroom on Chatham Street, the society's facilities provided the germ of the city's public school system.

Adding luster to the city's education system was the founding of New York University in 1831. Its first chancellor, minister James Matthews, upheld a religious approach to learning that was staunchly advocated by Presbyterian and Dutch Reformed educators. As the university gained in enrollment, it eventually receded from the religious emphasis imposed on it. From the beginning, the university "was expected to assume a vital civil role at a crucial moment in the city's history," reports Thomas Bender, a scholar who has chronicled New York's intellectual development. That role was to guide New York's ambitions toward cultural distinction now that its economic star had risen so dramatically following the Erie Canal boom. There was much to be accomplished in this regard, not only on the university level but also in the basic spheres of primary and secondary education. In 1831 the population had passed the two hundred thousand mark and schooling was not yet compulsory. Funding, curriculum, teacher training, physical facilities, attainment standards, moral authority, and civic supervision needed to come under serious consideration in both the private and public sectors in order for New York to expand its horizons beyond commerce. Because no communal consensus or speedy solutions were reached with regard to the best manner of providing a good education for thousands, these issues provoked constant controversy among city officials and ecclesiastical authorities, and in the press. No one could then predict how overwhelming those issues would become.

As the decades gave way to massive immigration an uneasy alliance continued between denominational and public schools within a school system inadequate to meet demands. Most notable among the philanthropic organizations that augmented the city's facilities was the Children's Aid Society, which had been founded in 1843 by Charles Loring Brace. An erstwhile student at Union Theological Seminary, Brace unflinchingly faced the fact that immigration was pouring in its multitudes of poor foreigners and that something

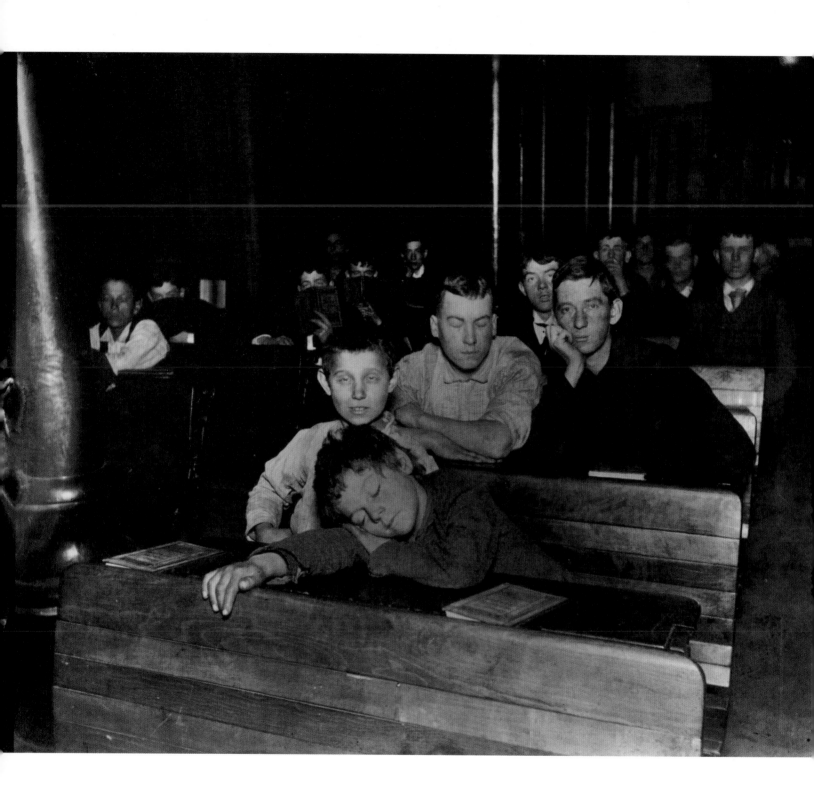

FIGURE 2.9

Night School in a Lodging House, 1890.
Hordes of nineteenth-century immigrants
missed schooling because of long working
hours. When they did have a chance to learn
late in the day, they were likely to fall asleep.
The photographer Jacob Riis registered the
fatigue lining the faces of young workers in
the night classes provided by the Seventh
Avenue Lodging House.

had to be done. "They will influence elections; they may shape the policy of the city; they will assuredly, if unreclaimed," Brace reasoned, "poison society all around them." To reclaim them was, primarily, to educate them. He believed steadfastly that "a child in any degree educated and disciplined can easily make an honest living in this country." Tirelessly Brace set about over the decades creating industrial schools, lodging houses, free reading rooms, and kindergartens in the poorest districts of New York.

By and large, school attendance in the nineteenth century proved to be unsystematic inasmuch as many youngsters were working and not free to learn. As late as the Civil War, there was still no compulsory education law for a city whose census had climbed to well over a million, nor were there any child labor laws. Not until 1874 was a measure adopted mandating compulsory schooling for New York's juvenile population. It did not necessarily work to the advantage of the millions of immigrants streaming into the city during the last quarter of the nineteenth century, for there simply were not enough schools to accommodate them all. Following the arrival of large waves of Irish and Italian immigrants, a network of Catholic schools was slowly formed in all the boroughs, funded almost exclusively by the donations of local churches.

Of tremendous advantage to the city in moving toward the cultural eminence so ardently desired by DeWitt Clinton and the educators of his day were the many libraries that were opening up throughout Manhattan and the outer boroughs. Private libraries had existed since colonial times; the so-called public or institutional libraries that were formed beginning in the eighteenth century generally required a subscription and, in this sense, were not public as the term exists today. Masses of the reading public could not afford them. A giant step forward was taken in the creation of a free facility when John Jacob Astor bequeathed funds for the formation of the Astor Library in 1854. A half century later, that library was joined with the Lenox Library and the Tilden Trust to form the incomparable New York Public Library on Fifth Avenue and Forty-second Street. A further gesture of lofty munificence came with the award of funds by Andrew Carnegie in 1901, empowering the city to build a system of sixty-five branch libraries throughout Brooklyn, Queens, Staten Island, and the Bronx. Carnegie graciously declared that he esteemed it a "rare privilege" to finance the system, adding that "sixty-five libraries at one stroke probably breaks the records, but this is the day of big operations, and New York is soon to be the biggest of cities." In each of these neighborhood libraries, youngsters of every generation have expanded their worlds through the stimulation of books free for the borrowing.

By the end of the century, the city's major academies of higher learning—notably Columbia College, New York University, and City College (founded in 1847)—had finally achieved prominent status in the moral, scholastic, and professional life of the city. Although none of the three continued to advocate a religious orientation to learning, clergymen were distinctly not out of the picture. Frederick Barnard, who was president of Columbia from 1864 to

49

FIGURE 2.10 *East Side Public School, ca. 1890.*
"In New York we put boys in foul, dark class-rooms," wrote Jacob
Riis, "where they grow crooked for want of proper desks [yet]
threaten them with the Jail if they do not come." Nineteenth-
century construction of school facilities lagged woefully behind
the successive waves of immigrants that swelled the population of
the young.

FIGURE 2.11 *Virginia Day Nursery, 1906.*
Unquestioning discipline was the rule in lower and upper schools from Dutch times to the mid-twentieth century. Children attending a day nursery were expected to dress uniformly, to have their hair traditionally cut, and to sit at attention with folded hands. A few of the children glance shyly at the visiting photographer, Percy Byron.

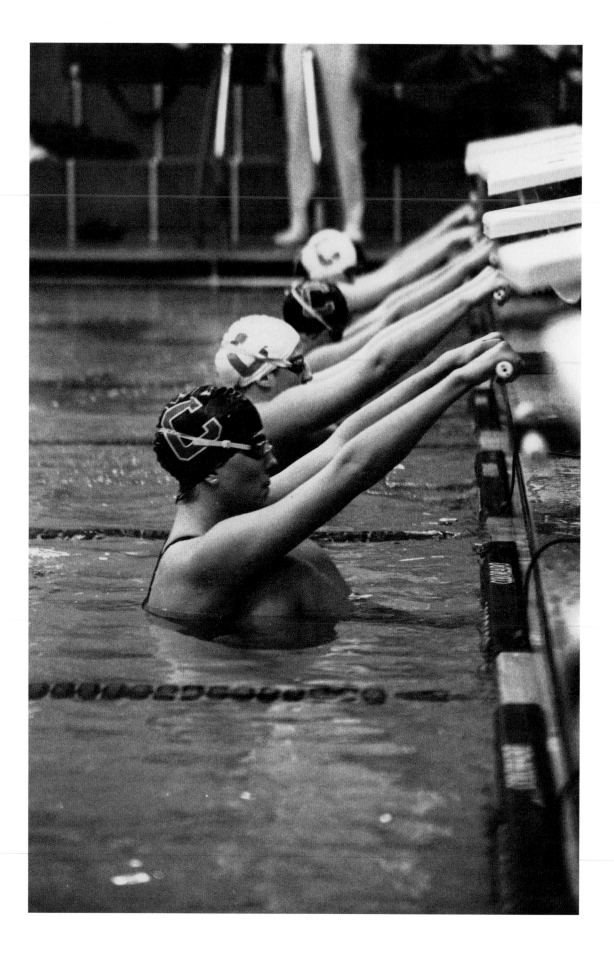

FIGURE 2.12

FIGURE 2.12
Women's Swim Team, Columbia University, 1999.
Well into the twentieth century, schools at all levels that had been formed for the sole education of boys remained staunchly closed to the opposite sex. Barriers were only slowly broken down. Columbia College finally admitted its first group of female students in 1981. Here the women's swim team lines up in the Uris Swim Center pool.

1889, was an Episcopal minister. All three institutions had long been considered marginal to New York's climb as a cultural metropolis, a dilemma evident in the grumbling of one of the trustees of Columbia College, George Templeton Strong. Columbia's "very existence is an obscure fact," he noted in his diary for the year 1858; "it is among the 'things not generally known.' It ought to be forcing itself on public attention at every corner." Columbia did just that following its third and final move uptown in 1905 to Morningside Heights. It made itself splendidly conspicuous with an expanded beaux arts complex designed by the firm of McKim, Mead, and White. By this time, New York University and City College could also boast enlarged campuses with structures designed by leading architects.

A happy turn of events took place during the mayoralty of John F. Hylan (1918–25) when a concentrated building effort equipped the city with 662 schools at the primary and secondary levels. During those predepression years, Gotham was heir to the largest school construction program and the largest education budget in its history. Today, there are primary school programs to suit all incomes, and there are secondary schools, both public and private, known for the vigor of their curriculum and the competitive performance of their students. Further, the city provides special education schools that cater to the underprivileged, to the gifted, to the physically disabled, and to a whole range of cultural and vocational interests. Adding to them is a whole loop of denominational schools in the five boroughs serving the religious needs of their enrollees. At the college and university levels, there are more than fifty "publick Seminaries of Learning"—to use William Smith's phrase—granting baccalaureate or graduate degrees. Is it all, however, quite enough to serve a highly diversified population of nearly 10 million?

Perhaps just as conspicuous as the accomplishments of the city's educational system in the year 2000 are its glaring deficiencies. These weigh heavily on the city's mayor, on the school chancellor, on church authorities, on parents, educators, and the children themselves. Many school structures are in deplorable condition, while violence and crime pervade the very halls of the buildings. Standards in teaching and in learning threaten to sink lower. A good private education is still available to those at the top economic rung as was true in the eighteenth century; it is true for members of the middle class as well but invariably at prohibitive cost for a sizable number among them. Meanwhile, the masses in the lowest rank of income who are herded into overcrowded classrooms are subject to a precarious intellectual future. Theirs is a destiny marked by a lack of municipal vision that runs counter to all good principles of a democratic society. It is not likely that young William Smith, DeWitt Clinton, Charles Loring Brace, and other educators of their pioneering ilk would be pleased with the current school scene. As a remarkable visionary in his own day, Clinton would be dejected to attest that thousands of young New Yorkers are denied "the power of rising to usefulness and acquiring distinction" for want of an inspired educational plan that is favorable to all.

Churches and Schools

SEAFARING SPLENDOR

The Shaping of New York's Destiny as a World-Class Seaport

From the four points of the compass Manhattan's streets lead resolutely to the water's edge. City dwellers of the nineteenth century, wanting a sniff of sea air, invariably strolled directly southward to the extreme end of the island known as the Battery. There, of a leisurely Saturday afternoon, multitudes would gather, sometimes rewarded by a spectacular nautical happening. "Look at the crowds of water-gazers there," urges the nineteenth-century voice of Melville in the opening pages of his *Moby Dick,* claiming he has often counted thousands upon thousands of mortal men fixed in ocean reveries on Manhattan's extensive shores. What most excites his fancy is the nautical lineup at the Battery. "But look!" he further insists, "here come more crowds, pacing straight for the water. . . . Nothing will content them but the extremest limit of the land. . . . And there they stand—miles of them—leagues. Inlanders all, they come from lanes and alleys, streets and avenues—north, east, south, and west. Yet here they are all united. Tell me, does the magnetic virtue of the needles of the compasses of all those ships attract them thither?"

Well, yes. All those ships for all those decades of seafaring splendor lured Manhattanites to the southern fringe of their island. From the days of discovery onward, nearly every type of vessel built in European shipyards found its way to New York's harbor. Graceful carracks of the Renaissance sailed into her waters, followed with the passage of time by ever-stouter vessels. At first they came directly from across the ocean; later they made their way to Manhattan from ports opening up along the New World coasts of North and South America, particularly from the lucrative ports of the West Indies. Carrying both human and commercial cargo, the succeeding parade of ships over four centuries have borne names as varied as their construction: barks, caravels, carracks, coasters, riggers, sloops, pettiaugers, tramps, transients, traders, packets, sloops, colliers, whalers, frigates, freighters, pinnaces, cutters, steamships, submarines, and liners. But this is not all: challenge any knowledgeable sailor and he will double the list within the blink of an eye.

The earliest arrival on record in Manhattan's open waters, and far and away the most sensational, was a sixteenth-century carrack: Giovanni da Verrazzano's three-masted vessel, the *Dauphine.* Rerigged from a man-of-war for her voyage of discovery in 1524, she must have presented a startling sight to the island's native Algonkians who paddled out in canoes to see her. They beheld a giant bird with layers of massive white bonneting that had descended

A World-Class Seaport

FIGURE 3.1 *Man-of-War and Galleys* by
Peter Breughel, ca. 1550.
Nearly every type of vessel built in European
shipyards found its way to New York's har-
bor, beginning with the three-masted carrack
of Giovanni da Verrazzano in 1524. A likely
exception to these transoceanic crossings is
the oared galley, largely powered by the same
human energy as were the modest canoes of
native Indians.

in their midst to present a beautiful and awesome sight. The same apparition greeted the Indians in the following year when Esteban Gomez, a Portu-guese pilot in the service of the emperor Charles V, sailed along the coast in the New York vicinity. The two fairly close-paced visits may well have set up an expectancy that more of these nautical marvels would subsequently pre-sent themselves, but the record is bare until the appearance of Henry Hud-son's lateen-rigged *Half Moon* in 1609. Nor is there on record any attempt-ed transatlantic crossing of an oared galley, used with fearsome dexterity by the Trojans in Virgil's *Aeneid*. Manhattan natives would have recognized, had they seen one, that it was largely powered by the same human energy as their own modest canoes.

The coastal Algonkians of Manhattan used their canoes extensively for fishing and for access to hunting sites. In some of the sixteenth-century maps that circulated following Verrazzano's return to France, their canoes are de-picted in action side by side with European caravels. Algonkians constructed their watercraft by burning and scraping out the insides of a tree log, then shaving the log into the shape of a long, pointed vessel. Handled by both men and women, the vessels were of varying sizes, with the largest capable of ac-commodating eight occupants. Their stoutness, and the skill of the Indians in maneuvering them, gave colonial settlers an indication of the modest "ship-building" that already existed on the island as a home industry.

Following the Dutch purchase of their island by Peter Minuit in 1626, local inhabitants witnessed a buzz of seafaring activity in and out of Manhattan wa-ters. The colonial territory staked out by the Dutch West India Company (DWI) included the area of Albany, called Fort Orange, which meant that the movement of ships extended up and down the Hudson River as well. Trading was particularly heavy with the Indian villages along the northern reaches of the river. To their holdings in this area of the New World, the Dutch gave the designation *New Netherland,* reserving the name *New Amsterdam* for the trad-ing post on the island of Manhattan. Since Amsterdam at that very time was enjoying a renown as one of Europe's greatest ports, officials of the DWI sure-ly had a splendid destiny in mind for the development of the New World is-land that Neptune had so advantageously placed.

Goods and merchandise flowed both ways between the colony and the mother country almost from the start. The number of beavers and otters shipped to Holland climbed steadily from six thousand skins in 1625 to ten times that number within a decade. Meanwhile, in the spring of that year, the Algonkians witnessed the arrival of an extraordinary cargo. Sailing directly from Amsterdam, a fleet of three vessels transported more than a hundred head of livestock—stallions, mares, bulls, cows, hogs, and sheep. To ensure the well-being of the animals, an ample supply of oats, hay, and straw had been taken aboard. A nautical innovation distinguishing the transport was the design of an extra lower deck in each ship where "three hundred tuns" of water were stored for the herd and pumped up daily for their consumption. Each animal had its own stall, supervised by attendants who were to be duly rewarded if

FIGURE 3.2
Seaport Scene in the Netherlands, ca. 1620.
An inventory of Dutch cultural traditions
passed on to New Amsterdam is paraded in
this colorful seventeenth-century view of
an anonymous coastal location. We see the
ambience of a town heightened by the sea,
the importance of canals to shipping, and the
Dutch love of a good life as embodied in
sports, merriment, and fashionable clothes.

their charges survived the trip. All but three of the livestock landed in the New World alive and well.

Upon assuming directorship of the colony, Peter Minuit had lost no time in promoting the maritime activity of his rustic settlement. Rather than viewing the English territories to the north and south of him as inimical to Dutch interests, he offered to trade with them. In a gesture of neighborliness, Minuit sent a "rundlet of sugar, and two Holland cheeses" via messenger to Governor Bradford of Plymouth in the summer of 1627. Though the English had been looking on New Netherland with a suspicious, if not a predatory, eye a deal was eventually struck whereby coastal trading began, first with New England, later with the Virginia settlements. In acknowledging the Dutch gifts, Bradford pleaded an empty cupboard: "[We] must remain your debtors till another time, not having any thing to send you for the present that may be acceptable." Minuit saw to the construction of a countinghouse where the Dutch West India Company's expanding trade could be conducted under the supervision of an agent known as a *koopman*.

During Minuit's directorship, the colony's main anchorage established itself in the East River where more protection was afforded within its land-embraced lower reaches than was true of the Hudson. A small dock, at the end of a rudimentary street that began at the fort, served as a landing place. Already a few sloops and shallops had been built in the makeshift shipyards set up along Pearl Street's eastern terminus. Something of a high point was reached in this nascent shipbuilding with a craft named the *Nieu Nederlandt*. Boasting an unheard of tonnage, or carrying capacity, of around six hundred tons—more than twice the usual size—it was launched from the yards in 1631.

What was needed was a pier, an ordinance to regulate shipping, and a naval authority, all eventually supplied when Peter Stuyvesant became director-general. To erect the pier, as well as to repair the crumbling fort and complete the building of a church, Stuyvesant imported wines and liquors for the raising of revenue. He also issued stringent orders with regard to the physical appearance of the trading settlement, which, far shy of Dutch standards, had "attained to a very poor and low condition." Property owners were enjoined to erect only decent dwelling houses (wood and stone preferred over bark) and to see to the control of their hogs, goats, horses, and sheep, which in their free wanderings, were causing considerable damage, something that filled the director-general with "vexation and disgust." A warehouse was built and the stone tavern at the head of Coenties Slip was converted to use as the *stadthuys* or city hall.

As was to be expected in a nascent seaport, smuggling had already become a problem. To counter this, Stuyvesant prohibited any resident from going out in small craft to meet an incoming ship before "such arriving Ships, Yachts or Barks" made their anchorage and declared themselves to the naval authority. Edicts to this effect had earlier been issued but infractions were rife. Stuyvesant, who operated with unbending authority, was nonetheless bound to keep in steady communication with his directors in Holland in all develop-

FIGURE 3.3 *Canal in Broad Street, 1659.*
Canals in colonial Manhattan were dug by
the Dutch who found them traditionally
useful in facilitating the entry and unloading
of ships. A principal canal was dug along
Broad Street, up from the Battery, with
three footbridges overhead. In 1625 more
than a hundred head of arriving livestock
were here successfully disembarked.

ments pertaining to the flourishing of trade. Members of the DWI were often less harsh in making judgments in matters under dispute than their colonial appointee; they beseeched him to be patient with pioneering conditions. Whereas Stuyvesant was often prone to letting loose "very wicked and spiteful words," the Amsterdam directors insisted that "in a new country, with only a small population, minor matters must be overlooked."

Defending the maritime colony was of no less a continual concern to the DWI than the matter of promoting its commerce. Members of the DWI admonished Stuyvesant more than once to be on his guard against embroilment with New England. Conducting peaceful trade with the English colonies, they felt, would ensure a population increase and a gain in seafaring prosperity. "For when . . . the ships of New Netherland ride on every part of the ocean," they clairvoyantly declared to him, "then numbers, now looking to that coast with eager eyes, will be allured to embark for your island."

The allure proved to be fatal. For many years, the English had viewed the New Amsterdam colony as a choice territorial morsel, especially since it was seen to lie, as one English observer put it, "in the midwaye betwixt Boston in New England and Virginia." He also totted up the amount of ordnance he observed there in 1647, recording not only the presence of a "considerable ffort" but also his judgment that the colony was "very delightsome." When the delightsome colony slipped out of Dutch hands in 1664 and became an English possession, there were fifteen hundred inhabitants, many of whom witnessed the menacing spectacle of warships in the harbor "well manned with sailors and soldiers." Yet the transition was peaceful and New Amsterdam, now named New York, entered a new phase in its seafaring history.

Like the Dutch before them, the English were bearers of a proud seafaring tradition when they assumed the sovereignty of Manhattan. That tradition did not spring solely from England's engagement on the high seas in commerce and in war, but had its origins in the Middle Ages. It was then that the necessary skills in developing ports and commercial towns had steadily moved forward. Practices already established in medieval Europe—charting of the high seas, celestial navigation, navies, convoys, port regulations, bills of exchange, coinage, and trading in shares—were absorbed by the colonial powers, together with the whole network of mercantilism, and brought to the New World. The immediate advantage of England's takeover for newly christened New York was the enlargement of trade routes to include the wide loop of British ports dotting Ireland, the Azores, the Madeira Islands, the North American continent, the West Indies, and coastal locations in Europe. The two English ports at the eastern end of the Atlantic that became part of regular routes were London and Liverpool.

Before the end of the first decade of English rule, another medieval practice was adopted to support this heightened seafaring activity: the operation of a merchants' exchange, put into effect by a proclamation of Governor Francis Lovelace in 1670. Merchants and sailors were now making up a sizable component of Manhattan's population. A notable boost was given to the ex-

pansion of local trade by the third English governor, Sir Edmund Andros, not long after his assumption of power in 1674, when he granted the city a monopoly on the export of flour. The bolting laws he issued, improving and regularizing milling practices, also ensured that flour, regardless of its origin, would become one of the port's leading exports.

"There are about nine or ten three Mast Vessels of about eighty or a Hundred Tuns burthen, two or three Ketches & Barks of about forty Tun; and about twenty Sloops of about twenty or five and twenty Tunn belonging to the Government—All of which Trade for England Holland & the West Indies except six or seven Sloops that use the river Trade to Albany," reported Sir Edmund's successor, Governor Thomas Dongan, to the Crown in 1687. By the opening decades of the eighteenth century, New York's port was humming with a lively annual traffic of well over two hundred vessels. To England, traders sent mostly beaver skins, whale oil, and some tobacco in return for a line of manufactured goods. To the West Indies, ships bearing cargoes of flour, bread, peas, pork, and occasionally horses were sent in exchange for rum, molasses, and sugar. Imports were averaging about £21,000 annually, while exports tallied more than twice that much. Just as the Dutch had intended, trade was dictating the prosperity of the city and making giant strides in that direction through measures now adopted by the seafaring English.

Already evident in these early days were seafaring practices that eventually became egregious: privateering and piracy. Goods plundered on the high seas through these ventures swelled the volume of the imports coming into Manhattan. Piracy was as profitable to almost everyone involved as it was dangerous; many a New York official turned a blind eye to the illicit operations. The practice of hijacking vulnerable ships and plundering them was, again, a medieval heritage, and so rampant did it become in the opening years of the eighteenth century, there were those who naively considered it akin to a profession. It was introduced to New York as early as the 1630s when the island of Curaçao, then controlled by the DWI, developed into an ideal base for smuggling operations. Located in the Atlantic near Venezuela, Curaçao was linked with pirate activities that were conducted along the east coasts of the Americas and the West Indies. Abroad, the region of the Red Sea swarmed with smuggling activities, while Madagascar served as a notorious pirate center. All these locations touched base with the port of Manhattan since outlets were required for the stolen goods. In time, the markets of the city were flooded with looted merchandise that had an undeniable appeal: spices, silks, brocades, porcelains, jewels, and Arabian gold.

Piracy sometimes developed from privateering, a practice wearing a legal cloak. Owners of private ships who received a government commission to plunder enemy vessels on the high seas were known as privateers. The legality of their nefarious operations was protected by so-called letters of marque. As England was often at war with France, there were many occasions for the looting and plundering of French ships as well as of ships on friendly terms with the enemy. New York vessels did not shy from privateering nor did

New York merchants object to the exchange of exotic goods brought into the port by pirates. On March 31, 1746, the *New-York Weekly Post-Boy* gleefully announced the capture of a 140-ton French vessel carrying wine, oil, olives, almonds, and other comestibles that the newspaper pronounced "a pretty valuable Prize." Captain William Kidd, a legendary pirate, functioned as a privateer for the English Crown in the late seventeenth century until he was seduced by the more bountiful rewards of piracy. His risky ventures and the fortunes he amassed sparked colorful tales. Kidd lived sumptuously in Manhattan until he ended on the gallows in England in 1701.

The outbreak of the Revolution caused a very mixed, unsettled maritime scene. Occupied by the British for seven years, Manhattan was used as a battleground; warships, rather than trading ships, dominated the harbor. A devastating fire in 1776 visited further havoc on the beleaguered city. War conditions took their toll on the wharves, piers, and warehouses, which rotted; some were dismantled for firewood. Trading, which took place in fits and starts, became disorganized. While a fair amount of activity occurred in New York's waters during the war, most of it was concerned with troop movements. When independence was finally achieved, New York (and the rest of the country) abruptly became foreign territory to England. Admiralty regulations accordingly excluded American vessels from the lucrative trade with British possessions in the West Indies. Here was another maritime blow for the port of New York, and for a while, the nautical scene was gloomy. New York's ever-venturesome pursuit of commerce took hold, however, with the sudden prospect of a new trade route that bid fair for the attention of enterprising merchants. All eyes were suddenly drawn in the direction of China.

The lure of the fabled China trade had been the primary incentive for the discovery of the New World. Geography had interfered with that lure in the form of two massive continents that unexpectedly blocked the route westward to the Orient sought by European explorers. New York trading ships now had the option, three centuries after Columbus, of sailing either to the west or to the east to connect with Chinese ports. The pioneering route taken by the *Empress of China* on February 22, 1784, as she weighed anchor in the port of New York, was eastward around half the world. She sailed down the South Atlantic, rounded the cape of Good Hope, crossed the Indian Ocean, passed the Straits of Sunda, and cutting through the waters of the China Sea, headed straight for Canton. When the 369-ton vessel finally dropped anchor, it was the first showing of the U.S. flag in the Orient. "The Chinese were kind to our people," reported Richard Henry Lee, "glad to see a new source of Commerce opened to them. . . . The Europeans there were civil but astonished." Lee's epistolary comments were made in May 1785 to his friend James Madison, the future U.S. president. Merchandise, and personal items that were highly cherished, began to appear in many American homes, ordered from China through merchants or carried home in a sailor's sea chest: carved ivory, silk handkerchiefs, hair ribbons, painted fans, lacquer, and appealing specimens of porcelain.

A World-Class Seaport

FIGURE 3.4 *View from the Hudson, ca. 1731.*
The expansive waters of New York's harbor
serve as a splendid base for this view of
New York as seen from the Hudson. A
British ship fires her guns in a show of
defense of the burgeoning colonial outpost.
At the outbreak of the Revolutionary War,
a flotilla of 52 enemy warships and 427
transports crowded the colonial harbor.

The New York seafaring scene became decidedly less gloomy upon contact with the Orient, though the opening decade of the 1800s brought other dark clouds: a destructive fire, a yellow fever epidemic, and the U.S. Embargo Act of 1807. The latter was meant to offset the disruption in trading caused by Napoleon's raging conflict with England. It did not. "So devastating were the effects of the embargo," noted the English visitor John Lambert, that "in the short space of five months [it] had deprived the first commercial city in the States of all its life, bustle, and activity." What was to give new impetus to New York's commercial role was the inauguration of yet another trade route, one much closer to home. This was the Erie Canal, an elaborate ditch that amazingly connected the port of New York with the interior of the country. When the possibility of linking the Atlantic with the Great Lakes was first put forward, even George Washington concerned himself with the daring idea; he saw it as a vehicle for political unity as well as for commercial expansion. In 1784 Washington visited part of the terrain under consideration and, so taken was he with the bounty of the country's natural waterways, that he wrote to his wartime ally the Marquis de Chastellux, "Would to God we may have the wisdom to improve them!"

The wisdom was there, along with the energy and even the money. As separate sections of the new waterway were completed, they were put into operation. The tolls collected were so large that the financial success of the undertaking was early assured, and in 1825, after eight years of labor, the job was done: a waterway had been built connecting Lake Erie with the Hudson River at a cost of $7 million. Towns and little hamlets, with their busy barges and pastoral charm, sprang up all along the line of the canal from Albany to Buffalo. New York probably reaped the greatest benefit from this invigoration of the economy. The 350 miles of the Erie Canal brought such a monopoly of trade to the city that it was able to wrest from Philadelphia final claim to the role of leading metropolis of the New World.

Nautical excitement of one kind or another continually rewarded New Yorkers of the nineteenth century who made their way to the Battery rails. On the afternoon of May 7, 1838, there was a special lure: two British ships were in view that had been the first to cross the Atlantic under power of steam alone. The first of these miraculous ships was the *Sirius,* which had arrived from Cork on April 22 after a record ocean crossing of nineteen days. Virtually in her wake, the *Great Western* arrived four hours later. A much larger vessel, with an engine of four hundred horsepower, she promptly broke a new record on arrival with her crossing of fourteen days. As she passed the *Sirius* in her New York anchorage, the packets exchanged salutes to the thrill of thousands of onlookers. With two such vessels in port and the excitement of crowding aboard to inspect them, the city was in high ferment the whole week, noted former mayor Philip Hone in his diary, adding that the two pioneering steamers became "the engrossing topic of our novelty-loving population." Nineteen-year-old Herman Melville, born a stone's throw from the Battery on Pearl Street, may well have had a firsthand view of it all.

A World-Class Seaport

FIGURE 3.5 *Castle Garden, ca. 1840.*
Castle Garden at the Battery was often
surrounded by gay flotillas assembled
for grand occasions. As a large seaport,
New York could stage spectacular water
events for its visitors, such as the reception
held for the Marquis de Lafayette in 1824.
The following year, an elaborate celebration
marked the opening of the Erie Canal.

At this juncture, the island of Manhattan was maximizing all the possibilities offered by its advantageous sea location: coastal trade, trade across the Atlantic, a trade route to China, and inland trade. The number of ships plying the seas to the Orient rapidly grew in numbers when it was learned that ship owners had realized a profit of 25 percent on their investment in the *Empress of China*. Those long months at sea began to appear even more worthwhile when news of the discovery of gold in California spread rapidly to the East in 1848. Ships promptly made schedules to proceed south and west by way of the Horn, carrying thousands of gold seekers as well as much-needed provisions for the settling of virgin territories on the Pacific frontier. Neither the routes east or west to Canton, however, proved to be as profitable as the long-established trading up and down the American coasts, trading with European ports, or the trade sparked by the Erie Canal. Although the China trade ultimately accounted for only 15 percent of America's overseas commerce, the romance of it was irrepressible, as was the delight in beholding the splendid sailing packets that confidently made their way to the spiced shores of the mysterious Orient. Packets reached their peak of popularity around 1840 when they were overtaken by the clipper ships.

The bold design of the clipper was initially greeted with incredulity by some seafaring authorities. Triple masts stretching so tall and a bow so sharply concave would never achieve a proper balance in conquering the rough ocean seas, they held. Those extravagant yards of canvas rigging that betokened beauty seemed to court mischief as well, while the fact that her cargo space was noticeably reduced in the interest of speed was viewed skeptically. No one at all denied her lines were stunning. "One of the prettiest and most rakish-looking packet ships ever built in the civilized world is now to be seen at the foot of Jones Lane on the East River," announced the *New York Herald*. The description pertained to the pioneering clipper *Houqua,* a six-hundred-ton vessel sailing out of New York on May 3, 1844, bound for China. Eighty-four days later, she dropped anchor off Canton. All America was jubilant to hear the news.

Fears that the innovative features of the clipper would be her undoing as the vessel faced challenge after challenge in circling half the globe were put to rest. So impressed were other New York shipbuilders with the *Houqua*'s performance that in the next two years Manhattanites were treated to the launching of two spectacular clippers named the *Rainbow* and the *Sea Witch*. Both set the tempo for the clipper era with their records of speed. Clipper after clipper made subsequent bids to outpace them in speed runs that held sail fanciers breathless. Landlubbers were goaded by the thrilling sight of clippers into acquiring the basics of nautical jargon. They learned that a sailor must furl, reef, back, strike, or douse sail when going slow and conversely hoist, spread, make, loose, or bend sail when the goal was speed.

A remarkable maritime scene now presented itself in which sailing packets, clipper ships, and steamboats overlapped and challenged each other in the mid-decades of the nineteenth century. The packet boasted more cargo space,

A World-Class Seaport

FIGURE 3.6

The Steamer Hartford *Bound for California, 1849.*

During the gold rush, numerous steamers
left New York bound on a long and arduous
trip around the Cape of Good Hope for the
fabled gold fields of California. Nearly 150
ships had left the East Coast by the spring
of 1849 to make the risky journey. The
steamer *Hartford* took almost a year to
complete her sailing.

FIGURE 3.7 *Docking of the* Pavonia, *ca. 1850.*
Ferryboats using steam proliferated along
the Atlantic seaboard following the arrival
from England of the 703-ton steam packet
Sirius in 1838. She was the first ship to cross
the ocean, in nineteen days, powered by
steam alone. Here the steamship *Pavonia,*
serving the East Coast, docks in New York
harbor carrying both cargo and passengers.

the clipper more speed, and the steamboat a near triumphant independence of the capricious weather gods. There was no doubt, following the appearance of the *Sirius* and the *Great Western* in New York's harbor, that steam would win out. Still, her rivals held on. For the moment, the clipper carried the greatest trump card with her spectacular beauty. She not only held "thousand upon thousands of mortal men" in thrall but seduced poets, artists, and novelists as well. No other era of American sail is as romanticized as that of the clipper. Even when the ugly steamboat had a Cinderella transformation and took on the sleek appearance of an ocean liner, the romance of the clipper lingered.

Packets, steamers, and clippers streaming in and out of Manhattan waters were regulated, routed, and managed by the merchant princes of South Street, a thoroughfare directly facing the East River. Like the fortunes created via the frequent odysseys of these vessels, South Street was entirely man-made, through landfill, and appeared on city maps only after 1800. The Dutch, inheritors of a water-logged country, became adept at landfill and passed on their skill in the seventeenth century to the colonists of their rustic Manhattan outpost. Michel de Crèvecoeur, visiting Manhattan in the 1770s, found it remarkable that the art of landfill had been pushed so far by then. "This is done," the French visitor explained, "with the trunks of pines attached together which they gradually sink, fill in with stone, and cover the surface with earth." The artificial strand of South Street extended from the Battery to Corlear's Hook (where Manhattan bulges) with Front Street briefly interrupting its near two-mile stretch. During its heyday from 1815 to 1860 as the center of New York's marine universe, South Street literally burst with business and busyness. Fifty numbered piers followed the course of the street and punctured the river's waterbed with a parade of ships whose bowsprits and jib-booms pointed directly over the street to the countinghouses where their destinies were prefigured. Here were the offices of most of the foreign packet lines and here was that concentrated world of ship agents, ship brokers, ship owners, and so-called ship's husbands whose talk and decisions reverberated around the ports of the world.

Visible, too, on South Street and elsewhere in the busy seaport were the overwhelming number of seamen who contributed to the spirited, often bawdy profile of the maritime city, where the noise, smells, and constant stir of ships being loaded and unloaded pervaded the atmosphere from morning to night. As seamen waited to ship out or as they came ashore, they looked to the city for the comforts denied them on board: fresh food, alcohol, and women. Manhattan swarmed with taverns, brothels, and overcrowded rooming houses that served the transient population. Sailors might lend a touch of color to the urban ambience but theirs was often a story of hardship as they wrested a difficult, lonely living from the capricious sea. This was particularly true of black sailors who, as freemen, looked to the sea for a taste of independence. Women were also willing to face the unpredictable sea on all types of vessels in order to travel with their husbands. When they were aboard, the

FIGURE 3.8
Yachting in New York Harbor, ca. 1850.
Handsome yachts were as much a part of
the nautical scene in the Victorian era as
commercial sailing vessels and steamboats.
They were introduced as a rich man's
diversion in the early decades of British
colonial rule. The first yacht to be depicted as
an exhilarating feature of New York's seascape
appears in the 1717 Burgis view (see fig. 1.9).

ship was called a "hen frigate." Maritime personnel were exposed to the oc-
cupational hazards of syphilis, rheumatism, frostbite, smallpox, typhus, and yel-
low fever, and to the authority of many a harsh sea captain. It was out of a
profound appreciation of their lot that the philanthropist Robert Richard
Randall founded Sailors' Snug Harbor in 1831 on Staten Island, a fine retire-
ment home for exhausted and impoverished seamen.

With the advent of steam, there was a diminishing demand for mariners to
learn the names of some 130 lines of rope that formed the strong, spidery webs
above the decks of sailing vessels. A choice now loomed in transatlantic ac-
commodations—sail or steam—not so much for working seamen as for pas-
sengers. In January 1842 Charles Dickens opted for the thrill of a steamboat.
The twenty-nine-year old novelist, then gathering fame and excited at the
prospect of a sea journey to meet his American readers, booked passage on the
steamer *Britannia*. Aglow with the teasing promises of travel posters, Dickens
eagerly climbed aboard to inspect his stateroom, only to be riveted at the
doorway speechless. His berth appeared to be no bigger than a postage stamp.
The novelist was convinced he could no more get himself bodily into the
room "than a giraffe could be persuaded or forced into a flowerpot." How was
it possible, he asked himself, that "this utterly impracticable, thoroughly hope-
less and profoundly preposterous box" was to serve as quarters for him and his
wife? He made the trip in eighteen days but never got over the cramped
space, the noise, the smells, the seasickness, the "bravely smoking" red funnel,
nor the unsettling feeling of ground that was "always tilted to the wrong side."
When it was time to leave New York, Dickens made the steadfast decision to
return to England by sail.

Dickens did not hide the fears he entertained aboard the *Britannia* that the
steamer might blow up or come to some other sorry end. Ships' disasters
formed a stark and consistent chapter of seafaring history through the ages not
easily forgotten during lifetime of the nineteenth-century traveler. The cata-

The Clipper Ship Eagle *Sailing Out of New York, ca. 1855.*

New York's seafaring history was darkened by the terrible tragedies so frequent a part of any nautical chronicle. Charles Dickens crossed the Atlantic under steam in 1842, terrified of an explosion. He accordingly chose to return by sail. A ship that could brave the furies of Neptune was the 1,304-ton clipper *Eagle,* here riding out a storm.

log of casualties tied to Manhattan began as early as 1613 with the arrival of Adriaen Block, an explorer for Dutch merchants seeking to establish a New World fur trade. Block's ship the *Tiger* was destroyed by fire, and only with the help of Indians were he and his crew able to build a new vessel, named the *Onrest,* for the passage out of the harbor to a transatlantic vessel they could book further north. A fatal accident occurred when Willem Kieft, one of the early directors of the Manhattan colony returning to Holland in 1647, perished with other Dutch officials aboard the *Princess.* Scholars still bemoan that wreck off the English Channel as the ship was carrying (it is almost certain) a set of exacting maps of the fledgling colonial settlement intended for the Dutch West India authorities.

A disaster that caught the attention of two continents was the downing in 1822 of the sailing packet *Albion,* a ship belonging to the famous Black Ball Line, the first to inaugurate scheduled sailing. Carrying cargo and passengers from New York, the decks of the *Albion* were swept clean by furious seas as she approached the Irish coast and was battered against rocks. Ship, captain, crew, and all but two passengers were lost. A catastrophe closer to home occurred when a fire consumed the luxury passenger steamboat *Lexington* on January 13, 1840, during its New York to Connecticut run. Only 4 out of 150 passengers survived. Acting quickly, Nathaniel Currier published an account "of the deplorable calamity" in the *New York Sun* three days later. Along with the account, he submitted a dramatic lithograph, thereby setting a journalistic precedent for illustrated news. Navigating in the other direction, westward, a ship could be punished for weeks rounding the Horn at South America's tip. Winds carrying rain, sleet, and snow could pitch the ships so violently that sailors who lost their hold were dashed to death, while scurvy sometimes whittled away at the crew.

By the 1860s the enormous seafaring traffic that enlivened the waters of New York dictated a gradual shift of its critical mass from the eastern shore of Manhattan to the Hudson River. There on the west shore, where the mouth of the river was wider, the larger steamboats could be better accommodated and there was less jostling for docking space. In time, steam-powered vessels lowered the curtain on the nautical drama provided by sail that had played so distinctive a role for so long in the East River.

Steam-powered vessels that met with disasters through collision, fire, and running aground were less in number than those claimed by the deep when their boilers exploded, a fact that legitimizes Dickens's fears. Schooners plying the coast were more likely to meet a calamity than the clippers that were circling half the globe en route to China because they were more vulnerable and had less able masters at the helm. Henry Wadsworth Longfellow, living in the age of concurrent sail, steam, and clipper, put his maritime faith in the genius of shipbuilders: "Build me straight, O worthy master! / Staunch and strong, a goodly vessel / That shall laugh at all disaster / And with wave and whirlwind wrestle!" Wrestle they did, and though disasters in the Victorian age were often averted through increasing maritime vigilance by the authorities, the list

A World-Class Seaport

FIGURE 3.12 *The Schooner* Theoline, *1936.*
Neither church steeples nor ships' masts
could compete with skyscrapers for
domination of the Manhattan skyline by
World War I. Aware of this, the photogra-
pher Berenice Abbott projects the masts and
rigging of the schooner *Theoline* as a
formidable, and once familiar, presence in
the waters of New York.

of tragedies was diminished but not halted. In the twentieth century, two
seemingly impregnable sea monarchs were lost much to the world's horror.
The *Titanic,* on her maiden voyage to New York in 1912, and the *Normandie,*
lying at anchor in the Hudson in 1940, succumbed to fatal disasters despite all
preventive measures. They were downed by nature's most formidable ele-
ments: fire and ice.

Performing steadily to avert catastrophes was the network of beacons,
lighthouses, harbor pilot boats, and tugboats, all attendant on the safe entry of
a vessel into harbor. Less spectacular in size, function, and authority than pas-
senger or commercial ships, these nautical props went into action long before
landfall was made. As aids to navigation, they functioned through a chain of
naval pilots, harbor masters, port wardens, quarantine officials, customs in-
spectors, and merchant marine personnel, becoming the chief guardians of
New York's port. Over time this officialdom—serving both safety and gov-
ernment interests, and drawn from personnel at the federal, state, and city lev-
els—has swelled significantly. "Nowhere outside the national capital," noted
the marine historian Richard G. Albion in 1939, "are the agents and agencies
of government as numerous and obvious as in a busy seaport." It is an offi-
cialdom that stands in sharp contrast to the early Dutch scene when a lone
flagstaff erected at the Narrows heralded the arrival of an incoming ship.

Perhaps the most conspicuous navigation guide serving New York's harbor
is the Statue of Liberty, with a torch held aloft functioning somewhat like a
safety beacon. She is of comparatively recent vintage. Lighthouses go back
much further than the Middle Ages to the reign of Ptolemy II (283–247 B.C.)
when Egyptians constructed a tower on the island of Pharos off Alexandria. A
high point in pharology (lighthouse engineering) was reached in the nine-
teenth century when Jean August Fresnel invented a cut glass lens that incor-
porated a system of multiple lenses. Fresnel's lens, used to this day, enormous-
ly expands the distance that light can be seen out at sea; all lighthouses serving
New York are equipped with them. An even earlier invention of incalculable
service today was the refinement of longitudinal calculation introduced by the
Englishman John Harrison. In 1761 Harrison perfected the chronometer that
allowed longitude to be determined aboard ship within eighteen miles, an ex-
actitude that helps avert dangerous sea-lanes. Navigational guides and shore-
line activities of almost every marine sort are currently regulated by the De-
partment of Ports and Terminals and by the Port Authority of New York and
New Jersey. The first of these twentieth-century government agencies was
firmly in operation when New York embarked on yet another buoyant chap-
ter in its seafaring history: the accommodation of transatlantic luxury liners.

In the early 1900s nine large docks known as the Chelsea Piers were built
along the Hudson River to accommodate the new ocean-going vessels that
were, to use Virgil's description of oared galleys in the *Aeneid,* "tearing open"
the sea to its depths. Iron, steel, electricity, the wireless, refrigeration, and all
succeeding technological marvels such as gyro-stabilizers went into the mak-
ing of ships that intensified a new, international maritime race, where the goal

SEAFARING SPLENDOR

on the high seas was size *and* speed. Tonnages in the tens of thousands soared ever higher to dimensions that would certainly leave Verrazzano, Hudson, and Stuyvesant thunderstruck. Interior ballrooms, dining salons, swimming pools, and sumptuous staterooms would rivet Dickens speechless in delight. The ocean liners being turned out were breathtakingly beautiful as well, with towering hulls rendered along sleek, sculptural lines. The greatest of the European liners were built in the shipyards of England, France, Italy, and Germany, and all used New York as their New World destination. Manhattan shipyards contributed two liners of the same world class of speed queens: the *United States* and the *America*. Many names of the liners turned out in this era were to have a ring of nobility and to be remembered with sweet nostalgia by their passengers: the *Rex,* the *Ile de France,* the *Aquitania,* the *Bremen,* the *Queen Mary,* the *Normandie,* the *United States,* and the *Queen Elizabeth.*

Thomas Dongan would have not been surprised to learn that more than two thousand ships cleared New York's port in the year the twentieth century reached its halfway mark. At the high point of English rule, just before the Revolution, that number was logged at about seven hundred. To serve the vessels of the modern era, well over fifty ship-repair yards were at the ready. Deep-water steamship berthage was bountiful as well, with simultaneous accommodations for more than five hundred vessels along seventy miles of waterfront. For Manhattanites of the 1950s, it was a gala week when several ocean-going monarchs paused at anchor in the Hudson's waters. Visitors scrambled aboard to inspect them with the curiosity of children in a fantasy world. So entrenched a part of Gotham's appeal was all this seafaring splendor that few noticed at this time the bidding of nature to look skyward for the next generation of transport monarchs. Well before 1960, New Yorkers were being given a choice of transatlantic accommodations more dramatic than anything ever offered to Dickens: a choice between air and sea.

Airlines developed and expanded at a rapid pace; by the end of the twentieth century, three hub airports were serving the city, with plans for expansion by all three. Speed records, like the earlier tonnage records of ships, became staggering. Pan American Airways' first jet plane to London from New York, launched in 1958, made the trip in seven hours and twenty-seven minutes. The French Concorde's current record as it flies into New York's international airport is three hours, outpacing the clock on the westward run. Air power alone, however, did not diminish the whirlwind of activity that characterized Manhattan's waterfronts during the great epoch of seafaring. Railroads, truck transport, and the process of handling large volumes of freight known as containerization played a role. Because new terminals were found outside the cramped city where space was abundant for the transfer of cargo containers, the city's piers slowly crumbled with disuse.

New York's harbor, relying on the city's traditional spirit of enterprise, awaits a reincarnation in the twenty-first century. Perhaps it will be in the service of pleasure, not transport or commerce, that her extensive shores will once more sparkle with activity. The creation of the South Street Seaport Mu-

A World-Class Seaport

seum with a tall ship often in sight, the handsome design of Battery Park City, and the revitalization of the Chelsea Piers are gladsome steps in this direction. Then there are plans put forward by the Hudson River Park Conservancy, a state agency, for a waterfront park from the Battery to Fifty-ninth Street to replace the collapsing piers and parking lots. Whatever new life Manhattan's seafront will eventually adopt, there is the assurance of Walt Whitman—who knew well the rivers surrounding his seaport home—that these waters can continue, if encouraged, to exercise their magic over time as an uplifting element. In this regard, he forges a poetic bond with all future New Yorkers:

I am with you,
you men and women of a generation,
or ever so many generations hence . . .
just as you are refresh'd by the gladness of the river and the bright flow,
I was refresh'd.

MERCHANT PRINCES

The Lure of Marketing, Merchandising, and Moneymaking

Merchant princes of New York can trace their lineage as far back as the Bible. There, where the ancient city of Tyre is presented as a glowing center of trade, the role of the merchant is ennobled. Tyre, says the Bible, is "the crowning city, whose merchants are princes, whose traffickers are the honourable of the earth." Links between the ancient capital and New York are striking. Biblical Tyre, an island city built on rocks, was a famous seaport, a citadel seething with commerce in the days of antiquity, and a vortex of Mediterranean trade. "The harvest of the river is her revenue," declares the Bible, "and she is a mart of nations." It is a description as apt for New York as it once was for Tyre.

In 1626 the infant Dutch trading post at the tip of Manhattan Island was struggling for its existence but already there was a countinghouse. Built of stone thatched with reed and located near the East River, it was one of the first buildings to be erected during the directorship of Peter Minuit. Merchants, not yet of princely lineage nor wealth, made up a robust element of the tiny colonial population and were busy trading in furs with the Manhattan natives. In November of that year, a merchant ship sent over to Amsterdam reported a New World cargo of "7,246 beaver skins, 178´ otter skins [178 half otter skins?], 675 otter skins, 48 mink skins, 36 wild-cat [lynx] skins, 33 mink [this second listing of mink is unexplained], 34 rat skins. Many logs of oak and nut-wood." There were also the skins of raccoons, foxes, skunks, deer, and wolves to be had in the New Netherlands colony, which the natives brought on their backs to the trading post in return for kettles, copper, knives, trinkets, and guns "but too often for Rum, Brandy and other strong Liquors."

The abundant furs of the Hudson River region were not the original lure that had brought the Dutch to the east coast of North America. Their attention had been directed further north to the expansive cod fisheries of the Newfoundland area. The Dutch made a stab at a stronghold there in the early 1600s but were quickly elbowed out by the French and the English who had already staked claims to that upper region. Henry Hudson unwittingly came to the rescue. He rekindled Dutch mercantile interests in North America when he reported on the bounty of the various pelts he espied during his exploratory trip of 1609 up the Hudson. The discovery of that wide waterway in his ship the *Half Moon* was a great disappointment to the English navigator, who had been looking for an ocean passage to the Orient and had to make do with a river instead. Hudson's Dutch sponsors sought to profit

nonetheless from his profound geographical error (the explorer was off course by five thousand miles) with the creation of a mercantile company that would scour New World opportunities for transatlantic trade.

Dreams of mercantile riches were high when the Dutch West India Company (DWI) received its charter from the States General in the Netherlands in June 1621. One of its goals was to duplicate, in the New World, the success of the Dutch East India Company, which was operating in Asiatic waters with an enviable profit. Another goal was to found the colony of New Netherlands extending to present-day Albany, and a third was to create a trading base on the island of Manhattan, which superbly commanded the Atlantic harbor. The company was accordingly granted a monopoly of the transatlantic trade from the States General, under obligation that it maintain a large fleet and that it contribute a share of its revenues to the continuing struggle with the archenemy Spain. The economic success of Catholic Spain in the New World was a bitter pill for all European nations to swallow but none more so than the Netherlands, which had for long suffered under Spanish tyranny. No mercantile prize was as valued as the loot plundered from a Spanish treasure ship; it was both a commercial and a political coup.

In Manhattan the DWI appointed Peter Minuit as the first director-general and Isaack de Rasieres as chief commercial agent of the company. As trade with Manhattan's natives got under way over the next decade, the Dutch looked forward to a lucrative New World connection. But they soon found that profits under the monopoly agreement were easily derailed by the expenses of staking out a fortified trading post in frontier conditions. A further problem was the persistent lack of population to ensure the viability of the fledgling Manhattan post. In 1639 the company decided to throw open the fur trade in the New Netherlands to outsiders. This brought in a motley influx of traders from colonies all along the Atlantic coast who contributed to the cosmopolitanism of the Dutch trading post but to disorder as well. It fell to Peter Stuyvesant, who arrived as director-general in 1647, to whip the colony into shape and bestir all efforts toward an upward spiraling of profits.

Himself a shrewd merchant and trader, Stuyvesant was single-mindedly committed to the success of the DWI. One of the first things he proposed was the erection of "a Pier for the convenience of the Merchants and Citizens." Then, to bolster the population, he ordained that nonresident "Merchants, Scots and Petty Traders shall not be allowed to do business unless they take up their abode in the province for three years." To ward off smuggling, Stuyvesant made it mandatory for merchants to exhibit their books and accounts when required, as well as to have all furs stamped by a public officer before exportation. Wampum, which had become poor in quality, was regulated by a decree that "no wampum except that strung on a cord shall be considered good pay." The rate of exchange was fixed at six white beads, or three of the more valuable black purple beads, to a Dutch stiver. When the governor turned his attention to irregularities in the processing of flour, he assigned a miller at regular pay to superintend "the Hon bel Companys Windmill." This typical Dutch

FIGURE 4.1

View of Tyre by the River Sidon, ca. 1650.
Links between the ancient capital of Tyre,
now part of Lebanon, and New York are
striking. Biblical Tyre, an island city built
on rocks, was a famous seaport, a citadel
seething with commerce, and a vortex of
Mediterranean trade. Her "merchants are
princes," declares the Bible in celebration
of the city, "and she is a mart of nations."

SECTION OF THE CITY WALL, ERECTED IN 1653.

FIGURE 4.2 *The Wall of Wall Street, 1653.*
Along the line of today's Wall Street, Peter Stuyvesant erected a defense barricade to wall off invaders; he enjoined colonial residents to help with the building of it. Though Stuyvesant soon lost the colony to the English, his pastoral lane acquired a new profile as Wall Street, eventually raising the colonial outpost to unprecedented heights.

structure became a conspicuous feature of the skyline in nearly all seventeenth-century images of the expanding colony. Volume in trading picked up noticeably. The commercial tone of the colony and its gathering air of consequence was noted by English observers, who viewed the Dutch venture with a predatory eye. "Since the yeare 1647," reported one visitor to waiting English ears, "they have much emproved their buildings aboute [the fort], that it is now Called the ffort & Cittie of New Amsterdam." He also reported that "the [said] Cittie New Amsterodam is very delightsome & convenient for scituation especiallie for trade having two maine streames or rivers running by, with an excellent harbour."

Finances of the delightsome Dutch colony were nonetheless shaky as reflected in one of the many DWI scoldings issued from Holland. On the occasion of Stuyvesant's building a church in the fort, considered a priority in propagating the Calvinist faith, the company directors were quick to chide him with the remark that "the colony cannot yet bear such expenses." The cost of raising arms against Spain and of sending shiploads of merchandise from Holland for the maintenance of New Amsterdam was outweighing profits. Then there were losses incurred through smuggling, a problem that persisted despite Stuyvesant's efforts and was reflected in the numerous suits filed by the DWI against colonists and former employees. But bolstering the economy was not the director-general's only concern. For all his authoritarian and heroic efforts, Stuyvesant was not able to hold on to the colony. He had no militia to defend it, and he was overpowered by a covetous English presence to the north and south of him. When the Dutch outpost fell in 1664, the DWI was forced to write off the island of Manhattan as a financial failure. Yet the Dutch legacy was writ large. It established forever the mercantile nature of the future city by joining the healthy stimulus of the sea to the idea of enterprise and profit. In this direction, merchants had already begun to form a distinct class. Commerce, after all, had first showed itself in the Netherlands of medieval times, as well as in the ports of northern Italy, and it was there that cities had developed most rapidly and vigorously. Here was an important legacy for New Amsterdam to follow.

The English won a nice prize in 1664 when they assumed the sovereignty of the Dutch colony in the New Netherlands. Under Charles II, the government in England was pursuing a vigorous commercial policy. The colonial authorities immediately proceeded to build on the newly named New York's mercantile foundations with an expertise in governance garnered in the administration of their New England and Virginia colonies. Manhattan's harbor not only provided a robust link with the other ports in the English colonial network but also allowed the new mother country to establish an uninterrupted presence along the middle Atlantic seaboard.

By the close of the 1660s, business was brisk enough to warrant the operation of a merchants' exchange, that practice of honorable traffickers dating back to the Middle Ages. It was put into effect formally when Governor Francis Lovelace proposed in 1670 a "fitt tyme & Place" for "ye keeping a

Marketing, Merchandising, and Moneymaking

FIGURE 4.3 *Interior of the Amsterdam Stock Exchange, ca. 1770.*
Along with canals, windmills, and trade, Dutch institutions like the mighty stock exchange of Amsterdam were the foundations of New York's growth and wealth. The first instrument of colonial finance was the modest wampum: six white beads, or three more-valuable black-purple beads, equaled one Dutch stiver (two cents).

Punctuall tyme for meeting at ye Exchange." In terms of a physical structure, none was proposed for "ye Exchange" at this early date but Lovelace was well aware of the pressing need for a proper locus where "Merchants . . . & other artificers may resorte & discourse of their severall affaires according to ye universall custome of all maretyme Corporations." Fridays between the hours of eleven and twelve were set aside for the discourse, while the place designated was to be "at or neare ye bridge (for ye present)," a spot in the open air at the junction of Broad Street and Exchange Place. It was further ordained that merchants were to be summoned by "ye ringing of a bell when they should come on, & when they should goe [off] & that care be taken by ye Mayor of this Citty that no interupcon or disturbance be given to any one that shall frequent that Exchange." In this manner, the powerful Merchants' Exchange was born.

Merchants continued to make up the largest segment of the colonial population for the remainder of the seventeenth century, being engaged in the exportation of furs, in the importation of rum, wine, and general merchandise and, increasingly, in shopkeeping. As English colonial rule wore on, merchants of note formed a cosmopolitan group coming from Dutch, French, and increasingly, from English families. A roll call of them would include names like Rip van Dam, Abraham De Peyster, Gabriel Minvielle, Richard Willett, Stephen de Lancey, Ebenezer Willson, and John Burrows. Stepping briskly in stride with her fellow merchants was the widow Helena Rombouts who did a landmark business importing rum from the West Indies and exporting furs to London.

Because funding from England was irregular, colonial governors in distress came to rely on the city's merchants for provisions. This allowed the mercantile community to gain substantial leverage. Merchants accordingly took a strong part in politics and looked to the honoring of their commercial interests as well as of their dignity. In 1678 a group of merchants headed by Thomas Griffith, Henry Griffith, and Thomas Harwood had lodged an official complaint to the effect that "a Whiping post is erected in New Yorke after ye Belgick fashion, far different from ye English manner by wch ye execution is much more dis[g]racefull to ye offenders wch (if English) are rendered thereby more ridiculous to ye netherlanders, & had in great derision by them." How many were whipped in this humiliating "Belgick" fashion is not recorded.

Before the seventeenth century ended, a business boom sparked from two different directions enlivened the colony. The colonial authorities passed a number of Bolting Acts that gave the city's merchants the exclusive right to bolt or process all flour that left from New York's port, ensuring a uniform quality that enhanced the port's reputation and expanding the city's market into a triangular trade. New York merchants sold the flour to the West Indies, to southern Europe, and to England. They marketed it along the Atlantic seaboard as well. Flour became the gold of the colony, with merchant princes like the van Cortlands, the Bayards, the Beekmans, and others reaping large re-

turns. More lucrative still were the profits to be had through privateering and piracy, practices that had assumed certain swashbuckling heroics in the days of Sir Walter Raleigh but were distinctly unethical. Privateering entered the scene at New York harbor when England, at war with France, issued so-called letters of marque in the 1680s allowing merchant ships to legally plunder enemy vessels on sight. Plundering was carried a step further into outright piracy when other ships were looted as well. Piracy was an old, old story, having been the initiator of maritime trade among Homeric Greeks and Norse Vikings. Because New York merchants willingly abetted in the disposal of plundered goods, the city's shops began filling up with hijacked wares from far-flung regions that were as seductive as they were ill-begotten. Throughout the course of the next century, privateering and piracy were distinct sources of New York's wealth.

The legitimate, unsmuggled trade of New York had meanwhile multiplied many times. In 1720 British goods worth £37,397 were imported; in 1764 that figure had leaped to £515,416. As to exports, the volume of goods shipped out sent merchant handlers to their countinghouses just as often. Significantly, very few of the nearly fifty different commodities exported to a string of destinations abroad could qualify as home products. Yet these exports all went through Manhattan's port as did the imports rerouted to internal sites. In terms of its own major resources, the city counted its shipyards, tanneries, distilleries, mills, and foundries, as well as its knack for turning a profit wherever an opportunity presented itself. A merchant prince of the early Georgian period was William Walton whose family amassed a fortune in shipbuilding. It permitted him, in 1752, to build the most exorbitant mansion of the day on Pearl Street. Already New York was beginning to qualify, like Tyre, as a mart of nations. By 1767 the distinctly urban aspect that Manhattan's former flowering woodlands had taken was recorded in a handsome map prepared by the cartographer Bernhard Ratzer. Merchants who could afford to buy the gold-bordered engraving, printed in London, were well aware that the impressive landmarks indicated on the Ratzer survey—residences, commercial buildings, churches, and port facilities—represented a tribute to their accumulated ingenuity. They were the New Yorkers who wore knee breeches and wigs—as opposed to workingmen's trousers and caps—and could boast a private carriage. The rising number of those who strutted in knee breeches had permitted the opening in 1765 of a third coachmaker's shop opposite Saint Paul's Chapel where Samuel Lawrence was turning out phaetons, chariots, chairs, and coaches "in the genteelest Taste . . . not inferior to any imported from London."

At the outbreak of the Revolution, merchants found themselves lined up on both sides of the political divide. What could not be gainsaid was that the essentially "American" quality of their economic interests was gaining ground. Though there were Royalists aplenty in New York, those who yearned for an American independence kept up a series of riots and protestations that ultimately led to war. Because Manhattan served as a principal battleground for

FIGURE 4.4
Wall Street from Hanover Street, 1790.
It was as a desirable place of residence that
Wall Street first began to assume an air of
consequence. It slowly opened its doors to
the brinkmanship games of banking, stock
speculation, and insurance. Townhouses were
built along this highly coveted address that
served into the nineteenth century both as
workplace and residence.

FIGURE 4.5
Portrait of John Jacob Astor, ca. 1802.
John Jacob Astor was probably the first resident New Yorker to amass colossal wealth, principally in the fur business and in real estate. His contemporary Herman Melville liked to repeat the name John Jacob Astor, "for it hath a rounded and orbicular sound to it," he declares in "Bartleby, the Scrivener," and "rings like unto bullion."

the English, the city's fortunes sustained a severe setback during the Revolution. As well as suffering the ravages of a prolonged war, the city was heavily damaged by a suspicious fire for which the warring sides blamed each other. "A most horrid attempt was made by a number of wretches to burn the town of New York," ran a royal dispatch of September 1776 to London. Postwar years were given over to reconstruction. James Duane, the son of an Irish merchant and a sizable property holder, returned from exile to find his two houses, one in King Street and the other in Water Street, almost entirely destroyed. His twenty-acre farm in the area of today's Gramercy Park had been spared because it was occupied by an English general.

Those first bleak years of independence were given a commercial lift in 1785, via the city's ever-bountiful harbor, with the successful inauguration of the China trade. Shops soon glistened with the fine silks, chinaware, cinnamon, and tea that made up the cargo imported from the Far East. In return, New York exported furs, woolens, pig lead, and large quantities of a wild root, grown principally in the Hudson River valley, that was akin to the curative ginseng so prized by the Chinese. Though it took upward of a year for the colorful clipper ships to make the round trip to Canton, it was well worth it. The *Empress of China* had realized a profit of 25 percent on the investment made in her risky maiden venture that was launched in 1784.

Successful merchants met regularly in the Tontine Coffee House (begun in 1792), situated on the northwest corner of Wall and Water Streets. Here many organizations—commercial, political, benevolent, and social—made their headquarters for meetings and dinners. It was a prominent business exchange and tavern for more than a generation. Soon to be counted among New York's prosperous merchants was a young European immigrant named John Jacob Astor, whose imagination was stirred by the riches to be had from the fabled China trade. Son of a butcher in Waldorf, Germany, Astor started as a Manhattan street peddler with twenty-five dollars in his pocket and was subsequently able to open a little shop selling musical instruments. When he was inspired to stock his shelves at 81 Queen Street with furs as well, it proved to be a giant step forward, for the wide use to which furs were put had not escaped Astor's attention. They served extensively as bedcoverings, rugs, carriage robes, sleigh throws, wall hangings, furniture coverings, coats, hats, gloves, cloaks, boas, muffs, and trimmings. The Far East became one of Astor's major fur markets and a beginning source of riches with the opening of his own American Fur Company, an enterprise endorsed by Thomas Jefferson in the White House. Jefferson mentioned to the explorer Meriwether Lewis that a powerful company was being formed "under the direction of a most excellant man, a mr Astor mercht of N. York, long enegaged in the buiness & perfectly master of it." Far richer still did he become when he began to invest in the real estate of Manhattan, shrewdly buying up whole swaths of available land in the years between 1800 and 1818 with the profits from his furs. For the rest of his life, he reigned as a merchant prince on the highest rung of the money ladder, the first post-Revolution New Yorker to have amassed colossal wealth.

Herman Melville admitted that he liked to repeat the name John Jacob Astor, "for it hath a rounded and orbicular sound to it," he writes in "Bartleby, the Scrivener," "and rings like unto bullion."

Astor's prudent moves underscored the many mercantile directions that had become possible in late-eighteenth-century New York. There was money to be made in shipping, in manufacturing, in trade, in retailing, in real estate, in moneylending, or in any commercial byplay that could be matched by aggressive entrepreneurship. Harking back to the practices of medieval Italian merchants and the German Fuggers of the Renaissance, Astor had dabbled in virtually all the city's entrepreneurial functions while making moves as well in the direction of banking and in buying stock and bonds. It was perhaps with John Jacob Astor that speculation in urban real estate came to be recognized as a major source of wealth.

New York's most famed merchant prince of the mid-nineteenth century was to move in an entirely new direction. His name was Alexander Turner Stewart and he opted for specialization in the city's wide arena of commerce by opening up a department store. No one was quite ready for the grand choreography the diminutive Stewart would employ in entering the dry goods trade. Of Scotch-Irish descent, the nineteen-year-old immigrant came to New York in 1821 and soon opened a tiny linen and lace shop near city hall. He promptly announced himself in the *Daily Advertiser* of September 2, 1823, ending his pitch with a firm pledge of service: "A. T. Stewart . . . hopes to merit patronage by strict attention to business." The strict supervision Stewart gave to his business during the following decades served him well. By 1846 his bundle of profits permitted him to open a store so sumptuous that it took the town by storm and became known as New York's "Marble Palace." The press gave it lavish attention and the diarist Philip Hone gushed that "there is nothing in Paris or London to compare with this drygoods palace."

The merchandise offered in the marble palace was so varied that Stewart created "departments" for easier access to its abundance. Eventually, the elaborate store became Stewart's warehouse when his undiminished drive led him to build yet a larger one at Broadway and Ninth Street, which still stands. It was one of the city's first structures with a cast-iron front, permitting the installation of large display windows to arrest the gaze of pedestrians and lure them inside. A grand central staircase crowned with a skylight greeted Stewart's awed customers, who were served deferentially by dandified clerks as they fingered gorgeous fabrics with the sensuality they deserved. A genius in the art of retail, Stewart left no stone unturned in satisfying the erotics of consumption and set standards for the string of eminent department stores that would one day follow his own. "He is, I suppose, next to the President, the best known man in America," was the way an English traveler of 1864 measured A. T. Stewart's fame. His wealth was almost beyond calculation in that Victorian era.

By the 1860s New Yorkers had a wondrous array of stores to satisfy their acquisitiveness, all adding to the city's renown as a shopping center. Many of

the proprietors of these prominent stores, such as Charles Lewis Tiffany, William Sloane, James Constable, Charles Macy, and Isidore Strauss, joined the ranks of merchant princes whose striped trousers and top hats replaced the breeches and wigs of their colonial forbears. They assiduously catered to the carriage trade, while fostering the democratization of shopping clienteles by following A. T. Stewart's lead of "free entrance." The poor could at least *look*. Shelves were stocked with merchandise from all corners of the globe, with a marked focus on the fabrics that went into the making of a fashionable silhouette.

That it took roughly eighty to a hundred yards of goods in the Victorian era to create a lady's costume with its voluminous underpinnings kept New York merchants on a prosperous run in the dry goods trade. They imported fabrics of staggering variety, all of them readily familiar to salesclerks and knowing customers. On demand were textiles with names mostly forgotten today such as afghalaine, barathea, batiste, boucle, calico, cambric, challis, chiffon, crepon, drill, faille, georgette, gingham, grosgrain, haircord, huckaback, lawn, matelasse, melton, organza, percale, pique, plisse, pongee, poplin, poult, ratine, repp, sateen, serge, shantung, surah, taffeta, tussah, velour, voile, and whipcord, as well as the basic varieties of cloth familiar to twentieth-century shoppers. The most exquisite of the fabrics deriving from the weaves of silks, woolens, and linens in a range of colors were snapped up by the would-be fashionable, just as the renowned silks of Tyre had been snapped up about 50 B.C. by a discerning shopper of antiquity, the peerless Cleopatra.

What made possible the bustling level of these elegant indoor markets was a support system of labor and transport that was developing along parallel lines as the nineteenth century wore on. That system in turn supported the city's other major industries, which were centered in the manufacture of machinery, furniture, clothing, tobacco, and cigars; in meatpacking; in printing and publishing; and in the refining of lard, sugar, and molasses. In manufacturing, many of the smaller mercantile houses concentrated on one commodity and saw their products brought to a wide level of acceptance. Henry Steinway linked his name globally with the manufacture of pianos, Eberhard Faber with pencils, John McKesson and Daniel Roberts with pharmaceuticals, Pierre Lorillard with tobacco, Thaddeus Fairbanks with scales, and Walter Marvin with safes. A host of others like them, with factories sometimes established in other states but requiring New York as a main storefront and channel of distribution, substantially contributed to the city's economic profile.

Behind all these commercial enterprises was a virtual flotilla of ships manned by the merchant princes of South Street. Both steam and sail provided for the frequent and dependable arrival of goods. Successive waves of immigrants, who were to be mercilessly exploited, supplied a labor force of skilled and unskilled hands and expanded the buying public. In ascendance, and at the service of commerce, was the city's newspaper industry, fueled since the 1830s by steam-driven presses. A ripple of inventions of no little importance also provided support, such as the sewing machine and the transatlantic cable. Telephone and elec-

tric cable cars appeared by the last decades of the century, directly serving commerce. On Broadway, thick crowds of shoppers were canopied by a black criss-cross of telegraph, telephone, and electric light wires, suspended from rough hewn poles, that all but obscured the sky. On the streets, a multitude of horse-drawn vehicles and electric cable cars served the flow of merchandise, messengers, and shoppers but contributed to noise, confusion, and congestion; they also contributed to the noticeable filth of the city.

New York, from these several urban aspects, was assuredly not pretty, but it was intensely and commercially alive. Panoramas of the city in all its guises, elegant and inelegant, had for some time been providing spirited copy for the burgeoning printing and publishing industry. The city also figured prominently in the fictional world of books created by its authors. Taking the commercial lead in book publishing were John Wiley, Daniel Appleton, the brothers James and John Harper, Charles Scribner, George Palmer Putnam, and David Van Nostrand, all merchant princes of their trade who were usurping the leads once held by Boston and Philadelphia in book production.

An undeniably noisy role in expanding the printing and publishing industry was being played by the newspaper press. Two uncontested princes among those engaged in the merchandizing of words were James Gordon Bennett and Horace Greeley. Their hierarchical status was gained as much in terms of money as in verbal notoriety. The vituperative Bennett, a gaunt, cross-eyed Scotsman who had tried his wits at newspapering in Boston and Charleston, launched the weekly *New York Herald* in 1835. Greeley, a restless crusader looking quite like a caricature of Dickens's Mr. Pickwick, created his *New York Tribune* in 1841. Both papers, which gave generous coverage to the doings of commercial enterprises, dug their heels deep into the politics of the city and of the federal government. A key issue of the times was the abolition of slavery and on this, Greeley and Bennett crossed swords. Both their papers raised the quality of New York journalism by attracting the most able reporters.

Advertising kept pace with the growth of newspapers, having long since been recognized as a sine qua non of commerce. Most of the papers accepted advertisements, which often consisted of the preposterous claims of quacks as well as notices of the quality products of the prominent department stores. James Gordon Bennett viewed his advertising columns as no less than legitimate "news"; accordingly, he began to require a daily change of copy for the announcements that were placed in his paper. By 1876 New York had moved to the position of the nation's advertising capital, with merchants spending nearly $10 million to plug their products. They found forty-two advertising agencies at the ready to handle the promotion. New York's printing and publishing houses had clearly garnered an undisputed lead in the industrial game of words.

Long since begun, and grooming its own hierarchy of merchant princes, was the game of money lending and speculation played in lower Manhattan. Before the nineteenth century was out, it made of New York the financial capital of the world. The story of that meteoric rise begins with Peter

Stuyvesant, whose part has little to do with finance but who will not be left out of the city's historical past. In 1653 Stuyvesant ordered a ditch to be dug along an east-west line half a mile upward from the Battery that marked the northern or land end of the Dutch colony. It joined the Hudson and East Rivers. He further ordered a palisade to be built along the northern face of the ditch, intending to wall off the nascent settlement against the feared incursions of outsiders. At both the east and west ends of the defending enclosure was a gate through which cattle were driven from the upper reaches of the island to the market below. That wobbly wall of palisades was never called on to do battle with an enemy but it eventually acquired strength of another kind under the name of Wall Street.

It was as a desirable place of residence that Wall Street first began to assume an air of consequence. When wealthy families like the Verplancks, the Ludlows, the Marstons, and the Winthrops settled there during the eighteenth century, it became a thoroughfare of some elegance. The street slowly opened its doors to the brinkmanship games of banking, stock speculation, and insurance in a shrewd offering of itself as a highly wanted address both as workplace and residence. Already in the 1790s, this once pastoral lane had begun to take on a little of its present-day commercial character. Three houses of finance then flanked the thoroughfare side by side: the Bank of New York, the New York Insurance Company, and a branch of the Bank of the United States. Within two decades they were joined by the Merchants' Bank, the Union Bank, the Bank of America, the Phenix Bank, and the City Bank. All occupied existing buildings, which continued to be used as residences.

In the post-Revolutionary decades of the early bank formations, stockbrokers had also been busy laying plans in coffeehouses (notably the Merchants' Coffee House, followed by the Phoenix and the Tontine) out of which the future New York Stock and Exchange Board was conceived. Alexander Hamilton, who had helped to establish the Bank of New York in 1784—the city's first—had a strong hand in these dealings. He looms as a major figure in New York's rise to financial prominence. The Exchange, together with banking and insurance, formed the backbone of the city's financial network with all three institutions proliferating in various forms. In its role as agent of the federal government, the Custom House also linked itself to the world of finance; so, too, did the New York Clearing House and the New York Chamber of Commerce. There was money to be made in the chambers of these financial houses and there was concomitantly no want of New York entrepreneurs to take up the challenge. Soon after the War of 1812, when the city had been virtually an armed camp, the first feverish buzz of activity in the securities market could be felt 'round the city; it has not abated since.

With its massed presence on or near Wall Street, the world of finance exuded undeniable authority. That colonial neighborhood had become by Jacksonian times a mart for bankers, brokers, underwriters, and stock-jobbers. In this circumscribed area were conceived and consummated speculations of every character and daring, from the sale of a single bond to the disposal of an

entire transatlantic cargo. Here, too, was quartered an enormous support staff
of lawyers and clerks sharing small offices in the various financial houses that
lined the diminutive, colonial streets; their need for business space would allow
for no more residences as the century wore on. In one of those small offices
of the 1850s sat Bartleby, the fictional scrivener created by Herman Melville
in the eponymous short story. He was assigned to endless copying of docu-
ments by a Wall Street lawyer successfully engaged, according to the narrative,
in "a snug business among rich men's bonds and mortgages and title-deeds."

From his office, Bartleby had no view giving onto Wall Street itself. The
second-floor chambers of his employer, shared with two fellow scriveners in
1853, faced a light shaft on one side and a stone wall on the other. But in
Bartleby's peregrinations in the area to and from work, he could not have been
indifferent to his surroundings despite his melancholy temperament. It per-
haps struck him that what Manhattan's financial institutions shared in com-
mon was a powerful architectural tradition that sought to project their money
dealings as sacred to the community. Temples, domes, arcades, rotundas, palazzi,
and colonnaded neoclassic facades, designed by leading architects, combined
to make that fantasy abundantly clear. On the Wall Street of his day, Bartleby
was greeted by a conspicuous showing of these noble structures. The Custom
House would have caught his eye as he strolled alongside Stuyvesant's former
ditch, as would the Union Bank, the National Bank, the Merchants' Bank, the
Bank of America, and the offices of an insurance company at 60–62 Wall
Street. By far, the showiest of the money temples lined up for Bartleby in the
mid-nineteenth century was the Merchants' Exchange.

FIGURE 4.8 *Merchants' Exchange, 1837.*
As a continuing and important icon of
marketing, merchandising, and moneymaking
in rising New York, a new Merchants'
Exchange was opulently designed in 1836.
A fire in 1835 had ruined the previous
edifice. The vast configuration of the new
Wall Street structure harked back in
architectural motifs to the *telesterion* of
ancient Greece.

Competition for the design of the Exchange had been intense. The com-
mission was ultimately won by Isaiah Rogers, an architect coming into
renown in a profession lately receiving acceptance as one significant for the
arts. Rogers's 1836 plans for the domed Exchange (to replace the building de-
stroyed by fire a year earlier), paid robust tribute both to Greek and Roman
revival motifs with its monumental, colonnaded portico extending along the
south face of Wall Street. Its vast configuration harked back to the *telesterion* of
ancient Greece, a large, ventilated space used in conceiving the commercial
exchange of Delos in the second century B.C. Leaders in the building arts such
as Isaiah Rogers, Alexander Jackson Davis, Calvin Pollard, Martin Euclid
Thompson, Ithiel Town, and their nineteenth-century contemporaries happi-
ly leaned on the collective heritage offered by ancient, medieval, and Renais-
sance architects in glorifying the financial houses of New York.

These impressive structures of the mid-Victorian era lent enormous pres-
tige to the personalities behind them as well, most of whom greeted the day
in spats, cutaways, and top hats. A name that resonates as the ne plus ultra
among the lineup of top-hatted financiers conducting business in New York,
such as Cornelius Vanderbilt, Daniel Drew, James Fisk, Andrew Carnegie, Jay
Gould, and John D. Rockefeller, is that of John Pierpont Morgan. The tall, bul-
bous-nosed financier established one of the world's most powerful banks and
made his presence felt in the city's manufacturing industries, as well as its rail-
road ventures, by strategies of refinancing, reorganization, and aggressive, if not
ruthless, entrepreneurship. His financial daring was likely to leave his own
peers breathless, as when he watered stock to effect the formation of the Unit-
ed States Steel Corporation; his banking company gained 50 percent profit
from the deal. As was true of New York merchant tactics before and after his
time, Morgan's strategies often bordered on the brink of dishonorable traf-

FIGURE 4.9 *The Scrivener of Wall Street, 1853.* Bartleby, the fictional and forlorn scrivener of Wall Street, was created by Herman Melville in an eponymous short story. Invariably silent and intense, Bartleby daily took up his quill to copy "rich men's bonds and mortgages and title-deeds" behind a screen in a small, viewless office. Artist Thomas Wesley Peck renders the scene.

ficking. Supreme testimony to the success of this New York merchant prince is the handsome Pierpont Morgan Library (1906) at Madison Avenue and Thirty-sixth Street designed by the firm of McKim, Mead, and White. Here are housed Morgan's collection of irreplaceable treasures of world learning and the arts; they are of a quality once collected by merchants of the Renaissance with whom Morgan strongly identified.

A merchant prince who made his debut in the Victorian era but whose nearly century-long life brought his financiering well past the First World War was John D. Rockefeller. He became a New Yorker by choice, moving to the

Marketing, Merchandising, and Moneymaking

FRANK LESLIE'S
ILLUSTRATED
NEWSPAPER

Entered according to the Act of Congress, in the year 1860, by FRANK LESLIE, in the Clerk's Office of the District Court for the Southern District of New York.

No. 257—Vol. X.] NEW YORK, OCTOBER 27, 1860. PRICE 6 CENTS.

GRAND BALL AT THE ACADEMY OF MUSIC, TO THE PRINCE OF WALES.

SUPERB TOILETTES OF THE LADIES OF NEW YORK, AT THE GRAND BALL GIVEN IN HONOR OF THE PRINCE OF WALES, AT THE ACADEMY OF MUSIC FOURTEENTH STREET, BY THE COMMITTEE OF THE CITIZENS, OCT. 12, 1860.—SEE PAG 352

FIGURE 4.10 *Dressing for a Grand Ball, 1860.*
Roughly eighty to a hundred yards of
cloth went into the making of a mid-
Victorian lady's costume for which miles
of extravagantly textured fabrics lined the
shelves of New York stores. The immigrant
Alexander T. Stewart, whose "drygoods
palace" of 1862 strove to satisfy the erotics
of consumption, rose to the rank of a
millionaire.

FIGURE 4.11
Portrait of J. Pierpont Morgan, 1902.
The financial daring of the merchant
prince J. Pierpont Morgan left his own
nineteenth-century colleagues breathless.
He watered stock to form the United States
Steel Corporation with a 50 percent profit
gained for his company. A monument to his
peerlessness as a financier is the splendid
Morgan Library.

city in 1884 when, under his guidance, the Standard Oil Company reached a
near-monopoly in an industry constantly marked by ruinous competition.
Rockefeller's staggering wealth from oil permitted him to wax philanthropic
on a scale previously unknown. Although partial to Baptist enterprises, which
he helped to support (like the building of the monumental Riverside Church),
he had the lofty ambition of promoting "the well-being of man-kind through
out the world" by creating the Rockefeller Foundation in 1913, one of the old-
est and largest charitable foundations in the country.

During the rise of John D. Rockefeller, New York's trade declined marked-
ly before World War I but its losses were restored during the seventeen months
the country participated in the conflict. The city's harbor buzzed with the em-
barkation of troops: well over 1.6 million sailed from her waters to France.
Tonnage directed toward the port was increased, moreover, by the widening
and deepening of the Erie Canal completed in 1918. It was now that the city
replaced London as the center of international finance.

When John D. Rockefeller Jr. came to maturity in the post–World War I
years, his father's expanded wealth allowed him to wax equally philanthropic.
Just before the Wall Street crash of 1929, the son's fortune had swelled to $1
billion. John D. Jr. was generous in giving money to ameliorate housing in
Harlem, the Bronx, and Queens and in enlarging park space. Out of his own
funds, he created Rockefeller Center during the depths of the depression.
Such an extraordinary complex of commercial buildings in mid-Manhattan,
the first of which opened in 1939, charted wholly new concepts in urban de-
sign and has forever elevated the city's aesthetic profile. Here is an unparalleled
tribute of a merchant prince to his adopted city.

A merchant prince of more recent vintage, drawn to speculation in real es-
tate as was John Jacob Astor, is the flamboyant developer Donald Trump. A na-
tive of the outer borough of Queens, Trump began to attract attention in the
1970s with his controversial development projects, particularly one facing the
Hudson River on the Upper West Side. Here he conceived of a dense com-
plex of luxury apartments and commercial facilities to be called Trump City.
Residents, fearing a drain on community resources with the demands of so
huge an architectural entity in their midst, opposed him. Though the com-
plex, not finished by the year of the new millennium, is now called Riverside
South, the name of the millionaire prince is echoed in the building complex
at Trump Plaza, a lavish skyscraper on Fifth Avenue known as Trump Tower,
and the Trump International Hotel and Tower at Columbus Circle. There are
likely to be other eponymous sites.

Dabbling for profit not in real estate, but in the highly risky arena of mo-
ney speculation, is the investor George Soros. The forays into finance of this
New Yorker of Hungarian birth were made in an era marked by the increas-
ingly volatile nature of stock markets, the end of the post–World War II dol-
lar domination, and the ability to monitor traders at computer consoles si-
multaneously in New York, Tokyo, London, and all points in between. At the
end of the twentieth century, the dollar numbers swirling about the success

Marketing, Merchandising, and Moneymaking

FIGURE 4.12.
Portrait of John D. Rockefeller, 1903.
A merchant prince of vast fortune, John Davison Rockefeller began with a small Manhattan sales office that eventually blossomed into the giant Standard Oil Company. His fortunes became staggering. When he attended the Fifth Avenue Baptist Church, people sought to catch a glimpse of the legendary millionaire.

stories of this merchant prince of finance alighted on a multiple of billion. As with his financial reach, Soros's philanthropic ventures are global rather than local or national. "With Big Money and Brash Ideas," ran a headline in the *New York Times* of December 17, 1996, "Billionaire Shakes Up Philanthropy."

Merchant princes who boast less spectacular fortunes continue to be made and unmade in New York's world of finance, real estate, and commerce. Those spheres of entrepreneurship have been expanded by a new-media industry, powered by electronics, that may well prove to be a generative element in the city's future economy. A media mogul has already emerged in the person of Michael Bloomberg, a legend on Wall Street whose outpouring of business news reports, market data, and securities prices has attracted a wide circle of subscribers among bankers, bond traders, and money managers. Part of this media empire is Bloomberg Information Television, which broadcasts twenty-four-hour news channels in four continents. This modern merchant prince employs three thousand workers in an industry that claims annual revenues reaching to $1 billion. No real competition is yet in sight.

Neither Michael Bloomberg nor any other Wall Street personality has the name recognition of the financier Dow Jones, who occupies pages and pages of newspaper print on a daily basis. Though not a flesh and blood personality, this merchant prince created by the *Wall Street Journal* has become the most widely followed stock market barometer. Conceived as an index of stock market activity, the Dow Jones average has moved from an initial tally of 40.94 on May 26, 1896, to the 10,000 mark on March 16, 1999, only to fall precipitously and rise past the 11,000 mark as the clock ticked toward the new millennium. Many New Yorkers, alarmed by such volatile trading, are wont to recall the horrors of the stock market crash of 1929, which after two generations have not been forgotten. But whenever dark voices are raised, the commercial persona of the city proffers a spunky indifference. Those more optimistic, who seek to penetrate the essential irrationality of the market's booms and busts, find the cycles indeed baffling but they are nonetheless lured by the Wall Street game of roulette because it offers its players a fantasy destiny. What makes the game irresistible is its unpredictable power to raise the status of modest speculators to that of anonymous merchant princes.

PEOPLING NEW YORK

Asia, Europe, and Africa Transplanted

Asia Transplanted

"O My America! My new-found-land . . . My Myne of precious stones: My Emperie. How blest am I in this discovering thee!" rhapsodized the poet John Donne in one of his exquisite elegies. Addressing the poem to his mistress in 1592, the twenty-year-old bard used America as a lusty metaphor for the delights uncovered in love, at the same time that he projected the sense of wonder felt by Europeans upon the disclosure of a New World. His joyful evocation of a "new-found-land" was to reverberate throughout the unprecedented transplantation of peoples from three continents to the Western Hemisphere over the next four centuries. They joined a population already flourishing here but about which little was known in the sixteenth century.

Anthropologists hold that the peopling of the Western Hemisphere began when small bands of migrants attempted to cross the hazardous land bridge of the Bering Strait from Siberian Asia to Alaska. Moving from place to place as a better means of subsistence was found, the Asian bands eventually spread throughout the two continents sometime between 30,000 and 13,000 B.C. Dates are ventured for the patterns of internal migrations and for the probable arrival time, around ten millennia ago, of the small band of descendant migrants that made it as far east as Manhattan Island. When Giovanni da Verrazzano landed in their midst, he could not identify them, and in his report of 1524 to the French sovereign Francis I, he referred to them simply as "the people." We "saw the land much populated," the Florentine explorer declared. "The people . . . came toward us joyfully, uttering very great exclamations of admiration, showing us where we could land with the boat more safely." Before the sixteenth century had ended, the descriptive term *Indian,* earlier coined in Spanish by Christopher Columbus, would be assigned to the inhabitants of Manhattan, as it would be to all natives of the New World. This sweeping appellation gave no indication that the natives of the two continents were divided into at least two thousand cultures. Columbus assigned the name *Indian* because he believed he had landed on the shores of the fabled Indies.

In 1524 the non-Indian population of Manhattan stood at zero. Aliens, or newcomers from Europe to this site, would begin to settle only in the early years of the 1600s. When they arrived, they encountered spirited bands of indigenous peoples with unchallenged possession of their territory. The Man-

hattan dwellers came to be grouped ethnographically into the two major linguistic stocks of Algonkians and Iroquois encamped throughout the Northeast. Subdivisions of these seaboard peoples established a strong ethnic presence over long periods of time in the Hudson River area and developed a culture suitable to a coastal environment. They spoke innumerable dialects, often incomprehensible to a nearby group, although their overall numbers were small. On the island of Manhattan, Algonkian settlers numbered only a few hundred or so when Henry Hudson made his exploratory visit in 1609.

Hudson and his men added to the lore of information brought back to Europe about the New World peoples but it was far from a detailed ethnography. An officer of the *Half Moon* described the repeated encounters with the natives during the voyage of 1610, writing in the ship's log on the fifth of September that "many of the people came aboord, some in Mantles and Feathers, and some in Skinnes of divers sorts of good Furres. . . . They had Copper Tabacco pipes, and other things of Copper they did weare about their neckes." The log for the sixteenth reports that "the people came aboord, and brought us eares of Indian Corne, and Pompions, and Tabacco; which wee bought for trifles." By 1626 an informal count was ventured by Isaack de Rasieres, a commercial agent of the Dutch West India Company, who reported that there "are about 200 to 300 strong, women and men, under different chiefs, whom they call *Sackimas* [sachems]."

In efforts to understand this newly introduced race dwelling across the Atlantic in both North and South America, Europeans developed epithets common to them all. Known alternately as the *wild men* or as *noble savages,* New World natives were also likely to be referred to as infidels, pagans, savages, and heathens, invectives based on religious bigotry not necessarily reserved for Indians. "Our people . . . bought the island Manhattes from the wild men for the value of sixty guilders," was the way Peter Jansen Schaghen, a Dutch official, circulated the news in 1626 of Peter Minuit's legendary purchase.

As European settlers grew in numbers and developed close trading relationships with the Indians in the Hudson Bay area, they began to distinguish among the various loosely confederated groupings of Algonkians in the territory they had named New Netherland. That large province extended from southern Delaware to western Long Island and up the Hudson as far as Albany and Schenectady; it brought the early settlers into contact with a whole cluster of small Indian bands, each of which had its own customs and languages. The largest of these were the Mohegans, the Delawares, and the Mahicans. Those who dwelled on the island of Manhattan were called alternately Manates, Reckgawawanes, Manhattans, or Lenapes, though often other bands made their way to this small territory. On the continent of Europe, where few distinctions were made, the designations *wild men* and *noble savage* in referring to New World natives persisted well into the eighteenth century. The term *wild men* was effective in ascribing to Indians some of Europe's starkest taboos, such as nakedness, cannibalism, lawlessness, and sexual promiscuity, all of which were underscored in the earliest pictorial images of Indians that circu-

lated on the Continent. At the other extreme, the term *noble savage* projected an enviable innocence. Enlightenment writers used the image of noble savage to attack the European social system of privilege, inherited power, and political oppression. It was a concept stretched to welcome a new race and condemn the old.

The Dutch, a practical people, attempted to channel these concepts into pragmatic ends as they established a New World presence on Manhattan Island side by side with the natives. Initially, trading posts, not a permanent settlement, were the objective but before long this proved impracticable. Traders faced the necessity of acquiring food, housing, and defense once they had determined on the Hudson River area as a base of operations. In these matters, peaceful accommodation with the local inhabitants was to be sought. Word went out from the Dutch West India company in 1625 that, in locating suitable places for the grazing of animals that were to be imported and in plotting fields for the sowing of crops, only lands *abandoned* or *unoccupied* were to be taken over. The island had not yet been "bought." If suitable places were already occupied by the Indians, the Dutch traders were to see "whether they cannot, either in return for trading-goods or by means of some amicable agreement, induce them to give up ownership and possession to us, without however forcing them thereto in the least or taking possession by craft or fraud, lest we call down the wrath of God upon our unrighteous beginnings."

How righteous could these beginnings have ever been? The Indians, unequally armed, had little control over the turn of post-Columbian events as they witnessed an expanding population descend on their territory. They were as unprepared as the Europeans in assessing the attributes of a foreign people and in making accommodations for their permanent stay. The Indians "sometimes manifest themselves with arrows, like enemies, sometimes like friends; but when they have seen the ships once or twice, or traded with our people, they become altogether friendly," was the judgment of Nicolaes van Wassenaer. What the natives had in their favor was a willingness to help the colonists adjust to a new terrain; much more importantly, they had access to a seemingly endless supply of furs. The arriving Dutch were neither outrageous nor cruel but they contributed, as did subsequent Europeans who flocked to Manhattan, to an alien and threatening presence. Still, a relative peace prevailed for a time. "The colony began to advance bravely and to live in friendship with the natives," van Wassenaer wrote to the Amsterdam authorities. As the rich trade in pelts got under way, the colonists learned more and more about the indigenous peoples. There was much to admire.

Agreed on by all European observers was the striking appearance of the Indians. "The natives are generally well-set in their limbs," observed the chronicler Adriaen van der Donck, "slender round the waist, broad across the shoulders, and have black hair and dark eyes. They are very nimble and active, well adapted to travel on foot and to drag heavy burdens." More remarkable in the eyes of Nicolaes van Wassenaer was the uniformity of comeliness. "It is somewhat strange that among these most barbarous people," declared van

FIGURE 5.1

Portrayal of New World Indians, 1493.
The first image of natives of the New
World accompanied a printed edition of
Columbus's letter to the Spanish monarchs.
A wholly imagined projection, the woodcut
depicts naked peoples frightened by the
sight of arriving Europeans. Columbus
called them *Indians,* a term that came to
be applied to all New World inhabitants.

Wassenaer, "there are few or none [who] are cross-eyed, blind, crippled, lame,
hunch-backed or limping men; all are well fashioned people, strong and sound
of body, well fed, without blemish."

Indian women were admired as much for their beauty as for their industry.
They were found to "ornament themselves more than the men," sometimes
painting their faces and drawing black rings around their eyes. Most of the agri-
cultural work was performed by women, who tended to the raising of corn,
pumpkins, and a variety of squash and beans. Though the Indians knew noth-
ing of plowing or spading, the yield from the soil was abundant enough for
"whole cargoes in sloops and galleys" to be sent back to Holland in trade. Nico-
laes van Wassenaer was amazed to find that the Indian women had an admirable
grasp of astronomy, using the stars as guides to their seasonal agricultural work.
"The women there are the most skilful star-gazers," he gushed. "There is scarce-
ly one of them but can name all the stars; their rising, setting . . . is as well known
to them as to us."

Men pursued the roles of fishermen, hunters, and gatherers. They made
their way along the waterways, as did the women, in blunt-ended canoes. So
identified were the Manhattan Indians with their swift canoes, that pictures of
them paddling along the rivers and out to sea appear in virtually all the en-
graved sixteenth-century maps of the New World. From the rivers came a
plentiful catch of carp, sturgeon, salmon, pike, perch, and eel; from the sea, the
yield was in haddock, codfish, herring, and shellfish of all sorts, particularly
oysters and clams. (Mounds of oyster shells that still mark the sites of Indian
encampments have served archaeologists in their attempts to reconstruct na-
tive life.) For the hunt, the Indians used a bow six feet or more in length,
viewed by the Dutch as "a truly formidable weapon." In the role of gatherers,
Indian men filled baskets with bounteous yields of apples, peaches, pears,
grapes, strawberries, and a wide variety of nutmeats. Such was the Edenic lay
of the land, replete with the seasonal music of birds and sweet smells of the
forest, when the Europeans made their appearance.

Complementing the industry of the Indians and their vaunted good looks
was a disposition not often matched by their new European partners. "The
Indians are naturally . . . of taciturn, steady, and pensive dispositions and tem-
pers, of few words, which are well-considered, uttered slowly and long re-
membered," reported van der Donck. "They say no more than is necessary to
the subject in hand. . . . On other occasions they talk of no subjects except
hunting, fishing, and war. Their young men frequently entertain each other on
their gallantry with young female connections."

For the most part, the Manates moved about in small groups, made up of
members related by blood or marriage. They were, as Montaigne surmised,
"governed by natural laws" and unfettered by layers of institutionalized au-
thority. Leaders, or sachems, were chosen by a demonstrated ability to assume
charge or through a matriarchal line of descent. Their culture appeared emi-
nently self-sufficient to the Dutch, and the Manates themselves projected a
host of positive attributes that augured well for a mingling of Old and New

FIGURE 5.2 *Fort New Amsterdam, ca. 1626.*
In the earliest engraved view of New Amsterdam, natives skillfully row large and small canoes in the presence of overpowering, transoceanic carracks. "Many of them came aboord, some in Mantles and Feathers, and some in Skinnes of divers sorts of good Furres," reported an officer sailing on the *Half Moon* with Henry Hudson in 1609.

World societies. But the initial compatibility did not last. What largely intervened was an overwhelming European materialism that stunned the native traders and put them at a disadvantage. More and more skirmishes took place and talk of "trouble with the Indians" entered the daily lives of the colonists. The nadir in Indian-Dutch relations came with the arrival in 1638 of Willem Kieft, the new governor-general of the expanding European colony.

Governor Kieft proved to be highly unpopular among his own countrymen, who feared him for the rancorous venom of his disposition toward opponents. Following a steady series of conflicts with the Indians, Kieft saw an opportunity to decimate their numbers when an Indian murdered a Dutchman in an act of revenge. On February 25, 1643, Kieft issued an order: "We authorized Maryn Andriessen . . . with his associates to attack a party of savages skulking behind Corlaers Hook [at the top of Manhattan Island] . . . and act with them in such a manner as they shall deem proper. . . . God bless the expedition!" More than a hundred men, women, and children of the native population were slaughtered. The Indians were quick to retaliate with their tomahawks. Mayhem ensued.

Though Kieft signed a peace treaty with the Indians in 1645, it took many years before the two sides accepted one another peaceably or with trust. During the succeeding governorship of Peter Stuyvesant, the colonists sent a request to Amsterdam for greater security from "the insufferable arrogance of the natives." In a report of 1655 referring to a hostile incident, the colonists claimed that they "had winked at this infraction of the Peace" but asked for three to four hundred soldiers "before greater Mischiefs overtake your Subjects." No such army was sent.

When the English arrived in warships and ended Dutch rule in 1664, they were on the alert not to repeat past embroilments with the local population. Still, an early chronicle of Indian-English relations published by Daniel Denton is cast in chilling terms: "To say something of the Indians, there is now but few upon the Island . . . and it is to be admired, how strangely they have decreast by the Hand of God, since the English first settling of these parts. . . . It hath been generally observed that where the English come to settle, a Divine Hand makes way for them, by removing or cutting off the Indians either by Wars with one another, or by some raging Mortal Disease."

During the period of English sovereignty, the steady acquisition of Indian lands led to the irrevocable displacement of most of the original Manhattan inhabitants. Worse still, epidemics of smallpox and other European maladies, for which the Indians had developed no immunities, decimated their numbers. Then there was the dilemma of being caught between the French and the English who battled for possession of the Northeast. Long intervals of peace marked the years of English rule but the coastal Algonkians were conspicuously left out of the scramble, enjoyed by the Dutch, English, and French populations, to gain ascendancy in commerce, politics, and society. As the eighteenth century wore on, some natives eventually adapted to the nomadic life practiced by fellow Indians in the West. Many worked for settlers as farm

t' Fort nieuw Amsterdam op de Manhatans

TOTIUS NEOBELGII NOVA ET ACCURATISSIMA TABULA.

FIGURE 5.3 *The Restituto View of*
New Amsterdam, ca. 1673.
Manhattan Indians are an integrated part
of the decorative cartouche that enlivens
an Atlantic seaboard map. It was issued in
triumph when the Dutch briefly recaptured
Manhattan from the English. By then, the
merchants of Holland were well aware of
the central role of Indians in furthering
their New World commercial ambitions.

laborers or servants. Hundreds joined mission communities outside Manhattan. Only a small number of the original dwellers whose ancient forebears had trekked from Asia remained in their ancestral Manhattan domain.

By the early years of the nineteenth century, the language of the Manates or Lenapes—called the Delaware people by the English—could no longer be heard. Indians were slowly absorbed into the alien lifestyle introduced by Europeans, becoming ethnically invisible in the process. Scarce accommodation was made, either during the colonial regimes of the Dutch and the English or the nineteenth-century decades of the young republic, to preserve the cultural heritage of the Indians native to Manhattan. Such callous indifference reflected a lamentable failure in the daring experiment of New and Old World coexistence. As early as 1655 the failure of this experiment was felt keenly by the sympathetic chronicler Adriaen van der Donck, who acknowledged that incoming Europeans were "in the highest degree" beholden to the natives. "Great is our disgrace, now," he wrote, "and happy we should have been . . . had we striven to impart . . . the Eternal Good in return for what they divided with us." By the end of the twentieth century, the once-dominant Algonkian culture of Manhattan was a thing of the past; New Yorkers retained little sense of their pre-Columbian inheritance. Because Manhattan Indians had been in the front line of the European invasion by sea, they were among the earliest North Americans to disappear. An anonymous Dutch chronicler of the seventeenth century had once ventured his judgment of the descent of the Old World on the New: "This liberty then [of coexistence with the Indians] which in every respect should have been most gratefully received, of which use should have been made as of a precious gift, was very soon perverted to a great abuse."

Europe Transplanted

The peopling of Manhattan by Europeans was attended by a multiethnic liveliness from the very beginning. Scarcely ever was the Dutch settlement on Manhattan Island exclusively Dutch. Within a year after the forming of the Dutch West India Company in 1621, French-speaking Walloons beseeched the company for permission to take part in the colonization of New Amsterdam. When permission was granted, they came with wives and children in a group of eleven families, seeking asylum from religious tyranny in France. The character of the Dutch settlement as a trading post soon attracted other outsiders. Traders of myriad tongues—English, Swedes, and Germans among them—headed for Manhattan from various ports as the shipping in and out of Manhattan began to pick up a little volume. By 1643 Manhattan's famed Tower of Babel was firmly abuilding. "On the island of Manhate, and in its environs, there may well be four or five hundred men of different sects and nations," recounted Father Isaac Jogues, a French Jesuit missionary visiting from Canada. "The Director General [Willem Kieft] told me that there were

FIGURE 5.4 *Notice of Runaway Slaves, 1763.*
The frequent notices of runaway slaves
in the eighteenth century attest to the
oppression of blacks and their continued
efforts to free themselves. Rewards were
offered for their return as in this notice,
which promises that "If any person can give
Intelligence of their being harbour'd, a
reward of TEN POUNDS will be paid."

eighteen different languages; they are scattered here and there on the river, above and below, as the beauty and convenience of the spot has invited each to settle."

These "different sects and nations" gave Governor Peter Stuyvesant a hard time of it on his arrival in 1647, when their leaders petitioned for the right to build a church and for the licensing of their ministers. He was loath to accommodate them, but the Dutch West India company decreed otherwise on behalf of the trading interests of the colony inasmuch as there were scarcely enough people to assure the survival of the tiny Dutch post. Multiethnicity and religious pluralism, Stuyvesant was forced to recognize, were inevitably paired. And just as the colony was never solely Dutch during Dutch sovereignty, so was it never exclusively English during the long interval (1664–1776) of English rule. At the very time that Governor Thomas Dongan was preparing an English charter for the governance of the newly named colony of New York, he registered the fact that foreigners dominated the population. "I [believe] for these 7 years last past, there has not come over into this province twenty English, Scotch or Irish Familys," he wrote in a report of 1687 to London. Because more French and Dutch settlers were expected, something had to be done, he held, in order "that a more equal ballance may bee kept here between his Matys [Majesty's] naturall born subjects and Foreigners which latter are the most prevailing part of this Governmt." To keep his mixed population under control, Dongan had issued a proclamation two years earlier against wearing or carrying "Daggers Durks Tucks in Canes, Pockett Pistolls Or Any Other Sortt of Concealed Weapons."

A plurality of foreigners did not at all please Dongan's fellow countryman Charles Lodwick, who wrote to a member of the Royal Geographic Society in 1692 that "our chiefest unhappyness here is too great a mixture of Nations, & English ye leastpart, ye French protestants have in ye Late Kings reign resorted hither in great numbers proportionably to ye other Nations inhabitants." The Dutch were also a part of his configuration; many who had remained kept a trading foothold on the island despite loss of sovereignty. Lodwick readily admitted that "ye Dutch are generally ye most frugall & Laborious, & Consequently, ye richest." His "too great a mixture of Nations" proved to have some fractious components. Before the seventeenth century was out, a conflict erupted along ethnic as well as religious and political lines.

The insurrection of 1689, known as Leisler's Rebellion, is sometimes viewed as a Dutch versus English controversy but the affair was more complicated inasmuch as political issues were equally at stake for both. Its leader, Jacob Leisler, a German-born merchant and antipapist, had a list of grievances against the authorities, which led him, through a series of clever maneuvers, to assume government control. Two smoldering passions, among many, kept the colony in a state of unrest for two years: Dutch against English, Protestants against Catholics. Lines of division did not clearly separate those for and against the insurrection since the English were largely Protestant and many Dutch merchants rejected Leisler's extreme views. The affair

FIGURE 5.6 *Bill of Sale for a Slave, 1785.* The Dutch were responsible for importing the institution of slavery to Manhattan. "New Netherland would by Slave Labor be more extensively cultivated than it has hitherto been," ran a report to Holland in 1646. In a typical bill of sale, "a Negro wench named Maria" is sold by Jacob Van Wagenan for the sum of sixty pounds.

ended when Leisler was convicted of treason and hanged. Subsequently, trade and commerce were the overriding factors that smoothed the troubled waters. The wily English governor who arrived in 1691, William Fletcher, soon made common cause with all the city's prosperous merchants regardless of their nationality.

English rise to ascendance and wealth in New York during the first half of the eighteenth century was not only a matter of mercantile profits but of the acquisition of large properties bestowed by the Crown. Though the population was mixed and non-English residents served in local political posts, the prevailing atmosphere was one in which Royalist guidelines were invariably invoked. English views were well served by the *New-York Gazette,* the city's first newspaper, which made its debut in November 1725. It soon faced a rival. Eight years later the *Weekly Journal* emerged, which delighted in satirizing the Royalist stance touted by the *Gazette.* John Peter Zenger, editor of the *Weekly Journal,* was a German immigrant, one of a large number of Palatine Germans who fled their homeland in 1710. Before too long, Zenger was hauled before the courts for libel. Ably defended by the venerable lawyer Andrew Hamilton, Zenger's acquittal promoted a spirit of civil disobedience that indirectly led to the Revolution.

During the early days of the republic, Catholics from Ireland emigrated to New York in ever-increasing numbers, anti-Catholic decrees now being a thing of the past. Lodwick's great "mixture of Nations" became even greater with leaps in the population that would have been strongly welcomed during colonial days. In 1822 New York's population stood at 125,000 of which fewer than half were native born. In that year the count included Indian, Dutch, English, African, French, German, Irish, Jewish, and Swedish residents in sizable numbers. To James Fenimore Cooper, who moved to the city just then, New York was "composed of inhabitants from all the countries of Christendom" that made it "exceedingly difficult to extract anything like a definite general character." Nor were there any signs in the midst of this melange of a pervasive English accent on the streets: "The language we heard spoken was different in tone from what we had been accustomed to," noted the Scotsman Basil Hall. "Still," he concluded, "it was English."

During the nineteenth century, Europeans contributed to the peopling of New York in astonishing hordes that sent the population figures of the city well above a million by 1875 and to nearly 2 million by the close of the century. The first three largest groups of arrivals came from Ireland, Germany, and the British Isles. Repeated famines in Ireland forced the exodus of large segments of its starving people starting in 1845; Irish arrivals numbered 30,000 that year. By midcentury the Irish had become the dominant group of aliens in New York, followed closely by Germans, many of whom fled their country in 1848 in the wake of political unrest or who later discovered, like British workers and other Europeans, that the mechanized wonders of the Industrial Revolution made their skills expendable.

Asia, Europe, and Africa Transplanted

FIGURE 5.7

Outdoor Scene on Greenwich Street, 1809.
At the corner of Warren and Greenwich
Streets, a mix of the city's passing population
is framed in a watercolor. There are whites,
blacks, and a waiting Asian pedestrian. The
genre artist, a titled noblewoman who
caught the scene from her window, was a
member of a sizable French colony in exile
from the rule of Napoleon.

FIGURE 5.5 *Portrait of James Duane, ca. 1784.*
The Irish formed a small part of the highly cosmopolitan population of eighteenth-century New York. (The first large wave of Irish immigrants came only after 1848.) James Duane, son of an Irish officer serving in the British Navy, was to become the first mayor of New York following the Revolution. Duane Street honors him.

RUN AWAY

THE 18th Inftant at Night from the Subfcriber, in the City of New-York, four Negro Men, Viz. LESTER, about 40 Years of Age, had on a white Flannel Jacket and Drawers, Duck Trowfers and Home-fpun Shirt. CÆSAR, about 18 Years of Age, cloth-ed in the fame Manner. ISAAC, aged 17 Years cloathed in the fame Manner, except that his Breeches were Leather; and MINGO, 15 Years of Age, with the the fame Clothing as the 2 firft, all of them of a middling Size, Whoever delivers either of the faid Negroes to the Subfcriber, fhall receive TWENTY SHILLINGS Reward for each befide all reafon-able Charges. If any perfon can give Intelligence of their being harbour'd, a reward of TEN POUNDS will be paid upon conviction of the Offender. All Mafters of Veffels and others are forewarn'd not to Tranfport them from the City, as I am refolved to profecute as far as the Law will allow. WILLIAM BULL.

N. B. If the Negroes return, they fhall be pardon'd. - 88

Immigrants from Ireland tended to live in West Side tenements or near to wherever they could find work, mostly as laborers and servants. The Germans were more likely to cluster in ethnically familiar territory, staked out on the East Side, where their language could be spoken and German customs sustained. As Europeans arrived in an almost unending procession, an English visitor of 1854 caught the scene one day at the waterfront. "The goods and chattel of the Irish appeared to consist principally of numerous red-haired, unruly children, and ragged-looking bundles tied round with rope," observed Isabella Bishop. "The Germans were generally ruddy and stout, and took as much care of their substantial-looking, well-corded, heavy chests as though they contained gold. The English appeared pale and debilitated, and sat helpless and weary-looking on their large blue boxes."

To handle the astonishing influx of newcomers passing through the port of New York, the city government opened the Castle Garden Emigrant Landing Depot in 1855. Originally a military fort, Castle Garden had long flourished as a theater. Five years earlier an overflowing audience there had thrilled to the voice of Jenny Lind. Before the Castle Garden conversion, employment agencies held out a helping hand in their own interests. "A free Emigrant Office," ran one poster advertisement, "is situated in Sixth-street . . . for the purpose of giving intelligence, directing to employment and affording disinterested counsel and advice to all foreigners coming to this country." Certainly a helping hand was needed by all newcomers after the harrowing passage across the Atlantic. Crossings in sailing packets over the stormy seas took anywhere from one to two months and were invariably remembered as a terrifying experience. In 1847 about 20 percent of the Irish emigrants who made the crossing died of "ship fever," and in the decade of the 1850s, more than forty emigrant ships were recorded as having foundered in the North Atlantic.

A growing number of benevolent societies serving distinct ethnic groups did their best to help new arrivals who sorely needed a sympathetic contact in terms of orientation, housing, and work. Immigrants who gained employment were usually abominably paid; a small number made straight for the almshouse when they arrived. Many newcomers could only afford lodgings that were little more than hovels. One area of concentrated wretchedness was known as Five Points, located near today's Foley Square. Despite the intense misery suffered by so many, new arrivals quickened the tempo of city life with their determination to make good. They contributed to the city's economy and to its democratic (if corrupt) politics, helping to build the city's infrastructure while effectively promoting the rewards of cosmopolitanism. What prevailed was an unwritten compact: immigrants needed America and America needed their labor.

Inevitably and frequently, sharp ethnic clashes erupted in the city, but little bloodshed resulted from them until the Draft Riots of 1863. In July of that Civil War year, racial prejudices and economic rivalry combined to leave more than a hundred dead and several hundred wounded. The riots

Asia, Europe, and Africa Transplanted

The 'Boots' Cleaner

PATRICK BRYANT

OYSTERS

The Oyster-Stand

TO

KNICKER[...] ROOT 3 Cents

The Butter and Milk Man

The Butcher.

FIGURE 5.8 *A Boot Cleaner and His Contemporaries in Trade, ca. 1840.* Five spontaneous, on-the-spot vignettes depict the activities and attires of vendors plying their trades on the city's streets in the post-Jacksonian era: a boot cleaner, a root beer seller, a butter-and milkman, an oyster seller, and a butcher. All wear colorful nineteenth-century garb topped by variations of the obligatory hat.

FIGURE 5.9 *The Terrible Draft Riots of 1863.*
Bloody riots erupted among the city's
population in July 1863 when Irish and
other laborers protested the Draft Act of
that year. Seeing the blacks as competitors
for their jobs, they attacked the latter,
burning houses and killing more than a
hundred. "How this infernal slavery system
has corrupted our blood!" fumed diarist
George Templeton Strong.

would prove to be the greatest ethnic disorder in the city's history. While much of the violence was the work of rowdies and thieves who seized upon the clamor to plunder and murder, the turmoil was sparked by the Irish response to rumors that black labor would be imported to replace workers conscripted into the Union Army. The Irish were infuriated that they were too poor to buy their way out of conscript as could the rich. "The riot was a savage one. The mob killed, pillaged, hung Negroes to lampposts, and mutilated and tortured their prisoners," wrote a young French observer. "Its cruelty was ungovernable."

During the Civil War and following it, New York's economic prosperity and mercantile base expanded steadily. Looking to that prosperity for rescue, a second great wave of Europeans descended on the city during the decade of the 1880s. Irish, German, and British settlers, whose children were native New Yorkers, were joined by Italians, Greeks, Czechs, Slovaks, Hungarians, and by Russian and Polish Jews. Their numbers were overwhelming enough to create whole ethnic villages in the city that were easily identifiable. The most conspicuous of them were little Germany in the east eighties, little Italy in the Village, Chinatown below Houston Street, and the Jewish quarter in the area surrounding Hester Street. The year 1881 marked a "turning point in the history of the Jews as decisive as that of 70 A.D.," writes the scholar Irving Howe, "when Titus's legions burned the Temple of Jerusalem, or 1492, when Ferdinand and Isabella decreed the expulsion from Spain." In 1881 a wave of pogroms following the accession of Alexander III in Russia sparked a major exodus to New York and other regions of the country.

By and large those who sought a fresh beginning in New York were in flight from poverty, frequent wars, high taxes, pogroms, and threat of military conscription, as well as from an overpopulated Europe where the steady outreach of the Industrial Revolution was displacing more and more workers. This was true for the third great wave of immigration that took place in the opening years of the twentieth century, when Italians and Russian Jews dominated the nationalities absorbed by the city. Crossing the huge distance to the New World was being made easier by the steamships that took less than two weeks; they were also cheaper and less hazardous, although the many who could only afford steerage still found the experience harrowing. Each immigration wave brought with it an extraordinary amount of talent; each brought an incalculable measure of neediness that taxed the city's resources. All who came sought personal freedom and the new opportunities—economic and otherwise—that could be found in a society still in the process of formation. Some entertained fantasies of rapid social mobility. Others, like the penniless carpenter Jacob Riis who arrived in 1870, had high hopes "that somewhere in this teeming hive would be a place for me."

Arrivals in the port of New York after 1885, whether destined for the city or the country's interior, were thrilled to be greeted by the towering figure of Bartholdi's crowned lady. A gift of the people of France, the Statue of Liberty now commanded the waters of the upper bay where in 1524 Verrazzano had

Asia, Europe, and Africa Transplanted

FIGURE 5.10 *View from Castle Garden, 1881.*
Following the first large wave of immigrants
in the mid-nineteenth century, a typical
downtown scene became the sight of new
arrivals being ferried over from Castle
Garden with their luggage. Originally a fort,
the Garden was assigned as an immigration
depot beginning in 1855 and served new-
comers for thirty-five years.

been greeted by the Indians. For newcomers and visitors alike, the statue be-
came a powerful symbol of America's welcoming hand. A further assurance of
welcome to immigrants was signaled with the opening of Ellis Island, a fed-
eral facility built to replace the decay and inadequacy of Castle Garden. The
main building that opened in 1900 was conceived in an imposing French Re-
naissance style and boasted wondrous facilities like showers and a canteen. By
the time it outlived its usefulness a quarter century later, 16 million immi-
grants had filed through its corridors, representing a tide of humanity of bib-
lical proportions. Many moved on to the interior of the country but a fair seg-
ment of them swelled the population of Manhattan and the four outer
boroughs that were annexed in 1898.

Immigrants from abroad continued to people New York throughout the
twentieth century, creating a mosaic of nationalities in all five boroughs. To
the European component of New York's population were added newcomers
from many locations in Asia, the Chinese predominant among them. Across
the East River, the borough of Queens took the lead as the most multicul-
tural, with the other four boroughs known for their clusters of distinct eth-
nic neighborhoods. A major shift in immigration patterns became apparent in
the second half of the 1900s. Europeans, for so long the dominant racial group
peopling New York, were replaced by the mix of racial groups hailing from
Asia, the Caribbean, and Latin America, with West Indians and Dominican
Republicans contributing the largest numbers. Their arrival was characterized
by a switch from New York harbor to Kennedy Airport as the principal gate-
way of East Coast immigration. By the onset of the twenty-first century,
scarcely a nation on the face of the earth was not represented in New York,
even if only minimally.

Immigrants arriving with the dawn of the new millennium, linked to the
millions before them, have allowed New York to continue to accumulate an
enviable tradition of assimilation. It is a process that has not been without nu-
merous trials and misfortunes. Each new wave of arrivals has been invariably
seen as a burden rather than an enhancement. Yet the great acculturation
process goes on as newcomers are lured to New York as though to a terres-
trial Eden.

Africa Transplanted

Peoples of Africa contributed, like the Dutch and the Walloons, to the found-
ing and shaping of New Amsterdam in the opening decades of the seven-
teenth century. Unlike their European counterparts, they came to the New
World involuntarily as slaves. The first blacks stepped ashore in the same year
that Peter Minuit purchased Manhattan from the Indians. After 1626 they kept
coming both on ships known as "slavers" and on those handling trade. A black
presence was fostered by the colonizers of New Amsterdam not only to swell
the minuscule population of the settlement but also as a much-needed boost

FIGURE 5.11 *Slum Life among Children, 1890.* Homeless children in New York formed a common sight as the nineteenth century came to an end. Known as "the Street Arabs," they found sleeping quarters wherever they could. Here in an alley off Mulberry Street, shoeless children are huddled in a heart-rending scene photographed by the city's chronicler Jacob Riis.

to the expansion of agriculture. "New Netherland would by Slave Labor be more extensively cultivated than it has hitherto been," ran a report on the affairs of the Dutch West India Company in 1646, "because the agricultural Laborers, who are conveyed thither at great expense [from Holland] sooner or later apply themselves to Trade, and neglect Agriculture altogether." Buying and selling slaves for profit was also on the Dutch agenda, as the company's directors made clear in 1661: "We have resolved not only that slaves shall be kept in New Netherland, as we have heretofore ordered, but that they shall moreover be exported to the English and other Neighbours." Already in the fall of 1655, some three hundred Africans had arrived aboard the ship *Witte Paert* to be sold along the Atlantic coast.

During the forty years of their rule, the Dutch proved to be more lenient toward African arrivals than their colonial successors. Following the English takeover of Manhattan in 1664, there was a heightening of the slave trade with more and more merchants engaged in this wretched activity. "It is by negroes that I find my cheivest [chiefest] Profitt," confided Frederick Philipse, a New York City tradesman. "All other trade I only look upon as by the by." The right of a slave to acquire a free or half-free status as granted by the Dutch and the right to own land were among the "privileges" eventually infringed upon by the English following the first black revolt in 1712. By that date, New York was accumulating the largest black population north of Maryland: there were about a thousand blacks and six thousand whites. By that date, too, a markedly racist attitude toward blacks was in the ascendance. "The Late Hellish Attempt of [your] Slaves is sufficient to Convince you," declared Governor Robert Hunter to the local assembly, "of the necessity of putting that Sort of men under better Regulation by Some good Law." That woeful attempt initiated by about twenty-three slaves to obtain their freedom was met with swift and terrible punishment; tighter restrictions on manumission were subsequently applied.

Executions, adversities, and continuing bondage of the harshest kind did not prevent blacks from contriving ways to circumvent the odious rules placed in their way of building a strong ethnic community. A serious setback occurred in 1741 when blacks were accused of concocting a plot to burn down the colonial town; whites were alleged to have been involved. Ethnic hostility quickly heightened as various versions of the plot followed in hasty succession. The result was the execution of about thirty blacks with double that number deported. There were further consequences, as noted by Alexander Hamilton, a Scottish visitor of 1744. "Ever since the negroe conspiracy," he writes, "certain people have been appointed to sell water in the streets, which they carry on a sledge in great casks and bring it from the best springs about the city, for it was when the negroes went for tea water that they held their caballs and consultations, and therefor they have a law now that no negroe shall be seen upon the streets without a lanthorn after dark."

Slavery continued to be an essential element of economic and social life throughout the eighteenth century. With the end of the colonial era came

FIGURE 5.12 *Ellis Island, 1938.*
The Immigration Building on Ellis Island, opened in 1900, replaced Castle Garden as a receiving depot for newcomers to New York. Built along massive, French Renaissance lines, it was the post-1900 immigrant's initial encounter with the New World. Such an imposing structure seemed to portend hopes for a stable future.

gradual changes in the social status of blacks due to a growing movement for manumission and abolition, and due as well to their own efforts. Sometimes visitors from abroad gained the impression they were an integrated part of New York life. "One striking feature [of New York] consists in the number of blacks, many of whom are finely dressed," commented a traveler in 1818. A milestone was reached in 1827 when all New York blacks became free citizens. Though few among them could vote, their newly won emancipation was easily detectable, claimed a visitor two years later: "Not even in Philadelphia," wrote Frances Trollope, "where the anti-slavery opinions have been the most active and violent, do the blacks appear to wear an air of so much consequence as they do at New York."

Unpredictably, the long-awaited Thirteenth Amendment of 1865 did not open up a bright future. Though blacks in all states were at long last free in the political sense of the word, they were primarily free to continue a long uphill battle. A Freedmen's Bureau was created to rehabilitate the black population, but the problems were enormous; a major issue now centered on the granting of suffrage. W. E. B Du Bois felt he could not write of this period calmly, so "mighty" the human passions involved. A civil war ended, he declared, "by beginning a race feud." There were to be unending setbacks in the struggle for the ballot, education, work, and housing as persistent prejudice set up daily obstacles. Class barriers were meanwhile slowly breaking down for whites and a sense of egalitarianism gaining ground. Large waves of immigration from Europe invariably meant diminished jobs for blacks, at the same time that the needy among them were swelled in numbers by the internal migrants who were fleeing southern racism. The worst of the race riots, provoked by the economic fears of whites, chiefly Irish laborers, that they would lose out in competition for work by blacks, occurred in the summer of 1863. Violent upheavals resulted in the deaths of more than a hundred blacks, some brutally murdered. Because the confrontations were sparked by the conscription of soldiers for the Civil War, they were called the Draft Riots. They proved to be the bloodiest of the city's ethnic conflicts but were by far exceeded in violence by the 1921 Tulsa, Oklahoma race riots..

During the course of the nineteenth century and the next, the optimism of Gotham's blacks was sustained by their growing numbers, the formation of church congregations steeped in racial pride, the emergence of political leaders, and the liveliness engendered by the colorful ethnic mix that existed within the black community itself. There were West Africans, East Africans, West Indians, Madagascarans, and an immeasurably large crop of native-born, sophisticated New Yorkers. Out of this vibrant chorus of voices came eloquent leaders, wondrous music, imaginative theater, and the kind of literary talent that arrested the attention of the world as well as of the city. During the 1920s and early 1930s, a marvelous burst of black creativity came to be known as the Harlem Renaissance. Euphoria prevailed among the leadership of the black community in those years—not among the masses—but unhappily it did not last. "Some Harlemites thought the millennium had come," wrote the poet

FIGURE 5.13
Arrival of New Immigrants, ca. 1950.
The role of Ellis Island in receiving new arrivals was greatly diminished soon after World War I when Congress curtailed mass immigration. A group of young Asians arrive via the island, shortly before it was closed in 1954 as an immigration center. With this historic closing, a vivid chapter in the peopling of New York ended.

Langston Hughes. "They thought the race problem had been solved through Art. . . . They were sure the new Negro would lead a new life from then on in green pastures of tolerance." The road would still be uphill.

Harlem itself, a neighborhood on the Upper East Side of Manhattan, subsequently came to epitomize the black presence in New York. Though African Americans, like other ethnic groups, were scattered throughout the five boroughs, Harlem stood for black leadership in politics, arts, and religion. (The word *Harlem* is Dutch, shortened from the place name Nieuw Haarlem that was given by Peter Stuyvesant to the Upper East Side area in the seventeenth century after a thriving community in Holland.) Increasingly, African Americans were becoming successful in creating a social and economic base from which to enter the mainstream of American life. By the second half of the twentieth century, blacks had attained eminence in all the professions vital to the life of the city: law, medicine, politics, finance, industry, education, theater, and sports. An extraordinary achievement could be claimed in 1990 when David Dinkins, a Harlem state assemblyman, was elected mayor of New York. Yet as the most visible of all minority groups in New York, blacks would continue to scale the racial mountain, many of them with the bracing image offered by Langston Hughes leading them on: "We have tomorrow / Bright before us / Like a flame."

Asia, Europe, and Africa Transplanted

A City of Contrasts

Ascent of the Rich and Struggles of the Poor

Ascent of the Rich

When the very young Miss Nixola Greeley-Smith was rebuked by the very rich Mrs. William Astor in 1902, she was quick with a searing counterattack. "Tell her," she bellowed to the servant who was instructed to escort her out of the Astor mansion, "that when John Jacob Astor was skinning rabbits, my grandfather . . . was one of the foremost citizens of New York." Well, not quite. The time frame is half a century askew. Horace Greeley acquired distinction only after his founding of the *Tribune,* by which time John Jacob Astor was a millionaire. John Jacob's rabbit-skinning days, or rather his early job in the 1780s of beating the moths out of furs, had long been over by the time the newspaper made its debut in 1841. Still, Miss Greeley-Smith's implication was resoundingly clear. Mrs. Astor was to consider herself a social upstart. Could anything be more humiliating to a lady of her patrician class?

Claims to social aristocracy in New York have always been of a rather fragile nature. In the absence of a hereditary governing class or of pioneering forebears who came from the landed gentry, the rules for gaining elitist status have been most flexible. The earliest settlers to arrive in Manhattan in the 1620s were of vigorous pioneering stock but largely of the lowest social rank. They were most often illiterate, quarrelsome, and given to heavy drinking as a way of coping with the wilderness and wary natives. No purple and fine linens filled their baggage during the Atlantic crossing; they had to make do on arrival with miserable log huts of their own fashioning, thatched with straw and bereft of the most basic comforts. Nonetheless, these early Dutch and Walloons who decided on a life in the New World had been reared in surroundings, common to all countries of Europe, in which the existence of a royal aristocracy, buttressed by layers of descending social classes, was a sine qua non in the configuration of civilized society. Tradition had honored such stratification for centuries. Was it likely therefore that this pyramidal structure would eventually be imported or would the future New York build anew on its social tabula rasa?

Kiliaen Van Rensselaer in seventeenth-century Amsterdam was pondering this very question. He did so less from a philosophical or political point of view than out of sheer practicality. As a board member of the Dutch West India Company, he was concerned that his company's trading posts in the New World were being threatened by extinction for want of population. To

this end, Van Rensselaer's proposal of 1629 for the promotion of settlement appeared to his fellow board members to be inspired; when it was adopted, it revealed vestiges of elitist, if not of feudal, overtones. A patroonship with all the rights of lordship was to be offered to anyone who, upon the purchase of land in the New Netherlands, would establish a colony of fifty adults within the space of four years. The title of *patroon* (patron, or lord), with its attendant privileges, would be vested in him and his heirs "as a perpetual inheritance for ever, without its ever devolving again to the Company." A host of other inducements were laid out with regard to shipping, trade, and coastal privateering, all published in a document entitled *Privileges and Exemptions for Patroons, Masters, and Private Individuals* issued on June 7, 1629.

Kiliaen Van Rensselaer himself promptly took advantage of the offer. He acquired seven hundred thousand acres along the west bank of the Hudson through shrewd barter with the natives, administered his vast domain through an agent, and set up the conditions that would accrue to fame and fortune for generations of Van Rensselaers to come. He himself was not of aristocratic stock. A prosperous, self-made merchant, he never set foot in the wilds of the New World. In time, Van Rensselaer descendants intermarried with other grand property holders like the Schuylers, Van Cortlands, Schermerhorns, and Livingstons, and all were quick to assume the social airs that traditionally accompanied wealth. No patroonships were possible in Manhattan proper because the 1629 document made clear that the members of the Dutch West India Company "reserve the island of the Manhattes to themselves." It would later be parceled out in small land briefs. An economic hierarchy was set up in the 1650s with the granting of various trading rights to great and small burghers (citizens as opposed to transients) who paid appropriate dues. The presence of powerful patroons surrounding the island, however, had the greater effect in introducing aristocratic notions into the fledgling colony inasmuch as the virtually autonomous patroons took a foremost role in the governance of New Netherland. They tended to ignore the fact that their claims to aristocracy arose from an exclusively commercial base.

It was during the tenure of the last Dutch governor, Peter Stuyvesant, that a roster of New Amsterdam burghers who could claim to be rich climbed to forty-three. Stuyvesant himself had notions of ascending the social ladder with the acquisition of both a town and country home; he also commissioned a portrait of himself. The rich in his day included the entire roll call of the city's magistrates as well as families with the names of Van Werekhoven, de Peyster, Van Couvenhoven, Kip, Lockermans, Stevensen, Steendam, Vinje, and others. A list had been drawn up by Stuyvesant so he could tap them for money in the building of a northern wall that would protect the inhabitants of the colony. When they gave it, they did so with a guarantee of 10 percent interest. So proud did New Amsterdam burghers in the 1660s become of the community's growing affluence that, in petitioning the Dutch West India Company for protection, they declared that "this capital is adorned with so many noble buildings, at the expense of so many good and faithful inhabitants, prin-

cipally Netherlanders, that it nearly excels any other place in North America." It was a proud boast, if highly exaggerated. It made the English all the more covetous.

A new social tone was introduced into Manhattan when the British relieved Stuyvesant of his command in 1664. Rules for proper behavior, borrowed from London society, now steadily crept into the scene and were meant to serve the ascendant members of the cosmopolitan colony—English, Dutch, French, Scottish, German, and a sprinkling of other Europeans—who formed a new class spoken of as the gentry though there was no real patrician cohesion among them. The gentry, or what was often loosely spoken of as "the better sort" in contrast to the "middling" or "lower" sorts, fell broadly into three categories: those with sizable land holdings, those who wielded power through the legal profession or the government, and those whose profits accrued from trade. A number of the clergy figured in this class as well. During the years of English rule, the colony became thoroughly familiar with notions of aristocracy as behavior and language inevitably took on a whole gamut of social nuances. Tidings of the king's court and of the upper crust of England were daily fare, while a few of the appointed governors, who were lords or earls in their own right, could claim kinship with royalty.

"The English go very fashionable in their dress," noted Sarah Kemble Knight, a visitor to New York from Boston in 1704 who sensed a marked difference in the demeanor of English and Dutch women. The latter were known more for their thrift than for their charm; still, their headstart in accumulating wealth in the busy seaport town was apparently obvious in a show of jewelry. The ears of the Dutch ladies, remarked Miss Knight, "are sett out with Jewells of a large size and many in number. And their fingers hoop't with Rings, some with large stones in them of many Coullers as were their pendants in their ears." In making similar social comments bearing on an earlier colonial period, Washington Irving couldn't resist a jibe when he held that "fashionable parties were generally confined to the higher classes, or noblesse, that is to say, such as kept their own cows, and drove their own wagons."

Transport was, indeed, a telltale sign of inchoate wealth, marked by the possession of a private carriage in the eighteenth century. A fine equipage for an appearance in town was among the most enviable of the possessions of a gentleman and much admired by onlookers. Lewis Morris's coach, bearing his coat of arms, crest, and motto, invariably caught the eye of pedestrians on Broadway as it did on February 23, 1736, when a correspondent in the *Weekly Journal* made public note of it that day. Coaches were imported from England during the greater part of English rule and were prized enough to be featured in engravings. The earliest coachmaker to set up shop in New York was James Hallett who announced his services in the *New-York Weekly Post-Boy* of January 22, 1749. Apparently the first woman to own her own coach and four was Maria de Peyster, of the family of Johaness de Peyster, one of the forty-three prosperous citizens in Stuyvesant's day. To keep a carriage or chaise was distinctly to be "in society."

Ascent of the Rich and Struggles of the Poor

This CHURCH
was founded
A.D 1727 & finish
A.D 1731. & is in
Length 100 F in Breadth
75 Foot

The Rev'd
Mr Walter Du Bois
& Mr Henry Boel
Ministers

To the Honourable

RIP VAN DAM. Esqr

PRESIDENT of His Majesty's Council for the PROVINCE of NEW YORK

Someone who could allow himself to make snobbish distinctions between privileged carriage owners who had inherited their wealth and the larger number who had accrued money in trade was Lewis Morris who belonged to the first category. "As New England excepting some Families was ye scum of ye old," declared the censoriously judgmental patroon, "so the greatest Part of the English in the Province [of New York] were ye scum of ye New." By whatever name they were called, New Yorkers of means brought about distinct improvements in the tenor of colonial life. They created solid cultural institutions like Trinity Church and the Merchants' Exchange as well as fashionable Niblo's Garden. In 1754 they also arranged for the opening of King's College, where future generations of the privileged would be tutored in Latin and Greek, and in propagating the privileges of their class.

The outbreak of the Revolutionary War and a horrendous fire that destroyed nearly half the city interrupted many social aspirations. The descent of this dark cloud, however, did not prevent another element of social glamour from being introduced. With thousands of His Majesty's regimental forces stationed on Manhattan Island and the surrounding areas, the social scene of the occupation years was awash with assemblies, pomp, dress uniforms, and social exchanges of the Royal Navy and Army. His Majesty's forces entertained themselves with balls, high teas, and dinners. Comedies were presented at the little theater in John Street in which military officers performed, and sometimes the theater orchestra staged concerts in the charred ruins of Trinity's churchyard. All this took place against a backdrop of severe privation, disease, and the horrors of crowded quarters suffered by the citizenry at large. While the military danced, captured revolutionaries languished in makeshift jails or in the rotting prison ships anchored in the East River.

Victory brought the opportunity to show with what measures of egalitarianism the populace of the new democracy would conduct its affairs. After four years of energetically reconstructing itself, the city was ready for the supreme event in its history: the inauguration in 1789 of the country's first president. As the time approached, an anonymous notice in that year's April fourth issue of the *Daily Gazette* warned of highborn follies: "Will it not be more Magnificent," ran the notice, "to receive the great Character [George Washington] as Citizens and Brothers, than with . . . vain Ostentation?" No, it would not. New York, as the temporary capital of the country, was determined to put a handsome foot forward, leaning in the direction of luxury, aristocratic pomp, and social pretensions. It preferred "the splendor of wealth and the show of enjoyment to the simplicity of manners," observed Brissot de Warville, a French journalist, himself from the aristocracy of France.

For the inaugural season, Mrs. John Jay, the former Sarah Livingston and now wife of America's first Chief Justice, presided. The 1774 marriage of the wealthy, teenage Sarah to John Jay had tied a dynastic knot of money, power, and property. A reigning beauty, Mrs. Jay was ready with her "Dinner and

Ascent of the Rich and Struggles of the Poor

FIGURE 6.2 *Portrait of Robert Ray, ca. 1771.*
Beyond the ownership of a horse-drawn carriage, another high point in the attainment of colonial wealth was to commission a portrait of one's family members. Robert Ray, an appealing youth painted in oil by the popular artist John Durand, strikes an aristocratic pose. He clearly belonged to one of the richest New York clans.

Supper List," which gave the names of about 150 august personages worthy to be invited to government soirees. There was even dickering about titles. Should the president be called His Highness? Or perhaps even His Mightiness? And should Martha be known as Lady Washington? It was a heady time, made all the more so by the glittering presence of ambassadors, ministers, newly appointed American officials, and the commanding presence of Washington himself.

That the city was already tending toward contrasts of luxury and want was largely ignored by those intent on red carpets, balls, and social airs. Indeed, poverty would expand rather than diminish as the city gained in wealth. Though New York was still only an outpost in world commerce, the small circle of Gotham's wealthy was ready to impress the royal, titled, and fashionable among the eminent visitors to the city; much more importantly, New York's homegrown plutocrats were becoming keen on impressing each other. The French exile Moreau de St. Méry observed in 1793 that the Americans were slavishly following English manners and introducing some affected postures of their own. During a visit to the home of the prosperous merchant William Bayard, he noted a particular affectation of his host in "the little nets that hung from his silk stockings which he had put on . . . to keep away flies."

For those who acquired wealth in the first half of the nineteenth century, the term *millionaire* slipped into the town's vocabulary. It applied particularly to the fortunes amassed by John Jacob Astor, Cornelius Vanderbilt, and the department-store mogul Alexander T. Stewart: all three stepped to the top rank of the moneyed class by self-propulsion. This was not true of most others who took advantage of New York's expanding arenas for moneymaking like real estate, banking, steam shipping, stock speculation, insurance, railroads, or the various branches of manufacture and trade. They invariably had some money to begin with or aggrandized their fortunes through the time-honored practice of marriage. By midcentury, nearly half the city's affluent represented first-generation wealth. When pre–Civil War guest lists were prepared, new names mingled with the old: Stewart, Astor, Vanderbilt, Coddington, Crosby, Jones, Hone, Grinnell, Minturn, and Phelps appeared with the older names of Livingston, Goelet, Lorillard, Beekman, Roosevelt, Schermerhorn, Stuyvesant, Bayard, de Peyster, and Van Rensselaer. Together they formed a sizable if diverse group, one that was interested in setting itself apart—from those less moneyed, from the middle class, and from the expanding world of the laboring poor—as the cream of Manhattan's society and as a group with special interests. There now entered a more conspicuous enchantment among them with fashion, with liveried servants, with extravagant coaches, with gentlemen's clubs, with town manses, with etiquette, and with all the social netting that protected exclusivity. As a class unto themselves, they joined in the creation of the Astor Opera House, the Mercantile Society, the National Academy of Design, and the New-York Historical Society. Their motives were both eleemosynary and self-aggrandizing; these lofty places raised New York's profile and became the hallowed haunts of the upper class.

FIGURE 6.3 *The Walton House, ca. 1780.* William Walton, a merchant prince of the shipyard industry, built an exceedingly lavish house in pre-Revolutionary New York (1752). Located at 326 Pearl Street, it offered indisputable evidence to the British that residents of New York could well afford higher taxes. Carefully tended gardens in the rear sloped down to the East River.

With due fascination, the *New York Sun* steadily watched the turnover of entrants into the nineteenth-century affluent class, publishing a small tome entitled *The Wealthy Citizens of the City of New York*. By 1855 a thirteenth edition was in print. Names appeared alphabetically, opposite an indication of wealth, followed by a crisp biographic note. Among the minority identified as "of an old Knickerbocker family" is Livingston Kip, while the family of Peter Stuyvesant earns the remark that the "transition from Dutch to English and ultimately to American political control does not appear to have affected their prosperity. To them wealth flows in as freely as ever, and with it the influence which wealth will ever bring." A newcomer with a fortune twice that of the Stuyvesants, made in real estate, is identified as John D. Wolfe, "formerly a hardware merchant." Only six are listed as having a fortune above the $2 million mark: William B. Astor (son of John Jacob), William H. Aspinwall, Peter Harmony, the Hendricks family, Alexander T. Stewart, and Stephen Whitney, none of so-called Knickerbocker stock.

Continual efforts were made by social watchdogs to distinguish the "true" patricians of New York from the arrivistes but the distinctions had constantly to be revised. Terms once meaningful in a hierarchical society—the nobility, the aristocracy, the titled, the well-born, the upper class, the gentry—had tenuous relevance in a society where traditional, elitist values were incompatible with the ideals of democracy. Yet the terms were bandied about by those who saw merit, for New York's cultural profile, in the cohesion of an urban upper class. True, enough generations had accumulated by the second half of the nineteenth century to speak of "old" families, yet social prominence in New York, as contrasted with Boston, Philadelphia, and Charleston, was largely a question of money. The city's entrepreneurial economy, together with its new position as the country's finance center, provided the chrysalis for turning out fresh millionaires with each decade. They, too, sought their share of recognition on the dazzling social scene.

What became truly dazzling was the size as well as the number of mansions that began to line Fifth Avenue during the final decades of the Victorian era; they contributed significantly to Manhattan's burgeoning architectural splendor. For more than three miles above Washington Square, the avenue was a showplace of handsome homes, shops, clubs, hotels, and imposing churches. North of Fiftieth Street, the Vanderbilts had no fewer than four mansions designed for them on Fifth Avenue, while the Astors commissioned a Loire-style chateau on that avenue at Sixty-fifth Street. Both families kept scores of servants, both kept equally extravagant mansions in Newport, and both jealously guarded their rank on the top rung of the social ladder. It was in the chateau on Sixty-fifth Street that the young Nixola Greeley-Smith was denied a second audience with Mrs. William Astor, née Clara Schermerhorn. If possible, there was more rather than less slavish imitation of European deportment advocated in the many books of etiquette. In setting the tone for comportment at the dinner table in the fourth edition of her *Manners and Social Usages,* Mary Elizabeth Sherwood advised that "no hostess ever apologizes, or appears to hear or see anything disagreeable. . . . No guest ever passes a plate or helps to anything; the servant does all that. Soup is taken from the side of the spoon noiselessly."

During those decades of servants, multiple mansions, and untold extravagance, lasting until the eruption of World War I, a certain importance accrued to the role of factotum to the rich, otherwise known as an arbiter elegantiarum. An eminent arbiter was Ward McAllister, knight errant to Mrs. William Astor. As the supreme ringmaster in the service of social pageantry, McAllister drew up a list of the four hundred families who, in his unquestioned judgment, rightfully constituted "society." The number was ever after indelibly engraved on the consciousness of society followers, lasting to this day as a metaphor for social exclusivity. McAllister was ready to share his wisdom in the sly game of gaining social prominence and did so in his 1890 book *Society as I Have Found It.* "In planning a dinner," he writes imperiously, "the question is not to whom you owe dinners but who is most desirable."

Ascent of the Rich and Struggles of the Poor

FIGURE 6.4 *A Quintessential New Yorker, 1820.*
The quintessential New Yorker Philip Hone acquired social and economic stature through his exertions as a merchant in the early years of the republic. He subsequently served as mayor in 1826-7. Hone's elegant mansion at 235 Broadway was the scene of glittering events, while his diary is a lively and invaluable New York chronicle.

The "most desirable," with their costumed balls, haute couture attire, mansions, yachts, and private clubs, had for long fed the Cinderella fantasies of New York's multitudes. They had also contributed with untold sums to the sculpting of their city's cultural persona. The Metropolitan Opera House, the New York Public Library (formed out of Astor, Tilden, and Lenox holdings), the Morgan Library, the Metropolitan Museum of Art, the Frick Collection, and the Carnegie branch libraries grace today's Manhattan profile as treasured bequests of the city's pre–World War I patrician class. With the gradual leveling of society following World War II—through property taxes and diminishing cadres of cheap labor—the elegant and inelegant doings of magnates and "pedigreed" families no longer held the spotlight, though eligible names were now being carefully tucked into the *Social Register*. This sacrosanct tabulation was initiated in the 1890s. As it is a listing that is compiled nationwide, an elaborate set of rules has been devised as the basis for inclusion; it is an exercise, however, that no longer holds the public in thrall.

By the second half of the twentieth century, those who belonged to the socially elite of the city, often termed the New York Establishment, dwindled in conspicuousness. They could afford townhouses but not chateau-like dwellings. No longer representing a social or political force of any real power, their comings and goings became of only mild interest in the press, which mostly recorded their participation in charity galas and receptions. At those events, they share attention with the organizing committees that are studded with luminaries from the arts, publishing, Hollywood, and Wall Street, none of whom rely on family lineage for stature. For long now, the showy mansions of the affluent have been given over to nonresidential enterprises; the wealth on Fifth Avenue is largely anonymous. Many reasons are given—beyond property taxes and the prohibitive cost of domestic help in maintaining mansions—for the dwindling of the New York Establishment. Some views were offered by one of its members, George W. S. Trow, in a book entitled *My Pilgrim's Progress*. Though his views prove largely personal, Trow points to the advent of television as a factor in withering the authority of the establishment. Given the cosmopolitanism of New York, with its whirlwind population changes and the sweeping dynamics of its economic structure, no social force as fixed as an "Establishment" has a permanent place.

From the very beginning, the socially elite had lacked cohesion in any organic way because the matrix of their society had been formed around class and ethnic fluidity. Even as far back as colonial times the well-to-do had been met, as they swam upstream, with persistent notions of egalitarianism that ultimately came to the fore. Those considered the truly elite of New York in the Roman sense of the word—writers, artists, intellectuals, athletes, politicians, virtuosi, and the otherwise accomplished—were gaining ascendancy as celebrities in their own right by the final decades of the twentieth century. Motion pictures had long begun to satisfy the fantasy longings once inspired by the doings of the rich, while the proliferation of television beginning in the 1970s

held the key to making instant celebrities of New Yorkers hitherto unknown. New fortunes being made by film and television stars, by athletes, and by technology geniuses in all five boroughs have laid pale the income of some families listed in New York's *Social Register*. The phenomenal sums accruing to the new moneyed class would turn the head of even so self-assured a social aspirant as Peter Stuyvesant and lead him to seek a new definition of aristocracy. Would he be receptive to one offered by the poet Emily Dickinson? In her brief, rhyming quatrain, she asserts: "The pedigree of honey / Does not concern the bee / A clover, any time, to him / is Aristocracy."

Struggles of the Poor

The expansion of poverty in New York began with the arrival of Europeans. Seventeenth-century settlers could attest that the Indians they encountered in the New Netherland region had no such class among them as the poor. The closely knit social fabric of their communities militated against this, as did their size; any indigents among them were invisibly absorbed. Nicolaes van Wassenaer found it remarkable that all New World natives with whom he came in contact in the 1620s were "well fashioned people, strong and sound of body, well fed, without blemish." Before half the century was out, the small number of those "blemished" among the Dutch colonial population of Manhattan had become a matter of some concern. They included the impoverished, the widowed, the elderly poor, orphans, and vagrants. A few settlers complained to the Amsterdam authorities that nothing of consequence was being done on their behalf. "Flying reports about asylums for orphans, for the sick and aged, and the like have occasionally been heard," protested Adriaen van der Donck and his cohorts in their remonstrance of 1650, "but as yet we cannot see that any attempt, order or discretion has been made in relation to them." The blame was being put on the colony's director.

Matters were not helped when, in 1654, the Dutch authorities in Holland announced they were shipping over a boatload of impoverished girls and boys to augment the colony's meager number of inhabitants. "If you consider that the population of that country," wrote the authorities in Holland to Peter Stuyvesant, "could be advanced by sending over such [impoverished] persons, we shall . . . lose no time to have some more forwarded." The irony of the situation was that the poor were being transported to revenue-shy Manhattan to relieve the overburdened almshouse in the wealthy city of Amsterdam.

In 1661 Peter Stuyvesant initiated the enactment of a Poor Code whereby donations were solicited and taxes levied. By then, several structures were in place for the relief of the needy, in addition to a board of overseers of the poor. These numbered an almshouse, a poor fund, and a poor farm. The latter, explained the Reverend Johannes Megapolensis, minister of the Dutch Reformed Church, consisted of "a certain bouwery situate on the other side of

Hellgate," meaning the present borough of Queens. The poor fund, or deacons fund as it was most often called, had its origins in a locked box hung on the wall of the director's house where paid-up fines and donations were kept. Deacons of the church had a key to it. The almshouse consisted of rented quarters in a house on Beaver Street. Already in operation was an orphan masters court at the service of "orphan masters" who had been appointed by the Common Council to care for deprived children. These seemingly substantial relief measures amounted to little, however, for they were unsystematic attempts to relieve the needy and were haphazardly supervised. Underlying any municipal service was the staunch belief, borrowed from traditions in Holland, that religious charity and private philanthropy were the best means of addressing indigence.

The numbers, in any case, were small. They continued to be so when New Amsterdam became New York. Under English rule, the same belief prevailed that caring for the distressed was a moral matter best left to the parish churches and therefore to be contained within an ecclesiastical setting. In 1700, with Manhattan's population passing the five thousand mark, no more than thirty-five people were deemed paupers, which is to say those who were destitute enough to be confined to the almshouse. Three decades later, with a population climb to eight thousand, church wardens indicated in their records that they had given relief to fewer than fifty persons. But it was not a complete picture. Others received what was called "outdoor" relief, a donation of clothing, firewood, and some money given to the poor who were lodged within a family household. Still others required attention as discussed during a meeting of New York's Common Council in 1734. "There is not yet any Provision made," members were informed, "for the Relief and setling on Work of Poor Needy Persons and Idle Wandring Vagabonds, Sturdy Beggars and Others, who frequently Committ divers misdeamonors within the Said City, who living Idly and unimployed, become debauched and Instructed in the Practice of Thievery."

Because the council deemed that what was wanting was a "Workhouse and a House of Correction," it set about seeing to the realization of such facilities. Envisioned was a two-story stone structure to be built on unimproved lands north of the settlement that would serve as combination almshouse, workhouse, hospital, and house of correction. When the building was completed in 1736, John Sebring was appointed keeper; he moved in with his wife and nineteen occupants. As was customary, church wardens were appointed the ultimate authority and dispensers of the funds. A good number of the distressed must have avoided shelter in the almshouse, for it carried with it institutional punishment. Provision had been made for "Fetters, Gives [gyves or chains], Shackles, and a . . . whipping post." The number of occupants did expand nonetheless. Somewhat more than four hundred were accommodated in the almshouse in 1772, with women in the majority; the population then stood at twenty-two thousand. Children were also admitted.

They were to be religiously educated and "employed in spinning of wool, Thread, Knitting, Sewing or Other Labour most suitable to their Genius." For the most part, those who required relief in the pre-Revolutionary era were the sick, the incapacitated, the widowed, the elderly, and the orphaned. Inability to find work in New York's bustling seaport was not yet the basic reason for needing support.

The difficult post-Revolutionary years saw the rise of a growing number of adults unable to make ends meet. Following an inherited English tradition, they were promptly imprisoned as debtors, a measure that would assuredly compound their woes. While the socialite Mrs. John Jay busily planned gala town dinners to celebrate the inauguration of America's first president, hundreds of residents, some joined by their families, languished in horrible confinement. In response to the plight of jailed debtors, the Humane Society was formed by a group of enlightened sympathizers who sought contributions toward their work. In the second year of the society's existence, a donation of fifty guineas, made on Thanksgiving Day 1789, was offered by George Washington. A published note of gratitude to the president was run, on behalf of the debtors, in the *New-York Weekly Journal* of December 3. Of the cluster of voluntary organizations that subsequently came into being during the following decades, the Humane Society was among the most effectual.

What would exhaustively test the dual system of public and private charity now in operation was the phenomenal population explosion that characterized nineteenth-century New York. The almshouse inaugurated under the care of Keeper John Sebring had already fallen into disarray for want of municipal supervision as the 1700s neared their end; a new structure was erected nearby. The number of those requiring relief was steadily multiplying not only by waves of newcomers in the 1800s but also by the dislocation that rapid industrialization and urbanization inevitably brought with them. Then, further, the financial panics of 1817 and 1835, coupled with epidemics and destructive fires germane to urban areas, caused a chaotic situation with regard to the needy and with regard to the growing class of unfortunates confined to debtors' prison. Municipal authorities were not indifferent nor were those among the merchants and the rich who sought solutions within private means. In 1816 the so-called Bellevue Establishment, put in place by the local government near the East River at Twenty-eighth Street, developed into a combination factory, poor house, and hospital. At the same time, relief through church organizations and ethnic charities augmented the public assistance programs. Horace Greeley, editor of the *New York Tribune*, who pounded away at the need for social reforms on behalf of the poor, cited in early 1845 that "there are Fifty Thousand people in this City who have not the means of a week's comfortable subsistence and know not where to obtain it."

Relief measures of whatever efficacy were invariably accompanied by pronounced ideas for reducing the level of welfare; they were put forth both by government authorities and by social reformers at large. Some ideas clung to

FIGURE 6.5
Fashionable Turnouts in New York, 1868.
By the post–Civil War era, private carriages
aplenty abounded in New York, where
Central Park was the ideal place to show off
one's fashionable equipage. Indeed such an
outing was one of the reasons that the park,
opened in 1859, had been promoted by
wealthy merchants. In the upper left, a
young woman daringly drives a phaeton.

FIGURE 6.6 *Tenement on Mulberry Street, 1879.* Increasing squalor attended successive waves of immigration as newcomers struggled to eke out an existence in wretched urban hovels. Rags assembled from the city's streets and garbage dumps were hung out for a wash by the rain before being sold for pennies. Beneath the hangings, children play in the squalid Mulberry Street court.

the conservative notion that the poor deserved their lot; others were pegged to the insistence that the poor must help themselves by performing assigned work. More zealous reformers focused on moral and religious education as the best way to strike at the so-called roots of poverty and vice. Most chose to ignore the social and economic inequities of an urbanizing, industrializing, capitalistic environment. In 1843 the Association for Improving the Condition of the Poor, founded by religious leaders, had taken a sympathetic approach with its introduction of the district visitor system. Several hundred educated volunteers, composed solely of men at first, made assigned visits to the poor in an effort to extend some moral uplift. The association, led by the able philanthropist Robert M. Hartley, was eventually responsible for the construction of public bathhouses, sanitary reforms, medical dispensaries, and the inauguration of the Working Men's Home on Elizabeth Street, which offered housing specifically to black men.

Ironically, the "real" city for the thriving half of the population—and for its admiring visitors—was not its slums but the shimmering wealth of Wall Street, Broadway, Washington Square, and equally fashionable Union Square, where business, money, and property were being elevated as the basic rights of man. Yet the city could not ignore the fact that the relief measures in place were simply not keeping pace with what was happening. The needy were not only products of a complex, mercantile society, they were being imported as well. Following the mid-1840s potato famine in Ireland, many Irish arrived in poor health as well as destitute; they went straight to the almshouse. In scarcely no time, they formed 25 percent of the population that could be accommodated there. Inevitably, the city felt burdened by its large budget appropriation for poor relief; there were outcries from the public and press as well. Referring to hospitalized immigrants, the *New York Sunday Times* of March 11, 1849, lashed out at the "hordes of the miserable outcasts [who] are charged with infection on the voyage and then they occupy the fever wards of our hospitals to the exclusion of our own citizens."

There was, of course, heavy reliance by the authorities on churches and benevolent organizations catering to special groups that were ethnically, religiously, racially, or otherwise defined. But just as the problems of the expanding city were becoming inordinately complex in terms of fire, police, water, light, transport, and other services, so was it the case with the expanding poor. Children now formed an alarming part of the world of the impoverished. "No one can walk the length of Broadway without meeting some hideous troop of ragged girls, from twelve years old down," wrote the well-to-do diarist George Templeton Strong in the summer of 1851, "brutalized already almost beyond redemption by premature vice, clad in the filthy refuse of the ragpicker's collections, obscene of speech, the stamp of childhood gone from their faces." The plight of children deeply concerned the philanthropist Charles Loring Brace, who founded the Children's Aid Society in 1853. He faulted New York's more-privileged population for hurrying on in pursuit of

A CITY OF CONTRASTS

FIGURE 6.7 *A Thompson Street Dive, ca. 1890.*
The photographer Jacob Riis draws the viewer into a lower Manhattan dive through one of his compelling images. "The moral turpitude of Thompson Street has been notorious for years," noted the compassionate Riis in his documentary account. "[It is] the borderland where the white and the black races meet in common debauch."

its wealth, leaving behind the destitute of many stripes. He warned that "the neglect of the poor and tempted and criminal is fearfully repaid." One form of repayment came in the spectrum of diseases arising out of poverty, including fearsome epidemics of cholera, of which there were three in the nineteenth century.

Undoubtedly the greatest divide between the prosperous and the impoverished of New York was in the area of housing. Slum landlords were merciless in their subdivision of already small apartments, devoid of basic facilities, inasmuch as no housing regulations were in place. On Mott Street, wooden privies were installed in 1852 in the backyard by the People's Washing and Bathing Establishment; the privies in turn set up breeding grounds for disease. Such primitive conditions put a particularly heavy burden on women in thwarting their ability to keep their dwellings decent. Women were generally more vulnerable to impoverishment through widowhood, male absence or desertion, lack of job training, and diminished fortunes of the husband, as well as through various forms of discrimination. Destitute female immigrants who were crowded into slums had scant hope for an amelioration of their lot.

The most notorious of the slum communities of the nineteenth century was the area known as Five Points near today's Foley Square. Its unsavory reputation spilled beyond Manhattan's borders. When Charles Dickens visited there in 1842, he was appalled by what he saw, recognizing the similarity of the neighborhood to London's slum area known as Seven Dials. "Where dogs would howl to lie, women, and men, and boys slink off to sleep, forcing the dislodged rats to move away in quest of better lodgings," were the bitter words of the novelist. "Such lives as are led here," he bemoaned, "bear the same fruits here as elsewhere."

Dickens was referring to the inevitable crime gangs that would claim the squalid neighborhood as they subsequently did. The first string of racketeering gangs numbered among them the Plug Uglies, the Dead Rabbits, and the Roach Guards, all mostly Irish. In 1839 crime gangs played a role in escalating a personal feud, between an American and an English actor, into a flaming riot. The scene, which took place at the Astor Place Opera House just below Eighth Street in May, gave the city a nasty taste of urban violence with strong ethnic and anti-elitist overtones. More than 20 people were killed and more than 150 injured. "This cannot end here," fumed Mayor Philip Hone; "the respectable part of our citizens will never consent to be put down by a mob." The Five Points Gang of later composition was chiefly Italian; by the start of the twentieth century, the bitter rivals of the Five Pointers were the Eastmans, a gang that was identifiably Jewish.

An astute observer of the Five Points scene was a young *New York Tribune* correspondent named Jacob Riis. Some years after his arrival as a penniless drifter from Denmark in 1870, Riis began his work as a reporter monitoring the appalling conditions in poverty-stricken neighborhoods of New York's Lower East Side. He drew rapt attention with his vivid vignettes of the Five

Points and other slum areas; later he mesmerized audiences with the horrifying photographs he took inside the slums. Both his prose and his pictures drove home to a wide audience the pitiful struggle of the poor to manage the barest of existences amid the city's wealth. He was sympathetic to the plight of blacks, whites, and Asians indiscriminately. Riis's most shocking photographs portrayed pauperized children of whom he wrote in his 1890 documentary *How the Other Half Lives:* "Their very number make one stand aghast." Estimates put the roster of city children then living as vagrants at forty thousand.

Riis's pioneering work led to a broader understanding of urban poverty that in turn sparked public action, particularly tenement reform and the creation of small parks. But as twentieth-century New York absorbed more and more newcomers who found only a sorry niche in Eden, there were still lessons to be learned and battles to be fought. The plight of immigrants in the workforce sent into action labor leaders such as Samuel Gompers, David Dubinsky, Emma Goldman, and others who led waves of laborers in a con-

FIGURE 6.8 *Notorious Five Points, ca. 1886.*
The Five Points neighborhood of the city,
located at the junction of Baxter, Worth,
and Park Streets, was notorious in the
Victorian era for its devastating poverty
and high crime. Charles Dickens, visiting in
1842, was appalled by what he saw. "Such
lives as are led here," he groaned, "bear the
same fruits [crimes] here as elsewhere."

FIGURE 6.9 *The Halls of Justice, 1896.*
New York's main prison, which came to
be known as the Tombs, was inspired by
Egyptian architecture. It is "a style well
suited," commented the *Evening Post* of April
1, 1837, "by its massiveness, severity, and
appearance of prodigious strength to edifices
of this kind." Conditions of prisoners in the
interior were less inspired.

FIGURE 6.10

Cheap Labor on Hester Street, 1890.
In a filthy, badly ventilated shop on Hester
Street, young and old alike work on the
sewing of trousers. Such conditions were
the lot of the working poor in many parts
of the city far into the twentieth century.
Jacob Riis wrote that the "faces, hands, and
arms to the elbows of everyone . . . are
black with the color of the cloth."

tinuing struggle to attain decent working conditions. They fought to end the sixty-hour workweek and the treacherous conditions in sweatshops that made disease and fires possible. The Triangle Shirtwaist Company fire of 1911, in which 146 young seamstresses died, had horrified the entire nation. Thousands of New Yorkers, along with newly arrived immigrants, braved arrests, beatings, and wintry weeks picketing to build a better future. A remarkable conjunction between the rich and the poor occurred during the first mass strike by women in 1909 when the socialite Mrs. August Belmont and her daughter Anne sponsored a Carnegie Hall benefit to support the twenty thousand strikers. It was not the first instance of help, nor would it be the last, but it was a particularly magnificent moment.

No one, of course, was ready for the jobless population that followed upon the Wall Street stock market crash of 1929. The ensuing depression, lasting until World War II, took its toll in all five boroughs, where breadlines were unending and where scenes of despair lurked around every corner. New York's middle class, which had heretofore stood as a solid component between the urban extremes of rich and poor, was thoroughly undermined by the crash. It required the massive intercession of the federal, state, and municipal governments to alleviate the tens of thousands of able-bodied residents thrown out of work, who swelled the ranks of the impoverished. A relief agency, popularly known as the WPA (Works Projects Administration), was established by President Franklin Roosevelt in 1935 and imaginatively administered in the city by Mayor Fiorello La Guardia. Accomplishments of the WPA in all areas affecting the welfare of the city were phenomenal: construction, engineering, housing, parks, education, and the various branches of the arts all derived benefits from WPA directives.

No depression of so drastic a nature occurred in the second half of the twentieth century though the city weathered some economic setbacks. Nor have there been, on the other hand, any dramatic panaceas devised to maintain low levels of city residents on relief rolls. True, "hideous troops" of children no longer roam the streets today, and slum areas akin to crime- and disease-ridden Five Points have no real counterpart. Perhaps the South Bronx of the 1970s came closest. With its burned-out buildings, street gangs, destitute adolescents, and its specter of a forgotten territory, it, too, garnered an international reputation, attracting the visit of President Jimmy Carter and some foreign dignitaries before a turnaround was slowly put into motion.

A new dimension in the misery that has become characteristic of late-twentieth-century downtrodden areas in all five boroughs is drug addiction. Heroin, cocaine, and the less harmful marijuana appear to be particularly favored. Added to that, an epidemic codified as AIDS (Acquired Immune Deficiency Syndrome) terrified the city, beginning in the 1980s, with the toll it was taking on young men and a sizable number of women (particularly among blacks). Of all American urban areas, New York City was the most badly affected in terms of the dreaded pestilence. As the new millennium ap-

FIGURE 6.11 *Breadline, 1932.*
A compelling image of the citywide poverty that followed the Wall Street crash of 1929 is this etching by Reginald Marsh. Behatted men, struggling to maintain dignity, push close in an effort to move nearer toward the handout. Thousands of able-bodied residents in all boroughs sadly swelled the ranks of the impoverished.

FIGURE 6.12 *Number 6, the Bowery, 1944.*
Reginald Marsh, of the so-called Ashcan school of artists, repeatedly sketched the army of derelicts in the Bowery and the seedy lodging houses of lower Manhattan. Though he could be brutally unflattering in his depictions, a sympathetic understanding plainly lurks beneath whatever human byplay the artist chose to record.

proached, the prevalence of AIDS, drug addiction, and the inevitable widening circles of poverty that both engendered were understandably making ferocious demands on all the charitable, medical, religious, and municipal agencies that exist in the city. Growing numbers of the homeless began to appear on the streets, prompting a host of churches, already steeped in relief work, to conduct soup kitchens for the first time since the Great Depression. In the 1960s more than 8,000 men lived in public shelters; another 8,000 lived in city flophouses, chiefly on the Bowery. Soon, these numbers were swelled by thousands discharged from mental institutions—men and women—for whom no proper housing had been planned. A tally of the homeless climbed steadily, reaching the appalling figure of 18,000 as the 1990s made their debut. A census of New Yorkers listed on the municipal welfare rolls came to about 1.15 million in 1991; in the year leading to the new millennium, that figure stood at well below 800,000.

No doubt Charles Loring Brace and Jacob Riis would find the scene utterly distressing if they were to visit the city in the year 2000, finding that poverty continued as a serious problem. But what they could attest to is that

FIGURE 6.13 *Stoopball in East Harlem, 1953.*
In a sunshine-filled street of East Harlem,
none of the distractions of billboards,
hanging laundry, or trash cans interfere with
a good neighborhood game of stoopball,
here caught in action by the photographer
Sanford Malter. The easy rules of stoopball
made the game accessible to anyone whose
playground was the street.

a more enlightened attitude prevails toward the multiple groups making up
the welfare population. Federal, state, and city governments have increasing-
ly acknowledged their share of responsibility (amid much hand-wringing
over the size of relief budgets) in providing basic shelter, while a commend-
able activism on the part of Gotham's citizenry of all ranks has reduced the
indiscriminate onus of outcast on the broad spectrum of the impoverished.
New Yorkers, who have increasingly come to an understanding that relief is
a fundamental right of the needy, bond in spirit with the modern scholar and
politician Daniel P. Moynihan who has labored to expand the body of useful
knowledge bearing on the problems of poverty. Moynihan insists there is no
one solution to the dilemma but rather a necessary *variety* of solutions.
"American social science can do better," says the enlightened New York sen-
ator, "and so it ought."

BROADWAY

The Metamorphosis of a Manhattan Street

Broadway was a highly desirable address when George Washington arrived in 1789 to take up his post as the first president of the republic. The victorious commander in chief of the Revolutionary army knew the street well. At the outbreak of the war, he had resided in the Georgian-style dwelling that bore the number 1 until he was routed by the enemy. Now, with New York newly designated as the nation's capital, he and his family were assigned presidential quarters at number 39 on the west side of the prominent thoroughfare. Dwellings on that side had been miraculously spared destruction by the fire of 1776 when a third of the city was ravaged. Punctuating the southern end of Broadway was Bowling Green, triumphantly derobed of the statue of George III, while at the northern, or Wall Street, end was the sobering presence of Trinity Church, slowly rising from the ashes of the terrible wartime fire.

In that inaugural year of 1789, one of the occupants of number 39 was unhappy with what appeared to others an enviable lot. "I lead a very dull life here and know nothing that passes in the town," moaned Martha Washington to a friend in a letter of October 22. "I never goe to any public place,— indeed I think I am more like a state prisoner than anything else; there is certain bounds set for me which I must not depart from—and as I cannot doe as I like I am obstinate and stay at home a great deal." At the age of fifty-eight, she was feeling a bit on in years and well aware that "many younger and gayer women would be extremely pleased" to occupy her place in a newly refurbished mansion that cost the government ten thousand dollars to put in order.

Poor Martha. Her self-imposed immobility in a household maintained by twenty-seven servants was surely cause for lament since the town was bubbling over with vitality and Broadway was at the center. The street was home to the cream of local society, all of whom were at Martha's beck and call, while a further gaggle of notables resided within easy reach. Alexander Hamilton, William Livingston, Daniel Verplanck, and Robert Morris lived on Wall Street; Aaron Burr, on Little Queen Street; John Jay, Henry Knox, and the French minister, in other townhouses on Broadway; and John McComb, who owned the mansion in which Martha was residing at number 39, lived on William Street. All kinds of services to please a discerning lady were also in easy reach. Right there on Broadway, scarcely a mile in length at the time, could be found

FIGURE 7.1 *Map of New Amsterdam:*
The Castello Plan, 1660.
Nowhere does colonial Broadway stake out
its terrain more boldly than in this map
known as "the Castello Plan." Dutch
colonists found this "broad way" already
marked out by the natives as a principal
north-south trail from the Battery to Albany.
Parts of the trail followed the earlier tracks
of indigenous animals finding their way
to water.

a peruke maker, a hatter, a breeches maker, a goldsmith, a saddler, a pewterer, an upholsterer, a silk dyer, a coachmaker, a cake shop, and a fruit shop. Surely these could have provided a nice diversion for the First Lady with temptations not readily available in the rural setting of Mount Vernon. Besides, at 91 Broadway was the home of Mr. John Foxcroft, an agent for British sailing packets who could certainly have arranged for a getaway.

American dignitaries and exalted visitors were, of course, all finding their way to the environs of Broadway, which had thoroughly shed the gloom accumulated during the seven years of war. Thomas Jefferson, serving as the first secretary of state, found it impossible to obtain a townhouse on this most fashionable of thoroughfares when he arrived in the spring of 1790; he had to be content with living nearby at 57 Maiden Lane. Taking the pulse of the city from the vantage point of his working quarters—which he had managed to locate on Broadway near the president's mansion—Jefferson found his new environment more than just a little spirited. New York City, the future president was to declare, is "a cloacina of all the depravities of human nature."

Europeans who came to Manhattan to trade in the early 1600s found the outlines of Broadway already marked out by the natives as a meandering north-south footpath all the way from the Battery to Albany. In slowly shaping this footpath, coastal Algonkians instinctively followed the favorable highs and lows of the rocky Manhattan terrain, seeking economy of movement and circumvention of obstacles. Parts of the trail followed the earlier tracks of animals that found their way to water on all sides of the island. The natives marked off at least two main arteries leading out of Manhattan: one reached north to Albany, the other northeast to Boston. Both began as a single road at the island's harbor edge, then forked somewhere below today's city hall. Breaking off from these "highways," a complex of smaller Indian paths found their way to the most rewarding fishing places and to hunting grounds. Through constant use, they were cleared of underbrush and entangling vines and slowly widened to accommodate a native wayfarer laden with bow and arrow or a good day's haul.

Natives of Manhattan named their paths according to the salient features of the terrain through which the path was cut. When the Dutch came and established their tiny trading post at the water's edge of Manhattan, they called the widest path they found in their midst Heere Straet, or Broad Street, and named the longer stretch of it leading to their northern trading post of New Orange the Heerewegh, or Broad Highway. By whatever name it was called—alternately Public Highway and Great Highway—Broadway kept its earth floor for quite some time during the colonial epoch as New Amsterdam grew. Where it cut through the midst of the settlement, it was frequently muddy and, with animals freely roaming over it from nearby *bowueries,* or farms, there were recurring piles of dung to avoid. Constant repairs were required to the fort erected at the southern end of the thoroughfare because of animals rooting there, a matter of abiding concern in terms of the colony's defense.

The Metamorphosis of a Manhattan Street

A small hint of the European-style street that Broadway would become dates from 1643 when ground-briefs for land began to be issued by the Dutch West India company. As landowners undertook to erect houses on crudely charted streets with numbers assigned to the lots, the character of the settlement slowly acquired the profile of a small Dutch town. It was in this year that the property at number 1 Broadway was staked out. Much to the approbation of the colony's inhabitants, Martin Cregier built a tavern at number 5 Broadway, located at convenient proximity to the colony's fort, which was the hub of activity. Reporting on the changing aspect of the Dutch colony, an English visitor in 1647 observed that "in the yeares 1641, & 1642 there was not six howses of free Bhurghers [townsmen] in it, but now there is many."

A more dramatic change was evident by 1660 when a fair number of roadbeds had been laid out and a protective east-west barricade erected from the Hudson to the East River to enclose the exposed settlement on its northern flank. Documenting this growth is a bird's-eye view of the New Amsterdam colony, drawn in 1660, showing the nascent streets that share in a colonial history with Broadway. On the plan, the Heere Straet is conspicuous as the major artery it was, rivaled somewhat in width, not length, by the Heere Graft, or Broad Canal. Settlers had dug the canal, leading from the East River, in order to receive incoming ships ready to unload. Peter Stuyvesant sent the 1660 plan to Holland, where officials of the Dutch West India Company were quick to comment on it: "According to our opinion," they huffed, "too great spaces are as yet without buildings . . . perhaps with the intention of cutting streets through them, when the population increases, although if [houses were] standing closer together, a defense might be easier." Worries about defending the colony were ever uppermost in the minds of the Holland directors. Just four years later, cause for worry ceased altogether when the British swooped in and acquired the colony. The canal was subsequently filled in and called Broad Street, the trench for the defense barricade became Wall Street, and Heere Straet was permanently anglicized to Broadway.

Slowly, the population expanded and by 1686 had moved past three thousand. In that year, the topography of the settled area of Manhattan was laid out in five wards. Broadway's small stretch was mapped within the rectangle designated West Ward. It was by no means the wealthiest neighborhood. That distinction had fallen to the Dock Ward, oriented toward the commerce of the East River. On Dock, Bridge, and Stone Streets were the homes of the prosperous merchants, and for this reason, the east side of town was for long the more dominant. Attempts were made to level and pave Broadway, with cobblestones first used in 1707 for the leveling of a stretch that extended from Bowling Green to Trinity Church. By midcentury, the former muddy cow path was assuming an urban profile. When Thomas Pownall, secretary to the colonial governor in the 1750s, made a topographical survey of Manhattan for submission to the Crown, Broadway had clearly begun to attract wealth away from Dock Ward, for the secretary remarked that "the Principal Street is a noble

broad Street 100 feet wide called Broad Way," noting that on its west side were "several very handsome Spacious Houses of the principal Inhabitants."

More effusive comments were to come regarding the "noble broad Street" when the British had long gone. It was the judgment of the Duke de la Rochefoucauld-Liancourt visiting from France in the final decade of the eighteenth century that "there is not in any city in the world a finer street than Broadway. . . . From its elevated situation, its position on the river and the elegance of the buildings, it is naturally the place of residence of the most opulent inhabitants." It may be that comments as to Broadway's nobility of appearance in the 1790s were exaggerated, or perhaps it was modest enough in length to have achieved a uniform elegance. Broadway had still far to go before it could claim all Manhattan in its reach. It barely existed as an urban artery beyond Houston Street. Further north, where it was known as Bloomingdale Road, the scene was, with its helter-skelter of farmsteads, appealingly rural, reflecting the "vale of flowers" that prompted its Dutch name of Bloemenvael for the area.

A truly radical street profile was imposed on the face of New York with the execution of the Commissioners' Plan of 1811. Quite suddenly, 2,000 city blocks were created on the municipal planning boards between the neighborhoods of Fourteenth Street and Washington Heights, then a distinctly bucolic neighborhood to the north. They were the offspring of a grid plan that was visited on the natural carpet of the city to facilitate the sale of government lands and to avoid any future emergence of "chaotic" street patterns. Just as suddenly, 12 numbered avenues running north-south sprang into conceptual being, crisscrossed with unrelenting regularity by 155 east-west streets. Such a supergrid of endless right angles was a distinctly uninspired vision for a burgeoning city that already prided itself on a certain chaos. No more would little streets shape themselves after the natural contours of the earth. Those twists and turns earlier followed by native wayfarers, which had characterized most of Manhattan's colonial lanes, would belong mostly to a picturesque past. Still, the commissioners felt that theirs was a democratic plan because it would break up great concentrations of property and facilitate widespread home ownership.

The checkerboard plan of 1811 took years to implement. Leveling and grading of the unyielding rocky terrain required extensive time and money as did the filling in of ponds, swamps, marshes, and portions of the waterfront. Although some changes were made in the 1811 design during the slow process of implementation, the master plan forever stamped the geometric character of Manhattan's cityscape. Disturbing to Edgar Allan Poe was the looming disappearance of the open country spaces still existing to the north that he described as "some of the most picturesque sites for villas to be found within the limits of Christendom." In "some thirty years every noble cliff will be a pier," fretted the poet, "and the whole island will be densely decorated by buildings of brick, with portentous *facades* of brownstone."

The scheme of 1811 was by no means the first grid to be imposed on a would-be American metropolis. Philadelphia, Savannah, and Washington had all

The Metamorphosis of a Manhattan Street

FIGURE 7.2

Broadway from Bowling Green, ca. 1834.
Post-Revolutionary Broadway became the
city's most elegant thoroughfare. George
Washington lodged there during his brief
sojourn in New York as first president of
the new republic. His wife, Martha, was
most unhappy in her official role living at
number 39, claiming that "I lead a very
dull life here and . . . I never goe to any
public place."

come into being based on master grids though they carried with them some irregularity and charm. Pierre L'Enfant, the landscape architect who designed the capital city, deliberately avoided what he called "tiresome and insipid" regularization by conceiving a mixed radial and grid pattern in which intersecting diagonal avenues would set up attractive focal points. In New York, Broadway remained the city's only major diagonal thoroughfare, proving too independent a creature to succumb to rigid geometry. It accordingly assumed the aesthetic mission of creating wonderful circles, squares, and grassy pauses where it intersected with other avenues. All born of Broadway's serpentine inclinations are the welcome draughts of space offered by City Hall Park, Union Square, Madison Square, Herald Square, Times Square, Columbus Circle, Sherman Square, Strauss Park, Edward M. Morgan Place, and Mitchell Square. Most of these squares and parks had not been created by 1826, however; in that year Broadway was only three miles in length, running from the Battery to Tenth Street.

A major improvement in the look of Broadway came about in 1835, following a terrible fire in the city, when a plan for macadamizing Broadway was adopted. It was modeled on Russian streets in Saint Petersburg. Because some of this took place in front of the mansion of the well-to-do Philip Hone, he recorded the operation in his diary: "The street is excavated to a depth of about two feet, then a layer of broken stone is placed . . . on the top of which is a regular pavement of round stones; the whole covered by a compact course of wooden blocks, sexagonal, one foot in length, and placed vertically." Interstices were filled with liquid tar covered with a thin coat of gravel. Hone wondered how long this kind of pavement would last given "the multitudinous train of omnibuses, carriages, carts, and wagons which infest Broadway." That multitudinous train would not decrease in volume as the street stretched steadily northward. Predominately residential in nature for several decades following independence, it was no longer so by the 1840s when Fifth Avenue became the choice location for those with the means to build palazzi. Broadway thereupon devised a role for itself—in terms of shops, restaurants, hotels, and entertainment—that was infinitely more diversified.

Scarcely anything was lacking in Broadway's shops—in clothing, household items, extravagant baubles, or other merchandise—to satisfy the yearnings of the carriage trade. Warehouses were continuously replenished with goods either manufactured in the city or brought back via clipper ships that had sailed to China and to European ports. Tiffany, Young, and Ellis, a splendid gift and jewelry shop at 237 Broadway, first established in 1837, had a warehouse that was, in the view of Edgar Allan Poe "beyond doubt, the most richly filled of any in America, forming one immense *knicknackatory* of *virtu*." Surely Martha Washington could have been coaxed out of her mansion on Broadway had Tiffany's, with its dazzling wares, existed in 1789. Broadway's hotels became celebrated, like the sumptuous three-hundred-room Astor House, which offered the unusual feature of a lock and key for each room. Hotels were built to accommodate merchants as well as visitors and were never far from the shops that proliferated on the avenue.

The Metamorphosis of a Manhattan Street

Broadway's other attractions tirelessly competed for the attention and purse of the pedestrian in pre–Civil War times. There was Niblo's Garden, a smart outdoor recreation center at Broadway and Prince, with a facility that could seat three thousand; the American Museum operated by the impresario Phineas T. Barnum at Broadway and Ann, which featured performers like Jenny Lind but mostly lesser entertainment bordering on humbug; and the Daguerrian Miniature Gallery at Broadway and Fulton, where the pioneering Matthew F. Brady photographed the noted personalities of the day. A number of restaurants, led by Delmonico's, began to assume the kind of grandeur that made eating out a social event; few could be reckoned more splendid than Taylor's Saloon on Broadway with its banquette seats of crimson and gold. Restaurants in the hotels on Broadway like the Astor House, the Saint Nicholas, and the American Hotel were also fine places where one could dine as well as be seen among the swells of the population.

Architectural styles for the steady construction of shops, hotels, and the many facilities enlivening Broadway were in direct contrast to the "brilliant uniformity" imposed on the city's grid design. Mercantilism rather than architectural harmony was shaping the steady lengthening of Broadway northward, though the introduction of cast-iron structures in the 1850s did unify the appearance of a number of important buildings on this stylish thoroughfare. In 1862 shops of all sizes and pretensions were eclipsed by the cast-iron emporium of Alexander T. Stewart at Broadway and Ninth. Boasting two acres of floors and a staff of more than three hundred, this department-store forerunner had an ornate facade of cast-iron columns and large plate glass windows easily supported by cast-iron frames. Lord and Taylor's followed on Broadway less than a decade later, becoming one of the shopping meccas on the famous Ladies' Mile, a segment of Broadway stretching from Alexander T. Stewart's store to Stern Brothers at Twenty-third Street. A little jingle making the rounds set off the boundaries this way: From Eighth Street down, the men are earning it / From Eighth Street up, the women are spending it / This is the manner of this great town / From Eighth Street up and Eighth Street down.

Those who swished their voluminous Victorian skirts along the celebrated Ladies' Mile made an indelible impression on visitors. Nineteenth-century Broadway had unquestionably become the premier avenue of fashion where ladies went to see and be seen and where excitement lingered long into the night. One Englishman was amazed by the extravagance whereby "pink satin, bonnets & feather and boots to match of the same material" should be paraded at ten o'clock in the morning. Watching the hatted and bustled ladies sashaying past her, the actress Fanny Kemble had earlier taken special notice of the ladies' headgear, estimating with astonishment in 1834 that upward of sixty dollars was lavished on a bonnet just for wearing "in a morning saunter up Broadway." Charles Dickens found the scene rather garish. "Heaven save the ladies, how they dress!" was the way he put it in 1842. "What rainbow silks and satins! what pinking of thin stockings, and pinching of thin shapes, and

FIGURE 7.3 *City Hall and Park View, 1835.*
The construction of City Hall in 1811,
which then defined Manhattan's northern
limits, immeasurably enhanced Broadway's
attractions. Countless views of the broad
avenue, with the imposing Georgian
building serving as architectural focus,
appeared in the new media of lithographs
and aquatints, as well as in paintings.

Broadway and Rector Street, ca. 1850.
A major improvement in the upkeep of
Broadway came about in 1835 with a plan
for macadamizing the avenue. It was mod-
eled on Russian streets in Saint Petersburg.
The diarist Philip Hone wondered how
long this surface would be able to support
Broadway's "multitudinous train of omni-
buses, carriages, carts and wagons."

FIGURE 7.5 *Broadway at Ann Street, 1855.*
Broadway remained the city's only major
diagonal thoroughfare following the
"brilliant uniformity" of the commissioners'
street plan of 1811. This curving westside
street created wonderful circles, squares, and
grassy pauses along the way where it inter-
sected with other avenues as at Ann Street.
A rowdy tangle of midcentury traffic there
makes a colorful scene.

fluttering of ribbons and silk tassels," he exclaimed, "and display of rich cloaks with gaudy hoods and linings!" It was a colorful scene that persisted to the early days of the novelist Edith Wharton, a wealthy Manhattanite of the Chelsea area. Her ambition, she declared as a child in the 1860s, was to be "the best-dressed woman in New York."

As the nation's great showcase of fashion, Broadway and its shops ensured that fabrics of the most exquisite textures and colors could be had from their shelves. New York merchants had a virtual monopoly on English woolens, Irish linens, and French lace. Initially, dry goods merchants had been located in the restrictive quarters bordering the East River wharves. By mid-nineteenth century they were established on the West Side of Manhattan where larger warehouses could be built or rented and where they were more accessible to out-of-town buyers who lodged in Broadway's splendid caravansaries. With businesses spreading above the one-third mark in the vertical stretch of the island, a sense of a "downtown" area developed in the spatial consciousness of New Yorkers. Lodgings were no longer part and parcel of what had become expensive commercial properties; in the earlier years of the century, there was scarcely a building without habitation.

Broadway's giddy path to commercial preeminence did not falter with the outbreak of the Civil War; as a matter of fact, New York profited by the terrible conflict. Some New York merchants were willing to espouse the sentiments of Mayor Fernando Wood who held that the war would certainly blunt New York's extraordinary economic growth. On that premise he made the startling proposal that the city secede from the Union! Certain it was that some merchants feared the conflict would threaten their southern markets. New York, however, ultimately proved itself as ardently pro-Union as did its other northern neighbors, though the sentiment was marred by four violent days of protest.

The conflict that took place in 1863, known as the Draft Riots, nearly wiped out the city's commitment to the Union cause. Incensed by the newly enacted Draft Law passed by Congress, workers clashed with the militia and with police in resisting conscription. Some stores were attacked, including that of Brooks Brothers on Cherry Street, which supplied uniforms to the Union Army. Its newer shop on Broadway at Grand remained intact. The black population suffered the most since whites, chiefly impoverished Irish immigrants, feared a loss of jobs to them. More than a hundred died, some brutally, in the July carnage that had quickly swept through several of the city's neighborhoods. New York recovered painfully from the upset, resuming its war efforts with pledges of money and soldiers. Walt Whitman, the Civil War's most sensitive chronicler, describes the wartime scene on Broadway during those four agonizing years: "Broadway, with the soldiers marching. . . . / Manhattan streets with their powerful throbs, with beating drums as now, / The endless and noisy chorus, the rustle and clank of muskets."

Not long after the clank of muskets ceased on April 9, 1865, the city entered a new phase of construction and demolition. "I notice more building

this season than usual," noted the diarist George Templeton Strong on May 11, 1868. "The southeast corner of Cedar and Broadway and several old buildings adjoining it are coming down, and a grand insurance building is to take its place." A few days later on May 19, he reported that "all the west side of Broadway between Eighteenth and Nineteenth Streets is coming down—a row of twopenny little two-story shops. Cheever's Meetinghouse, west side of Union Square, is in course of rapid demolition. Tiffany and Co. are to build on its site." Broadway had indeed set up an attractive focal point at Union Square where it traversed the east-west roadway of Fourteenth Street.

Union Square in the 1870s was an appropriately elegant address for the location of stores with luxurious wares. Once known as the Forks and then as Union Place, it was originally a potter's field for burying indigent people. In 1828 the city was still clustered south of Fourteenth Street. Now the square boasted a foliated oval park, dense with the planting of trees and made magnificent by an overflowing fountain erected in its center. It had become a fashionable quarter by mid-nineteenth century, surrounded by mansions, concert halls, and theaters. Nearby was the famed Academy of Music brought into being in 1854 by the contributions of the square's wealthy residents. Sumptuous retail stores like Tiffany's dominated the square past the turn of the century. At the same time, this park-dominated intersection took on another nineteenth-century profile as the rallying site for political demonstrations.

Broadway acquired a quite different persona when the upper of the two triangles formed by its intersection with Sixth Avenue at Thirty-fourth Street became the site of the New York Herald Building, a magnificent structure designed in Italian Renaissance style. In a pleasing innovation, the press rooms of the influential *Herald,* launched by James Gordon Bennett Sr. in 1835, were made visible to the public through plate glass windows. When the building opened in August 1893, the *New York Times* praised it as a "show, an exhibition, a palace." A little less than a quarter century later, it was demolished. Two clocks, a small sculptural group mounted on a pedestal, and the name Herald Square are all that survive. The lower of the two triangles at the Thirty-fourth Street intersection was named Greeley Square after Horace Greeley, the founder of the *New York Tribune.*

Broadway was given a boost in its image, as were other streets, when George Waring was appointed commissioner of the Department of Street Cleaning in 1895. Waring had served on the battlefield during the Civil War and brought such military discipline to the conduct of his department that New York actually enjoyed a reputation for cleanliness during an all too brief period of five years when his cadre of street cleaners took to the streets. Not only did Waring introduce the notion of recycling, he was the first to bestow dignity to the labors of sanitation employees. Prior to Waring's reign, street conditions were unimaginably awful. Dickens complained loudly, walking down Broadway, of scavenging pigs, while well-heeled ladies carried scented handkerchiefs. The removal of garbage, trash, mud, piles of manure, and dead horses proved a perennial problem. As both private and public transportation

The Metamorphosis of a Manhattan Street

FIGURE 7.6
Union Square in the Gilded Age, 1890.
At Fourteenth Street, Broadway's serpentine
inclinations shaped Union Place, later called
Union Square when a park was created there
in 1831. Elegant mansions, the Academy of
Music (1854), famed restaurants, and stores
long profiled the area. The intersection is
depicted in a rainstorm by the Gilded Age
artist Childe Hassam.

depended on horses, their numbers were sizable. Politics eventually interfered with Waring's reforms, and battles over trash removal resumed following the close of his tenure.

By the early 1900s New York had experienced a quantum leap forward in population and in commercial status. Census figures had been swollen to 3.5 million, owing to immigration and to the 1898 bonding of the five boroughs. New York ranked over all other American cities in the number of its factories, its employees, and the gross value of goods produced. While these factors enforced New York's status as an unmistakable world metropolis, the problems engendered by the expansion were mind-boggling. The wealth of the city—and of Broadway—was underwritten by the labor of immigrants but it was not expended on them; they lived in squalid tenement houses and worked under appalling conditions. Broadway itself began to take on a showy-shabby appearance. Horse-drawn omnibuses and carriages competed with trolleys now led on tracks, with resulting pedestrian confusion and pockets of depressing sanitary conditions. New protests were heard from residents and travelers alike about the condition of streets no longer groomed by Waring's white-uniformed troops. Part of the trouble then, as it is today, was the great dependence on cleaning machines; Waring had wisely emphasized the virtues of employing hand labor (brooms and carts) in tandem with technology. Nothing, however, seemed to blunt the vitality of Broadway, which proved eminently adaptable in adjusting to unheralded changes in the rhythm of the city's life.

In 1904 the construction of the Times Building at the junction of Broadway and Seventh Avenue at Forty-second Street gave the uptown intersection—known at the time as Long Acre Square after a site in London—a new name and a decided luster. The Times Building was modeled on Giotto's campanile in Florence and became a world-famous landmark that would be sought out by every visitor in the twentieth century. Still, the presence of three prominent newspapers along its length did not subsequently give Broadway the character of London's Fleet Street. Instead, the avenue slowly became synonymous with the word *entertainment* as more and more theaters established themselves along its stretch or on the side streets of the forties and fifties that were approachable from Broadway. In the wide palette of distractions that Broadway began to offer, it proved not only flexible in satisfying most tastes, but it became an irresistible lure by night following the electrification of the city beginning in 1880. The once rough-hewn Heere Straet of the seventeenth century became the Great White Way of the twentieth.

Electrification did not prompt a bid for renewal of the elegance that Broadway once boasted and that had shifted conspicuously to more residential avenues. Madison and Fifth to the east, and Central Park West, West End Avenue, and Riverside Drive to the west were more aesthetically pleasing. At the turn of the century, street elegance was daringly taken up as a challenge from an unexpected quarter. Across the Harlem River, Manhattan's new sister borough of the Bronx had no less an ambition for its swelling population than

The Metamorphosis of a Manhattan Street

FIGURE 7.7
Broadway at Madison Square Park, 1898. Madison Square Park, created by Broadway's junction with Fifth Avenue at Twenty-third Street, remains as elegant an outdoor pause as it was at the turn of the century. Long-skirted women airing their infants in high-wheeled carriages intrigued photographer Joseph Byron. Today, the Metropolitan Life Insurance skyscraper boldly frames the park to the east.

to build a Champs Elysees on this side of the Atlantic. It was to be named the Grand Concourse, a splendid north-south thoroughfare extending for nearly five miles, with plans that called for eleven lanes, two tree-lined dividers, and underpasses that alleviated the flow of traffic at crucial points. The grandiose roadway became the natural pride of the borough when it opened in 1909 but, like the prominent parkways of Queens, Brooklyn, and Staten Island, the Grand Concourse achieved only local fame.

"Will Broadway reach all the way to Albany?" the Marquis de Lafayette had asked during a visit to New York in 1824, amazed by the unrecognizable extent to which the street had gained in stature since Revolutionary times. Then it had reached only to Houston Street. The marquis proved to be clairvoyant because Broadway indeed treks those 147 miles to the state's capital, bonding along the way with the precolonial footpaths frequented by local Algonkians. As it passes through Yonkers, Peekskill, Poughkeepsie, and its final destination of Albany, it is not always called Broadway but bears an impersonal highway route number. Everywhere that it traces its path, it tells a different tale, though nowhere is its story more colorful or more dense than in the Manhattan stretch from the Battery to the island's Harlem River edge past 207th Street. This fourteen-mile run links Broadway to a cluster of urban neighborhoods so diverse as to give the impression of separate towns. Their neighborhood names and profiles—Battery Park City, Tribeca, SoHo, NoHo, Greenwich Village, Chelsea, Times Square, Lincoln Center, Upper West Side, Morningside Heights, Washington Heights, and Inwood—are for the most part creations of the twentieth century. New York city dwellers of old like Peter Stuyvesant, Washington Irving, Herman Melville, Walt Whitman, Edgar Allan Poe, Henry James, and Edith Wharton would find them mostly unrecognizable.

Battery Park City is the newest and richest of them all. Figuratively, it serves as a base for Broadway's leap northward. A man-made space created through landfill, it is remarkable for its commercial, residential, and bucolic blend. Imposing buildings serving finance flank the picturesque esplanade along the harbor front where ships, yachts, and ferries pause. Melville, who was fond of "ocean reveries," would find a new experience in the breathtaking views of the harbor to be had from the skyscraper windows. The adjoining neighborhood of Tribeca (an abbreviation of "triangle below Canal Street") looks to the Hudson River rather than the bay to provide a waterfront view to its affluent residents. If Poe or Whitman were to visit this familiar area, they would be dejected by the disappearance of beautiful Saint John's Park, which now serves as the noisy exit of the Holland Tunnel. Both poets would find the professional and artistic population of Tribeca quite spirited, and they would identify the lofts imaginatively converted from mercantile warehouses and cast-iron factories as a nineteenth-century heritage to this trapezoidal site.

Neighboring SoHo (short for "south of Houston") was still farmland in the 1600s when a portion of it was staked out by freed slaves as their first settlement. Just before the Revolution, students of King's (now Columbia) Col-

FIGURE 7.8 *A Cast-Iron Emporium, 1936.*
Shops of all sizes and pretensions were eclipsed in 1862 by the huge cast-iron emporium of Alexander T. Stewart at Broadway and Ninth Street, which boasted two acres of floors and a staff of more than three hundred. Eventually bought by the entrepreneur John Wanamaker, it was demolished in the mid-twentieth century.

lege could be found reading their texts on the grassy knoll leading from Broadway and Murray Street, with an occasional glance in the direction of a flourishing bordello two blocks away. A commercial boom in the 1800s led to a concentration of ornate cast-iron buildings that, having happily escaped demolition, now define the neighborhood. Artists largely revitalized this area when they created an "art scene" downtown; the neighborhood is thick with galleries, as it is with shops, shoppers, and gawkers. Crowds flock to the SoHo Arts Festival, which has grown from a neighborhood block party to an internationally known event. Were the same crowds to cross Houston Street and follow Broadway for a few blocks north to Eighth Street, they would find themselves in a newly designated landmark district called NoHo (north of Houston) running west-east from Mercer Street to Lafayette. Here was once the heart of the city's textile industry. As the area is rich in a collection of nineteenth-century loft buildings of varied architectural styles, the city hopes to spur revitalization of the district by the landmark designation awarded it on June 30, 1999.

Leading directly from NoHo is popular Greenwich Village, which undeniably gives the impression of a diminutive town. Its absence of skyscrapers, its rows upon rows of brownstone dwellings, and the colorful little streets that defied submission to the gridiron plan of 1811 render it inimitably appealing. And so it was to Henry James, who confessed in his novel *Washington Square* (1881) that "I know not whether it is owing to the tenderness of early associations, but this portion of New York appears to many persons the most delectable. . . . It has a riper, richer, more honorable look than any of the upper ramifications of the great longitudinal thoroughfare." James would be pleased to know that despite the lengthening of the city northward, the Village held fast to its residential claims and charm.

The neighborhood of Chelsea, which runs roughly from Eighteenth to Twenty-ninth Street, once claimed a slice of the fashionable Ladies' Mile. Today, with as many as sixty galleries in the area, it claims a large slice of the downtown art scene. Edith Wharton, member of one of New York's richest families, lived first on Twenty-third then on Twenty-fifth Street but had no fond memories of her childhood neighborhood, which she felt was "cursed with its universal chocolate-coloured coating of the most hideous stone ever quarried . . . without towers, porticoes, fountains or perspective, hidebound in its deadly uniformity." An intriguing mix of commercial palazzi, row houses of Wharton's time, and apartment dwellings like the Romanesque-fronted London Terrace make for good architectural ogling. Broadway cuts no serpentine interruption in the "deadly uniformity" of Chelsea's grid-planned streets but serves as a strong eastern boundary.

The Broadway neighborhood that has the densest pavement population is known as Midtown, leading from Times Square. Pedestrians are made up almost equally of residents and visitors who seem to bask in the flood of colored advertising lights that promise them a world of happiness in wares and entertainment. To some pedestrians, such as the artist Fernand Léger, the lights

FIGURE 7.9 *Broadway below Wall Street, 1938.* The photographer Berenice Abbott traces a segment of Broadway depicted in the Castello Plan of 1660. Although now hemmed in by skyscrapers, the colonial thoroughfare makes its way southward toward the open sea. Out in the harbor, the luxury liner *Ile de France* can be spotted steaming into a Hudson River berth.

offer a sparkling dialogue as well. "I was struck by the illuminated advertisements that swept the streets," Léger wrote. "You were there, talking to someone, and suddenly he became blue. Then the colour disappeared and another came, and it became red, yellow. . . . I wanted to do the same thing in my canvases." Leger did just that in a 1945 oil painting entitled *Adieu New York.* Long before the era of the colored advertising lights that bewitched Léger, stage luminaries of the nineteenth century were wont to make a show of themselves in their open carriages on Broadway. This is less true today. Actors, actresses, and musical stars who perform tirelessly in the network of nearly forty theaters on or adjacent to Broadway usually pass unrecognized in the streets. They are absorbed in spirited theater-going crowds tinged with rogues, rowdies, and purse snatchers.

Almost abruptly, the makeup of the crowd changes in the Lincoln Square area, where a marked show of elegance abounds in the beckoning presence of the Lincoln Center complex, in the broad sidewalk cafes, and in the surrounding high-priced buildings. Here New Yorkers and the city's visitors come to satisfy their cravings for the best in opera, ballet, plays, and music and are often delighted by "happenings" like antiques fairs or innovative performances staged outdoors on the landscaped grounds during summer. The architecture of the complex itself causes as much comment as the performance of a visiting virtuoso in one of its theaters, though often with controversial overtones. Some view the complex admiringly as a modern nod to classicism, while others, such as the architecture critic Paul Goldberger, find the design of the buildings laden with "a heavy-handedness of form and a vulgarity of detail."

Further north, in the Upper West Side neighborhood, there is a continuing choice of cafes and restaurants in a somewhat less affluent setting, together with fewer visitors. In the eighteenth century and continuing into the nineteenth, the area here was known as Bloemenvael and the entire neighborhood carried the name. Broadway itself was called Bloomingdale Road until 1899. The neighborhood evolved from an open woodland of farms and homesteads to rundown shanties before giving rise to the residential wonders of the twentieth century such as the majestic Apthorp, or the Belnord on the east side of Broadway where Isaac Bashevis Singer lived. The ubiquitous chain stores unifying the sartorial look of the middle class—Banana Republic, the Gap, Ann Taylor, and Talbot's—are there, as is the remarkable food emporium called Zabar's, known to shopping gourmets in all five boroughs and elsewhere for the dizzying variety of its delectables. Bookstores and book readings satisfy area residents, who are generally educated, politically active, and not unlikely to have generational ties to the city.

A broad but unprepossessing crosstown street (110th) introduces the environs of Morningside Heights, which bids fair to being the most coherent of the neighborhoods traversed by Broadway. Its ever-widening racial mix, its core of cultural homogeneity, its solid residential buildings old and new, its proximity to park and river, and its ties to the eighteenth-century past of the

The Metamorphosis of a Manhattan Street

FIGURE 7.10
Broadway Boogie-Woogie, 1942–43.
A twentieth-century tribute to Broadway was conceived by the Dutch artist Piet Mondrian in his painting *Broadway Boogie-Woogie.* Mondrian's abstraction dissolves to the heart of things by projecting the rhythm of movement and change that is a true constant in Broadway's profile. Its rhythm stands as a metaphor for the entire city.

city in the presence of Columbia University make for a unique combination. A whole cluster of prominent institutions serve the soul, the imagination, and the ailing body: Union Theological Seminary, Barnard College, Riverside Church, the "God Box," which is the unofficial name of the Interchurch Center, the Jewish Theological Seminary, Manhattan School of Music, Saint Luke's Hospital, and the Cathedral of Saint John the Divine. Not everyone by far is college educated, but the talk in cafes is likely to drift toward the arcane. Residents shop in the local supermarkets side by side with Nobel laureates, budding geniuses, shoplifters, and the homeless.

Further north is the extensive area of Washington Heights. Peter Stuyvesant knew it as open farmland, while in the following century George Washington fought desperately for the survival of his troops on these heights. Country estates dotted the area before successive waves of immigrants, beginning in the 1880s, dominated the population because of cheap rents and good transportation; they have continued to do so. By the close of the twentieth century, Broadway was unhappily brought to its shabbiest here, though the area boasts the magnificent grounds of the museum known as the Cloisters. Some of Washington Height's immigrant history has been shared with the linked neighborhood of Inwood, which punctuates the uptown end of Manhattan. Like the Battery at the downtown end, Inwood enjoys water views on several fronts. But unlike the artificial terrain of the Battery, the northern neighborhood is distinct in having held on as fiercely as it could to its original topography. Magnificent Inwood Hill Park claims nearly two hundred acres of hilly woods, which slope down to the river and boast a large remnant of primeval forest that characterized Manhattan when Henry Hudson sailed past.

If Broadway neighborhoods can all claim a share in colonial history, they share as well in a history of recycled images. There is a diminished use of Broadway as a staging area for strikes, demonstrations, or the kinds of glorious parades that heralded the visits of the Marquis de Lafayette in 1824, Louis Kossuth in 1851, Charles Lindbergh in 1927, or war's end in 1945. Still, the avenue was ever at the ready on October 29, 1999 for a tumultuous tickertape parade to celebrate the Yankees in their win of yet another World Series championship. Broadway performs in new guises many of the major roles assigned it in the past. It is still a hub of commerce, a residential address, a theatrical center, a fashionable clothes runway (featuring the daring, the eccentric, the stylish, and the awful), a transportation corridor, and a whirlblast of human activity mirroring the best and the worse. Through all changes, Broadway continues to course with aplomb on Manhattan's West Side, accumulating a transcendental quality and standing as a metaphor for the city's irrepressible capacity to renew itself. Artists, poets, and musicians have sought to capture that transcendence in a variety of ways. A twentieth-century artistic tribute to Broadway, Dutch in origin, is a painting entitled *Broadway Boogie-Woogie.* Conceived by Piet Mondrian, it depicts neither the street nor any part of Manhattan in realistic terms. Rather, it is a colorful abstraction that dissolves to the heart of things by projecting the rhythm of movement and change that is a true con-

BROOKLYN AND STATEN ISLAND

The People, Parks, and Ambience

Brooklyn

"What do your Lordships understand regarding the Ferry between this City [of] New Amsterdam and Breucklen—is it granted to this city or Not?" The question was put, by mail, to the colonial directors in Holland in 1654. Underlying it was a scramble for city revenue. A lively ferry service had developed between the two fledgling cities on either side of the East River. People were ferried across; cattle, horses, oxen, wagons, carts, trunks, boxes, bundles, and the destinies of entire families were ferried across the East River as settlers made their way to the bucolic heights across from Manhattan. But the ferry service was in private—and mischievous—hands, and the local burgomasters saw no reason why this should be so. Besides, the crossing was so miserable, so much a matter of whim and weather that the situation was in dire need of being regularized. Passengers were sometimes stranded out in the open for whole days and nights because of winds, blizzards, tides, fog, storms, ice jams, or because of disputes with the ferryman who might ask double the fare. Or he might row his clients over in a crowded or risky boat, separate passengers and possessions, or decide not to make the crossing at all, if the weather threatened or the tavern beckoned.

To remedy these vexations, Peter Stuyvesant issued the first ferry ordinance wherein fees and crossings were regulated. The authorized lessee was to have a sufficient number of boats and boatmen and, for the shelter of his passengers, he was to provide a covered shed or lodge on both sides of the river. He was not bound to convey anyone over "in a tempest, or when the Windmill hath lowered its sail in consequence of storm or otherwise." Eventually, the wooden lodge ordered by Stuyvesant was replaced on the Brooklyn side of the water at Fulton Street by a two-story house of stone and brick. There, men and horses might have "good Accommodation att Reasonable Rates" and there the ferry agent was ordered to keep a "publick house of Entertainment."

The site of the "publick house" had already taken on a good bit of local color as seventeenth-century settlers, grouping themselves into six small towns, made constant use of a ferry service that was vital to their farming interests. Five of the six towns that came into being on the western end of Long Island were Dutch: Breucklyn, New Amersford (Flatlands), Midwout (Flatbush), New Utrecht, and Boswick (Bushwick), to each of which a magistrate was assigned directly responsible to the colony's director-general. A good part

FIGURE 8.1 *Ferry House in Brooklyn, 1717.*
Brooklyn and Manhattan, facing each other
across the East River, had already developed
a lively ferry service by the time of Peter
Stuyvesant's arrival in 1647. He imposed fees
and regulated the crossings of the boats.
During the British era, the ferry house on
the Brooklyn side served as a "publick house
of Entertainment."

of colonial Long Island harbored English settlers, as did Connecticut and Westchester, a fact most worrisome to the Dutch. Lying in the shadow of English colonies to the north, east, and south of them, they were always struggling for clear title to their territories. The sixth town that formed part of the present Brooklyn area was founded in 1645 by English Anabaptists under the leadership of Lady Deborah Moody. It was named Gravesend and was the only one of the six towns to boast a properly laid out settlement.

Reports circulated time and again that the Dutch were plotting to plunder and kill off English inhabitants in the area with the connivance of French and Indian assassins hired for the purpose. An investigation of these reports held that they were propagated by English refugees from New England with the intent of causing disaffection. Stuyvesant issued an ordinance in 1654 for the apprehension of the propagators and offered an award to anyone bringing about an arrest and conviction. Ten years later, the problem was completely resolved in favor of the English: they vanquished the entire New Netherland colony. The six small towns, formed before the takeover, were now grouped under the jurisdiction of Kings County. This administrative unit was conceived during English colonial rule to define what were now the Duke of York's holdings in all the "territoryes towards Connecticut" for which "true and exact Mapps" were to be sent forthwith to the duke. By this time, the town of Breucklyn had already taken a lead in establishing a weekly market as well as an annual autumn fair for cattle and agricultural products. When the first census was taken in 1690, the population of the entire county stood at two thousand, with blacks numbering just under three hundred of the total.

It was the area of Gravesend that witnessed one of the most dramatic of all battles during the Revolutionary War. British warships that had been anchored off Staten Island under Admiral Sir Richard Howe made their way northward to Kings County on August 22, 1776, landing troops along the shore between Gravesend and New Utrecht. By noon of that day, almost fifteen thousand men, the horses of the dragoons, and at least forty cannon had been put ashore; they were joined a few days later by two brigades of Hessian troops.

The ensuing military engagements culminated in the disastrous defeat of George Washington's forces. American soldiers, fighting in the hills of what would later become Prospect Park, were crushed in a vise of enemy soldiers twenty times their number. When possible, they fled down the slopes through muddy swamps hoping to make it to the American forts at Boerum Hill and Fort Greene. Some of the heaviest fighting took place near Baker's Tavern, close to the intersection of modern Fulton Street and Flatbush Avenue. "On Tuesday last [August 27] we got a severe flogging on Long Island," admitted Henry P. Johnston in a letter to his wife; he was an American officer who had taken part in the battle. Washington, reporting on September 19 to the president of the Massachusetts assembly, crisply commented: "In respect to the attack . . . the publick papers will furnish you with accounts nearly true. I shall only add, that . . . we lost about eight hundred men, more than three-fourths of which were taken prisoners."

FIGURE 8.2
The Heights Near Brooklyn, ca. 1820.
Savoring the pastoral stretches of their
villages, Brooklyn residents of the six
communities flourishing there also had
the advantage of unsurpassed views of
New York and the surrounding waters. This
was particularly true from lookout points
like Bergen Hill, where courtly gentlemen
and working farmers animate the early
nineteenth-century scene.

FIGURE 8.3

Brooklyn Viewed from Wall Street, 1825.
From the foot of Wall Street, Manhattanites
could gain a good view of their bucolic
neighbor across the East River. A steady rise
of houses with a pastoral background met
their gaze in 1825. Breucklyn, as it was
called in colonial times, was one of six
independent towns that were grouped to
form Kings County during English rule.

A victorious end to the conflict allowed traffic over the mile-wide East River crossing to pick up in volume as the decades went by, with Brooklyn and its environs playing the role of Manhattan's breadbasket. From the east side of the river were ferried pigs, sheep, game, chickens, great quantities of fruit, vegetables, and grains, as well as eggs, fish, and oysters. Flat-bottomed boats carried wagons, carts, plows, and cattle to the opposite side. Much was at stake in the transport of these cargoes and in the carrying of passengers, yet maritime mishaps were still part of the scene when the eighteenth century came to a close. Ferrymen were just as often drunk, and capricious weather played havoc with the lightly crafted boats. "We were doused with a wave so large," moaned Médéric–Louis–Elie Moreau de St. Méry, a French exile who often made the crossing in 1794, "that I arrived at my New York lodging soaked and shivering with cold. I . . . only could end this shivering state by swallowing a large glass of sassafras liqueur fortified with brandy." Ferry charges could be paid in money or in kind, the French aristocrat observed, as he watched farmers pay their fare with eggs: two out of each hundred eggs they were transporting was the bartering price.

From the beginning, Brooklyn felt itself a location quite distinct from its raucous, seafaring neighbor across the river. It, too, had a generous stretch of waterfront but it also had abundant farms, wide reaches of bucolic splendor, and more than enough room for residential expansion. As elsewhere in the former colonial territories of the surrounding area, slavery was an essential part of economic life, with roughly one of every four residents of Kings County enslaved in the eighteenth century. From early on, Brooklyn wore a proud, independent air and intended to keep it that way. Moreau de St. Méry had the impression that Manhattan benefitted greatly from its proximity to Brooklyn in a variety of ways: "Thousands of people from New York go for walks in Brooklyn where they eat and exhaust all the fruit, even unripe, that they can reach. . . . Everyone carries away as much as he wishes." Earlier chroniclers were of the same opinion with regard to the lure of the wondrous, water-lapped area forming the western end of Long Island.

Because the town of Brooklyn was just opposite Manhattan near the ferry, it was the most visited among the towns in the Kings County chain. It accordingly made the greatest strides in cultivating a cosmopolitan identity beginning in the early nineteenth century. The designation of a U.S. Navy shipyard in 1801 on Wallabout Bay, the inauguration of Fulton's steamboat service in 1814, and the opening of the Erie Canal in 1825 were major elements in sparking an industrial bustle along its waterfront. Robert Fulton's genius had been locally acclaimed in 1815 when the first warship powered by steam, the *Fulton*, was built in the Brooklyn Navy Yard. For the rest of the century, Brooklynites were busy both as participants and spectators in a steady parade of innovations that enhanced their lives and insured the kind of prosperity that would eventually allow their once diminutive village of Breucklyn to annex all its Kings County neighbors. A newspaper reporter for the local *Daily Eagle* named Walt Whitman watched the rapid expansion of his town with elation,

The People, Parks, and Ambience

chronicling local happenings in both prose and poetry. In his elegiac *Song of Myself,* Walt Whitman affirmed:

This is the city and I am one of the citizens,
Whatever interests the rest interests me, politics, wars, markets,
newspapers, schools,
The mayor and councils, banks, tariffs, steamships, factories, stocks,
stores, real estate and personal estate.

Under the poet's very eyes, nineteenth-century Brooklyn rapidly expanded in several directions. Brooklyn City Hall was completed in 1849; gaslight was introduced, the Brooklyn Academy of Music founded in 1859, and a network of transport lines reinforced. Already, the imposing Green-Wood Cemetery, commissioned in 1838, had became the most renowned burial ground serving the New York area. Well before its enhancement with Gothic revival gates designed by Richard Upjohn in 1861, the cemetery's fame as a wondrous expanse of tranquility had set in motion plans for Manhattan's Central Park. A proud self-consciousness marking the distinct character of the borough took enough hold by 1863 for the creation of the Long Island Historical Society to which Brooklynites entrusted their historic memorabilia. Looming on the horizon as grandiose projects for the post–Civil War era were the Brooklyn Museum (1893) and the Brooklyn public library system (1897). Perhaps what brought the greatest swell of pride to the area meanwhile was the introduction of two major amenities that streamed from impulses quite unjoined: Prospect Park and the Brooklyn Bridge. In both instances, art and engineering combined to produce stunning results.

The landscaping of the great greensward of Prospect Park was completed in 1874 under the imaginative direction of Calvert Vaux and Frederick Law Olmsted, a team that had only lately been hailed for their design of Central Park in Manhattan. Their conversion of 126 acres in west central Brooklyn into rolling green lawns, ravines, pavilions, meadows, arbors, and bridges was considered by the two men, as well as by an admiring public, their greatest achievement. That no detail escaped their attention is captured in a letter written by the architects to Brooklyn's park commissioner in which they insist that, for a pastoral effect in the stretch of meadow they had created, it would "of course be necessary that sheep and cattle should be allowed to graze in the meadows; beautiful specimens of fine breeds should be selected." Much later, when the poet Marianne Moore assumed the volunteer rank of Prospect Park custodian, she declared it "my only mortal entanglement."

Before another decade passed, the Brooklyn Bridge was completed. Not since the tower of Babel and the great pyramids of Egypt had there been a construction conceived in such massive proportions, went the excited talk among Brooklynites when the bridge was opened to traffic. As an engineering feat, the bridge was the achievement of John and Washington Roebling and the devices by which father and son would make the high suspension pos-

FIGURE 8.4 *Ferry at Brooklyn, 1830.*
A nineteenth-century ferryboat makes its
approach to Brooklyn charged with horses,
wagonloads of hay, and passengers. On its
return, the ferry carried pigs, sheep, game,
chickens, great quantities of fruit, vegetables,
and grains, as well as eggs, fish and oysters.
Brooklyn was then nicely serving as
Manhattan's breadbasket.

FIGURE 8.5 *Brooklyn City Hall, 1850.*
There was no doubt that Brooklyn had
evolved into a proud and independent city
when its city hall was erected in 1849. The
designation of a federal shipyard in 1801,
the inauguration of Robert Fulton's steam-
boat service in 1814, and the opening of the
Eric Canal in 1825 were major elements in
sparking its industrial bustle.

sible were examined with interest and awe at the Philadelphia Centennial Fair.
Once construction got under way, there were the usual mishaps, the running
out of money, the death of the older Roebling, hesitations, jealousies, acci-
dents, and the shattered health of the son. But on May 14, 1883, all that wire,
stone, steel, and wood, so long shuffled in random piles, had at last been skill-
fully woven into a soaring arch. The poet Hart Crane, born as he said "with
one toe in the 19th century" (the year was 1889), praised the "swift / Frac-
tioned idiom" of the awesome architecture in "To Brooklyn Bridge":

And thee, across the harbor, silver-paced
As though the sun took step of thee, yet left
Some motion ever unspent in thy stride,—
Implicitly thy freedom staying thee!

Crane had actually spent little time in Brooklyn, unlike the older Whitman
who had made it his home for a great portion of his life. Before living out his
final years in the New Jersey town of Camden, Walt Whitman had witnessed the
influx of ever-continuing waves of European immigrants who crossed over from
landing points in Manhattan to start life anew. Thousands and thousands of Old
World families peopled Brooklyn in a sympathetic bonding that rendered the
borough a pulsating mosaic of ethnic groups. Blacks pouring in from the South
added to the African Americans already there. The influx continued well after
the year 1898 when Brooklyn, despite its fierce independence, became one of
the five boroughs making up the mighty profile of Greater New York.

FIGURE 8.6
Opening of the Brooklyn Bridge, 1883.
Not since the tower of Babel and the
great pyramids of Egypt had there been
a construction conceived in such massive
proportions, went the excited talk when
the Brooklyn Bridge was opened to traffic
in 1883. Though it unites two boroughs, its
name insists that this engineering marvel
belongs to the outer borough of Brooklyn.

FIGURE 8.7 *Tennis in Prospect Park, 1885.*
The landscaping of the great greensward
of Prospect Park was completed in 1874
under the imaginative direction of Calvert
Vaux and Frederick Law Olmsted. They
considered their poetic conversion of the
126 Brooklyn acres as their greatest
achievement. Wasp-waisted women enjoy
a game of tennis doubles there.

Not that all Brooklynites were pleased with this marriage of boroughs or with opening their doors to more newcomers. Anticonsolidationists like the Reverend Richard Salter Storrs of the Church of the Pilgrims spoke of the "political sewage of Europe" now discernible in the more recent immigrant waves that his borough would have to absorb. Others of his elitist, Protestant leanings feared the influence of Manhattan's corrupt underworld and of its Tammany Hall. St. Clair McKelway, editor of Whitman's paper the *Brooklyn Eagle,* was certain that benefits would flow only one way inasmuch as "our Brooklyn is so lovely and domestic that . . . New York wants it as a moral and spiritual infusion." The nagging question was, Did Brooklyn really need consolidation for its growth? After all, in 1897 it was the fourth-largest city in the country with a yearly quotient of two thousand ships moored in its docks. In the end, consolidation was voted by the slimmest of margins 644,467 against; 644,744 in favor. Those on the losing side were certain that Brooklyn would now live in the cursed shadow of Manhattan. One of the politicians who helped draft the charter for a Greater New York City was Seth Low, a native Brooklynite and a one-time Brooklyn mayor; he would become the second mayor of the grandly expanded city.

Newcomers continued to pour into Brooklyn after its loss of independence for the very reasons touted by those opposed to their increasing numbers. There they could find "American customs and institutions—including the public schools—[which] are maintained free from evil influence," as Mayor Frederick W. Wurster put it in 1896. They could also find there the resources for a new life in the many churches that conspicuously dotted the landscape, the ever-expanding cultural amenities, the small houses on tree-lined streets, and the exhilarating pleasures of thirty-five miles of beach.

Ah, the beaches! Ah, Coney Island! Was there ever such a fantasy land accessible to pleasure seekers right at their doorstep? Extending five miles (8 km) from east to west, this finger of an island flung out in the Atlantic to the south of Gravesend began its history as a summer resort in the 1830s. When a host of zany pleasures were later added to the natural attraction of the sandy beaches, untold thousands were lured there, especially from the 1890s to the 1950s. "They are going to Coney Island this afternoon," wrote Delmore Schwartz in a fictional story about the 1909 courting days of his parents, "although my mother considers that such pleasures are inferior . . . being beneath the dignity of so dignified a couple." The underworld, the rich, the prosperous, the undignified, and the poor all found their place there at one time or another. When the subway line was extended to Coney Island in 1920 and the automobile had lured the rich elsewhere, it became the favorite playground for those with less than a dollar to spare. "I had been in America for eighteen months," wrote Isaac Bashevis Singer of his arrival in the 1930s, "but Coney Island still surprised me. . . . From the beach came a roar [of people] even louder than the ocean."

The roar did not last. The public lost many of the attractions of its democratized playground when a series of catastrophes and an urban renewal program in the 1960s, led by Parks Commissioner Robert Moses, changed the

The People, Parks, and Ambience

FIGURE 8.8
The Boardwalk at Coney Island, ca. 1897.
Ah, the beaches of Brooklyn! Ah, Coney Island! Was there ever such a fantasy land accessible to pleasure seekers right at their doorstep? From the 1890s to the 1950s, untold thousands were lured to its zany pleasures. "It was futile," writes Joseph Heller wistfully of his boyhood days, "to search anywhere in the universe for a tastier . . . knish."

demographics of the area. Steeplechase Park, Luna Park, and Dreamland—three of the highly popular amusement centers that were forerunners of Disneyland—were forced to close, leaving behind a deep nostalgia for the legendary stretch of beach. For some New Yorkers, the memories are indelible. Writing of Coney Island as the poor man's paradise of his youth, the novelist Joseph Heller conjures up in his autobiographical memoir *Now and Then: From Coney Island to Here* (1998) the tantalizing taste lures of his lost Brooklyn playground. "It was futile," he insists, "to search anywhere in the universe for a tastier potato knish than Shatzkin's."

If Coney Island was one of the great turn-of-the-century attractions, the Brooklyn Dodgers ran a close second. The antics of these baseball players, as well as the antics of their fans, made them one of the most popular teams in the country. Dodger personalities were truly esteemed by their public; particularly beloved was Jackie Robinson, the first black National League player. A loud, boroughwide wail followed the eventual transfer of the Dodgers in 1958 to a home base in Los Angeles. It was a dark patch in the lives of Brooklynites. But they could take sustained cheer in the many cultural diversions of the borough, particularly in the expanded offerings of the Brooklyn Academy of Music, whose highly applauded Next Wave Festival was launched in 1981. Located in the Fort Greene neighborhood, the neo-Italianate structure (1908) was once host to Enrico Caruso, Isadora Duncan, and Arturo Toscanani. BAM has since become a magnetic performing arts center for dance, theater, and music that ventures audaciously into the new and the bold. Audacious, too, was the exhibit put on by the Brooklyn Museum of Art in the fall of 1999. Entitled *Sensation*, it forced Manhattan as well as the rest of the nation to sit up and take notice. Brooklynites can take sustained cheer as well in the accolades awarded their borough over the years by a host of writers and poets. Walt Whitman claimed that the nineteenth-century "Brooklyn of ample hills was mine." Carson McCullers found living there in 1941 akin to the company of "a comfortable and complacent duenna" compared with life in Manhattan, "her more brilliant and neurotic sister." The stylish Truman Capote who had worried that Brooklyn was not altogether a fashionable address, opened a literary homily of 1959 with words flung out like a gauntlet: "I live in Brooklyn. By choice. Those ignorant of its allures are entitled to wonder why." In the closing years of the twentieth century, Hope Cooke chose Brooklyn Heights as her home after a long sojourn in Asia as Queen of Sikkim. "Though borough it may be," declared the *Brooklyn Eagle* at the time of consolidation, "Brooklyn it is, Brooklyn it remains, and Brooklynites are we!"

Staten Island

Staten Island was host in the early hours of September 11, 1776, to a highly dramatic scene. A decision was to be made that morning on its southern shores as to whether the colonies would revert to British dominion or press

on with their revolt. Just two months earlier, the Declaration of Independence had been promulgated and, in response, ten thousand soldiers of His Majesty's troops had been put ashore on the island in preparation for battle. In a last-ditch effort to ward off more of the bloodshed and destruction that had taken place in the ensuing Battle of Long Island, the Continental Congress agreed to send a peace delegation to negotiate a standoff. Lord Richard Howe, admiral of His Majesty's Fleet, received the members of the delegation—John Adams, Benjamin Franklin, and Edward Rutledge—in the Christopher Billopp mansion located in Tottenville at the southern tip of the island. As it was Lord Howe who had initiated the attempt at reconciliation, he received the delegates with courtesy. But the negotiations came to naught. The English extended a proposal that the colonies reaffirm their allegiance to the Crown in return for concessions. In response, the Americans paraded a list of the tyrannies that had impelled the colonies to revolt in the first place and declared that "a return to the domination of Great Britain was not now to be expected." With that, the delegates took their leave, passing once again through long lines of grenadiers who "looked as fierce as ten furies," in the view of John Adams, "making all the grimaces and gestures, and motions of their muskets, with bayonets fixed, which, I suppose, military etiquette requires, but which we neither understood nor regarded."

Staten Island had been chosen as the locale for this pivotal event because of its easy accessibility. Giovanni da Verrazzano had stepped ashore here in 1524 during the course of his New World discoveries, but it was from Henry Hudson that the island received its European name in 1609. Hudson claimed the diamond-shaped island of some sixty square miles and called it *Staaten Eylandt* after the parliamentary States General of Holland under whose flag he was sailing. The Indians had several names for it: Monacknong, Eghquous, and Aquetonga. Attempts at settlement were made some three decades after Hudson's visit by the Dutch patroons Avid Pieterszoon de Vries and Cornelis Melyn. "The 5th January [1639] I sent my people to Staten Island to begin to plan a colony and build," asserted David de Vries in chronicling his American voyages. He viewed Cornelis Melyn as a rival, but the efforts of both patroons to plant a colony were equally undermined by natives who had suffered remorselessly at the hands of the colonial governor Willem Kieft and were seeking revenge. Kieft had accused the Indians of theft and had followed this up with the dispatch of his militia, who killed a number of them. Though the charge proved unfounded, the atmosphere was seriously poisoned by the director-general's hostility. "Thus I lost the beginning of my colony on Staten Island," wailed de Vries, "through the conduct of Commander Kieft who wished to charge upon the savages what his own people had done."

Early on, Staten Island natives appeared willing to "sell" parts of the island to European arrivals. The first tract of territory went to Michael Pauw in 1630, after whom Pauw Street in New Brighton is named. Trading with the Indians for a variety of furs proved profitable, and though it behooved Europeans to propagate this trade, misunderstandings led the island to an unhappy share

FIGURE 8.9 *Brooklyn Skyline, 1925.*
It was exactly over the site of the colonial
ferry house that the first tower of the
Brooklyn Bridge rose like a colossus in
1875. Completed eight years later, the
bridge was widely recognized as an archi-
tectural wonder. To this day, it continues to
dominate the borough's profile as it did in
1925 when Glenn O. Coleman painted it.

of the larger conflict between the Dutch and the natives. Kieft was largely blamed for fomenting the wrath of the native population by his misguided treatment of them. Summoned back to Holland to give an account of his stewardship, he was not able to do so for he died en route.

Not long after the English routed the Dutch, Governor Francis Lovelace "bought" the island in 1670 from native inhabitants who saw no problem in re-selling the same territory; subsequently a majority of them moved elsewhere. The territory was administered under English rule as the county of Richmond, a name assigned to honor the Duke of Richmond, one of the illegitimate sons of King Charles II. Thomas Dongan was allotted some five thousand acres in the northern reaches of the island when he was appointed royal governor in 1683. Not surprisingly, the attractions of this ocean-fringed territory were as apparent to the English as they had been to the Dutch; Dongan swelled his holdings to twenty-five thousand acres and named his large estate the Manor of Castleton after his property in Ireland. Apart from the charms of the island's terrain, so prized a gateway to a magnificent harbor did Staten Island represent that both the territories of New York and New Jersey vied for it in colonial times. It was ultimately assigned to New York during English rule, though the link with New Jersey forever remained, not only geographically but culturally and economically as well. In 1744 the Scottish visitor Alexander Hamilton noted that the place abounded in good pasture and was largely inhabited by farmers. He reported with eighteenth-century wit on the picturesqueness of the terrain: "A great many of the trees here are hung thick with long, hairy, grey moss," Hamilton wrote, "which, if handsomly oild and powdered and tyed behind with a bag or ribbon, would make a tollerable beau-perwig."

Staten Island's strategic location rendered it a Tory staging ground through-out the Revolutionary War. At the start of the conflict, the residents of the island consisted of a small number of native Americans, of descendants of sev-enteenth-century Dutch settlers, and of the families of English and French emigrants. Into the island's harbor sailed 130 ships with thirty-one thousand British and Hessian soldiers; they rendered the hills of Staten Island a sea of crimson with so many redcoats present. The vast numbers of soldiers stationed there during the course of the conflict swelled the population to figures ten times the number of the local inhabitants. To accommodate them, the land was severely deforested, many houses plundered, and others destroyed. Staten Is-landers were obliged to feed and house the combatants until they felt them-selves thoroughly drained by the demands and outrages descended on them during the years of military occupation. Devastation of property began as early as the first year of the war with the requisitioning of the manorial dwelling belonging to the Englishman Christopher Billopp. When John Adams went there to negotiate a peace, he reported that "the house had been the habita-tion of military guards, and was as dirty as a stable."

Following the war and a difficult period of reconstruction, Staten Islanders turned to the hard work of promoting the prosperity of their region through a variety of occupations that were dominated by the sea and to a larger extent

FIGURE 8.10

Flotilla Approaching Staten Island, 1776.
The Declaration of Independence had not
yet been declared when a flotilla of His
Majesty's warships appeared in the waters
off Staten Island. Their presence became far
more menacing when troops numbering
into the thousands were put ashore on July
12, 1776, following the bold proclamation
of July fourth that year.

by agricultural pursuits. The arability of wide stretches of terrain constituted
one of the strong resources of the island. While land cultivation as a staple of
the local economy had long since been spurned by neighboring Manhattan,
which had opted for a destiny in trade, Staten Island became a haven for farm-
ers. Coastal waters also constituted a major resource, allowing the inhabitants
to engage in fishing, shellfish cultivation, boat building, shipping, and naviga-
tion. For the building of ships, shipyards could take advantage of the stands of
timber on the island, though now largely depleted by the British; the yards
were generally located on the northern shore while the east shore became the
site of shipping terminals.

Those shipyards of the nineteenth century turned out a considerable num-
ber of schooners—a small craft distinguished by a fore and aft rig—which were
used primarily as pilot boats and coastal freighters. Pilotage was undertaken on
the island by government-licensed pilots who intercepted ships as they ap-
proached the Narrows and escorted them until they were safely moored. It was
a job not without its risks, for wrecks could be blamed on pilot negligence. Ships
of sizable tonnage drawing larger drafts of water paid proportionately more for
the service. In 1821 a marine semaphore was installed on Staten Island's north-
ern shore, which signaled news of incoming ships to an observer stationed at
Manhattan's Battery. Sometimes news of world import was first relayed in this

The People, Parks, and Ambience

FIGURE 8.11

Quarantine on Staten Island, 1833.
Ships were routinely delayed on Staten
Island for purposes of quarantine: the fear
persisted that contagious diseases might be
imported. Passengers who arrived aboard a
"fever-laden" vessel, with ominous signs of
a disease, were taken to the marine hospital
on the island established by the government
for that purpose.

way by the moving arms of the semaphore before newspapers went to press. Ships were routinely detained on the island for purposes of quarantine; there was always the persistent fear that contagious diseases might be imported. Passengers who arrived aboard a "fever-laden" vessel with ominous signs of a disease were taken to the marine hospital established by the government for that purpose.

Transport to and from the island eventually required the operation of sixteen ferry services that kept up a steady traffic on the island's surrounding waters. The endless stretches of sea were everywhere visible to islanders as a source of wonder, too, stirring the imagination and transfixing the viewer. One nineteenth-century Staten Islander so transfixed was Cornelius Vanderbilt. His imagination took flight at the sight of the sea, undoubtedly much as the mesmerizing expanse of ocean off Portugal's coast had once riveted the fifteenth-century eye of Prince Henry the Navigator and later of Christopher Columbus. Gazing at the sea from the New World side of the Atlantic, young Vanderbilt sought to make his mark not in discovering new territories but in the business of maritime transport. He succeeded beyond all predictability.

The youthful Vanderbilt had left his Port Richmond school in 1805 at the age of eleven to work on a lighter owned by his father; at the age of twenty-four he achieved the rank of sea captain of the passenger steamboat *Bellona*, which plied the waters between Elizabethtown Point and New York. Though the owner of the *Bellona* was in legal trouble because of collusion in 1818 with another ferry service, the sea-smitten Vanderbilt maneuvered around these difficulties with great shrewdness. His orthography at the time was wanting, but the same could not be said of his swordplay when required in battles of ruthless competition. In an undated letter regarding repairs to the *Bellona*, Vanderbilt wrote:

Mr. Gibbons—Sir
According to Williams requst I have aplide to Lawrance & Sneeden and another Ship carpenter of New York to no [know] the lowest price they would hall up the Bellona and make hir 12 feet longer.

In time, the Staten Islander assembled his own fleet of vessels as had Prince Henry and Columbus, and refining the art of undercutting his competitors, he achieved the rank of millionaire by 1846. He did not stop there. Vanderbilt's business ambitions went well beyond local ferry services; he became the nation's merchant prince of transport by enlarging his sights to encompass the gold rush traffic to California. When he turned his attention to rail transport, he became czar of a formidable railroad network serving North America.

Staten Islanders who claimed less spectacular careers busied themselves, alongside their neighbors in maritime pursuits, in a whole loop of small, land-based occupations that included tanneries, distilleries, mills, market gardening, trucking, blacksmithing, cooperage, and a substantial basketmaking industry that took its raw materials from the abundance of swamps and wetlands. Farming continued to lead these occupations as the main staple of the economy.

The People, Parks, and Ambience

The generous size of the farms, the small scale of the industries, and the communities of individual homes were all elements of an agreeable domesticity that was cherished by the island's inhabitants. There was little wish to aspire to the commercial brilliance or neurotic tempo that characterized Manhattan to the north. Frederick Law Olmsted tried his hand as a gentleman farmer on Staten Island before going on to acclaim as a landscape architect and won a silver spoon award for the quality of the pears he raised. Invariably, the bucolic appeal of the island was remarked upon by visitors from near and far. "We had a fine drive through the most interesting parts of the island, the surface of which is much varied," reported the British traveler James Stuart in 1829. "We saw many comfortable-looking farm houses, amidst rich valleys and lands, and orchards abounding in fruit."

Henry Thoreau was saying much the same thing thirteen years later. "The apricots growing out of doors are already as large as plums," wrote the New Englander to his sister Sophia in a letter of 1843. "The whole island is like a garden and affords very fine scenery." During his stint for some months as a tutor for the family of Judge William Emerson, brother of Ralph Waldo Emerson, Thoreau scoured much of the island's reaches and wrote running commentaries to family and friends from the judge's house, called the Snuggery, which was located on what is now known as Emerson Hill, on Douglas Road. Thoreau was never really happy there, nor anywhere except in his hometown of Concord. Yet there were two aspects of Staten Island he particularly enjoyed: its proximity to Manhattan, where he could meet other writers and dally in the book shops, and its proximity to the ocean, which often held him in thrall. "My life is like a stroll upon the beach / as near the ocean's edge as I can go" are the beginning lines of a poem he wrote while living on Emerson Hill.

The sea was honored in other ways on Staten Island, notably in the establishment of Sailors' Snug Harbor, a haven endowed by Robert Richard Randall for seamen adrift. Randall was a merchant prince of Manhattan who had made most of his fortune at sea through "honest" privateering. The philanthropist proposed "an Asylum . . . for the purpose of maintaining and supporting aged, decrepit and worn-out sailors," for which there was assuredly need in the vast port region of New York. The so-called asylum opened in 1833 in an imposing Greek revival style building at the north end of the island with twenty-three occupants; over the next century and a half, it expanded to sixty buildings with some one thousand occupants. A one-time shipmate of James Fenimore Cooper was harbored there in the 1840s, after whom the novelist entitled his story *Ned Myers*.

Sailors' Snug Harbor became legendary both for size and munificence. Thoreau tramped the grounds with interest during his stay on the island. When Theodore Dreiser visited in 1904, he wrote of "the orderly and palatial buildings, the beautiful lawns and flowers, and then the thousand and one characters who . . . found their way here." In a spoof on the splendor of the place, the weekly *Independent* remarked in a 1908 issue that the sailors enjoyed "breakfast on plovers' eggs, and terrapin, lunch on pate de foie gras, and [they]

BROOKLYN AND STATEN ISLAND

FIGURE 8.12

Clipper Ship Sweepstakes, *ca. 1853*.
Giovanni da Verrazzano stepped ashore
on Staten Island in 1524 but it was Henry
Hudson, sailing for Holland in 1609, who
gave the diamond-shaped isle its Dutch
name of Staaten Eylandt. Ships like the
Sweepstakes of the great clipper era relied
exclusively on sail, just as did the caravels
of those earlier New World explorers.

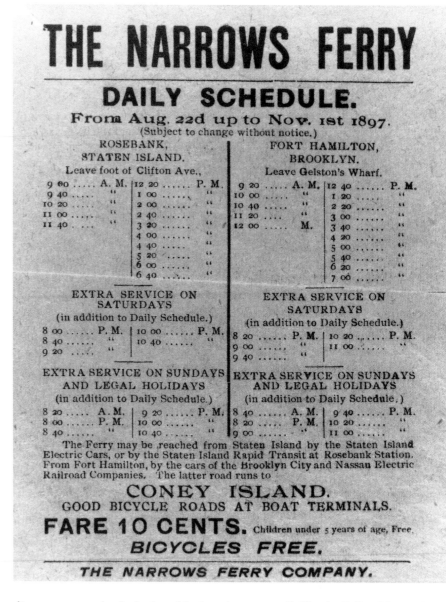

dine on canvas-back duck, with dry champagne." Clearly, Sailors' Snug Harbor was continuing to fulfill the wishes of its founder seventy-five years after it opened. The facility was also charting new paths in the care of the aged.

By the time of the Civil War, large numbers of immigrants had escalated the population of the island. In 1860 it stood at twenty-five thousand, rising from seven thousand in 1830. The populace was made vividly aware of the horrors of a city riot when the terrible confrontation between blacks and whites, known as the Draft Riots of 1863, spilled over to the island from Manhattan. Several black homes were burned, and blacks who were forced to flee inland from the mobs were often sheltered by islanders. Long after the Civil War was over, the riots left serious racial scars. A steady stream of immigrants increased the number of small industries on the island with the variety of their craftsmanship, and they developed clusters of parochial communities. In 1870

FIGURE 8.15 *Sailors' Snug Harbor, 1899.*
Sailors' Snug Harbor, built in 1833 on
Staten Island to support "aged, decrepit and
worn-out sailors," became legendary for its
size and munificence. Theodore Dreiser
wrote in 1904 of "the palatial buildings, the
beautiful lawns and flowers, and then the
thousand and one characters who found
their way here."

Frederick Law Olmsted proposed Staten Island as a site for an industrial exhibition, touting as the appeal of the island its ocean views, land availability, and proximity to Manhattan. He was convinced that an industrial exhibition would greatly advance the Richmond County economy. Perhaps so, but it did not happen. Staten Island had to do without the spur of such an exhibition in developing its industries, real estate, and commerce. This it did through the energy of its residents and with the help of newcomers who continued to supply a wide array of skills. At the end of the century, the chamber of commerce was able to proclaim that the borough's number one resource was its "progressive public spirit."

Industrial development had its fair share of ups and downs during the course of the twentieth century, reflecting changes wrought by the Great Depression of the 1930s, by two world wars, and by changes in technology. The number of factories and employees were invariably of modest size, as befitted an island that

FIGURE 8.16
Country Estate at Hope Avenue, 1937.
Like the colonial governor Thomas Dongan, many who made their way to Staten Island dreamed of an estate on this ocean-fringed land. Michael Berardini, a Neapolitan immigrant of 1880 who amassed a fortune as a banker, realized his dream in a colonnaded house built for him and his family in the Rosebank section of the island.

had been population shy since colonial times and had little wish to aspire to the frenzied tempo that characterized her far more densely inhabited sister island to the north. Though consolidation of the five boroughs in 1898 prompted a rise in population, the island so much preferred to keep her distance from Manhattan that several attempts were later made to move out from under the giant claw of the newly created Greater New York. Ironically, the vote on proconsolidation had been, unlike that of Brooklyn, overwhelming, yet secession developed into a political issue. Fear of erosion of the island's strong Republican base, as opposed to the Democratic base led by Tammany Hall in Manhattan, kept secession a recurrent theme. In 1993 the borough voted two to one to secede from New York City, though the state legislature, which rules on such declarations, chose to ignore the option. Still, the advantages of locating a business or a home on the island continued to be touted by the local chamber of commerce as including an enviable proximity to Manhattan.

The People, Parks, and Ambience

Spectacular changes affecting Staten Island have invariably been tied to its geographic placement by Neptune. On November 21, 1964, the Verrazano-Narrows Bridge opened to traffic, connecting Staten Island with Brooklyn and honoring the Florentine navigator who had sailed through that narrow opening of the sea 440 years earlier. It was the sixty-sixth bridge to be built over navigable waters in the New York area, but it was far ahead of nearly all of them in its claim to breathtaking beauty. A population increase of nearly 300 percent followed the opening of the bridge, with the Irish and the Italians making up the largest ethnic groups. Today, they are being joined by enterprising newcomers and their families from a variety of Asian countries. Retired sailors, however, are no longer a part of the population profile. The Staten Island chapter of Sailors' Snug Harbor came to an end when the model institution was moved to North Carolina. Buildings of the once-famed facility are used today to accommodate the Staten Island Botanical Garden (1960) and a Children's Museum (1989). A model farm and vineyard was opened on the grounds in 1999, as was a children's maze and an antique rose garden with rose breeds dating from the Renaissance. That same end-of-the-century year, a most imaginative complex known as the Chinese Scholar's Garden was created, gracing the Sailors' Snug Harbor grounds.

And the island's traffic link to Manhattan? Ah, the only municipal connection still remains that staple transport of colonial times: a ferry. While three handsome bridges—the Goethals, the Outerbridge, and the Bayonne—tie the island to the mainland of New Jersey, none reaches across the sea to the north. Still, the ferry trip of Stuyvesant's day is now being made in full view of a most majestic sight, the Statue of Liberty (1886). At the Battery end, the ferry terminal has been programmed to undergo a sleek facelift with appealing accommodations for travelers in the twenty-first century. There will be markets and cafes, as well as the staging of cultural performances. These welcome innovations are long overdue: a ferry trip to Staten Island from Manhattan has, after all, become a legendary affair.

FIGURE 8.17 *Chinese Scholar's Garden, 1999.*
A delightful addition to the grounds of
the Staten Island Botanical Society is the
Chinese Scholar's Garden opened in 1998.
A place of contemplation and beauty, it
stands on the terrain of the erstwhile Sailors'
Snug Harbor, where its conception pays
tribute to Asian culture and to the Asian
segment of the island's multiethnic
population.

THE BRONX AND QUEENS

The People, Parks, and Ambience

The Bronx

The Bronx, the most northern of the boroughs, lies like a giant, opened oyster on its watery bed, flashing pearls and other iridescent lures nestled in the web of its forty-two square miles of topographic stretch. Essentially a peninsula, the Bronx has shores washed by the flows of the Hudson River, the Harlem River, the East River, the Bronx River, and Long Island Sound. So varied a maritime claim is unique among the five boroughs, as is the land claim of the Bronx in establishing the city's only attachment to the North American mainland. Vital expressways such as the Major Deegan, the Cross Bronx, and the Bruckner provide motor links to the continent, while a network of bridges over the meandering waters allows for local and interborough connections. An astonishing number of green patches dot the peninsula throughout; the most conspicuous among them is formed by the combined parklands of the famed Botanical Gardens and Bronx Zoo. Bordering the Hudson is a small emerald tract called Wave Hill. It is little known, yet its wooded heights with a grand overlook on the Hudson River lend a glimpse of what the area looked like when the Weckquasgeek Indians greeted the Dutch.

Among the earliest of those sailing from the Netherlands to establish a home here were Jonas Bronck and his wife, Teuntie Jeuriaens. They arrived aboard the chartered ship *De Brant Van Troyen* (Fire of Troy) and settled in the lower regions of the peninsula in 1639. The director-general assigned by the Dutch West India Company at the time was Willem Kieft, who was actively promoting large-scale settlement. Born in Sweden, Bronck had emigrated to the Netherlands, where he acquired both respectability and money as a sea captain. When he subsequently made his way to the New World as one of the Dutch settlers in the Hudson River region, his interests turned to agriculture. The energetic Bronck set up a farmstead on property located on the banks of the Harlem River centered near today's 132d Street. His southerly domain consisted of 652 wooded acres bought from local sachems, either through direct barter or through the Dutch West India Company. In time, this extensive farmstead would become known as Bronckland. Bronck's transatlantic entourage on *De Brant van Troyen* included his wife, her maid named Clara, and three Germans whose passage he paid as indentured servants. The latter were to clear away the trees and ready the land "situate on the mainland opposite

the flat of the Manhates" for the planting of tobacco, barley, rye, wheat, maize, and peas. Livestock had also come over on the chartered ship as had an unusual cargo in the form of a small but precious library. The books it contained reflected Bronck's cultivated interests in theology, history, and navigation.

Bronck's flourishing farmstead was deemed quite suitable, in 1642, for the staging of a peace conference to end friction that had developed between the Weckquasgeeks and the Dutch settlers. An understanding did result from this sensitive confrontation but, owing to Kieft's inept management of Indian affairs, it did not signal an end to future hostilities. Bronck continued to manage his affairs peaceably, though his New World patroonship was short-lived: by the close of the following year, Teuntie Jeuriaens was widowed. Eventually the future borough, whose colonial boundaries reached well into the current locations of Yonkers and Westchester County, would bear the appellation *Bronx*. The river bordering Jonas Bronck's property had long since acquired that manorial designation, so that when the borough was named, in 1897, after the Bronx River running down its center, it appropriated the distinctive definite article as well.

Many settlers of the colonial years were to leave their eponymous mark. One of the earliest was John Throckmorton who settled in the neck of land to the east and gave his name to Throgg's Neck and to Throg's Neck Bridge (only one *g* this time); another was the unfortunate Anne Hutchinson after whom the Hutchinson River and the Hutchinson River Parkway were named. Both were English, and both had made their way to the area as settlers, with Dutch permission, to escape the religious intolerance of the New England Puritans. Hutchinson, who attempted to lay down her roots with a large family and servants on the west bank of the river that now immortalizes her, came to a disastrous end during the Dutch-Indian hostilities of 1643: the fiery preacher and all but one of her children were killed by the natives. Throckmorton escaped.

Skirmishes with the local population did not deter the continual arrival of seventeenth-century homesteaders who looked to the generous tracts of woodlands for their timber supply and to the excellent salt marshes for cattle grazing. Young Adriaen van der Donck was able to arrange in 1646 for the purchase of no fewer than twenty-four thousand acres on the east bank of the Hudson; no wonder the spirited Dutch lawyer looked to the New World as to a terrestrial Eden. He learned the language of the coastal Algonkians and chronicled their culture out of a genuine understanding. Known as *der jonkheer* (young gentleman or squire), he built a sawmill on his property, which eventually gave its name to the Saw Mill River Parkway, while the oft-invoked honorific *der jonkheer* survived in the form of Yonkers. The energetic van der Donck penned his eloquent tract on the Indians in order, as he put it, "that after the Christians have multiplied and the natives have disappeared and melted away, a memorial of them may be preserved."

Following the English takeover in 1664 of the entire New Netherlands colony reaching to Albany, the Weckquasgeeks and other Algonkian-speaking

FIGURE 9.1
Colonial Negotiations in the Bronx, 1642.
The vast farmstead of the patroon Jonas
Bronck, called Bronckland, was deemed
suitable for the staging of a seventeenth-
century peace treaty. Its aim was to end
friction that had developed between the
Weckquasgeek natives and Dutch settlers.
The colonial treaty did not last but
Bronckland has endured as the name for
today's outer borough of The Bronx.

Indians were indeed "melting away." By the end of the century, there were few natives left. The English were in the majority, with black slaves making up about 14 percent of the population. Administratively, the entire area was designated under English rule as part of the county of Westchester. Ambitious men such as Thomas Pell, John Archer, and Lewis Morris acquired large tracts of land, giving their manors the now-familiar cognomens of Pelham, Fordham, and Morrisania. Archer, who was of Dutch origin, chose a name of Saxon derivation for his domain. Fordham means "village by the ford." In 1695 the first bridge linking the territory of Manhattan was opened near the ford on this property and called King's Bridge. When the county was divided in 1789 into twenty-one townships, the combined towns of Westchester, Morrisania, and parts of Yonkers, Eastchester, and Pelham were to define the territory of today's Bronx.

Skirmishes of a highly political turn disturbed the peace of this northern region following the appearance of British troops at the outbreak of the Revolution. It was in the control of enemy forces for the duration of the war and it bore witness to a series of bloody battles. In the very first year of the conflict, a painful event involved the evacuation of George Washington's army to the western shores of the Hudson. Aligning himself passionately on the side of the patriots was Lewis Morris, a signer of the Declaration of Independence who spent most of the war years as a member of the Continental Congress. At war's end, victory emboldened the ardent patriot to propose his handsome property of Morrisania, largely plundered by the British, as the new capital of the country. "The said manor," Morris proclaimed in a letter addressed to the Continental Congress of 1783, "is more advantageously situated for their [Congressional members'] residence than any other place that has hitherto been proposed to them, and much better accommodated with the necessary requisites of access, health, and security."

Though the proposal was turned down, the area that would become the Bronx far from languished. The key to its destiny was not national politics, as Morris envisioned, but proximity to the thriving seaport of New York, as well as the land access it afforded to the western and northern reaches of the continent. The region also allowed for an easy population spillover from ever-burgeoning Manhattan, which by the early decades of the new republic was moving ineluctably to the north of its limited island confines. Many working New Yorkers longed to stretch their legs in the country or purchase property that was affordable. Both these aspirations, and more, were possible in the still-rural Bronx, which had ceased to be part of Westchester County and was developing a profile of its own. The inauguration of the New York and Harlem Railroad beckoned many Irish and German immigrants in the nineteenth century who, like van der Donck, saw their destiny in the area. Railroad stations became the centers of new villages—Melrose, Tremont, Wakefield, Highbridge, Morris Heights, Kingsbridge, Fordham, Williamsbridge, Riverdale, and Morrisania—where newcomers set up shops and worked on the construction of bridges, roads, and model housing. Morrisa-

nia, ever in the forefront, smartly numbered its streets to make them conform to street numbering in Manhattan.

Steady expansion of the population notwithstanding, a bucolic air long clung to the place that had earlier prompted Edgar Allan Poe to move into a modest cottage in Fordham village. He lived there from 1846 to 1849, initially for the benefit of his ailing young wife, Virginia Clemm, who died there in 1847. Here he conceived the twelve-stanza poem *The Bells,* wrote a tale or two, and penned those haunting lines from *Ulalume* that read:

These were the days when my heart was volcanic
As the scoriac rivers that roll
As the lavas that restlessly roll.

Some years before, the poet had completed what would be his most oft-recited verse, *The Raven* (1844). His writing of *Ulalume,* considered by many his greatest poetic achievement, was at the instigation of Cotesworth P. Bronson, an Episcopal minister. When Bronson and his daughter visited Poe at his Fordham cottage in the summer of 1847, they reported that the beguiling Poe "apologized for not having a pet raven." He could have had one. Ravens and birds of various plumage were to be seen and enjoyed in the countrified spaces of the still lightly populated region. Those spaces attracted a New York entrepreneur of impressive means, who, unlike the impoverished Poe, viewed the open area in the northwest quadrant of the Bronx not as the inspiration for poetry but as a solid site for more mundane pleasures. Would it not be, he wondered, an excellent locus for a racetrack and a high-toned sporting club? Both were thereupon installed in 1866, on the site of the ancient manor of Fordham. The enterprising New Yorker was Leonard Walter Jerome. When the Belmont Stakes were launched the following year, they thrilled the moneyed throngs who came until the turn of the century, at which time the Jerome Park Reservoir claimed the site. Jerome (whose stunning daughter Jennie married Randolph Churchill and gave birth to Winston) linked himself forever to the Bronx with the naming of Jerome Park and Jerome Avenue, the park's eastern boundary.

More and more newcomers poured into the area with the great immigration waves of the 1880s and then in the early decades of the twentieth century. By this time, some had relatives established there with whom they could connect in the ethnic clusters that had formed. With the immigrants came a supply of highly skilled labor that could be tapped for the expanding infrastructure of the borough and for a whole line of services that branched into the aesthetic. The dome of Washington's most imposing edifice, the Capitol, was produced by immigrant craftsmen in a Bronx ironworks foundry. In another artistic assignment, Italian sculptors, who were part of the large pre–World War I European migration to the area, carved the statue of Lincoln, designed by Daniel Chester French for the Lincoln Memorial. Here were two monumental Bronx contributions to the nation's glory: could not Lewis Morris be coaxed to accept them as consolation for losing out in 1783 to the Po-

FIGURE 9.2
Woodruff Stables in the Bronx, 1861.
A bucolic air clung to the Bronx well
into the decades of the nineteenth century,
attracting the brief residency of Edgar Allan
Poe. Its woodland acres also beckoned horse
lovers such as Leonard Walter Jerome
(Winston Churchill's maternal grand-
father), who built a racetrack, and Hiram
Woodruff, who set up stables near today's
Jerome Avenue.

FIRST SKETCH OF A TRANSVERSE ROAD DRAWN BY LOUIS A. RISSE AS VISIONIZED BY HIM IN THE CONCEPTION OF THE ORIGINAL PLANNING OF THE GRAND BOULEVARD AND CONCOURSE — 1892 —

FIGURE 9.3
Planning the Grand Concourse, 1892.
The design of the Grand Concourse was hailed as rivaling any of the boulevards conceived by Pierre L'Enfant for the capital and outpacing Manhattan's avenues. A sketch of the eleven-laned thoroughfare shows a transverse road in the conception of the boulevard that was completed following consolidation of the five boroughs.

FIGURE 9.4 *Interior of a Bronx Store, 1935.*
In preparing a series of city views following
the depression, the photographer Berenice
Abbott focused her camera on a country
store interior in the Spuyten Duyvil
neighborhood. The store had then a century-
old history and had first been a barber shop.
It failed as a luncheonette following the
Wall Street crash of 1929.

FIGURE 9.5
Lion House at the Bronx Zoo, 1936.
Among the lures of the Bronx to foreigners
like Leon Trotsky were apartments in 1917
amazingly equipped "with electric lights,
gas cooking-range, bath, telephone, auto-
matic service-elevator, and even a chute
for the garbage." Attracting foreigners and
residents alike was the Bronx Zoo, which
had opened at the turn of the century.

tomac? He certainly would have lauded the amazing thoroughfare that was completed, following consolidation of the five boroughs in 1898, and named the Grand Concourse. Morris would have triumphantly remarked that the eleven-laned thoroughfare rivaled anything designed by Pierre L'Enfant for the capital's boulevards.

The Grand Concourse gave rise to elegant apartment houses where residency became a symbol of economic success for the thousands of immigrants, mostly Italian, Jewish, German, and Irish, who sought a new life in this northern borough. When the English writer Arnold Bennet visited the Bronx in 1910, he was impressed with what he called the borough's "interiors." Tenants "enjoyed the advantages of central heating, gas, and electricity," he wrote with amazement, "and among the landlord's fixtures were a refrigerator, a kitchen range, a bookcase, and a side board. Such amenities . . . [do] not even exist for the wealthy in Europe." Nor did they always exist for the working population of Manhattan, either in the range of amenities that could be had or the price level that was true of housing there. For this very reason, the inauguration of subway lines between the two boroughs swelled the population growth of this northern peninsula.

All the latest comforts were assuredly available in the Wave Hill mansion situated on a twenty-eight-acre (eleven hectares) estate bordering the Hudson in Riverdale. It was originally built in 1843 by the Morris family but eventually sold. Sometime after the financier George W. Perkins acquired the property, he rented it to the author of *Huckleberry Finn*. Mark Twain stayed there for two years with his family in 1901–3, greatly enjoying the attractions of the house and its surroundings. "This dining room is a paradise," he wrote in one of the daily notes to his wife, "with the flooding sunshine, the fire of big logs, the white expanse of cushioned snow and the incomparable river. I wish you were down here sweetheart." But his wife could not be, for she lay terminally ill upstairs. Woodrow Wilson was a guest in 1918 in yet another Riverdale manor, owned by the Dodge family. There he received the news of World War I's end and immediately began the formulation of the armistice terms. Lewis Morris would have surely tied the presence of Wilson, at so sensitive a time, to the glory of the Bronx and added it to his growing list of consolations.

Two notable Europeans who occupied more humble Bronx dwellings during the terrible years of World War I were the writer Sholom Aleichem and the self-styled socialist revolutionary Leon Trotsky. The unknown Aleichem thrilled to the modest success he achieved while there when posters appeared in Bronx elevated railway stations proclaiming "Read Sholom Aleichem the Jewish Mark Twain! . . . Original! New! Humoristic!" A native of the Ukraine, Aleichem died in the borough's Kelly Street in May 1916. Trotsky, a fugitive from Russia, reported with gusto that he had rented an apartment in a workers' district of the Bronx and furnished it on the American "instalment plan." He was surprised to find that the apartment was already equipped "with all sorts of conveniences that we Europeans were quite unused to: electric lights,

FIGURE 9.6 *Van Cortlandt Park, 1944.*
Nearly a quarter of the entire area of the
Bronx is graced by a loop of large and small
pleasure grounds. One of the largest is
Van Cortlandt Park, a holding of more
than a thousand acres that was originally
a seventeenth-century gift to Jacobus Van
Cortlandt upon his marriage to a daughter
of the equally wealthy Philipse family.

gass [sic] cooking-range, bath, telephone, automatic service-elevator, and even a chute for the garbage." The telephone made a particular impression, he noted, for "we had not had this mysterious instrument either in Vienna or Paris." The year was 1917.

Neither Sholom Aleichem nor Leon Trotsky witnessed the specter of the depression of 1929 with its horrific scenes of breadlines and deep gloom, true of all five boroughs. Later, when the miseries of the depression had been eased by Franklin Roosevelt's New Deal policies, the building of forty thousand housing units in the Parkchester area bolstered the borough's fame for model apartments as well as for garden-front homes. Meanwhile, the Bronx had found a conspicuous place on the country's sports map with the opening of Yankee Stadium in 1923. Designed with a triple deck and a seating capacity of more than sixty-seven thousand, the new home of the New York Yankees became the most famous baseball diamond in the United States. It was here that legendary baseball players such as Lou Gehrig and Babe Ruth thrilled capacity audiences.

As a recreational oasis, Yankee Stadium did not reckon in the astonishing percentage of parkland that set the borough apart. Nearly a quarter of the entire area of the Bronx is open territory where a loop of large and small parks like Van Cortland, Crotona, Ferry Point, Pelham Bay, and Sound View offer a refreshing change of terrain in their scattered settings. Just as notable as these parks is the Bronx's network of educational facilities serving the area and beyond. There are eleven colleges and universities, with Fordham University, founded in 1841 as Saint John's College, the most renowned. Fordham's law school and several other divisions of the university established an additional campus in the 1960s right in the middle of Manhattan at Lincoln Center. But neither the fame of its housing, its parks, its colleges, its churches, nor the popular Yankee Stadium could lure the poet Ogden Nash who quipped, "The Bronx? No thonx!"

In the area of housing, alas, the Bronx suffered searing damages to its profile when a prolonged burning of abandoned buildings ravaged its southern tier during the 1970s. The South Bronx became a metaphor, nationally and internationally, for urban blight. Lewis Morris would assuredly be aghast to know, having already experienced the plundering of his property in the eighteenth century, that this occurred in the southwest quadrant that he had once proposed for the nation's capital. Prospects for reconstruction began to glimmer some twenty years later when a population surge of chiefly blacks and Hispanics took up the challenge of urban renewal. With the support of a coalition of South Bronx churches and the municipal government, they made an about-face.

Meanwhile, the once-fabulous Grand Concourse had become less so, as had many of the Bronx's smaller avenues and neighborhoods. "All the time we hung around the warehouse of Park Avenue and I don't mean the Park Avenue of wealth and legend," declares Billy Bathgate in E. L. Doctorow's eponymous 1989 novel, "but the Bronx's Park Avenue, a weird characterless street of garages

and one-story machine shops and stonecutter yards and the occasional frame house." The young Billy proves to be an able tour guide of the Bronx neighborhoods that provide the setting for Doctorow's *Billy Bathgate*.

If the Bronx cannot match Manhattan in terms of a Park Avenue of "wealth and legend," it can boast an entire splendorous neighborhood known as Riverdale. It is a complex of stately homes and elm-lined streets where the Hudson River, to the west, widens its flow and presents breathtaking views of the opposing Palisades. Riverdale is the kind of neighborhood that Adriaen van der Donck surely had in mind for the development of his twenty-four thousand acres. It is one of the lustrous pearls of the Bronx, as are the wooded walkways of the Bronx Zoo in the midst of the borough, the superbly maintained Botanical Gardens, Wave Hill, and a nest of parks that allow for relaxation, sports, local education, or poetic inspiration. As might be expected, Ogden Nash later retracted his quip:

I wrote those lines, "The Bronx? No thonx!"
I shudder to confess them.
Now I'm an older, wiser man I cry,
The Bronx? God bless them!

Queens

The borough of Queens closed one of the colonial chapters in its history with a resounding victory for religious tolerance. Cobelligerents in the feud were Quakers who had emigrated from England and the Dutch colony's wrathful director-general, Peter Stuyvesant. Forbidden to practice their faith, Quakers were also forced to submit to an added element of harshness in the stricture that any settlers daring to harbor a Quaker would risk being whipped, fined, put in the stocks, or banished. Settlers of nearly all other faiths were allowed to worship, though only within the confines of their homes; public worship with a licensed minister was reserved for the Dutch Reformed Church. In 1657 a group of English Quakers drew up a pioneering plea for tolerance, still extant, known as the Flushing Remonstrance. When the document reached Stuyvesant, his response was to deal brutally with the three messengers who brought it. Eventually, the Holland authorities forced their overseas director-general to back down. The Quaker faith, or that "abominable heresy" as Stuyvesant termed it, was allowed the privilege of flourishing in private quarters.

In the early decades of Dutch rule, many English settlers set up farms and rustic homes in the Queens area. The English, who came from nearby Connecticut and eastern Long Island with the permission of the Dutch authorities, created the seventeenth-century farming hamlets of Maspeth, Hempstead, Flushing, and Jamaica, alongside the settlements of the Dutch. This actually did not augur well for the Dutch West India Company's claims to the area, which were constantly being challenged by the English. As soon as the

FIGURE 9.7

The Quaker Bowne House, 1661.
The oldest dwelling in Queens is the
Bowne House, where Quaker followers
held meetings in defiance of a ban against
them issued by Peter Stuyvesant. The Dutch
governor termed their religious beliefs an
"abominable heresy." Quakers held to their
faith despite the threat of being whipped,
fined, put in the stocks, or banished.

political moment was propitious, His Majesty's troops descended on the entire New Netherland colony and promptly claimed it, in 1664, for the English crown. In the new colonial administration, the area roughly comprising those nascent villages was carved out as Queens County in honor of Queen Catherine of Braganza, the Portuguese wife of England's Charles II. With their royally derived names, Queens County and nearby Kings County (Brooklyn) solidly proclaimed the English dominance of Long Island. The population of the five rural units making up Queens County—Jamaica, Flushing, Hempstead, Newtown (Elmhurst), and Oyster Bay—was, at the time, nearly exclusively European. Natives were severely reduced in number owing to successive waves of Dutch-Indian hostilities. Those indigenous to the area belonged to Algonkian-speaking bands, including Jameco Indians who gave their name to Jamaica, and the Reckowackys who left their imprint on the Rockaway peninsula. Blacks and their families were ferried over from Manhattan and made up a small segment of the area's dwellers.

To boost the English quotient of this former New Netherlands colony, a second-generation Queens County dweller was called upon, through "the instigation of divers Persons in England" as he phrased it, to give firsthand testimony to the virtues of his New World surroundings. His name was Daniel Denton and he went about his task with gusto, publishing two editions of his promotional account in 1670 in London. Denton, who served as town clerk of Hempstead and Jamaica, touted the excellence of the area's climate, the soil, the resources, the trading opportunities, and the endless enchantments of nature:

On the west end [of Long Island] is four or five Dutch Towns, the rest being all English to the number of twelve, besides Villages and Farm houses. The Island is most of it of a very good soyle. . . . Yea, in May you shall see the Woods and Fields so curiously bedecked with Roses, and an innumerable multitude of delightful Flowers, not only pleasing the eye, but smell, that you may behold Nature contending with Art, and striving to equal, if not excel many Gardens in England: nay, did we know the vertue of all those Plants and Herbs growing there (which time may more discover) many are of opinion, and the Natives do affirm, that there is no disease common to the Contrey, but may be cured without Materials from other nations.

"Spacious Medows or Marches [marshes]" also abound, wrote Denton, where excellent grass allowed for the raising of all types of cattle, as well as of horses, that had been imported. During the tenure of the first royal governor, Richard Nicolls, horse racing was inaugurated in the town of Hempstead to encourage the breeding of fine equine strains. "Once a year the best Horses in the Island are brought thither to try their swiftness," Denton recounts, "and the swiftest rewarded with a silver Cup, two being annually procured for that purpose." Horse racing grew in popularity during subsequent colonial administrations and was the incubus for the modern aqueduct race courses in Queens. With an increase in English settlers and the concomitant

The People, Parks, and Ambience

rise of a propertied class came an increase in slaveholders. Africans numbered as high as 15 percent of the Queens County population in the 1760s, a time when the little-known poet Jupiter Hammon reached maturity as a black slave and found his lyrical voice. Hammon's talents were evidently nurtured by the Joseph Lloyd family to whom he was bonded: he was the first black poet to be published in the New World. Of an intensely religious nature, Hammon drew inspiration most frequently from the Bible. A poem he addressed to his fellow poet Phillis Wheatley of Boston contains the following exhortative stanza:

Come you, Phillis, now aspire,
And seek the living God,
So step by step thou mayst go higher,
Till perfect in the word.

As soon as independence was declared in 1776, Queens County was overrun by British and Hessian troops who spread out over the entire Atlantic harbor area. Though Queens County was a Tory stronghold, its residents did not escape the depredation of their homes and the multitudinous privations that came with the quartering of militia in private dwellings during seven years of conflict. Those who had declared themselves for independence were forced to flee, as did the Joseph Lloyd family; Jupiter Hammon made his way in the company of the Lloyds to Hartford where his work continued to be published through "the Assistance of his Friends," a phrase that appears on a Hartford publication. The patriot Jabez Fitch, closely watching Revolutionary developments, noted in his diary for September 3, 1776, that "the forepart of ye Day there was a mighty movement of ye [British] Transports in ye Harbour, a great number of them mov'd up toward Town." English troops appeared to be stationed everywhere. Some found in the horse races of Queens a means of amusement; all demanded to be housed, fed, and feared. Since almost every Queens County family farmed or bred livestock, there had been no shortage of food up to the outbreak of the war but now stores were quickly depleted, houses ruined through military occupancy, and structures of any notable size taken over for official use. When the meeting house, which the Quakers had at long last erected in Flushing, was requisitioned, it served the English militia for the alternate uses of prison, hospital, and barn.

Victory in 1783 trailed with it decades of painful restoration. Population expansion was slow, not reaching ten thousand by the expiration of the heady Jacksonian era. A new crop of faces burst on the scene when Irish and German immigrants debarked in Manhattan's harbor in the 1850s and made their way to the farmlands and towns of Queens. They clustered together in small, compatible communities that were the beginning elements in the grand ethnic mosaic defining Queens today. Entrepreneurs and small manufacturers took advantage of the steadily increasing labor supply, of the long stretches of

commercial waterfront, and of the land availability. A crisscross of turnpikes began to make areas accessible that had hitherto been dependent on wretched wagon roads; they allowed stagecoach companies to set up reliable routes as well as to institute schedules that were beneficial to commerce and homesteaders alike.

Nineteenth-century Queens could also offer to newcomers with idle change in their pockets the lure of two racetracks: the Union Course and the Eclipse. They had been opened in the 1820s, in the large open spaces exuberantly described by Denton a century and a half earlier. That colonial chronicler did not mention the attractions of Far Rockaway, a peninsula bathed by Atlantic waters; in the 1850s it became an elegant seaside resort for those who could afford it. As for boating and water travel, James Fenimore Cooper had long since counted them among his pleasures when he summered in Astoria a decade earlier and commuted to Manhattan daily by sloop. The voluble author was gathering fame with the characters in his *Leatherstocking Tales,* which would lead to his designation as America's first great novelist. Sea fiction was one of his specialties.

The sea as a transatlantic link to ever-burgeoning Manhattan continued to bring increasing waves of newcomers from Europe who made Queens as near a would-be Eden as circumstances and grit could devise. Immigrants provided a spur in the post–Civil War years to land developers who set up whole communities and fostered the growth of neighborhood churches, schools, parks, and factories. What the area could claim at this time was an abundance of real estate that made all this possible. Because business entrepreneurs were aware of the opportunities open to them, growth in this period of Queens history was phenomenal; among the most visionary of the arrivals in Queens in the Reconstruction era was the William Steinway family. Members of this Central European unit had tucked into their transatlantic luggage advanced techniques for the building of pianos, as well as a dedication to music that matched their extraordinary craftsmanship.

In an embrace of a New World life, the Steinways anglicized their name from the German Steinweg. They first set up successfully in Manhattan and then, taking advantage of the land bounty in Queens, acquired four hundred acres along its northwestern shore during the early 1870s. Their aim was not only a spacious piano factory, which they indeed built, but also a full-fledged settlement for employees with homes, a church, trolley line, and a library. Within ten years their visionary town rose from virgin land. When the Steinways exhibited their Queens-made pianos in international shows, they garnered prizes against excellent European models. Most of their employees worked in the Queens factory complex, turning out thousands of grand and upright keyboards per year. The family, meanwhile, maintained a solid Manhattan connection through the presence of Steinway Hall, a showroom and auditorium that became a mecca for keyboard virtuosi. Its Victorian era address was on prestigious Fourteenth Street; later it moved to its equally imposing and current address on Fifty-seventh Street.

The People, Parks, and Ambience

FIGURE 9.8
Steinway Factory in Long Island City, 1902.
Among the most visionary of the arrivals
in Queens during the great waves of
immigration was the William Steinway
family. Tucked into the transatlantic luggage
of these Central European immigrants were
advanced techniques for the building of
pianos. They set up a factory and a colony
of workers in Long Island City.

The Steinway success story gave strong underpinning to the 1913 declaration by the chamber of commerce that the "Borough of Queens has so many advantages that it seems to be pre-ordained to be a manufacturing center, and is without doubt destined to be the greatest industrial center of the continent." That is a prediction yet to be realized, but the chamber's understandable optimism was based on two hundred miles of water frontage, twenty miles of operating docks, seventy miles of railroad, and the 1898 consolidation of the borough as part of Greater New York. What was certainly true was that other American cities looked to Queens to gain proximity to the dynamic Manhattan market, while factories already existing in Manhattan that required larger and cheaper sites looked to Queens as well.

More than 130 commodities were being produced in Queens by three times that number of factories in the early decades of the twentieth century. They included a range of massive products like automobiles, airplanes, printing presses, and turbine engines, as well as a wide gamut of more diminutive wares like buttons, chewing gum, hats, and biscuits. Some of the factories were noticed by F. Scott Fitzgerald during his frequent trips between Long Island and Manhattan during the 1920s. "As my train emerged from the tunnel into sunlight, only the hot whistles of the National Biscuit Company broke the simmering hush of noon," recounts Nick Carraway in *The Great Gatsby*. Residents of Queens of Nick Carraway's time could take great pride in the borough's economic dynamism, as well as in the increasing number of schools, libraries, churches, an enviable sewer system, surface transport, parks, beaches, and the kind of health record that could be touted by the chamber of commerce: "The Borough of Queens not only had [in 1911] the lowest death rate per thousand of any of the five Boroughs but also of the twenty leading cities of the United States."

Some of those healthy residents were by then involved in the new movie industry that was being developed under the aegis of the Gaumont Company in Flushing and the Kineamacolor Company in Whitestone. Spectacular leaps in Queens's transportation facilities were in the making as well, involving the completion of the Queensboro Bridge in 1909, the Long Island Railroad Tunnel in 1910, the magnificent Pennsylvania Station in 1911 (as the main rail entry to Queens from Manhattan), and the Triborough Bridge in 1936. It was the two-leveled span of the Queensboro, with its ornate ironwork and finials, that delighted the eye of the fictional Nick Carraway. "The city seen from the Queensboro Bridge," he insists in *The Great Gatsby*, "is always the city seen for the first time, in its wild promise of all the mystery and the beauty in the world." Fitzgerald places the climactic murder scene of that novel near Northern Boulevard at a site where Shea Stadium now stands.

An event that would take Queens to soaring international heights was still ahead. The completion of the Triborough, with its trinity of viaducts joining the boroughs of Manhattan, the Bronx, and Queens, was a preparatory step for the event. So, too, was the completion of the subway's Flushing line and other

QUEENSBORO BRIDGE

FIGURE 9.9 *Queensboro Bridge, 1908.*
The design of this East River link between Manhattan and Queens rendered it one of the largest cantilevered bridges in existence with no suspended spans. "The city seen from the Queensboro Bridge," declares F. Scott Fitzgerald in *The Great Gatsby,* "is always the city seen for the first time, in its wild promise of all the mystery and beauty in the world."

FIGURE 9.10 *View of Flushing, 1923.*
The English chronicler Daniel Denton described the area of Queens in 1670 as abounding in such beautiful woods and fields that here "you may behold Nature contending with Art." A lingering bucolic atmosphere of many sections of contemporary Queens continues to lure a host of immigrants seeking permanent homes.

transport lanes. Now all routes were leading, not to Rome, but to the colossal exhibition staged in Flushing Meadow Park known as the World's Fair of 1939. President Franklin D. Roosevelt delivered the opening remarks in April, whereupon all the world rushed in, beckoned by the gleaming, geometric icons of the Trylon and Perisphere, which promised and delivered a futuristic environment. Visitors were mesmerized by the technological wonders on display and by the entertainment extravaganzas such as Billy Rose's Aquacade. It was an international happening on a grand scale that thrilled millions, and it all took place in Daniel Denton's "spacious Medows or Marches."

In 1964 another international fair followed. Conceived by Parks Commissioner Robert Moses on the same site, it did not, though successful, have the same magical impact of its predecessor. Moses had had a strong hand, during his long years as New York's most controversial parks commissioner, in developing the bridges and motorways that made the boroughs so accessible. Using transportation connections built by Moses were hordes of tennis fans who poured into Queens, intent on the thrills of their favorite spectator sport. They came—and still come, along with foreign enthusiasts—to watch championship matches at the West Side Tennis Club in Forest Hills and at stadiums in Flushing Meadows that are part of the National Tennis Center. In Forest Hills, outsiders gain a glimpse of a Queens neighborhood that makes bona fide claims to architectural distinction. The private homes in Forest Hills, with their half-timbered facades, pitched roofs, and front gardens gracing tree-lined streets, present the borough at its best. For tennis fans from other countries on their first crossing of either the Atlantic or Pacific oceans, it introduces the New World in an ideal setting.

Those overpowering sea boundaries of the Atlantic and Pacific, which had challenged a long line of Renaissance explorers, were now being most frequently traversed by air as the decades of the twentieth-century rolled on. It was in Queens that overseas travelers to New York began making their landing in a facility known today as the John F. Kennedy International Airport. The airport, originally known as Idlewild, was built on the shores of Jamaica Bay in Queens, which offered the terrain necessary for the layout of landing

The People, Parks, and Ambience

FIGURE 9.11 *Triborough Bridge, 1937.*
The Triborough Bridge spanning the
waters between Queens, the Bronx, and
Manhattan had a most dramatic beginning:
construction began on the day the Wall
Street stock market crashed in October
1929. A suspension bridge, a lift bridge, and
a truss bridge make up the trinity of this
engineering triumph.

FIGURE 9.12 *World's Fair, 1939.*
Completion of the Triborough Bridge,
the Flushing IRT, and other transport lanes
prepared the way for the mammoth show
in Flushing Meadow Park known as the
1939 World's Fair. The striking symbols of
Trylon and Perisphere are caught in a pre-
opening, winter photograph; the Trylon
can be seen still trussed.

FIGURE 9.13 *Tennis Star Pancho Gonzales
in Forest Hills, 1959.*
When the powerful West Side Tennis Club
moved to Forest Hills at the outbreak of
World War I, it remained an all-male
preserve. Champion Pancho Gonzales
poses with the author on club grounds at
the height of his fame. Today, women
compete in matches at the club and share
the limelight in the much-televised game
of tennis.

strips. Together with La Guardia Airport, which serves domestic flights, the
two facilities handle passengers and cargo in staggering numbers. Though
some foreign travelers, destined to go elsewhere in the United States, have lit-
tle notion they have touched down in Queens, that borough has forever
cinched its claim to international status through its busy air terminals. Daniel
Denton would not be surprised to learn that the "large and spacious Medows"
he had so buoyantly chronicled in the seventeenth century have acquired for
Queens a world renown.

On a more local scale, Queens attracts visitors to its Queens County Mu-
seum, which boasts the only full-scale model of New York City among its
treasures. Visitors are attracted as well to the remarkable P.S. 1 Center for Con-
temporary Art in Long Island City, founded in 1971. As the century approached
its end, the imposing Museum of Modern Art (MOMA) across the East River
in Manhattan announced that it would join forces with the infinitely more
modest Queens facility. This would allow MOMA to embrace aesthetic devel-
opments that go beyond the designated world of "modern" art. "An established
museum is taking a sip from the fountain of youth," declared the *New York Times*
of February 2, 1999, following the extraordinary announcement.

CHAPTER TEN

POLITICIANS FOR ALL SEASONS

Peter Stuyvesant, Thomas Dongan, Fernando Wood, and Fiorello La Guardia

Peter Stuyvesant

Peter Stuyvesant arrived in Manhattan in a convoy of three ships to establish his presence as director-general of New Netherland. The day was May 11, 1647. The Dutch native of Friesland carried with him an official declaration of trust in his "probity and experience" along with generous doses of cockiness and a fiery temper. Now he could dissolve the lingering impatience he felt that this glorious moment had taken so bureaucratically long to evolve. All augured well on this spring day as, with body erect in breastplate and plumed hat, he walked down the gangplank of his ship the *Great Crow* moored in the East River. Accompanying him was Judith Bayard, his bride of two years now pregnant with their first child. Even the wooden limb banded in silver that had replaced his amputated leg no longer interfered with the authority of his stride. Cannons were fired in ceremonious salute from the dilapidated fort at the Battery to welcome the new governor sent out by the Dutch West India Company (DWI).

As he subsequently surveyed conditions in the fledgling trading post named New Amsterdam, it took little time for Stuyvesant to sense that administrative matters were untidy and that the cosmopolitan, raucous, hard-drinking, church-shunning occupants of the island needed to be taken in hand. His first public pronouncement was that he would be as a "father" unto his nearly seven hundred subjects, comprising Dutch, English, French, German, and Swedish residents. Their welfare, he proclaimed assuringly, was his uppermost concern. Thereupon he set about organizing a council of six men directly responsible to him and mapped out strategies bearing on the colony's defense, on concentration of trade in New Amsterdam, on peace with the Indians, on a modus vivendi with the neighboring English colonies, and on expansion of the population. Being a minister's son with a Calvinist zeal approaching bigotry, he had no doubt as to his priorities: observance of the Sabbath. "We have remarked the insolence of some of our inhabitants," he declared, "who are in the habit of getting drunk on the Sabbath." Accordingly, he prohibited the sale of liquor during the hours of divine services on Sunday—held both in the forenoon and afternoon—and further ordered that all taverns were to be closed every day by nine in the evening "after the ringing of the Bell." It was one of the earliest of the many proclamations he would issue; it hardly endeared him to the town's

population. Nor would his decree of a year later be any more popular. Fully one-fourth of the nascent city consisted of taverns, the new director calculated, leading to a serious debauchment of the common people. Accordingly, he ordered that no "new Alehouses, Taverns or Tippling places" were allowed to be opened without his consent so that "more honorable Trades and occupations [would not] be neglected and disregarded."

Stuyvesant's commission held that he was "not only to maintain the trade and population on the Coast of New Netherland and the places situate thereabout; [but] also, the Islands Curaçao, Beunaire, Aruba, and their dependencies." The listed territories were the far-flung holdings of the Dutch West India Company, a commercial conglomerate with chambers in Amsterdam and other cities in the Netherlands. A monopoly of trade in the New World had been granted to the DWI by the directors of the ruling States General in the Netherlands, who were generally addressed as "High and Mighty Lords" or "Your Mightinesses." Stuyvesant was first and foremost an employee of the DWI and though he was to render the company unflagging allegiance, he did not hesitate to invoke his commission from the mightier States General when challenged. "I have more power here than the Company; therefore I may do whatever I please," he was to declare in a rage on one occasion. Responsibility for overseas territories was not entirely new to the thirty-seven-year-old Stuyvesant; his previous assignment as a young employee of the DWI was first as commercial officer and then as governor of Curaçao, where he served for six years and where his right leg had been crushed below the knee by cannon shot while attempting "to inflict as much injury as possible on the enemy" in a 1644 sea battle with the Spanish.

New battles were to engage Stuyvesant, more by land than by sea, during his seventeen years working for the profit and glory of the DWI in New Netherland. He set about his work with tireless energy. All inhabitants were charged by him, that first year of 1647, with mending their fences properly so the roaming cows, goats, and pigs who scattered their offal and undermined the foundations of the fort could be contained. An enclosure was erected to herd errant animals until a fine was levied for the damage they caused. Shipping ordinances were announced whereby "all private Yachts, Barks, Ketches, Sloops and Boats under Fifty lasts, whether Dutch, English, French, Swedish or other, desiring to anchor under the Manhattans, shall not seek for . . . any other roadstead than in front of the City New Amsterdam, between Capske Point and the Guide-board near the City Tavern." Incoming vessels, large or small, were to be boarded by officials, their goods inspected and entered in a log. Outgoing vessels were to solicit advance clearance and take on passengers only with a pass signed by the governor or his deputy.

The most pressing of the public works on his agenda were the erection of "a Pier for the Convenience of the Merchants and Citizens," repairs to the crumbling fort, the building of a proper church, and the construction of sheet-piling to prevent the erosion of the town's waterfront. To procure the materials and pay workmen, Stuyvesant resolved "to ordain and establish a reason-

FIGURE 10.1

New Amsterdam in Stuyvesant's Time, ca. 1650.
Peter Stuyvesant arrived in New Amsterdam
in a convoy of ships in 1647 to establish his
presence there as director-general. Cannon
were fired from the dilapidated fort to
welcome him. Three years later, he was
still hard at work improving the scruffy
conditions of the Dutch trading post
depicted in a watercolor drawn that year.

The Governor's House and the Church in the Fort, under the Dutch.

FIGURE 10.2 *The Governor's House, ca. 1650.*
The governor's house in the fort served as
Stuyvesant's official residence and "town"
house. Built at Stuyvesant's order, it was
the grandest dwelling in New Amsterdam.
Located beneath the church in the fort, the
house faced the colony's southern shore
with an unimpeded view of the coming
and going of ships.

able Excise and impost on the Wine, Brandy and Liquors which are import-
ed from abroad." Repairing the fort was of such major concern that in addi-
tion to workmen "every male person from 16 to 60 years of age," command-
ed Stuyvesant, "is required to work 12 days in the year at the fort." In further
improvement of the conditions in the trading post, a housing code was de-
vised. The director-general viewed a heightened look of things, together with
continuing improvements, as redounding to the dignity of the province and
giving it a measure of greater strength in the eyes of its would-be enemies. His
efforts were not unnoticed. "We were not less rejoiced to hear," wrote the di-
rectors of the DWI, "that some villages are springing up [in New Netherland]
and that fine buildings are being erected around Fort New-Amsterdam."

Little was accomplished without grumbling. Constant complaints on the
part of the inhabitants, legal hearings, and sharp criticism of the governor's
tactics often interrupted progress. Traders and merchants certainly stood to
gain by the continuing improvements, but they were far more anxious to ac-
quire a measure of political control that would be effective in clipping Stuy-
vesant's autocratic leanings. Already in 1647 they succeeded in having a Board
of Nine Men chosen from among them who were to cooperate with the gov-
ernor and his council in improving the public welfare. Another small victory
followed when the trading post was granted a semblance of municipal gov-
ernment that set New Amsterdam apart from the administration of the entire
New Netherland province. Throughout, Stuyvesant still managed to keep a
tight rein. Not until 1653 did he permit a local government in which a "bench
of justice" was set up composed of a *schout,* two *burgomasters,* and five *schepens*
(a public prosecutor, two mayors, and five aldermen) approaching the demo-
cratic pattern of local governments in Holland, though without the power to
levy taxes and elect officers.

A continuing problem was the meager number of residents. To encourage
the growth of population, large and small *burgher* (citizen) rights were estab-
lished upon the payment of set fees which, in time, spurred the formation of
a local aristocracy based on wealth alone. But whether in dealing with the
burghers, his council, the Board of Nine Men, or the *schepens,* Stuyvesant let it
be known that he derived his authority "from God and the Company, not
from a few ignorant subjects" and that if anyone attempted to criticize his ad-
ministration to the authorities in Holland, he would be made "a foot short-
er." When the Board of Nine had the temerity to denounce his administra-
tion in 1650 to the States General in a lengthy *Remonstrance,* Stuyvesant had
the author of the protest, Adriaen van der Donck, summarily imprisoned. The
very notion of a remonstrance had sent him into a profound rage.

In 1655 the director-general could claim two military triumphs by way of
satisfying his mandate to crush the enemy "by sea as by land." Leading a fleet
out of New Amsterdam's harbor, Stuyvesant effectively routed the Swedish
colony that had established three trading posts on the Delaware River, and re-
turning from that bold venture, he contained an outbreak of violence between
the natives and colonists with a strong show of leadership. Diplomatic over-

FIGURE 10.3 *Property Deed, 1651.* Stuyvesant had grandiose notions of how he should conduct himself as the Dutch colony's ruler. Though the residents lodged a stinging complaint about him to Holland, he resolutely went about purchasing property. This deed gave him title to a "country" house near today's East Eighteenth Street, with 120 acres and two young slaves.

tures to the English were less successful, and their threatened encroachments on the DWI territories were a serious source of worry. This did not, however, prevent Stuyvesant from seeing his permanent destiny in the New World. He installed himself in two Manhattan residences, building a fine town house near Whitehall Street, as well as a *bouwerie,* or farm, located near today's Eighteenth Street and Fourth Avenue, far away from the noisy center. It was on the *bouwerie* that he happily passed whatever leisure time he had in the company of his growing family. Though he was always busy on behalf of the province, he looked after his own commercial interests as a brewer, a merchant, a trader, and a part owner of ships.

Periodic attempts were made to discredit or dislodge Stuyvesant. These were initiated mostly by the members of the city council who complained bitterly to Holland of the governor's "excesses." The DWI appointee was, in fact, ordered to return to Amsterdam for a showdown but his recall was later revoked. To the end of his administration, Stuyvesant continued to strengthen the profile of Manhattan in both its physical and commercial aspects, providing a dock, promoting the merchants' exchange, building a protective palisades along the roadbed of Wall Street, and paving the frequently used streets at the southern tip of the island. Compared with the three Dutch governors who preceded him—Peter Minuit, Wouter van Twiller, and Willem Kieft—he was the most effective and the least corruptible. When the more powerful English inevitably seized the New Netherland colony in 1664, Stuyvesant chose to spare the town's destruction by agreeing, albeit reluctantly, to a peaceful surrender with attractive terms. It had become *his* town, after all. He and Richard Nicolls, the English officer who planted his country's flag on Manhattan, formed a solid friendship after the vanquished director-general sold his Whitehall house to the victors and announced retirement to his *bouwerie.* The New World had become his permanent home. Stuyvesant died on his farm in 1672, religious, irascible, and colorful to the last.

During subsequent English colonial rule, Stuyvesant's post was filled by a succession of the Crown's governors, men of startlingly different temperaments and ambitions. Thomas Dongan, who served as governor from 1683 to 1688, is distinguished among them as an enlightened administrator and the first to introduce representative government to New York. His handling of the post of governor and of seventeenth-century problems peculiar to his administration serves to reflect the flavor of colonial rule under the British Crown.

Thomas Dongan

It is "a very hard thing upon mee coming over hither in troublesome times, finding noe Revenue established & yet having three Garrisons to look after," declared Colonel Thomas Dongan on surveying his New World domain. Peering into an empty city purse as the newly arrived governor was certainly cheerless, but it would prove to be only one of the contributing factors to "trouble-

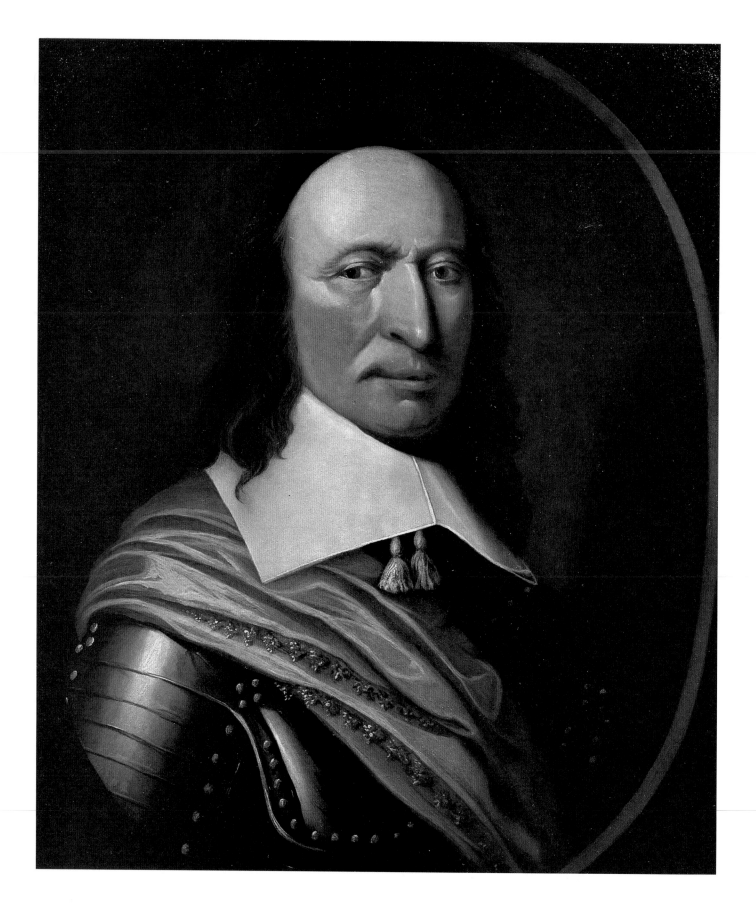

FIGURE 10.4
Portrait of Peter Stuyvesant, ca. 1660.
Busy traveling about on behalf of Dutch
concerns in all the regions of New Nether-
land, Stuyvesant nonetheless looked after
his many private interests as a merchant, a
brewer, a trader, and a part owner of ships.
Coming from a strong Dutch tradition of
portrait painting, he also took time to sit
for a formal likeness.

FIGURE 10.5
Signature of Peter (Petrus) Stuyvesant, 1664.
Peter Stuyvesant was proud of his erudition,
which included training in Latin. Here he
signs a property deed in the last year of his
rule with the Latinized version of his name.
Many Dutchmen in colonial administration
could only affix an *X* to letters, whereas
Stuyvesant could embellish his reports with
quotations from the classics.

some times" the colonel faced on his assumption of rule in New York. A loud
clamor for representative government greeted him from all sides not long after
he alighted with a considerable retinue from his ship the *Constant Warwick* on
August 25, 1683. His appointment as governor of the colony issued from the
Duke of York who, following the Dutch surrender, had been given the New
World territory—promptly named after the duke—by his brother King Charles
II. This ducal attachment made New York a proprietary, rather than a royal,
colony. The size of the territory placed under Dongan's jurisdiction extended
into the reaches of Maine: it included Manhattan, all of Long Island, Martha's
Vineyard, Nantucket, Esopus (now Kingston), Albany, and Pemaquid in Maine.

Dongan was the fourth of the English colonial governors assigned to New
York City. During the administration of Richard Nicolls, the Duke of York's
first appointee, the Dutch municipal system of *schout, burgomasters,* and *schep-
ens* was replaced by an English system of mayor, sheriff, and aldermen. Nei-
ther system allowed the population any political clout or more than a token
of representative government. With the succeeding appointments of Francis
Lovelace and Edmund Andros, the crucial power to levy taxes and impose laws
continued to remain in the colonial governor's hands. A shift in the political
scene was to be the distinguishing mark of the Dongan administration, which
lasted for six years. The small measure of civil liberties now granted to the
population allowed New Yorkers for the first time to characterize themselves
in official parlance as the *people* rather than as *subjects.*

Colonel Thomas Dongan was the youngest son of an Irish baronet from
the County of Kildare whose family, staunch Stuart loyalists, enjoyed connec-

Stuyvesant, Dongan, Wood, La Guardia

FIGURE 10.8 *Portrait of Thomas Dongan, ca. 1666.*
Thomas Dongan was appointed the fourth governor of
New York by his patron the Duke of York. On arrival in 1683,
he announced that it was "a very hard thing upon mee coming
over hither in troublesome times, finding noe Revenue."
Because he was a Catholic, suspicions of a "papist" plot clung
to Dongan's governorship.

FIGURE 10.6 *Stadthuys (City Hall) of New York, 1679.*
The Dutch city hall, located on Pearl Street at the corner of
Coenties Slip, continued in this function during early English
rule. Two days after arriving, Governor Thomas Dongan
promoted legislation leading to self-government, trial by jury,
freedom of worship, and other civil liberties that came to be
known as Dongan's Charter.

tions with the royal court. As successor to the autocratic Edmund Andros, Dongan brought to his post of governor the admirable qualities of moderation, tact, affability, and overseas experience. He was by no means self-effacing; he looked to his own interests and acquired considerable properties in his North American surroundings, particularly on Staten Island. Dongan's merits did not go unrecognized by the populace; yet for many, he had arrived under a cloud inasmuch as he was a Catholic. So was Dongan's patron, the Duke of York, whose conversion to Catholicism was characterized by Charles II as *le sottise de mon frère* (the folly of my brother). Suspicions of a "papist" plot preceded Dongan's arrival and would persist in clinging to his office throughout his rule.

The twenty-nine-year-old Irishman came bearing a pleasing political gift for the residents of his coastal province. Two days after arriving, Dongan summoned the town's prominent magistrates and announced that he had been "ordered to give and Confirme to this Citty all their Rights and priviledge & more if necessary." It was an extraordinary, if vague, proclamation and no time was lost by the magistrates in putting it to the test. On October 17, 1683, representatives from all parts of the ducal province came together in a general assembly that sat for three weeks and proposed fourteen legislative acts. The vigor of the proceedings as well as the provisions of the fourteen acts took the governor somewhat by surprise. All the proposed legislation, which called for the right to self-government, freedom of worship, trial by jury, and other civil liberties, pointed to the bold assertion that true legislative power lay not with the Duke of York but with the *people's* representatives, the governor and his council.

The most important of these acts, in which the entire scheme of government in the colony was outlined, came under the heading "the Charter of Libertyes and priviledges granted by His Royall Highness to the Inhabitants of New York and its Dependencyes." The duke, of course, had not yet granted any such thing; it would be several years before the listed "Libertyes and priviledges" would gain his transatlantic approval. But Dongan took the initiative in decreeing that the "fforme and Method Ffor ye Weal and Governmt of ye sd [said] Citty" would become immediately operative pending his patron's signature. By granting this concession, the duke's appointee showed a willingness to meet his people more than halfway. Though he had had no part in initiating the pioneering document, it came to be known as Dongan's Charter.

In establishing twelve counties "for the better governing and settling Courts in the same," the new colonial legislation transferred more English names to New World soil. The first to be cited was the city and county of New York, followed by Westchester, Ulster, Albany, Dutchess, Orange, Richmond, Kings, Queens, Suffolk, Dukes, and Cornwall. In a subsequent proviso, the city itself was divided into six political wards: North, South, East, West, Dock, and the Out Ward, the latter standing for the unsettled territory stretching to the north beyond Wall Street. Each ward was to have popularly elected

(not appointed) officials, an innovation that opened a fresh era in municipal politics. A "Court of General Sessions of the Peace" for the city and county of New York was also constituted, which was to hold sessions four times a year.

Medieval measures still clung, nonetheless, to legal deliberations. In the first meeting of the Court of General Sessions, one Henry Thomassen was brought to judgment "for that he nott haveing the feare of God before his eyes but being led by the instigation of ye devell" had burglarized the house of the merchant William Cox. After due consideration, Thomassen was sentenced to be branded on the forehead with the letter *B*, whipped eleven times, and required to pay the costs of prosecution. His wife was condemned to be branded on the "fatt of the thumbe" for her complicity in the crime. Harsh measures were meted out to black and Indian slaves, who were not allowed to assemble or meet together above the number of four "On the Lords Day or att Any Other tyme att Any Place" other than the house of the master. Nor were they permitted to carry arms of any sort under the penalty of "being whipped att the Publique Whipping poste Tenn Lashes unless the master or Owners of Such Slave will Pay Six Shillings to Excuse the Same."

Dongan's major preoccupation with the natives of the region was to keep them from forming an alliance with the French in Canada, lest the French preempt the lucrative fur trade along the Hudson. He also wished to avoid hostile raids in New York territory. In these matters, he overcame innumerable obstacles, concluding a pact with the so-called Five Nations of Iroquois whom he made English citizens. Because they constituted the most powerful native forces east of the Mississippi, the Five Nations loomed as a vital factor in the rivalry between France and England for domination of North America. Dongan worked untiringly to head off French aggression, spending enormous sums in military expeditions that were sometimes ill advised inasmuch as some New Yorkers, who resented being taxed for these ventures, moved elsewhere. During Dongan's governorship the Catholic Duke of York ascended the throne and in 1685 was crowned King James II. New York accordingly became a royal, rather than a proprietary, colony.

More than halfway through his colonial assignment, Dongan was able to file a substantive report to his superiors on the state of the province, noting problems as well as progress. In this official commentary of 1687, he touched on wide matters of trade, legislation, court proceedings, religious pluralism ("the most prevailing opinion is that of the Dutch Calvinists"), shipping, real estate, exports, and the size of the militia, which he estimated at four thousand foot soldiers, three hundred horse, and one company of dragoons. He sounded a note of warning on the scant numbers of English families among the multiethnic population, urging that "a more equal ballance . . . bee kept here between his Matys [Majesty's] naturall born subjects and Foreigners which latter are the most prevailing part of this Government." Could not immigrants, he inquired, be coaxed from Ireland?

Probably Dongan himself was not ready for the sweeping changes that would be made to the status of his province the following year. James II de-

Stuyvesant, Dongan, Wood, La Guardia

His Royall Highnes James Duke of Yorke and Albany
K.t of the most noble order of the Garter, and sole
brother to his sacred Ma.ty King Charles the 2.d &c.a

FIGURE 10.7
Portrait of the Duke of York, ca. 1682.
James, Duke of York, never visited the
colonial city named after him. When he
became king in 1685, he decreed by royal
fiat that the charter of liberties he had
earlier granted to New York "soe bee forth-
with repealed and disallowed as ye same is
hereby Repealed, determined and void."
It was a bitter blow to the nascent city.

FIGURE 10.9
Seal of the City of New York, 1686.
During Thomas Dongan's governorship,
an official seal of the city of New York
was adopted, which was retained until
independence in 1783. In one of his official
reports to London, Dongan urged that "a
more equal ballance may bee kept here
between his [Majesty's] naturall born
subjects and Foreigners which latter are
the most prevailing."

creed by royal fiat that the important "Charter of Libertyes and priviledges,"
which he had finally signed as Duke of York was henceforth null and void.
"You are to declare Our Will and pleasure," the governor was instructed, "that
ye said Bill or Charter of Franchises soe bee forthwith repealed and disallowed
as ye same is hereby Repealed, determined and made void." Further, in an ef-
fort to consolidate his English holdings in North America, the king ordered
the bonding of New York, New Jersey, and New England into a single unit to
be called the Dominion of New England. New Yorkers watched in horror as
their municipal records were carted off to Boston, the new colonial seat of
power. The monarch intended to strip this artificially created unit of elected
assemblies and of other popular institutions that might prove fractious or trou-
blesome to his reign. Edmund Andros arrived in August 1688 as supreme gov-
ernor of the megacolony, with Francis Nicholson as his subordinate detailed
to New York. Dongan was honorably recalled.

The dominion proved to last only as long as the reign of the monarch who
created it. In 1689 James II's militant Catholicism forced his flight from Eng-
land during the so-called Glorious Revolution. This chaos in the mother
country was echoed by disorder in the colonies. New Yorkers' mounting rage
at the turn of local events—political, religious, and social—fed into an up-

FIGURE 10.10

Portrait of Fernando Wood, ca. 1856.
Fernando Wood is a man of "great energy, ambition, and perseverance, and most prolific in resource," commented the diarist George Templeton Strong in 1857, "pity he's a scoundrel." Elected for three short terms as the city's mayor in the pre–Civil War era, Wood audaciously promoted himself in a book entitled *A Model Mayor.*

heaval known as Leisler's Rebellion. It erupted in the spring of 1689 with Lieutenant-Governor Nicholson forced to flee. Under the agitated leadership of Jacob Leisler, a Dutch merchant of German origin and a militant antipapist, the city experienced bitter factionalism. Not until 1691 was a royal governor restored, whereupon Leisler was tried for treason and executed. Thomas Dongan had undoubtedly seen the disruption coming when he filed his 1687 report and spoke of "troublesome times." He had astutely discerned that New York's cosmopolitan population, with its chaotic political mix, was "of a turbulent disposition." Fortunately for Dongan, his governorship had been spared the humiliation of so protracted a revolt.

During the early phase of English colonial rule, the office of mayor was created but only after the birth of the American republic did the mayoralty post achieve importance. From the time of the first post-Revolutionary mayor (1784–9) to the year 2000, New York has known sixty-eight incumbents in the mayoralty chair. Two of those incumbents have been arbitrarily chosen here—one from the nineteenth and one from the twentieth century—to propel the narrative of the city's political history in this chapter. Both mayors served during dramatic episodes in the city's history. The nineteenth-century career of Fernando Wood unfolded in the pre–Civil War days of Tammany Hall when the issue of slavery was of great moment; the twentieth-century incumbency of Fiorello La Guardia is a tale of the depression and World War II.

Fernando Wood

Fernando Wood is a man of "great energy, ambition, and perseverance, and most prolific in resource," commented a New Yorker in 1857, "pity he's a scoundrel." That damning mix of attributes was to attend Wood's reputation for most of his political career. At the time that the New York lawyer George Templeton Strong made his assessment in a diary notation, Wood was nearing the end of his second term as New York City's mayor. He had made an overwhelming impact on the city, both as an energetic reformer and as a thoroughgoing rogue. Alternately reserved and flamboyant, the tall, debonair Wood played out all his mayoral moves with an impressive style as he strove to project an image of unwavering respectability and power. Even his first name had an exotic tinge that capped his personality and hinted of unexpected motives and moves. It had been given to him by his mother who, at the time of his birth in Philadelphia in 1812, was much taken by a popular dime novel called *The Three Spaniards.* Wood, who began and ended his political career as a U.S. congressman, was to serve as New York City's mayor for three short terms, winning the mayoralty in 1854, 1856, and 1859. He was a product of Tammany Hall, and introduced nefarious practices that swelled Tammany's incipient reputation for corruption.

New York City of the 1850s was a bustling seaport that had long surpassed Philadelphia and Boston in the magnitude of its shipping. The increase in pop-

Daguerreotype by Haas Engraved by J.C.Buttre

Fernando Wood

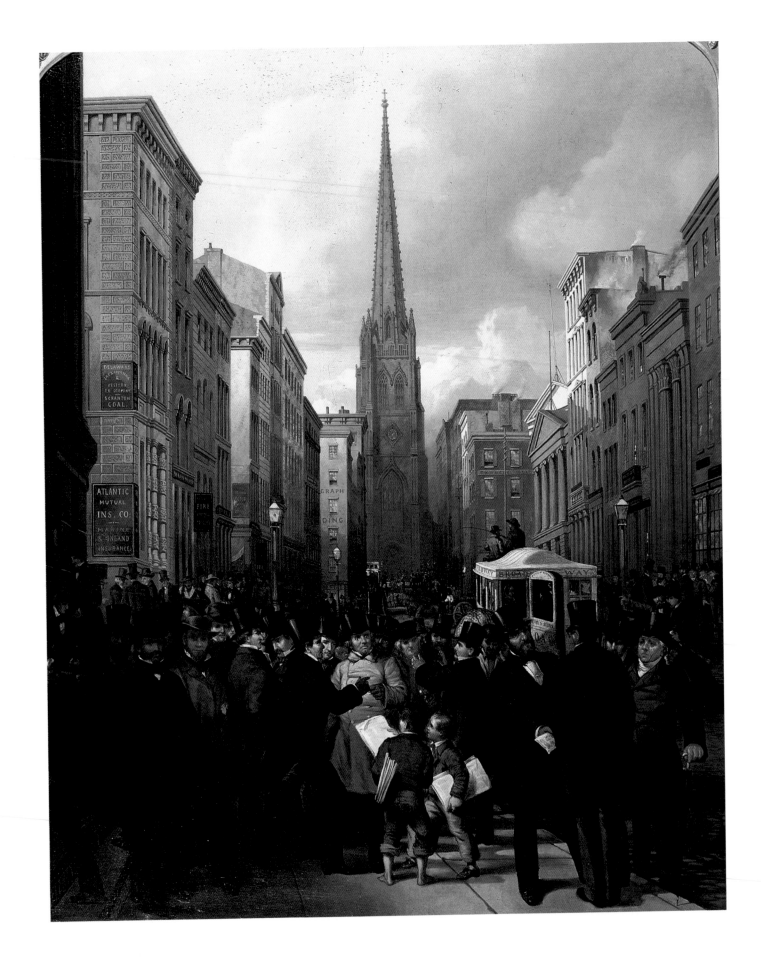

FIGURE 10.11 *Wall Street, 1857.*
Fernando Wood's triple tenure as mayor witnessed great changes in New York. The population figure of seven hundred thousand rose to more than double the count of a decade earlier, while its bustling seaport continued to surpass Philadelphia and Boston in the magnitude of shipping. Wall Street was abuzz with commercial and financial trading.

ulation that both Stuyvesant and Dongan had devoutly wished was now taking place on a dramatic scale following the first large waves of immigration. When Wood took office in 1855, the count of seven hundred thousand was more than double the population figure of a decade earlier. Public buildings, residences, warehouses, stores, and tenements were moving inexorably north, reaching nearly to Forty-second Street, and the six political wards of Dongan's era had expanded to twenty-two. Pigs still roamed the streets as they did in Stuyvesant's day, and cattle were driven through the city on their way to slaughter downtown. Extremes of wealth and poverty abounded, the rich to be seen in their Victorian finery bobbing in and out of Broadway shops, and the poorest of the poor offering a sorry spectacle in the notorious slum area known as Five Points, located at the intersection of Park and Worth Streets. Celebrities were attracted in steady procession to the dynamic city. Jenny Lind, Edwin Booth, Louis Kossuth, Adelina Patti, and the young Prince of Wales made appearances in the 1850s amid great fanfare and throngs. In the wilds outside the city proper, the noble task of creating Central Park had finally begun.

Fernando Wood kept his controlling eye on the whole urban scene. He was determined to cinch that control with all the talent and wiles at his disposal, and so well did he succeed in his first term at the city's helm that he became known as the "Model Mayor." The accolade paid tribute to the wide range of reforms Wood embraced, including the restructuring of the police force, the crackdown on prostitution, the closing of saloons on Sunday, the championing of Central Park, the proposal of a city university to parallel elitist Columbia College, and his incessant fight for greater municipal powers.

Reformers were elated at this mayoral turn of events and so were large masses of immigrants, especially the Irish, who became his ardent supporters. We told you so, crowed the *New York Herald,* responding to earlier accounts circulated by Wood's detractors. "People said he was to be their rowdy's man, the rum Mayor, the blackguard's friend, and many other things," scoffed that paper; "what a blunder was here." Along with the *New York Herald,* the newly christened *Irish American* lined up as a paper solidly behind him. And there were further published tributes. From anonymous supporters at large came a prolonged accolade in the form of a biographic account. "It is especially gratifying in a great city like this, where lawlessness, immorality, bloodshed and murder have been almost unimpeded," ran the introduction to the biography, "to see a magistrate rise above the selfish desire to aggrandize himself." The book was entitled *A Model Mayor* and was largely conceived by the mayor himself.

If Wood had assembled an impressive complement of admirers, he had gathered a gaggle of enemies as well. Matching the laudations was an anonymous 1856 volume with a title that minced no words: *A History of the Forgeries, Perjuries, and Other Crimes of Our "Model" Mayor.* An undoubted product of the opposition, it was addressed to prominent citizens such as William Astor and Schuyler Livingston. The unnamed authors detailed a series of mercantile and political frauds "proven beyond the possibility of a doubt" that

RECEPTION OF THE PRINCE OF WALES AT CASTLE GARDEN BY THE MAYOR OF THE CITY OF NEW YORK AND COMMON COUNCIL, THURSDAY, OCTOBER 11, 1860.—SEE PAGE 856.

FIGURE 10.12

were committed by Wood. "No rogue," fumed the attackers, "ever resided within the walls of a State prison, or ever will, who was convicted of forgery by more unmistakable evidence." It was certainly true that Wood, who hailed from an impoverished family with Quaker origins, had acquired a modest fortune through dishonest deals in the gold rush trade, in shipping, and in real estate. He managed to withstand the attacks against him with denials and with the rapier of disdain; he had much more powerful opponents in the form of the Republican state legislature and hostile factions within Tammany Hall. In 1857 the Albany government, seeking to reduce Wood's authority, passed a series of legislative acts that dramatically interfered with municipal affairs. Now began the tug of war between Republicans upstate and Democrats downstate that was to characterize New York politics and prevail to the present day.

The powers of the Common Council—that body that had served both Peter Stuyvesant and Thomas Dongan—were curtailed by the creation of a Board of County Supervisors directly responsible to the state legislature. Yet another board was created to take down the mayor a peg, to be known as the Commissioners of Central Park. These commissioners were given full and exclusive powers to manage and direct the proposed spacious park, replacing the board appointed by the mayor on which he himself sat. This took the thunder out of Wood's attempt to make the park his special project. A still more hostile move on the part of Albany was the Metropolitan Police Act, which merged the police of Kings, Richmond, and Westchester Counties. Modeled after English legislation creating the London Metropolitan Police, the new force, or "Metropolitans" as they were called, came directly under Albany's control. When the new police commissioner attempted to install himself in city hall, Wood was theatrically defiant and had him thrown out. The power of the Republican state legislature prevailed in the end, however, and Wood, abandoned by Tammany Hall, lost the following election.

Wood had hoped that the divisiveness within the Tammany Society would redound to his benefit. A supreme manipulator, he visualized himself as the one man who could steady the dizzying turn of the machine politics that characterized it. Founded in 1789 as a fraternal order, the society in time acquired a political arm that came to be known as Tammany Hall after the building it occupied. As it steadily expanded, it sought its power base in the support of the newly swelling masses rather than in a narrow political elite. What caused the spiraling of its corrupt machine politics was the bewildering impact of nineteenth-century urbanism on a city and population unprepared for its consequences. Because needs for housing, sanitation, hospital care, police protection, and other basic amenities were being poorly met by the city's primitive infrastructure, Tammany sought to have voters identify their aspirations with its vaunted powers to realize them. By the time Wood joined the hall in 1836, any number of warring factions were on the scene. Those active in the 1850s were the Barnburners, the Free-Soilers, the Hunkers, the Loco-Focos, the Softs, the Hards, and the Know-Nothings, each tied to a burning

FIGURE 10.13
A Thomas Nast Lampoon, 1871.
Though elected mayor as an insider of
Tammany Hall, Fernando Wood fell out
with that organization. Having learned all
their nefarious tricks, he then created his
own, short-lived Mozart Hall. When
Tammany's formidable influence waned,
it was in no small part due to the constant
lampooning by the cartoonist Thomas Nast.

contemporary issue. The Know-Nothings, for example, represented a virulent nativist group opposed to immigration.

Wood had learned all the tricks that made Tammany formidable: the assignment of ward heelers, the doling out of patronage, rigged nominations, influence peddling, and the manipulation of the immigrant vote. Nor was he hesitant in using thugs or henchmen when muscling tactics in political meetings or the wards could prove effective. He was to put it all to good use when he parted with Tammany. Determined to remain in politics—hopefully running for president one day—the former mayor formed his own set of backers in a society called Mozart Hall and aimed to make himself the strongest link between the Democratic White House and the city by courting the friendship of President James Buchanan. Mozart Hall was named after the building at Bleecker and Broadway where its meetings took place. Like Tammany, the new group claimed to be the true Democratic organization in this pre–Civil War era. Though ultimately less successful than the older order, Mozart Hall won for its founder his third term as mayor in 1859.

The burning issues of the day—slavery and the preservation of the Union—tested Mayor Wood to the utmost and found him wanting. Neither the morality of Stuyvesant nor the patriotic ardor of Dongan were virtues looked to by Wood as guides in these two serious issues that were to lead to war. He championed slavery because the city's banks flourished through their loans to the southern states and because the shipment of cotton via the port of New York swelled the city coffers. He was also a racist. As for the Union, was it really so sacred to New York's prosperity? Let New York stand alone as a free city, the mayor declared, unfettered by national concerns. In response to this proposal of secession, there was a loud public gasp.

New Yorkers were offended by the crassness of their mayor's views, which flirted with treason and exposed unmitigated avarice. Whatever popularity Wood had gained in his first term as "ideal" mayor and reformer, he subsequently lost. George Templeton Strong, who kept up a running denunciation of Wood in his diary over the years, cried out in an 1857 entry: "How long, O Fernando Wood, wilt thou abuse our patience?" The answer, following Wood's unsuccessful bid in 1861 for yet another mayoral term, was, No more.

Fiorello La Guardia

Fiorello La Guardia was scarcely an overwhelming choice for mayoral candidate in the 1933 elections of New York City. Few party politicians felt that the former congressman would be successful in such a competitive vote-getting scene. Didn't he cut a rather unlikely figure for so prominent a leadership post? Barely over five feet in height and lumpy in weight, the would-be nominee had a high squeaky voice and was given to both rages and clownish antics. Then, too, he was a sartorial disaster. Even at his best he looked disheveled, adding a touch of the outlandish when he donned a broad-brimmed Stetson, which became his signature hat. Besides, how to

identify someone who loomed as the personification of the city's ethnic melting pot?

Fiorello Henry La Guardia was born in New York City and raised in Arizona. He had an Italian father of Jewish origin, an Austrian mother of Protestant upbringing, and a lingual proficiency in about seven languages. His political identity also eluded stereotyping: nominally a Republican, he ran for mayor on a Fusion ticket, formed by a coalition of reform Democrats, Republicans, and nonpartisan civil groups opposed to Tammany Hall. Only one major politician, the incorruptible Samuel Seabury who had sensed an equal incorruptibility in the Fusion candidate, came forward with vigorous support. The wonder of it all was that the feisty Fiorello knew exactly who he was and where he was going. On winning the nomination and then the election, this American original set his sights on nothing less than dazzling New York with his leadership. He subsequently realized his goal in brilliant fashion during the course of three consecutive terms.

New York was in a sorry state on January 1, 1934, when La Guardia was sworn in as mayor for the first time. The city was sinking ever further into the depths of the depression that followed the stock market crash of 1929, and a heavy gloom enveloped the population of all five consolidated boroughs. Nearly one out of every four New Yorkers was jobless, with blacks and immigrants the worst hit. There was an alarming increase in the numbers of the destitute, with thousands reduced to the hovels of back alleys or to shacks in Central Park. On top of this, so severe a winter set in that shelter was provided in an armory lest many of the homeless freeze to death. Breadlines were a common feature of the streets, and soup kitchens were often the only source of food for large numbers of both white-collar and blue-collar workers. Construction, so important to the city, was virtually at a standstill; gone were the dazzling projects conceived in the 1920s that led to the rise of buildings like the Chrysler and the Empire State.

What could turn the tide in so hopeless a scene? Little relief was in sight, for the city was still reeling from the Seabury investigations, ordered by Governor Franklin Roosevelt, into municipal finances. What issued from the probes conducted by Counsel Seabury was a shocking tale of bribes, pay-offs, rigged contracts, Tammany profiteering, and corruption at all levels, going right to the top, in the municipal administration. Jimmy Walker, the popular, debonair mayor who still had more than a year to serve at the time of the probes in 1932, thought it prudent to resign and make a getaway to Europe, leaving municipal affairs in shambles. Facing bankruptcy, the city was forced to accept crippling loan terms, sending the deficit soaring. On assuming office, La Guardia had every provocation to echo Thomas Dongan's seventeenth-century sentiments when the latter, on taking colonial charge, had wailed, "It's a very hard thing upon mee . . . finding noe Revenue established."

The new mayor moved quickly to set his city on an upward course. His decisions would be in keeping with his inaugural vow that "we will transmit this city not only not less, but far greater and more beautiful than it was trans-

Fulton Fish Market Dock 1934 Anthony Velonis '58

FIGURE 10.15
Demolition of the Sixth Avenue El, 1938.
On December 20, 1938, workers began
the demolition of the southern portion of
the Sixth Avenue elevated train at Twenty-
seventh Street. For many, it was the tearing
down of a beloved city icon. La Guardia
donned goggles and pitched in with the
work on that day; his participation was
captured nostalgically by the watercolorist
Maurice Kish.

mitted to us." What sullied New York more than anything else, in his view, was organized crime; accordingly, a first and dramatic gesture was to arrest Lucky Luciano, the reputed warlord of narcotics and prostitution. The mayor then turned, for appointments to the top posts in his administration, to the most qualified men and women, usually those without political ties. All department expenditures were forthwith trimmed, while county and borough offices deemed unnecessary were abolished. Breaking a campaign promise, La Guardia forced city employees to accept pay cuts, and he levied a 2 percent sales tax on the purchases of the population at large. A tax of one-tenth of 1 percent was levied on gross profits. What was of vital importance, as the dynamic mayor well knew, was the need for revenues that would keep the city's relief program from collapsing: there were as many as 142,000 families on the welfare rolls.

Steadily, the city's ninety-ninth mayor proved himself to be an effective leader as he built up a strength that was independent of all political machines. He also demonstrated his talents as a full-fledged clown who smashed slot machines and hurled telephones out of his office, all the better to drive home the mission he set himself to rid the city of vice and inefficiency. Though many resented his frenetic, sometimes bullying, style of leadership, nothing deterred him from forging ahead and from making certain that he was always present, or so it seemed to the city's populace, at every fire, every riot, every disaster. He totally exhausted himself with his long working hours and constant trips to Albany in foul and politically cloudy weather. "Wear your rubbers, Mr. La Guardia," admonished the *New York Daily News* during the whirlwind of the first one hundred days, "you're turning out to be too good a mayor to lose." What he achieved was solvency. Within a year of his taking office, the budget was balanced and New York no longer had to accept humiliating credit terms from the banks. Yet it was only a small step in the achievement of still loftier aims. He would not be satisfied, he declared, until his city was "not only out of debt but abounding in happiness."

The Little Flower, as he came to be called (based on a translation of Fiorello), won a second term easily. As a Fusion mayor, he bent every effort to bring Tammany Hall to its knees, not by structuring a countermachine as did his nineteenth-century predecessor Fernando Wood but by striving to prove that a nonpartisan, nonpolitical local government was possible. That was his specific, declared aim. He was a happy witness to the fact that the sources of Tammany's strength were visibly falling away because immigration was on the wane and no longer did Tammany chiefs have access to a wide array of patronage jobs. Then, too, stepped-up city and federal programs were replacing the old reliance on clubhouse relief; immigrants themselves, now increasingly better educated, could make independent decisions.

Because La Guardia wished to demonstrate unceasingly that he was on the side of the poor and downtrodden, and had particular sympathy for the plight of blacks, he scheduled countless trips to Washington to plead on behalf of the city and its needy. As a former congressman who had served seven

FIGURE 10.16 *Fiorello H. La Guardia, 1939.*
Fiorello Henry La Guardia cut an unlikely
figure for a politician. Barely over five feet
in height and lumpy in weight, he had a
high squeaky voice and proved a sartorial
disaster even at his best. But the Little
Flower, seen here in a radio broacast,
displayed an on-the-job exuberance and
incorruptibility that soon brought him to
national prominence.

times between the years 1916 and 1932, he knew well the corridors of power there. Now, during his trips to the capital, he could continue the camaraderie he enjoyed with President Franklin Roosevelt, which dated back to the time when the latter was governor of New York State. The two men were of one stripe politically: they were anti-Tammany and steadfastly incorruptible. Further, both believed profoundly in themselves and in their ability to govern. They did diverge on some particulars, one being the role and personality of Robert Moses.

Ah, the irrepressible Robert Moses. Was there ever a parks commissioner so controversial as he? When La Guardia appointed him in 1934 to that post, Moses had already writ large his personality with the state park system he had built for Governor Alfred E. Smith, Roosevelt's predecessor. Aware of his imperial manner, La Guardia privately called Moses "His Grace," while Roosevelt never disguised his utter aversion to the brilliant but driven Yale graduate. With seemingly no end to his daring, his energy, and his arrogance, Moses circumvented rules and assumed powers beyond those delegated to him in his zeal to change the landscape of New York. Within a year, he created 60 new parks and then went on to establish 255 playgrounds and a dozen swimming pools. The energy he subsequently invested in transportation resulted in three major bridges—the Triborough, the Whitestone, and the Henry Hudson—as well as a host of smaller bridges and miles upon miles of intersecting roadways. He was not the only one to change the landscape. During the same post-1934 years that Moses was busy with his pursuits, one of New York's private citizens was realizing his special vision for New York in a sweeping cityscape change that would come to be known as Rockefeller Center. This extraordinary complex of fourteen massive buildings, artfully designed and just as artfully grouped, was a product of the genius and money of John D. Rockefeller Jr..

Much remained to be done despite the spectacular gains of the 1930s. Unemployment figures were still sadly high and, despite the creation of a New York Housing Authority, problems with slum areas continued to be glaring. This was particularly true in the neighborhood of Harlem where a migration of blacks from the South was adding to congestion. By the end of La Guardia's second term in 1941, the city was no longer enveloped in gloom but neither were its finances rosy; that would not happen until the defense contracts of World War II changed the fiscal tide. Still, it was because the Little Flower had set his town on a sound economic course that Washington was encouraged to pour considerable allotments of New Deal funding into WPA projects for New York. La Guardia's second term of office was always to be remembered, not only for the extraordinary work accomplished through the WPA but also for the colossal 1939 World's Fair staged on the site of a former refuse dump in Queens. Some of the 45 million visitors to the fair had crossed the Atlantic by air, landing at an airport realized through the mayor's efforts and later named in his honor.

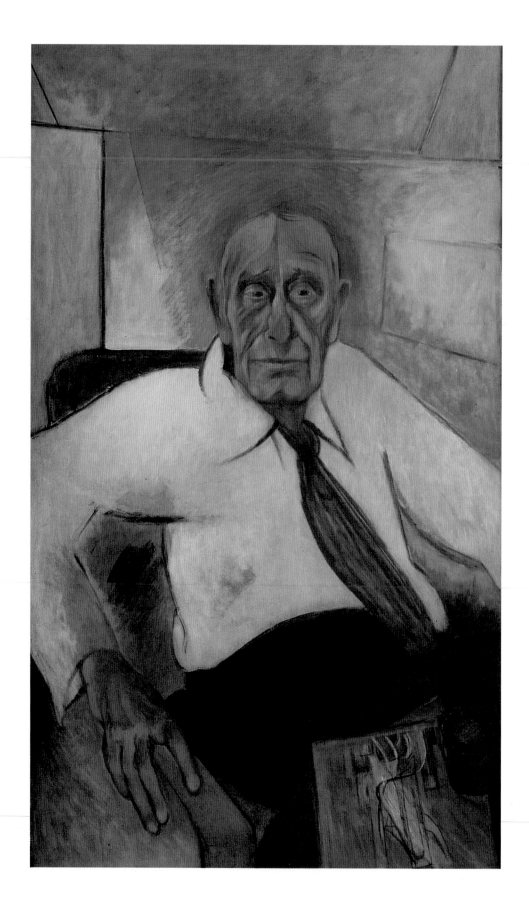

FIGURE 10.17 *Portrait of Robert Moses, 1978.*
During the long mayoralty of Fiorello
La Guardia, the most controversial member
of his team was the irrepressible Robert
Moses, appointed parks commissioner in
1934. Aware of his imperial manner,
La Guardia privately called Moses "His
Grace," while Franklin Roosevelt never
disguised his aversion to the brilliant
Yale graduate.

By this time, the Little Flower was a national figure, possibly second in popularity only to the president himself. From the very first months of his mayoralty, he had shrewdly taken to the airwaves for direct contact with New Yorkers and established himself as a vivid radio personality. Now, World War II was to dominate the years of his third and final term. It was inevitable that memories of his career as a World War I major in the air force would begin to press in on His Honor as war talk and war measures intensified: he longed to serve. "My dear Chief," he wrote to his friend President Roosevelt in February 1943, "I still believe that Genl Eisenhower can *not* get along without me and am awaiting your order [as a soldier]." But the *New York Times,* as well as his supporters, reminded their popular mayor that his very own "front line trench is right here in the five boroughs." And so he stayed until the end of his term, fighting municipal battles of every sort with his awesome brand of integrity. "He was as incorruptible as the sun," declared President Harry Truman in a 1947 telegram to the Little Flower's mourning widow.

TRIUMPHS OF ARCHITECTURE AND URBAN ENGINEERING

Buildings, Bridges, Parks, and the City's Underground

Architecture

"Buildings lift New York toward the sky," declared the chronicler Bernard Faÿ on first arriving in the city in the late 1920s. The visiting French scholar was entranced at the sight of the city's skyscrapers and had the distinct impression that New York was "constructed to the scale of the United States, as Athens was built for the Greek Republic, and Paris for the Kingdom of France." A similar enchantment led the the poet W. H. Auden to avow that "skyscrapers use / Their full height to proclaim the strength of Collective Man." These lofty responses to the physical wonder of the city continue to be shared by visitors whose dominant conception of twentieth-century Gotham is that of a canyon of skyscrapers. In reality, only a small portion of the area comprising greater New York is characterized by sky-reaching colossi, yet their visual impact is as indelible as that made by the pyramids of Egypt, the Gothic cathedrals of Europe, and the stone temples of Inca and Maya builders in territories of the New World. Indeed, New York's signature buildings share common architectural impulses with these creations of former times. Pyramids, cathedrals, temples, and skyscrapers all reach for the sky, all seek maximum exposure, and all represent power: the power of kings, the power of gods, and the almighty power of commerce.

Manhattan's architectural history began quite humbly. Crude wooden huts with thatched roofs of reed constituted the earliest dwellings; they were built by the Dutch with techniques borrowed from coastal Algonkians. By 1626 there were nearly thirty of them, though scarcely enough to go round for an incoming European population then numbering more than two hundred. "The Director and *Koopman* [agent] live together," noted the Dutch chronicler Nicolaes van Wassenaer in his news journal for that year, by way of marking the Dutch West India Company's cramped settlement quarters. Appropriately enough for a trading post intent on a quick profit, the only makeshift structure reinforced with stone that was noted by Wassenaer in 1626 was the countinghouse. Over the subsequent six decades, the lower reaches of Manhattan Island took on a distinctly Dutch look, defined by rows of dwellings with crow-stepping gables and steeply pitched, tiled roofs. This Netherlandish stamp lingered long after the arrival of the English in 1664, though the latter were anxious to proceed with building styles for the expanding colony that were more familiar to them.

An architectural gem of the English colonial period was Trinity Church. Benjamin Bullivant, visiting from Boston in 1697, saw it go up. He described it as "new from the ground, of good brown square stone & brick exactly English fashion with a large square steeple at the west end, not yet half carried up." This modest "Gothic" showpiece, honoring the Church of England and opened in 1698, was given what proved to be an enduringly choice location—Broadway at Wall Street. The lines of the new edifice were not strictly Gothic but its "large square steeple" proudly dominated the New York skyline for three quarters of a century, remaining higher than other notable structures erected during pre-Revolutionary times: a modest merchants' exchange, a city hall, and the Eglise du Saint Esprit. Several splendid homes and a few more public buildings came into view, along with these colonial landmarks, prompting Thomas Pownall, secretary to His Majesty's governor, to observe in 1753 that "since it came into the hands of the English New Churches & New Houses have been built in a more modern taste & many of the Gabel-ends of ye old houses . . . have been new fronted in the Italian stile." Yet it struck him that the city "still retains the general appearance of a Dutch-town."

A further nod to English influence was the erection, a few years after Pownall's observations, of the King's College building in the vicinity of today's Murray and Church Streets. It boasted a splendid facade designed in the neo-Georgian manner that faced the Hudson River from a commanding height. The laying of the cornerstone was an auspicious occasion "whither his Excellency [Sir Charles Hardy, the governor] came in his Chariot and proceeded . . . to the College Ground, near the River on the North-west Side of the City," as reported by the *New-York Weekly Post-Boy* of August 30, 1756. King's College suffered severely from the vicissitudes of the Revolution, though it escaped the sweeping fire of 1776. Faculty, students, and library holdings were scattered while British troops used the premises as a hospital; major restoration was needed following the war to render the building once more functional as a college.

As the eighteenth century came to a close, a visitor from Dublin named Isaac Weld deemed that "many of the private houses in New York are very good, particularly those in Broadway." In the same 1799 chronicle of his wideranging North American travels, Weld also remarked that "of the public buildings there are none which are very striking." That latter judgment would soon change. Feverish construction took place throughout the decades of the nineteenth century as New York experienced an economic boom following the opening of the Erie Canal and the expansion of the city's role as a seaport. Several different styles made a claim for elegance that tapped a wide range of building concepts. The Gothic was never far away, for it had been revived as the favorite architectural style of the Romantic era and was variously applied to secular structures in Europe and imitated in New York. Other chosen styles dated back to Roman and Greek concepts or to Renaissance adaptations evolved by the French and the English. During the first half of the nineteenth century, designs for projects as widely varied in function as city hall (1811), the

Interior of a Dutch Home, ca. 1658.
Colonial Manhattan took on a distinctly
Dutch look, defined by rows of dwellings
with crow-stepped gables and a steeply
pitched, tiled roof. Though scant record of
the early interiors exists, they undoubtedly
followed the character of homes in Holland
depicted by leading Dutch artists Jan
Vermeer and Pieter de Hooch.

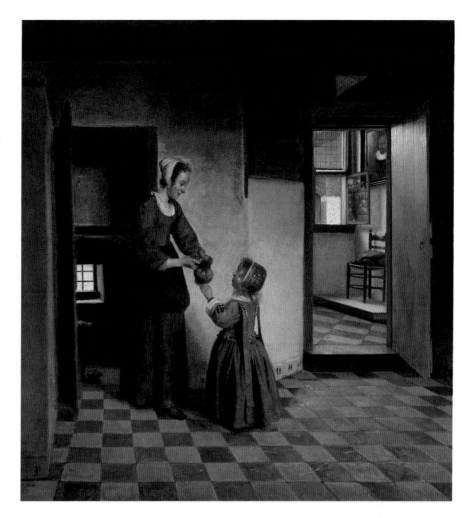

Merchants' Exchange (1827), Sailors' Snug Harbor (1833), and the Crystal Pal-
ace (1853) borrowed variously from historic motifs.

The city hall, with its French Renaissance and Georgian features, was the
undisputed pride of the city and deservedly so. Beautifully proportioned
wings, flanking the central portico of a splendid marble palace, made city hall
a favorite subject of image-makers turning out aquatints, engravings, and
lithographs. Though dwarfed today by skyscrapers, its charms have proved en-
during. A building of central importance in advancing the city's commerce
was the new and grand Merchants' Exchange, completed in 1827 on the
south side of Wall Street. Exterior columns of Westchester marble rising two
stories high were of an Ionic order inspired by the Greek temple of Pallas
Athena. Inside, a spacious rotunda rising to forty-five feet and crowned by an
overarching dome served as the trading floor. To the rear, four principal
rooms were given over to auction sales of real estate, shipping, and stocks,
while the cupola was used as a "telegraph" station. This merchants' pride was
destroyed by a fire of 1835; a new exchange was begun the following year
with a still higher dome.

FIGURE 11.2 *Trinity Church, ca. 1717.*
Considered a modest "Gothic" showpiece, the first Trinity
Church was an architectural gem of the British colonial
period, opened in 1698. Though not strictly Gothic, its steeple
proudly dominated the New York skyline for three-quarters
of a century, remaining higher than the Merchants' Exchange
and City Hall.

FIGURE 11.3 *View of City Hall, ca. 1835.*
Architectural styles of the new republic dated back to Roman
and Greek concepts or to Renaissance adaptations. The city hall,
with its beautifully proportioned wings flanking a central
portico, leaned on French Renaissance and Georgian motifs.
It was the undisputed pride of the city following its opening
in 1811.

The Greek revival style, popular because of its democratic link with the ancient Greek republic, was called on for the design of commercial structures as well as of public buildings. The Astor House (1836), the city's first extravagant hotel, was so designed by Isaiah Rogers. Located on Broadway between Vesey and Barclay Streets, its doorway was flanked by Doric columns leading to a handsome reception area and to as many as three hundred guest rooms that enjoyed running water privately supplied by the hotel. Greek revival was also used by the architect John Snook for A. T. Stewart's marble-fronted department store (1846) further north on Broadway between Reade and Chambers Streets. It was dubbed the "Marble Palace" and so lavish were some of its features that it outclassed the Astor House, which had enjoyed the role of being Broadway's chief ornament for a decade. The Gothic revival was also the inspiration for the new and grand Merchants' Exchange on Wall Street (now Citibank) and the U.S. Customs House (now Federal Hall) located in the financial center.

Decidedly conspicuous among Manhattan's architectural wonders of the nineteenth century was the Crystal Palace (1853). Completed in time for the World's Fair of 1853, the Crystal Palace for the Exhibition of the Industry of All Nations, as it was officially named, was located west of the receiving station of the Croton Aqueduct on the site of today's Bryant Park. The architects George Carstensen and Charles Gildemeister, who took as their inspiration the Crystal Palace of London and were elated with the commission, were less than enthusiastic with regard to the site selected for the building. Nature did wonders for the Crystal Palace of London, grumbled the architects, and "as she does nothing for us, we must have recourse to art." What they produced was not only an aesthetic, basilica-like spectacle but also an edificial phenomenon made of uniform, interchangeable, and mass-produced parts. The building was constructed of glass braced with iron trusswork in the form of a Greek cross; wood was used only for the floors, doors, and sashes, while the exterior was maintained "mostly in the Venetian style" because, according to the architects, it was "the most favorable for lightness and elegance, combined with strength." Within five years of its completion, the prefabricated palace completely burned down; it had been considered thoroughly fireproof.

Motifs that derive from the great architectural eras of the past were adapted for any number of less lofty but enduring structures of the nineteenth century such as grit chambers, pumping stations, the firehouse at 87 Lafayette Street, and the countinghouses of Schermerhorn Row. Many dwellings, commercial buildings, and unsung structures built in the Victorian era—rows of brownstones, community homes in Forest Hills, cast-iron buildings in Chelsea, mansions in Riverdale, and theaters on and off Broadway, to mention only a few—can claim to be architectural gems. Taking pride of place among them are the forthright masonry warehouses and windowed brick factories of the Brooklyn waterfront, many of which have survived in the Red Hook and Greenpoint neighborhoods. These inspired creations were also witness to the

rise of some of the worst slums that characterize an overpopulated city. Attempts were made with projects such as Gotham Court (1850) on Cherry Street and the Workingmen's Home (1855) for blacks between Mott and Elizabeth Streets to provide attractive lower-income housing, but there were not nearly a sufficient number of them and few were maintained adequately enough to sustain their promise.

A century of giving physical shape to New York engendered the rise and prestige of the architectural profession. The word *architect* had little currency during the early Victorian period: carpenters and masons were seen as the primary builders. In time, however, building designers such as Alexander Jackson Davis, Seth Geer, Gamaliel King, James Renwick, Isaiah Rogers, M. E. Thompson, and Ithiel Town attracted interest in their work as the creations of distinct professionals. When the American Institute of Architects was founded in New York in 1857 by a group of building designers who had achieved renown, one of its impassioned goals was to have a distinction made between architects and carpenters. It also sought to propagate the influence of the Beaux Arts School in Paris on architectural practices in New York. That aim was flamboyantly achieved in the mansions of the rich that began to define Fifth Avenue during the Gilded Age and in some of the extravagantly appointed social clubs that set an elitist tone.

Two of the many club buildings that elevated the city's architectural profile as the nineteenth century approached its end, and that survive to this day in their original splendor, are the Century (1891) at 7 West Forty-third Street and the Metropolitan (1894) overlooking Grand Army Plaza. Both were designed by the architect Stanford White, a supreme master of the beaux arts aesthetic; he lent his talents to interiors and exteriors alike and was a central figure in creating the scintillating opulence of the city's Gilded Age. Like other architectural treasures of the time, a good number of White's creations have vanished. Those that remain "are essential elements of our urban memory," declares the beaux arts architecture chronicler David Garrard Lowe, "and a priceless legacy of a designer genius." Tragically, White overreached himself in emulating the lifestyle of some of his rich patrons.

By and large, building commissions for notable projects were gained through competition, and such prestige had the role of the architect attained by the end of the nineteenth century that when the firm of Carrère and Hastings capped the prize for designing the New York Public Library, an apprentice in that office threw up his hands in glee exulting "architecture is the greatest profession!" A high point in the city's beaux arts gallery of buildings was marked with the 1911 inauguration of the library on Fifth Avenue and Forty-second Street. That neoclassic structure of white Vermont marble is as imposing as it is splendid; its interior was designed to render it a true pleasure dome of learning. So prodigiously did the city's building styles stretch America's architectural vocabulary, that innumerable books have subsequently been written to answer a basic question, What style is it?

Architects were, of course, beholden to engineering developments in real-

izing new building concepts. The stately, palacelike buildings of cast iron that came into vogue in the mid-nineteenth century in the Chelsea area and elsewhere were made possible by a structural formula originating in England following the Industrial Revolution. A prime figure in promoting cast iron designs and manufacture was James Bogardus, who imported to New York the building ideas he had learned abroad about this versatile ferrous alloy. The enduring palaces built of cast iron had the economic advantage of prefabrication in Manhattan's foundries; their heavy structural frames replaced the load-bearing walls that characterized buildings up to that time. Such an innovation proved to be only one step away from the design of the earliest skyscrapers where a skeleton of steel carries the weight of the building to its foundations while its outer covering is hung like a skin. Chicago first and then New York carried the banner in establishing the aesthetic for the new steel colossi. Of central importance to the realization of skyscrapers were engineering advances in excavation, elevators, electric lighting, plumbing, heating, ventilation, and fireproofing. All these achievements made possible the creation of some magnificent buildings that continue to give enduring pleasure to New Yorkers and a sense of wonder to the city's visitors. Conspicuous among them are the Fuller Building (1902) at Twenty-third Street, the Woolworth Building (1913) at Park Place, the Chrysler Building (1930) at Forty-second Street, and the Empire State Building (1931) at Thirty-fourth Street.

The Fuller structure—now affectionately known as the Flatiron Building because of its compressed triangular-prismatic form—was an ingenious response to the awkward, sharp-pointed space allotted to it at the intersection of Broadway and Fifth Avenue at Twenty-third Street. Its architect was one of Chicago's great modernists, Daniel Burnham, who conceived his design in terms of French Renaissance detail, giving the building a facade as richly textured as a tapestry and a forward thrust as dramatic as a ship cutting through the resistance of the sea. The problem of wind-bracing engendered by the narrow form of the design was solved by the structural engineer, Corydon T. Purdy, who supplemented the steel frame with triangular gusset plates set in all four corners; they were placed in the connections between the girders and the box columns. Like City Hall in the days of the documentary aquatint, the Flatiron Building became the darling of photographers. Somewhat to the south, the Woolworth Building on Broadway between Barclay Street and Park Place was designed by Cass Gilbert with a steel frame sheathed in ivory-colored terra cotta. On completion during the First World War, this "Cathedral of Commerce" was second in height (792 feet, 241 meters) only to Paris's Eiffel Tower and second to none in New York City in its lyric embrace of Gothic features.

Lyricism of another variety characterizes the exterior and interior decor of the tapering Chrysler Building on Forty-second Street and Lexington Avenue. Designed by William Van Alen, it is a near-fantasy art deco structure with tiered fan-shaped panels forming the glistening steel spire; brick designs are based on automobile hubcaps; and gargoyles are modeled after radiator ornaments. In just one year's time, the Chrysler Building was outdistanced in

height by the Empire State Building, erected on Fifth Avenue and Thirty-fourth Street after plans conceived by the firm of Shreve, Lamb, and Harmon. Millions of visitors have thrilled to the breathtaking views this midtown edifice offers from its rooftop. With its clean lines, commanding dignity and gargantuan height (1,250 feet, 381 meters), the Empire State Building dominated New York's skyline for nearly half a century, a record nonetheless short of that achieved in its heyday by diminutive Trinity Church.

A sleek complex of buildings on the shores of the East River and 42nd Street houses the United Nations. Constructed in 1950 on land donated by John D. Rockefeller, Jr., the complex lends the city enormous prestige by underscoring New York's role in the international community.

Benjamin Bullivant's seventeenth-century wonder in watching Trinity taking shape has been matched more recently by wonder in the technology of the glass boxes that have been shaping Manhattan's profile. Upright masses of glass began to appear as office buildings on Sixth Avenue and elsewhere following the completion in 1952 of Lever House, designed by Gordon Bunshaft at 390 Park for the soap manufacturing firm Lever Brothers. The wonder has been, How is so much glass held in place? For some five thousand years, traditional theories of architecture were based on stone construction. Now builders dared to turn to the fragility of glass.

Bunshaft himself began with no firm idea of how to structure a transparent edifice but found a solution of stunning appeal in his avant-garde geometry of steel frame and glass walls. It became the paradigm for the postwar "curtain wall" trend and spawned a generation of hackneyed imitators on Park Avenue and midtown. One of the engineering keys to the realization of Lever House had little to do with the many concerns involving form, structure, support, or aesthetics; rather, it was concerned with something highly practical: how would all that glass be cleaned? Collaborating with the Otis Elevator Company, a solution was put forward by a firm of mechanical engineers, Jaros, Baum, and Bolles; together they produced an exterior cleaning apparatus, stored on the roof on railroad tracks encircling Lever House that would do the job. This instance of engineering bravura sparked a delighted response from the public, as well as from the press and the professional journals: they all recognized that it was a significant component in the total architectural achievement.

With its twenty-one stories above a marble base, Lever House made no attempt to achieve a record in its vertical thrust. Nor did the nearby Seagram Building (1958), exquisitely designed by Ludwig Mies van Der Rohe and Philip Johnson. Located at 375 Park Avenue, it rises from a travertine plaza and lobby, piercing the air with its bronze curtain-wall tower fronted by fountains. The Seagram's austere classical lines distinguish it stylistically from the International style, which eschews symmetry. A much higher reach was attained when the twin skyscrapers of the World Trade Center rose to eclipse the height of the Empire State Building. Load-bearing curtain walls, as opposed to Bunshaft's stainless steel anatomy, were reintroduced for these modernist style buildings by the architect Minoru Yamasaki and given dramatic sculptural

FIGURE 11.4 *Woolworth Building, 1913.*
Vital to the realization of skyscrapers were
prewar engineering advances in excavation,
elevators, electric lighting, plumbing, heating,
ventilation, and fireproofing. They made
possible the creation of some magnificent
structures such as the Woolworth Building,
here rendered by the modernist artist
John Marin.

properties. Yamasaki integrated several square blocks with a raised plaza to create the Center, enlivening the complex with shopping concourses, gardens, restaurants, and links to the subway and PATH trains. The public largely lamented the absence of pedimented windows, crowning spires, towers, or steeples; these, it was felt, would have softened the blunt impact of the twin buildings against a Manhattan skyline that was once defined by the graceful steeples of churches. Still, the elongated motif of ogival arches surrounding the base and the top make a courteous bow to Gothic inspiration.

A return to postmodernist elements was signaled by the completion of the World Financial Center designed by Cesar Pelli for location in Battery Park. Here, again, a complex was conceived; Pelli's took the form of four towers ranging from thirty-three to fifty-one stories in height. Shops and restaurants are grouped around a plaza as well as a landscaped park. Perhaps the most breathtaking feature of the complex is the Winter Garden, a vaulted glass and steel structure that serves as home to sixteen giant palm trees 45 feet (13 meters) tall. They lend an exotic touch to nontropical New York and can be lingeringly admired by audiences attending the popular entertainments staged in the vaulted hall. The design trends reflected in the configuration of this complex, as well as in the World Commercial Center on Eighth Avenue at Forty-ninth Street, have revived public interest in skyscrapers that evince a comfortable connection to the past by embracing some of the pleasing architectural vocabulary of Greece and Rome. "They loom more user friendly," comments Sanford Malter, an architect and astute observer of the urban scene, "than the high risers of glass or brick that went up during the decades following World War II; most of them, as well as many that continue to go up, are characterized by a blunt functionalism and lack of narrative content."

A widening public interest in the city's structured environment has been further kindled by the work of the New York City Landmarks Preservation Commission; it was founded in 1965 following the needless destruction of the midtown Pennsylvania Railroad Station. The demise of that extraordinary neoclassic colossus (1911) conceived by Charles Follen McKim, which represented both an engineering and design triumph, stirred an effective outcry. Not only has the commission subsequently saved hundreds of buildings from the demolitionist's ball, it has also designated more than fifty districts in the five boroughs as "historic." Neighborhood activism sparked by the commission has, in turn, brought with it local economic benefits, as well as a boroughwide pride on the part of New Yorkers in helping to guard the city's claims to the historic and to the beautiful.

Urban Engineering

The many arts of urban engineering practiced in New York are most conspicuous in the dizzying network of bridges, roadways, railways, and tunnels that stitch the boroughs together and make a sturdy lacework of the terrain.

Buildings, Bridges, Parks, the Underground

FIGURE II.5

The Fuller Structure at Twenty-third Street, 1916.
The Fuller structure of 1902 acquired the
popular name of the Flatiron Building
because of its compressed triangular-
prismatic form. This was an ingenious, and
spectacular, response by the architect Daniel
Burnham to the sharp-pointed space allot-
ted to it at the intersection of Broadway
and Fifth Avenue at Twenty-third Street.

Three little bridges that have long since disappeared were the first European
constructs to introduce that network. They were built by the Dutch over what
is now Broad Street in the 1620s. Running from the shore on the east through
the center of the tiny settlement, that rustic pathway had been dug up to cre-
ate a canal that could receive loaded barges entering from the East River. It
was the largest of the several canal beds created by the Dutch who, by the sev-
enteenth century, had developed a sophisticated canal technology in Holland.
Beyond these artificial waterways, the building of a fort was a distinct priori-
ty, needed to protect the interests of the fledgling trading colony in unfamil-
iar territory. "A fort has been staked out by Master Kryn Frederycks, an engi-
neer," noted the chronicler Nicolaes van Wassenaer. "It is planned to be of
large dimensions." Built at the southern edge of Manhattan Island, it was never
as large as the classical five-pointed bastion intended by the Dutch West India
Company and, no sooner erected with just four prongs, it was constantly in
need of repair. Maintenance was never to be the city's primary strength.

Engineering was also required for the erection of a windmill and for the
construction of a dock that would offer good facilities for the discharge of car-
goes. The windmill, that most familiar of Dutch landscape features, went up
during the governorship of Peter Minuit just outside the fort facing the Hud-
son, while a small dock was built at the mouth of a creek leading to the East
River. By the time of Peter Stuyvesant's arrival in 1647, a rustic infrastructure
was in place but already a number of vexing repairs were required. The wind-
mill had been reduced to two arms; the fort was crumbling; the waterfront,
eroding; and a pier was desperately needed for the increased coming and
going of ships and people. With characteristic energy, Stuyvesant saw to the
repairs as well as to the building of a defensive stockade at the land end of the
settlement. No engineering art could keep the English out, however. Arriving
by sea with a fleet of warships, the enemy took summary possession of the
colony in the name of their king, Charles II.

Appointed English governor of the colony in 1674, Sir Edmund Andros un-
dertook the construction of a "great dock" near Water Street. To this end, he
issued an ordinance whereby "all Merchants and other that Shall at any time
come and trade at this place before the new Docke or Wharfe . . . Shall bee fin-
ished and paid for, Shall pay . . . towards the buildinge of the Said Docke." So
important an engineering project did Sir Edmund consider it that he person-
ally supervised the workmen. On one occasion he canceled a collegial visit to
the governor of Connecticut because, as his secretary hastened to explain by
mail in September 1676, "having undertaken a great worke of making [a] new
wharfe . . . hee hath alter'd his designe of goeing." During the governorship of
Sir Edmund, the Broad Street canal dug by the Dutch was filled in with stones
and leveled in line with adjoining streets. The Common Council ordered this
work to be undertaken by inhabitants of the area, that is "Soe far as every In-
habitants house shall be fronting towards the [said] graft Or Ditch."

Transport streaming into Manhattan from the northern region that is now
the Bronx prompted the erection of the first toll bridge. Following Governor

FIGURE 11.6 *Chrysler Building, ca. 1933.*
An exceptional architectural lyricism characterizes the exterior and interior decor of the tapering Chrysler Building built in 1930 on Forty-second Street and Lexington Avenue. It is a near-fantasy art deco structure, designed by architect William Van Alen, with tiered fan-shaped panels forming the glistening steel spire seen from far away.

Benjamin Fletcher's proposal in 1693 of "ye building of A Bridg att Spikendevil," the Common Council replied that "itt cannott be well Accomplished without A great Charge, unto this Citty which att present they are not Soe Capable to Defray." But as it was clearly in the city's interest to have "a good and Convenient draw bridg for the passage of all Travellere, Droves of Cattell, & passage of Carts & Waggons" descending into Manhattan from northern parts, certain specified tolls were programmed to make possible a bridge spanning the half-mile tidal strait connecting the Hudson and Harlem Rivers. Cattle were driven over the bridge for sale and slaughter in the lower reaches of Manhattan well into the nineteenth century.

Continued work during the English colonial period on docks, piers, shipyards, hauling equipment, ship repair facilities, and launching pads accrued to a bustling buildup of the city as a seaport engaged in transatlantic commerce. Reporting to the Crown in 1687 on the commodiousness of the East River waterfront, Sir Edmund's successor, Colonel Thomas Dongan, had declared that "a thousand Ships may ride here safe from Winds and weather." Dongan thought of this hypothetical number as exaggerated, yet at the high point of English colonial rule, seven hundred ships were clearing the port annually as compared with twenty in the days of that country's takeover more than a century earlier.

If concern was given to the seafaring needs of the colony during the pre-Revolutionary era, not much had been done with regard to the leveling and paving of streets. New York's "streets are Nasty and unregarded," the Bostonian Benjamin Bullivant had complained during his visit in 1697, "ye which they excuse at this time, saying the Multitudes of buildings going forth are ye Occasion, but being over, the City government will rectifie all those matters." Some grading of the main streets had been done in the eighteenth century but "rectification" on a grand scale finally came, following independence, in the form of the so-called Commissioners' Plan of 1811.

The ambitious 1811 plan succeeded in leveling the major portion of Manhattan Island. One hundred fifty-five east-west streets were designed to be crossed by twelve numbered avenues running north-south. To the criticism, on health grounds, of this endless sea of right angles, the commissioners pointed to the salutary presence of the Hudson and East Rivers. "Those large arms of the sea which embrace Manhattan Island, render its situation, in regard to health and pleasure . . . peculiarly felicitous," they declared. Others were aesthetically discontent with what one of the commissioners defended as the "beautiful uniformity" of the plan. The Russian revolutionary Leon Trotsky was later moved, during a sojourn in the 1920s, to define New York's street pattern as a "triumph of cubism."

An engineering project of even greater challenge than leveling the undulating terrain of the city was the construction of the Erie Canal, begun in 1817. Nothing so ambitious had been undertaken either in New York or anywhere else in the new republic; when completed, it was the crowning achievement of its day. Here was a vast engineering feat, fostered by Governor DeWitt Clinton, that capped the canal technology of the Dutch. It set New York on an unswerv-

FIGURE 11.7 *Commissioners' Plan, 1811.*
New York's "streets are Nasty and
unregarded," grumbled the Bostonian
Benjamin Bullivant in 1697. Leveling and
grading on a mass scale came only with the
Commissioners' Plan of 1811. The ensuing
sea of the plan's right-angled streets led
Leon Trotsky in 1920 to define the city's
street pattern as a "triumph of cubism."

FIGURE 11.7
Commissioners' Plan, 1811.
Detail.

ing course to mercantile prosperity by robbing the West of a commerce that until then had floated down the Mississippi to New Orleans and by stripping the South of any future seafaring glory. Chosen as engineer for the project was Benjamin Wright, a former lawyer whose only previous experience was as a frontier surveyor. It was Wright's job to superintend the building of a 363-mile canal connecting the Hudson River with the Great Lakes through endless stretches of wilderness reaching to Lake Erie. Realization of such a canal required some eighty-four locks, numerous aqueducts, and nearly a decade of labor. From its opening in 1825, traffic on the Erie was phenomenal and reached such proportions ten years later that Clinton's Ditch, as it was called, became incapable of handling it. Eventually, this mighty waterway lost out to railroad competition. Though it served the city well in its later redevelopment as the New York State Barge Canal (1905–18), not many traces of it remain. None of its locks nor great aqueducts endured to enjoy the historic renown of structures surviving from ancient Rome, such as the much-admired Pons Augustus erected in Rimini in 20 b.c.

Lost as well to posterity is the sight of the Croton "aqueduct" in the midst of Manhattan. Long a familiar structure on the half block now occupied by the New York Public Library, it was not an aqueduct in the Roman sense of the word; rather it was a receiving plant that distributed the water piped into the city from the Croton Dam in upstate New York. Up to that time, the water came from three sources: the town pumps, the Manhattan Company, and Knapp's spring. "To this," commented the chronicler Asa Greene in 1837, "we should add a further source, namely, the clouds; from which the chief supply for washing is obtained."

The massive construct of the Croton receiving plant (strongly resented as a next-door neighbor by the builders of the Crystal Palace) looked to Egypt for its mastaba-like design and was a welcome sight to New Yorkers when it began functioning on October 14, 1842, under the supervision of engineer John B. Jervis. Forty-one miles (65 km) of iron pipes covered with brick masonry conducted water from the upstate dam and gave New Yorkers their first public running water supply. "Nothing is talked of or thought of in New York but Croton water," recorded erstwhile mayor Philip Hone in his diary; "fountains, aqueducts, hydrants, and hose attract our attention," he wrote. "Water! Water! is the universal note which is sounded through every part of the city." The excitement was understandable: from that day to this, New Yorkers have been able to rely on a most abundant and dependable reserve of water. The city's monumental water supply system of today provides nearly 1.5 billion gallons daily; it is of a quality considered unrivaled in any urban area of the world. Already under way is a "third water tunnel," massive in concept and cost, that is slated to be completed in 2020; it will safeguard this water supply and finally permit inspection of the other tunnels so vital to the city.

A pre–Civil War engineering feat, similarly greeted with loud clamors of joy, gave the New York populace enduring pleasure of quite another kind. This

Buildings, Bridges, Parks, the Underground

was the completion in 1859 of Central Park, masterminded by Frederick Olmsted and Calvert Vaux. For their extravagant wedding of art and engineering, a small army of about twenty thousand workers was assembled. Together with a corps of engineers, they labored over a period of ten years to transform acres of blighted earth into a blend of pastoral and woodland stretches. Creation of the park involved the design and construction of roadways, tunnels, bridges, arches, stairways, fountains, benches, lampposts, gates, fences, bridle path, bandstands, reservoirs, and an underground drainage system running the length of sixty-two miles. The price for this vast poetic oasis covering 843 acres (340 hectares) was high, including the lamentable displacement of more than fifteen hundred residents whose shantytowns were summarily demolished as was the flourishing black settlement known as Seneca Village. Unlike the Grid Plan of 1811, the aim here was to honor the rugged, undulating terrain of Manhattan and to leave intact many of its natural features. As Olmsted put it to the park commissioners in 1857, "in the greater part of the Park the natural characteristics of the ground will be accepted and turned to account."

As part of the creation of Central Park, more than forty bridges were built to eliminate grade crossings in the park area between the looping routes. This number has fed into the inventory of bridges throughout the five boroughs constructed from the mid-nineteenth century to this day, rising to the astonishing figure of more than two thousand (the count rises higher or alternately dips, depending upon which bridge authority is counting). These two thousand bridges spanning water, land, and railways, represent all types: suspension, cantilever, lift, swing, arch, bascule (drawbridge), retractile, and fixed. The most magnificent of the suspension models are the Brooklyn Bridge (1883), the George Washington (1931), and the Verrazano-Narrows (1964). Less spectacular, but taking their place among the many engineering gems, are the Henry Hudson (1936), a steel arch bridge hovering over the same waters as the "Bridg att Spikendevil" ordered by Governor Benjamin Fletcher in 1693; the Triborough (1936), a viaduct structure containing three steel spans; and the Goethals (1936), a cantilevered arch reaching from Staten Island to New Jersey.

The grandeur of New York City's bridges has inspired lofty poetry—Walt Whitman and Hart Crane were two of the earliest bards to pay tribute—while keeping artists of all talents busy at their easels or peering through the lens of their cameras. The one-time parks commissioner Robert Moses, long involved in realizing many of the twentieth-century transportation amenities of the city as well as its smaller parks, was moved to declare that "among beautiful and useful things made by men this side of genius . . . these gigantic, suspended rainbow arches of steel and stone are surely evidence of Divine inspiration." Moses held a whole cluster of official and unofficial posts, during which he became a self-styled master builder of New York. Trained as a political scientist, the energetic Moses asserted that he "finally became a sort of engineer by association, predilection, and adoption." In his forty-year role as an urban vi-

FIGURE 11.8
Manhattan Company Receiving Reservoir, 1825.
Water comes from three sources, commented
a city chronicler named Asa Greene in 1837:
"the town pumps, the Manhattan Company
[on Chambers Street], and Knapp's spring."
To this we should add a further source,
Greene continued, "namely, the clouds;
from which the chief supply for washing
is obtained."

FIGURE 11.9 *A Central Park Bridge, ca. 1890.*
A dizzying network of spans, roadways,
railways, and tunnels have inalterably
stitched the boroughs of the city together.
Gotham's inventory of bridges alone
numbers well over two thousand. This
includes the spectacular span of the
Verrazano-Narrows promoted by Robert
Moses, as well as the jewel-like Gapstow
shown here amid flowering Central Park.

sionary, he wrought more changes in the physical makeup of the city than any of his peers in municipal officialdom. As a tribute to both the city's bridges and its water supply, the conceptualist artist Marcel Duchamp proclaimed that "the only works of art which America has contributed to society are its plumbing equipment and its bridges."

Underground transportation in time rivaled the transport lines that were constructed overhead to connect the five boroughs. Tunneling for the city's vast subway system through forbidding terrain was a technological challenge that sent engineer William Barclay Parsons scurrying in 1894 to London, where the world's first subway had opened on January 10, 1863. That momentous occasion was considered by the London *Times* to have been "the greatest engineering triumph of the day." Not only London, but also Boston and Budapest had outpaced New York in offering subway service, yet the city's fundamental well-being depended as much on efficient transport as on mercantile pursuits. The consolidation of the five boroughs in 1898 made an efficient transit system all the more imperative. Ever fascinated by rapid transit engineering, Parsons masterminded the construction of the city's first major subway line (IRT), which was finally opened in 1904.

Over the decades, the installation of the IRT was followed by the construction of two additional major systems, the BMT and the IND. Always the question was, How deep should the engineers go, or how deep *can* they go? The rock formation of the island known as the Manhattan schist proved formidable to penetrate, and obstacles already loomed underground in the form of a wide network of electric cables, telephone lines, telegraph wires, water pipes, steam mains, and sewers. In time, more than seven hundred miles of track were laid, allowing residents constant access to each of the boroughs except for ferry-accessible Staten Island. During that time, another important goal was achieved with the 1927 completion of the first vehicular tunnel connecting New York with the mainland: the Holland Tunnel. No European model existed to guide engineer Clifford M. Holland in devising plans for a ventilating system that would expel the exhaust gases and bring in fresh air. His innovative solution for the tunnel named after him subsequently served as a model to tunnel engineers in New York and around the world.

Expansion of transportation facilities leading New Yorkers out of the city by railroad to far-flung destinies and locations was punctuated by the erection of two architectural monuments in their midst: the Pennsylvania Railroad Station on the west side at Thirty-fourth Street (1911) and Grand Central Terminal on the east side at Forty-second Street (1913). Nothing less than the spectacular Baths of Caracalla in Rome served as the inspirational design for the grandiose Pennsylvania Station, while Grand Central was conceived as a conspicuous tribute to the elegance of beaux arts design. In the construction of both stations, which were the centerpieces of a vastly complex engineering network, aesthetic concerns kept pace with the intricate technology involved in laying rails near the busiest junctions of the city. Ludwig Fulda, a German

Buildings, Bridges, Parks, the Underground

FIGURE 11.10 *Laying Tracks at Union Square for a Railroad, 1890.*
The first transport bridge to exact a toll connected the
Harlem and Hudson Rivers at Spuyten Duyvil in 1693. It was
"for the passage of all Travellere, Droves of Cattell, & passage of
Carts & Waggons" descending into Manhattan from the north.
Two centuries later, workers laid tracks for the Broadway
Surface Railroad.

FIGURE 11.11 *Manhattan Bridge, 1936.*
In preparation for the joining of the five boroughs in 1898,
and soon after, new bridges accommodated the territorial
union. One of the spans that followed on consolidation was
the 1909 Manhattan Bridge linked to Brooklyn. Its upward
thrust and massive steel patterns intrigued the photographer
Berenice Abbott.

FIGURE 11.12 *The Connectors, 1934.*
The creation of skyscrapers that give
enduring pleasure to New Yorkers and a
sense of wonder to the city's visitors
involves a staggering roster of architects
and anonymous workers. Those daring
performers on high-rise beams, here
called "the connectors," are paid tribute
in a striking etching by the artist James
E. Allen.

dramatist who visited the city in 1913, viewed the two railroad depots as
"proud ornament[s] of the city—marvelous, monumental buildings which do
not suggest their function. . . . They are proof of the inevitable triumph of
American architecture." And of American civil engineering, he might have
added, since the two stations represent the greatest architectural-engineering
works undertaken in the United States. A citywide cry of horror followed the
demolition of the Thirty-fourth Street station in 1965 to make way for New
York's fourth Madison Square Garden. Because of this callous disregard for a
building the public had come to revere, Grand Central Terminal was subse-
quently protected as a landmark. Plans are afoot to convert the Thirty-third
Street Post Office—an imposing edifice (1913) built in the classical revival
style—into a transit hub reminiscent of the once-majestic Pennsylvania Sta-
tion. President Bill Clinton joined New York officials in the spring of 1999 to
announce this welcome scheme.

The wondrous legacy bequeathed to the five boroughs of New York in
terms of architecture, bridges, parks, streets, a water supply system, tunnels, rail
stations, and rapid subway transportation carries with it the great responsibil-
ity for maintenance. It engenders a financial burden that climbs higher with
accumulated neglect. There is also an aesthetic heritage that demands to be
honored: all projects in the city's vast infrastructure were imaginatively under-
taken with an eye to beauty as well as function. "The railway and its equip-
ment . . . constitute a great public work," declared the city fathers in issuing
the first subway contract in 1902. "All parts of the structure where exposed to
public sight shall therefore be designed, constructed, and maintained with a
view to the beauty of their appearance, as well as to their efficiency."

Stalwarts of the past such as Peter Stuyvesant, Benjamin Fletcher, Thomas
Dongan, Benjamin Bullivant, and other colonials once concerned with the
shaping of the future city would undoubtedly find themselves bewildered, on
a visit in the twenty-first century, by the dramatic transformation of Manhat-
tan Island and the adjoining boroughs. They have evolved from bucolic land-
scape to complex cityscape. Adjusting their spyglasses, the erstwhile colonial
observers would scan what has become a triple-tiered vista: an aerial tier, cre-
ated by the reach of skyscrapers; a ground tier, stitched together with a ser-
pentine loop of roads, bridges, and viaducts; and a subterranean tier, dug deep
beneath the surface to accommodate a maze of subways, tunnels, conduits,
pipelines, steam mains, sewers, and endless electrical connections. No longer
recognizable is the horse and pedestrian milieu of their former days. It would
surely be a source of wonder to them how all this came about. So startling a
change in the topographic fabric of the city, they would learn, developed
along lines as complex as its labyrinth of political strategies, its embrace of new
technologies, its multiethnic population, and the dynamics of its ever-chang-
ing economic structure.

PAINTING, THEATER, MUSIC, AND DANCE

New York's Rise As an International Center in All Phases of the Arts

The Visual Arts

For artists commissioned to cross the Atlantic and bring back sketches of all they encountered, the New World emerged as a fascinating tabula rasa in the sixteenth century. Curiosity was rampant about the fauna, the flora, and the peoples of a vast territory that had so suddenly, it seemed, sprung into view. Artists were enjoined to "drawe to lief [life] one of each kinde of thing that is strange to us . . . all strange birdes beastes fishes plantes hearbes Trees and fruictes." Such a commission, given to the Englishman Thomas Bavin in 1583, held true for most pioneering artists who were undertaking the heady assignment of depicting the lands and populations of hitherto unknown continents.

Artist John White soon followed Thomas Bavin in this sixteenth-century transatlantic quest, sailing west under the banner of Sir Walter Raleigh. As part of a dazzling album of New World images that was to hold Europe in thrall, White made watercolors of the many coastal Algonkians he encountered, as well as of a wide range of animal and plant life. His album includes more than one drawing of the turtles he found in abundance along the Atlantic seaboard. The year of his assignment was 1585 and the location Virginia. In the same century, and farther north along the same coast, an Algonkian Munsee of Manhattan was busy executing a native version of a turtle, working with stone tools that pecked and incised the reptilian form on the surface of a rock. The resulting petroglyph, found in 1987 on the grounds of the Botanical Gardens in the Bronx, is one of the first works of art identified with New York City. It features an important symbol in the culture of coastal Algonkians: According to native mythology, the domed back of the turtle served as the terrain for the creation of the physical world. Indeed, the shell of the turtle embodies the cosmos in many cultures.

The petroglyph and the watercolor speak volumes for the art of the Old and the New Worlds at the dawn of colonization. At play in the native rock carving is an unself-conscious art practiced for use and enjoyment in daily life; it relies on nature for design but reaches into ontological beliefs and intuition for its motivation. The John White watercolor, made as much for the purposes of documentation as for the scrutiny of the critic, relies equally on nature for design but bespeaks a volumetric approach that played according to studio rules.

FIGURE 12.1 *Native Rendering of an Atlantic Seaboard Turtle, ca. 1585.* One of the first works of art identified with New York City is a petroglyph of a turtle. Vital to Algonkian mythology, this reptile was once found in abundance along the coast. Scholars date the native rock carving no later than the end of the sixteenth-century. Artist Thomas Wesley Peck renders a bold likeness of it in ink on paper.

During the first decades of colonization in seventeenth-century New Amsterdam, the art practiced by incoming Europeans was essentially topographic, resulting in maps and views of the fledgling settlement. Because the Manhattan natives had a pictorial understanding of their geography, they could indicate to the Dutch, with stones and grains of corn, the placement of villages or undulations of the neighboring coastline. When given a piece of chalk, they evinced a facility for graphic expression with this new tool as well. Colonial maps, views, and charts that were conceived in situ were engraved and printed in Europe until well into the eighteenth century since this conversion required special equipment as well as highly refined skills.

Easel painting, on the other hand, was launched quite early in New Amsterdam: it dates at least from the arrival of Peter Stuyvesant in 1647. The Dutch governor, who brought paintings with him to decorate his home and who had a strong sense of self, indulged his narcissism by the commission of a portrait that survives to this day. The impulse to have himself painted was strong, for Stuyvesant hailed from a country in which the arts were flourishing grandly and were taking a distinctly secular turn. In that seventeenth-century era of

PAINTING, THEATER . . .

FIGURE 12.2 *European Rendering of an*
Atlantic Coast Turtle, 1585.
Depictions of turtles along the Atlantic
seaboard were made in the sixteenth century
by the English artist John White. Sailing to
the southeast coast of North America under
the banner of Sir Walter Raleigh, White
assembled a picture album of New World
encounters that was to hold Europe in thrall.
His rendering of a turtle bespeaks a detailed,
volumetric approach.

Rembrandt, Hals, Rubens, Van Dyck, and Vermeer, the art of the Netherlands
went far beyond that of England. Probably the first professional painter to
practice in Manhattan was a Dutchman named Hendrick Couturier and most
likely it was Couturier who executed the portrait in oil of the indomitable
Stuyvesant. An artist born in New Amsterdam in 1660 was Gerardus Duyck-
inck whose primitive paintings manage to retain a provincial but familial re-
lationship to the Dutch tradition. In the next generation of New Netherlan-
ders, several native-born painters were at work in the patroon strongholds up
and down the Hudson valley region. Some of them have been identified, but
for the most part they remain anonymous.

During the long span of English rule in the seventeenth and eighteenth
centuries, portraiture was to dominate painting in the colonies. Generally
practiced by itinerant painters, it was an art that subscribed to formulas for
ease of execution. Two English portraitists of this ilk practicing in New York
in the mid-eighteenth century were John Wollaston and Joseph Blackburn.
They were products of formal training in London, a city then gaining preem-
inence in the arts. Although the two painters were considerably versed in an
English rococo style of pleasing artificiality, they found themselves eventually
outpaced by three American-born artists: Benjamin West, John Singleton
Copley, and Gilbert Stuart. None of the three was a New Yorker, but they all
managed visits to the thriving seaport city to snap up some lucrative com-
missions. The Bostonian Copley felt he had been inspired to do some of his
best portrait painting in New York: the portrait of Mrs. Thomas Gage is a fine
example. Copley confided to his half-brother, the artist Henry Pelham, that
"the Gentry of this place distinguish very well, so I must slight nothing," clair-

. . . Music, and Dance

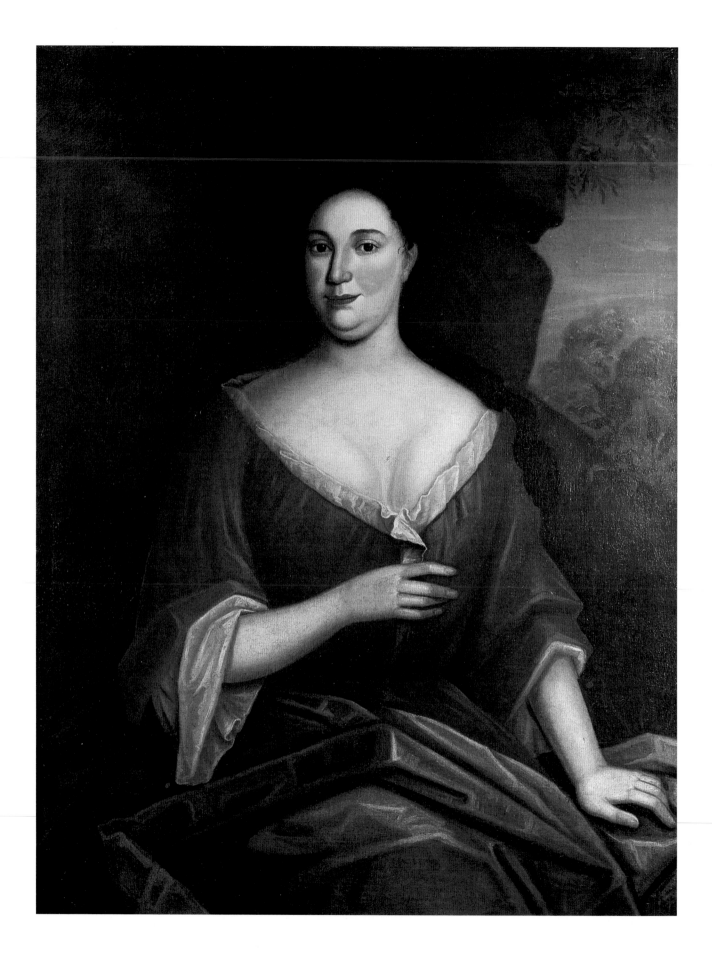

FIGURE 12.3

Portrait of Grace Mears Levy, ca. 1720.
Topographic art, resulting in maps and
views of early New Amsterdam, was
followed during English rule by portrait
painting so popular in England. Affluent
residents invariably commissioned family
portraits, as did the Jewish merchant Moses
Levy. His wife, Grace Mears Levy, sat for
the artist Gerardus Duyckinck.

voyantly divining the critical role that New York would one day play in the
world of art.

The Revolution interrupted the advance of the arts. But not long after victory, New York opened the doors of an art school founded by the British-born brothers Archibald and Alexander Robertson. Located at 89 William Street, it was appropriately named the Columbian Academy, and it set about in 1793 instructing ladies and gentlemen "in the arts of designing and drawing (in India ink, watercolours, chalks, etc.) of heads, figures, landscapes, flowers, patterns, architecture, and perspective." The William Street school, which lasted for some thirty years, represented a bold start in what would become the city's vast institutional network in support of the arts. The playwright and art critic William Dunlap wrote of his friend Archibald Robertson that "his exertions in his profession . . . entitled [him] to the gratitude of the country as one of those who forwarded the progress of the fine arts."

Contemporaries of the Robertsons—Alexander Anderson, John Hill, Joshua Shaw, and William Guy Wall—brought additional European techniques to bear on the Manhattan art scene. Anderson's wood engravings illustrated everything from sheet ballads to scientific treatises. Hill as artist and Shaw as engraver collaborated on a set of prints entitled *Picturesque Views of American Scenery* (1820), following which Hill worked with engraver Wall to produce the *Hudson River Portfolio* (1828). That significant name surfaced in French when the visiting Jacques-Gérard Milbert had his drawings of Manhattan and the river region reproduced in the new medium of lithography. The more than fifty reportorial lithographs were issued in an album called *Itinéraire Pittoresque du Fleuve Hudson* (1829).

By then, the National Academy of Design (1826) had been founded, on the London model, to provide facilities for teaching and to furnish halls for the exhibition of prints and paintings presented to a panel of judges. One of the academy's instructors was William James Bennett, a draftsman and aquatint engraver from England whose stunning aquatints of American views promoted a taste for landscape that would soon engulf the practice of painting. Indeed, it was the emphasis on landscape of the so-called Hudson River School of painting that brought attention to New York in the first half of the nineteenth century as an emerging center of art activity and as a locus for the unceasing flow of talent. While the landscapes were conceived outside of urban confines in a variety of locations, the artists identified with the school were directly tied to New York City, where patrons and promoters fostered the paintings principally produced in their Manhattan studios. The highly detailed and atmospheric landscapes of Thomas Cole, Asher B. Durand, John Frederick Kensett, Sanford Gifford, Jasper Francis Cropsey, John Ferguson Weir, and Frederick Edwin Church eventually eclipsed the vogue for portraiture and historical allegories, both of which had hitherto long enjoyed a strong following. "I believe . . . that it is of the greatest importance," opined Thomas Cole in 1826, "for a painter always to have his mind upon Nature, as the star by which he is to steer to excellence in art." He persisted in this belief at a time when, as

he himself admitted, "it is usual to rank it [landscape painting] as a lower branch of the arts, below the historical."

One of Cole's patrons was the Manhattan merchant Luman Reed, whose impressive holdings of European old master paintings and contemporary American art led in 1844 to the formation of the New York Gallery of Fine Arts, the first permanent collection of art in the city. By the mid-nineteenth century, a solid infrastructure in support of the arts was taking shape with the mushrooming of art schools, art dealers, art galleries, and art critics. Prints, illustrations, cartoons, and posters were also a vivid part of the scene as the proliferation of magazines, newspapers, and books elevated the practice of the graphic arts through their demand for illustrations. Art was being popularized as well through the staggering turnout of prints by a number of print shops, particularly that of the printmakers Nathaniel Currier and James Merritt Ives, whose presses went into high gear when the two became partners in 1857. During the half century life of the firm, Currier and Ives produced some seven thousand images from their shop on Nassau Street that were widely disseminated throughout the country. Coming to prominence in those same decades was a New Englander by the name of Winslow Homer; he dazzled the public with the wood-engraving designs he was turning out, working in Manhattan for *Harper's Weekly*. Yet another New Englander, Daniel Chester French, was winning high accolades, as the turn of the century approached, for work executed in New York. French was in the vanguard of a whole line of sculptors who enlivened New York's outdoor environment with predominantly beaux arts masterpieces.

While American artists looked to Manhattan for commissions, approbation, and fame, many among them continued to look to Europe for a more profound aesthetic exposure; they made treks to the famous ateliers of Europe right up to the years preceding the Second World War. Nor did the existence of the notable repositories of art created in the nineteenth and twentieth centuries, such as the New-York Historical Society (1804), the Metropolitan Museum of Art (1870), the Morgan Library (1924), the Museum of Modern Art (1929), the Whitney Museum of American Art (1930), and the Frick Collection (1935), keep them here. Still, the prolific New York artist William Merritt Chase was able to put his European training in perspective: "I studied the work of the masters," he said in 1910, "but . . . modern conditions and trends of thought demand modern art for their expression."

Chase's elaborate work space in Manhattan's Tenth Street Studio building reflected the growing professionalism of artists and their demand for facilities specifically designed for them. That famed Tenth Street building attracted the visits of patrons, collectors, dealers, and art critics, as did studios elsewhere in the city; they admired the aesthetic clutter usually found there and felt themselves close to the inspirational source of the paintings they viewed. Chase honored his work space through a series of handsome paintings; so, too, did the younger George Bellows who executed a colorful oil on canvas entitled *The Studio* (1919). An ardent admirer of Velasquez, Bellows could confidently

declare that "I am deeply moved by the great works of former times, but I refuse to be limited by them."

The determination of Chase, Bellows, and many of their contemporaries to be of their own time and place confirmed that new American trends were already afoot. A group of New York artists who commanded wide attention just before the outbreak of the First World War came to be known as the Eight: Arthur B. Davies, William Glackens, Robert Henri, Ernest Lawson, George Luks, Maurice Prendergast, Everett Shinn, and John Sloan. Some of them had been newspaper illustrators whose craft was replaced by the practice of photography; all eight were quite disparate in temperament, style, and technique. What they shared in common was the belief that American art had been in the stifling sway of European academicians for much too long. The Eight helped stage the landmark Armory Show of 1913 as a venue for airing their modernist work and for introducing Americans to some of the startling innovations of their fellow artists abroad. The artist Walt Kuhn, who had traveled to Europe a year earlier to round up some of the most advanced art he could find for the show, felt the decided magnetism of New York from abroad. "The more I get about, the more I feel that New York is the coming place for art and for everything else," he exulted in a letter to his wife.

With paintings from both sides of the Atlantic hanging side by side in the Armory Show, a subtle declaration was made that American art need feel no subservience to that of Europe. Following World War II, art in New York took new aesthetic directions, some of them essentially nonfigurative. Sculptors largely abandoned the grandiose style of beaux arts masterpieces for creations of a highly diverse order. In painting, the most dominant of the new trends came to be called abstract expressionism or, alternately, action painting. Here, a basic premise prevails that the image is generated by the very act of applying the paint, whether by pouring, dripping, or using a brush. As practiced chiefly by Jackson Pollock, Franz Kline, and Willem de Kooning, this highly subjective art with its almost secular mysticism riveted the attention of the art world on what was being shown in New York in an anointment of the city as a center of art replacing that of Paris.

A dizzying array of artistic styles has followed abstract expressionism, leading to art movements, as the twentieth century ended, that borrowed from every artistic tradition espoused by Asian, African, European, and native civilizations of the Americas. Color field painting is typical of the work of Helen Frankenthaler, Jules Olitski, Larry Poons, and Kenneth Noland; the art of Ellsworth Kelly, with its large blocks of primary colors, is identified as hard-edge or post-painterly abstractionism. A surprising embrace of figurative painting and flat, two-dimensionality surfaced in the pop art movement of the 1950–80s where essentials of the comic strip and advertising elements are combined. The work of the pop artists Andy Warhol, Roy Lichtenstein, Jasper Johns, and Keith Haring has been snapped up by European museums and collectors.

New York artists have not been alone in forging these new paths, but in its buoyant support of artistic innovation, New York finally wrested from Paris

the role of supreme arbiter. "The strength of contemporary American art has been so irresistible, its impact so stunning that Europeans have neglected," declared the curator of painting at the Louvre in 1984, "to inquire into its beginnings and the steady development that led to its maturity." An exhibition of American paintings staged that year in the Grand Palais of Paris addressed the benign neglect. With no dominant school of art commanding the scene as the millennium dawned, art of wildly divergent directions—untrammeled and global in its reach—continues to emerge in the galaxy of Manhattan's art galleries and in some of the more than 120 art museums or historical collections throughout the five boroughs. A welcoming of what is called "outsider" or nonprofessional art took hold in the 1990s. It is being shown in major galleries and attests to the fact that New York art is no longer solely defined by those who live here but by those (from almost everywhere) who contribute to the vigor of the city's art scene. New Yorkers welcome the novel, the strange, and the traditional whenever work in these directions is offered with freshness and verve. They are all components of the aesthetic buoyancy that renders the city a global arena for turning points in art.

The Theater

"By my troth, I am not nervous," declared Fanny Kemble when asked one September morning in 1832 about her imminent theatrical debut in New York. Newly arrived in America, she was to play Bianca in Henry Hart Milman's neo-Jacobean tragedy *Fazio,* which was being staged for her in the elegant Park Theatre opposite the city hall. While Kemble feigned indifference to success, she confided to her journal some hours before her debut that "the Yankees may like to show their critical judgment and independence by damning me." They assuredly didn't damn her. Erstwhile mayor Philip Hone wrote in his dairy that she gave "such an exhibition of female powers as we never before witnessed, and the curtain fell amidst the deafening shouts and plaudits of an astonished audience."

New Yorkers had been attempting to refine their thespian sensibilities for just about a century by the time of Kemble's appearance, theater being one of the unspurned inheritances of British colonial rule. Long before that, the native inhabitants of Manhattan had entertained themselves in a variety of ways but, like the incoming Dutch, did so without the benefit of an enclosure set aside for the purpose. The Dutch themselves could not lay claim to a grand tradition in seventeenth-century theater as they could in the visual arts. In the New World as in the Old, they were wont to adapt the coffeehouse or the ubiquitous taverns that dotted the minuscule New Amsterdam settlement as a threshold for their merriment. By contrast, the English, who settled in as conquerors in 1664, had a strong predilection for the theater, one that had recently survived a dark period imposed by the puritanical restrictions of the Cromwell government. With the return of the monarchy in 1660 under Charles II,

Restoration plays brought renewed brilliance to a London acting tradition initially ennobled by Elizabethan drama.

The first formal stage erected in New York for theatrical performances in 1732 was in a warehouse, probably on Nassau Street. It was bravely dubbed the New Theater. Chosen for its December inauguration was a popular Restoration play by George Farquhar entitled *The Recruiting Officer,* with the lead role assumed by "the ingenious Mr. Thomas Heady, Barber and Peruge-maker to his Honour [the governor]." Farquhar's comedy was an appropriate choice for the amateur New York performance inasmuch as Restoration plays are often witty, bawdy, cynical, and amoral, qualities that served visitors handily in registering their impressions of the raucous, seafaring population that made up a good part of the audience in the colonial city.

It may well be that a second, provisional theater existed in the 1730s; there are vague references to it. Thespian enchantment eventually led to seven makeshift playhouses in Manhattan before the Revolution when the population had reached ten thousand. In 1753 New Yorkers were introduced to the performances of a professional repertory company led by Lewis Hallam, an English actor-manager. So delighted was the Bostonian Josiah Quincy with Hallam's troupe when visiting twenty years later that he claimed he would have gone to the theater "every acting night" if he could have prolonged his visit. The most notable of the city's eighteenth-century makeshift playhouses was the theater in John Street just east of Broadway that was built in 1767 by the London actor-manager David Douglass for his troupe.

Revolutionary war and a sweeping fire in 1776 drastically curtailed acting nights of a professional order. British officers relieved the gloom of the war by staging amateur theatricals; they revived Douglass's John Street playhouse, grandly giving the name of Theatre Royal to the rickety wooden structure. In the summer they playacted outdoors in the charred ruins of Trinity Church. At war's end, the heroic George Washington, not much given to frivolity, attended the theater three times when he made his residence in New York in 1789 as the republic's first president. He was actually caught laughing during the premiere of William Dunlap's farce *Darby's Return.* "Our beloved Ruler seemed to unbend," noted the *Daily Advertiser* in its review the next day.

It was the impression of the English traveler John Lambert that New York, in 1806, had "rapidly improved within the last twenty years." He added that Broadway and the Bowery Road—future sites of so many Manhattan theaters— "are the two finest avenues in the city, and nearly of the same width as Oxford street in London." As an avid theater-goer, he noted that most performances consisted not only of the classics but "of all the new pieces that come out on the London boards." The only shortcoming he could find was that the pieces were "too much curtailed, by which they often lose their effect." It was, of course, inevitable that a New World city speaking Shakespeare's tongue would rely heavily on London's theatrical canon to build up the reputation of its playhouses, and so it did. Major roles, whether curtailed or no, were often assigned to some of London's finest actors who made the transatlantic crossing.

. . . Music, and Dance

FIGURE 12.4
John Street Theatre Handbill, 1785.
Three performances a week were given at the John Street Theatre beginning in 1767. The program for November 30, 1785, featured a performance of Shakespeare's *Merchant of Venice.* Theater patrons arriving in carriages were requested by the handbill to direct their servants to have all horses' heads face the East River to avoid traffic confusion. It is signed "Vivat Republica."

A particularly brilliant period of the New York stage marked the decades from the 1820s to the 1850s when there were as many as twenty-seven theaters in operation and a host of celebrities graced the boards. Audiences were always enthusiastic, Fanny Kemble observed, but others noted that not all were always respectful. The English visitor Henry Fearon had been exasperated in 1817 to find that none of those in the pit deported themselves "in dress, manners, appearance or habits above the order of our . . . bricklayers," while the Spanish Ramon de la Sagra found it startling in 1835 "to see the parterre filled with lightermen and porters with their hats on, eating pastry and gnawing apples." Frances Trollope had meanwhile come down hard on the ignominious American habit of spitting tobacco, even on the raked floors of the playhouses' interiors.

Theater took to the streets during riots that erupted in May 1836 and May 1849. The earlier of the two upheavals involved two British actors who were forced from the stage of the Park Theatre by a mob. Far more violent was the 1849 occurrence when a feud erupted in front of the Astor Place Opera House between the admirers of the English actor William Macready and followers of the American actor Edwin Forrest—both playing Macbeth in different theaters. Twenty-two persons were killed and more injured. The smoldering factors at play in the militia-quelled riot bore on class and religious differences, incited by the Anglophobia of an expanding Irish population. "The barbarous and brutal practice of theatrical rows is unknown in every country but England and America," thundered William Cullen Bryant in a *New-York Evening Post* editorial; "It is a custom for which . . . there is not the slightest excuse."

Somewhat of a divide along geographical lines was slowly becoming noticeable among New York audiences. The ethnic mix that was steadily swelling the nineteenth-century population of New York increasingly looked to performing arts, more populist in scope, that skirted the barriers of language in minstrels, circus acts, melodramas, burlesque, musicals, vaudeville, and freak shows; it was the type of fare more likely to be found in Bowery theaters. Classical fare with imported actors was the specialty of the more upscale houses near Broadway, whose patrons also looked to balls, concerts, operas, assemblies, teas, card parties, and endless lectures to fill their leisure hours. Attractions of every lofty or bizarre variety kept nineteenth-century theaters abuzz and they considerably nurtured local talent: German, Jewish, and black performers enlivened the New York stage in the post–Civil War years with their original conceptions and distinctive forms of humor. In no other capital was the range of theatrics so broad as that emerging from the wings of New York's playhouses. Serious drama saw the rise of American acting dynasties such as the Jeffersons, the Drews, the Booths, and the Barrymores.

Theater-going had become so integrated a part of New York cultural life in the Victorian era that theaters began to form a distinctive district following the Civil War. The initial neighborhood centered around Union Square and steadily moved northward, along with all of expanding New York; a concentration

New-York, Nov. 20 1785.

THEATRE.

By the Old American Company.

On *Wednesday Evening*, the 30th of *November*, will be performed,

A COMEDY, of *Shakespear's*,

CALLED, THE

Merchant of Venice.

Shylock,	Mr. HENRY,
Baſſanio,	Mr. HARPER,
Gratiano,	Mr. BIDDLE,
Lorenzo, *(with Songs)*	Mr. WOOLLS,
Launcellot,	Mr. MORRIS,
Salanio,	Mr. LAKE,
And, Anthonio,	Mr. WIGNELL.
Neriſſa,	Mrs. HARPER,
Jeſſica,	Miſs TUKE,
And, Portia,	Mrs. MORRIS.

End of Act 3d, a *Hornpipe.*

To which will be Added,

An ENTERTAINMENT, *Called*, The

Miller of Mansfield.

King Henry,	Mr. HENRY,
Dick,	Mr. HARPER,
Joe, *(with a Song)*	Mr. WOOLLS,
Lord Lurewell,	Mr. BIDDLE,
And, The Miller,	Mr. MORRIS.
Peggy,	Miſs TUKE,
Margery,	Miſs DURANG,
And, Kate,	Mrs. MORRIS.

The Doors will be open in future at *Five*, and the Curtain drawn up preciſely at, *A Quarter after Six o'Clock.*

Places in the Boxes may be taken of Mr. *Delamater*, at the Box Lobby, every Day, from *Ten* to *Twelve* in the Forenoon, and from *Four* to *Five* in the Evening; where alſo TICKETS may be had, and at Mr. GAINE's Book-Store, in *Hanover-Square.*

Ladies and Gentlemen are requeſted to deſire their Servants to take up and ſet down with their Horſes Heads towards the *Eaſt-River*, to avoid Confuſion; alſo as ſoon as they are ſeated, to order their Servants out of the *Boxes.*

BOX 8s. PIT 6s. and GALLERY 4s.

*** *No Perſon to be admitted behind the Scenes, on any Account whatever.*

The Public are reſpectfully informed, the Days of Performance will be, *Mondays, Wedneſdays* and *Fridays.*

Vivat Reſpublica.

of playhouses first marked Broadway intersections like Madison Square and Herald Square, before finding what proved to be a permanent home around 1900. Playhouses then clustered along Broadway sites near Long Acre Square at Forty-second Street. When the *New York Times* erected its headquarters at that easily reached crossing of Broadway and Seventh Avenue, the intersection became known as Times Square. It was a location that speedily gained international renown not only for the theaters but also because of the lavish restaurants, hotels, and brothels to be found there. The name *Times Square,* like the name *Broadway,* soon served as alternate appellations for New York's entire theater district, sharing that role with the *Great White Way* following the electrification of the neighborhood in 1895.

"There are nearly twice as many first-class theaters in New York as in London," marveled the British novelist Arnold Bennett in 1912. What particularly delighted him was the architectural recognition that "every member of the audience goes to the play with a desire to be able to see and hear what passes on the stage." According to him, this was not true in Europe "where in almost every theater seats are impudently sold and idiotically bought from which it is impossible to see and hear." A more significant departure from European practices was the increasing commercialization of the New York theater, with its abandonment of both the actor-manager tradition and repertory companies. Serious drama and other forms of stage presentation were seen to be as much of a commercial venture as any other industry that fueled the economic dynamics of the city. As entrepreneurs such as Oscar Hammerstein, David Belasco, and Charles Billingham came to dominate the scene, more theaters were built and more attention was given to musical extravaganzas that would turn a good profit, establishing a financial emphasis that would forever after dominate the theater.

Commercialization did not blunt the brilliance of the legitimate theater in New York during the 1920s. The works of American playwrights such as Elmer Rice, Eugene O'Neill, George S. Kaufman, Robert Sherwood, and Maxwell Anderson were brought to great prominence during those post–World War I years, while the extraordinary gifts of New York's Harlem residents held audiences in thrall as black performers expanded the horizons of the American entertainment world yet further. So, too, did the Yiddish theater on the Lower East Side, which began in 1892 and accumulated a brilliant history until cut down by the Holocaust. In its heyday, it had a strong following among Jews and among non-Jews who recognized its contributions, such as the introduction of the Stanislavsky acting method, to mainstream drama in New York. Meanwhile, a host of alternative theaters and companies were widening the dramatic arena following the first Off Broadway production that was staged in a small Greenwich Village theater in the early twentieth century. These smaller ventures offered experimental ideas in drama, while shunning both the prices and the commercialism of Broadway. All this activity spawned a creative range in New York playhouses that belied the city's rustic Nassau Street theater origins: it was now London's turn to begin borrowing actors, plays, directors, and concepts from its former suppliant colony.

PAINTING, THEATER . . .

Films and television inevitably siphoned away a large part of the theater-going public beginning in the 1960s. Sections of the Great White Way fell into disrepair as playhouses were abandoned, and as Forty-second Street succumbed to X-rated entertainments. This persisted for more than two decades until a spirited turnaround was launched by outside entrepreneurs and New Yorkers alike who recognized that the Times Square theater district held too strong a sway in the cultural life of the city for it to be abandoned. West Forty-second Street entered a new and sparkling life when Walt Disney enterprises of Hollywood took the initiative in refurbishing the New Amsterdam Theater in 1995. Renovations and new construction along that famed thoroughfare followed, resulting in a triumphant facelift and a renewed theatrical vigor. Several playhouses farther north in the district were returned to their former glory, revealing interior architectural gems like the Walter Kerr on Forty-seventh Street. Meanwhile theatrical experimentation was at an all-time high as Off Broadway spawned Off Off Broadway, with both districts warmly hailed as part of the wider theatrical scene. Though an end-of-the-century countdown confirms that the number of playhouses and the number of playgoers have been permanently reduced by the competitive offerings of film and television, all signs pointed at century's end to New York's fierce resolve to remain a theatrical center of global renown.

The Sounds of Music

Could it be that the Algonkian Indians of Manhattan Island produced music that had the same thunderous and exhortative power as today's rap? No chronicle exists to prove this to be true or untrue, yet music was certainly a part of whatever local culture flourished in Manhattan at the time European explorers ventured into its surroundings. Dutch settlers also left scant record of their seventeenth-century musical activities beyond indications that psalms were sung in their ramshackle church in the fort and that *lieder* brought from Holland echoed within the walls of the taverns. Vermeer's paintings of this period offer eloquent testimony that music was a strong tradition among the Dutch people. During British colonial rule, the importation of instruments stepped up the quality of music that was played at home and in public places. Trinity Church, which acquired an organ in 1740, was so intent on having the contractual services of the best organist possible that it set aside funds in 1744 for "his comeing here and Returning." It was planned that the organist "change three Treble stops that are now in wood for Pewter . . . Change the Trumpet stops for a Double Cornett and . . . Make a Pedell compleat for the organ for the sum of twelve pounds." When the Scottish physician Alexander Hamilton visited the colony later that year, he granted that Trinity did have a "pretty" organ but he did not have the satisfaction of hearing it play, "they having at this time no organist; [still] the vocall musick of the congregation was very good."

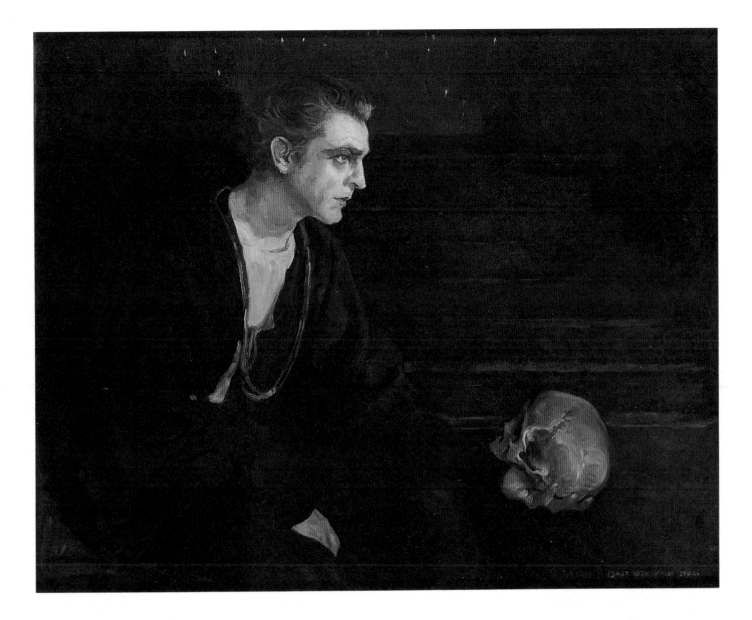

FIGURE 12.5 *A European Actress Plays in New York, 1896.*
Sarah Bernhardt, who made nine American tours, posed for
the camera of Percy Byron during the course of her fourth
theatrical run. She followed other famed European actors who
performed on Gotham's boards. One of them was the English
actress Fanny Kemble whose stage appearance in 1832 was
tumultuously received.

FIGURE 12.6 *John Barrymore As Hamlet, 1922.*
Serious drama saw the rise of acting dynasties like the
Jeffersons, the Drews, the Booths, and the Barrymores. What
made the range of New York theatrics astonishingly broad in
the same decades was the input of German, Jewish, and black
performers who introduced original conceptions and distinctive
forms of humor.

It was in a tavern that the Scottish visitor was to hear a public recital; he described it as "a tollerable *concerto* of musick performed by one violin and two German flutes." Had the same observant gentleman made a visit to the city a century later, he would have been astounded at Manhattan's leap in musical standing. Not only were organists, instrumental ensembles, and numerous choral groups in place performing in churches, public rooms, and halls that were steadily expanding, but the city could boast its own symphony orchestra, formed in 1842 as the Philharmonic Society. For its inaugural concert, the sixty-three musicians performed Beethoven's Fifth Symphony and from there went on to ever greater fame. Though music was primarily imported from Europe, the widening ethnic presence in the city—particularly the German and black components of the population—supplied the fervor and talents of an expanding pool of musicians.

Manhattan was now well poised to broker the appearance of its first international celebrity: the Swedish singer Jenny Lind. Her recitals in Castle Garden in September 1850 sparked a clamorous following. Crowds trailed her wherever she went, and seven hundred eager music lovers competed to compose a song in her honor. In that same decade, opera was endowed with a worthy house of its own when the lavish Academy of Music opened on Fourteenth Street and Irving Place. Its four thousand seats of crimson velvet beckoned opera devotees to its programs while its showy private boxes proved a lure for the wealthy, many of whom came to see and be seen. Some of the box holders fancied themselves reputable music critics. "Went to *La Traviata,*" the prominent lawyer George Templeton Strong wrote in his diary for December 11, 1856. "*Traviata* is utter drivel, I could write as bad an opera myself." Fortunately, Strong kept to his lawyering; the works of Verdi and all other composers of like genius were welcomed in the academy, as were Europe's principal vocalists and instrumentalists.

In time, freshly minted millionaires found it an affront to their status when they could not be accommodated in the fixed number of the academy's boxes. Not to be left out, their solution was to underwrite the creation of a larger auditorium uptown at Thirty-ninth Street and Broadway. Named the Metropolitan Opera House, it opened its doors in 1883 to an even grander and tonier alliance between high society and opera. Because it boasted more than five times as many boxes (122 in all) as did its Fourteenth Street rival, the more splendiferous Met spelled the eventual demise of the beloved academy. During the brief three years that the two rival houses coexisted, however, competition between them resulted in a feverish crossing of the Atlantic by Europe's best talents. In 1883 "the public had the luck," marveled the Italian visitor Carlo Gardini, "to hear in a single winter all the living celebrities of the world, a luxury certainly not afforded by any capital in Europe." Italo Campanini and Christine Nilsson sang the principal roles when the Met's inaugural season was launched with Gounod's *Faust.*

Before the century was out, New Yorkers had a continuance of good fortune in witnessing the opening of Carnegie Hall on Fifty-seventh Street.

The text within the illustration reads:

BURLESQUE DAMES QUARREL AS TO WHO WILL TAKE THE NEXT VICTIM OVER

COUNTRY GENTLEMEN LURED BY SLICK CITY WOMEN

SHE'S PRETTY AND WILL MAKE A MAN OF 60 FEEL THE THRILL OF YOUTH AGAIN

Norma SHEARER JOAN BENNETT Allyn JONES

Screen Snapshots

Flirtation THE WELL-KNOWN COMEDY

Ann SHERIDAN Susan HENE Mickey ROONEY Screen Snapshots

LLOYD NOLAN J. CARROLL NAISH SHIRLEY ROSS PRISON FARM JOHN HOWARD

25¢

FIGURE 12.7

The Harris Theater on Forty-second Street, 1940.
Following the Second World War, theater in
New York had an overwhelming rival in the
movie house, which featured entertainment
on stage as well as moving pictures on
screen. The Harris Theater, located at 226
West Forty-second Street, enjoyed a run as
a playhouse, specializing in musicals and
revues, before converting to films.

FIGURE 12.8 *Palmo's Opera House, ca. 1847.* Palmo's Opera House featured ballet, drama, minstrels, and "divertissements" as well as opera, claiming its performers "attracted the most Brilliant and Fashionable Audiences." It opened in 1844 on Chambers Street near Broadway; eventually it was converted to a theater. Boxes seating eight people sold for five dollars.

Hailed for its superb acoustics and generous sightlines, the stage boards of Carnegie were forever to be graced by the world's greatest musicians as they arrived, often to conduct their own works. The roster of premieres and debuts that have been staged there ever since began on a dazzling note with the appearance of Peter Ilich Tchaikovsky as conductor during the hall's 1891 inaugural festivities. When Tchaikovsky was invited to Carnegie's home for a post-performance dinner, Carnegie mimicked the conductor's movements "so solemnly, so well, and so like me," Tchaikovsky afterward wrote, "that I myself was delighted." During the course of the following century, the city would continue to explode with a wide range of melodic sounds that aired in tandem with classical music: jazz, folk renderings, swing bands, and extravagant musicals. There was something to beguile the ear of everyone in all five boroughs as the city's pronounced multiethnic population contributed in every sphere of music to New York's stature as a musical capital. Musicals—that wondrous pastiche of theatrics and song—emerged as a distinct American innovation with an 1866 production of *The Black Crook* featuring the gorgeous Floradora Girls. Charles Dickens and Mark Twain were both in town to catch a performance, then considered risqué entertainment. Twain rightly surmised that "the scenery and the legs are everything," while coyly noting that the meagerness of dress "would make a parasol blush." Bare legs were the chief attraction of the long-running revues (1907–31) known as the Ziegfeld Follies; they were conceived by the impresario Florenz Ziegfeld who produced a number of musical comedies as well.

As a distinct art form, musicals competed with dramatic plays for the most lavish of the city's performance spaces. Those spaces were conspicuously expanded in the 1960s when the complex known as Lincoln Center for the Performing Arts revitalized a downtrodden area of Manhattan reaching from Sixty-second to Sixty-sixth Street along Broadway. A new Metropolitan Opera House was born, as were two major performance halls, smaller auditoriums, and a solid network of studios and offices. The Juilliard School of Music, chartered in 1904, became a part of the complex, where it continues its role as the preeminent supplier of musical talent. Reaching well beyond the Center are the frequent television broadcasts of live performances, which attract listeners not only across the entire nation but also across the world by satellite. So great has been the impact of Lincoln Center's varied offerings on local, national, and international audiences, in addition to offerings elsewhere in the city, that the number of those subscribing to music programs has climbed to more than 5 million annually. With so many music lovers swarming the city, it has become more important than ever for Americans and foreigners alike to have a musical debut in a New York house.

Clearly, the Scottish Alexander Hamilton, who heard only a mediocre concerto during his 1744 visit, would find his cup overflowing with the range of music emanating from the city's hundreds of locales. What would truly intrigue him, however, if he were to make a visit in the year 2000, would be the breathtaking expansion of the musical world through technology. He

INTERIOR VIEW OF PALMO'S OPERA HOUSE CHAMBERS STREET, N.Y.

From an original drawing in the possession of G.P. Elder

FIGURE 12.9 *Academy of Music, 1854.* Manhattan was well poised, by 1850, to broker the appearance of its first international celebrity, the Swedish singer Jenny Lind. She gave well-attended recitals in Castle Garden. Opera was soon endowed with a lavish house of its own when the Academy of Music opened on Fourteenth Street with four thousand crimson velvet seats.

FIGURE 12.10 *Niblo's Garden Playbill, 1866.* Musicals emerged as a distinct American innovation with an 1866 production of *The Black Crook* featuring the gorgeous Floradora Girls with bare legs. Charles Dickens and Mark Twain were both in town to catch the risqué presentation, with Twain coyly noting that the meagerness of dress "would make a parasol blush."

would need to adopt a new vocabulary that embraced the words radio, television, tapes, compact discs, sound studios, digital programming, synthesizers, and earphones. And he would need to widen his eighteenth-century musical sensibilities to pass judgment on rock music, hard rock, folk rock, grunge rock, punk rock, heavy metal, speed metal, rap, hip hop, gangsta rap, reggae, and ska. Surely he would be moved to describe them in words other than *tollerable musick.*

The Dance

Colonial New York had been alive with dancing for some decades past when it was treated to a remarkable spectacle in April 1768. Cherokee chiefs, on an official visit north, mounted a New York stage and beguiled the spectators with the rendering of a war dance. The Cherokees had come from South Carolina to negotiate a peace settlement with the Five Nations of the Iroquois with the help of the English colonial government. Invited to attend a pantomime called the *Harlequin Collector* at the John Street Theater presented by Lewis Hallam's troupe, they were visibly diverted by the antics of the clown. It was following the pantomime that they took their places on stage. That impulse was a distinct departure from their usual practice in which neither a stage, a director, nor a dancing master was required for a native performance. A long tradition had refined the ritualistic choreography of the Cherokees, as of all native Americans, and succeeding generations have sustained it. By contrast, colonialized Manhattan was forced to start anew.

PAINTING, THEATER . . .

NIBLO'S GARDEN

LESSEE AND MANAGER WM. WHEATLEY.
STAGE MANAGER L. J. VINCENT.

Doors open at Seven. Curtain rises quarter before Eight.

September 12 1866 — First Night —

EVERY EVENING

AND

SATURDAY AFTERNOON

AT TWO,

Will be presented, after a preparation of several months, and

AN ACTUAL OUTLAY OF OVER

FIFTY THOUSAND DOLLARS

The Original, Grand, Romantic, Magical and Spectacular Drama in Four
Acts, by CHAS. M. BARRAS, Esq., entitled The

BLACK CROOK

The SOLE RIGHT of which production in New York and its vicinity
has been purchased by MR. WHEATLEY; who has also entered into an agreement with

MESSRS. JARRETT & PALMER

For the introduction of their Great

PARISIENNE BALLET TROUPE,

Under the direction of the renowned Maître de Ballet

SIGNOR DAVID COSTA,

(Of the Grand Opera, Paris,) who will appear in the

MOST COSTLY AND MAGNIFICENT DRAMATIC SPECTACLE

EVER PRESENTED IN AMERICA.

FIGURE 12.11 *A German Band Playing in Manhattan's Streets, 1879.*
With successive waves of immigration in the nineteenth century, a widening ethnic presence in the city—particularly the German and black components of the population—supplied the talents of an expanding pool of musicians. Here, the wind instruments of a German band playing outdoors fascinate a group of children.

Dutch residents of the nascent seaport had brought some dancing habits with them that were entrenched in the lifestyle of the mother country; they often used taverns as the backdrop for impromptu performances. The dancing was mostly country-derived and self-taught. By 1687, following the English takeover, the small colony was ready for a dancing master who arrived from Boston. Named Francis Stepney, his career was, alas, short-lived for it was brought to the attention of the town fathers that "he hath been of loose carriage here." An order was accordingly issued by the City Council that he "never hereafter teach dancing within this province."

The English practice of assemblies and the refinements introduced by French dancing masters essentially shaped New York's terpsichorean profile during the eighteenth and early nineteenth centuries. As the Victorian era wore on, waves of immigrants swelled the repertory of folk dances that enriched the cultural life of the city. The English observer John Lambert, visiting in 1806, held that the ladies of the town were already known to be passionately fond of dancing; "They are said to excel those of every city in the

PAINTING, THEATER . . .

FIGURE 12.12

Dance in a Dutch Inn, ca. 1652.
The Dutch brought to Manhattan lusty attitudes toward life, particularly in the forms of drinking, dancing, and singing. The fair number of inns and cafes established in New Amsterdam provided venues for spontaneous performances by the population, much like those recorded in the inns of Holland by the artist Adriaen van Ostade.

Union," he wrote. When the international star Fanny Elssler made her debut in May 1840 in the Park Theatre, she showed the thousands in attendance how the cachucha, the cracoviennae, and the tarantella could be executed to perfection. Those who performed their dancing more anonymously than Elssler could claim among them, at various times over the decades, talented performers in the bolero, cinquepace, czardas, fandango, fox-trot, galliard, gavotte, hornpipe, jig, mazurka, one-step, polka, reel, rigadoon, saltarello, saraband, two-step, waltz, and ziganka. A new category was added to the growing list when clog steps, taken up by black and Irish dancers alike, were combined to produce the seductive, staccato rhythms of tap. It would come to be practiced equally by the clumsy and the skilled, remaining forever after a favorite gambol in New York, offstage and on.

Not all the dance idioms current in the nineteenth century were incorporated in the popular balls of the time, which were held in public spaces and staged privately as well. These social diversions were apparently lively enough to seduce the likes of the novelist William Makepeace Thackeray who visited

. . . Music, and Dance

FIGURE 12.13
Dancing the Grecian Bend, 1868.
Performing in the Park Theatre in 1840, Fanny Elssler showed the
thousands in attendance how the cachucha, the cracoviennae, and
the tarantella could be danced to perfection. As the decades wore
on, a score of other dances were to be learned that, following the
Civil War, included a new sensation, the Grecian Bend.

FIGURE 12.14
Sheet Music for Telephone Waltzes, ca. 1883.
Victorian dances were often created for special occasions
or to pay tribute to important breakthroughs in technology.
Telephone waltzes appeared with sheet music following the
introduction of the telephone in 1877 by Alexander Graham
Bell. New York's first telephone directory listed 252 subscribers.

the city in 1853. Returning home to England, he confided to a friend his opinion of a London ball: "Pish this is nothing—Go to New York if you want to see what a ball is . . . as if there could be any balls after New York!" Thackeray refused for some weeks to change his watch to London time, so exhilarated was he by his Manhattan diversions.

Ballet meanwhile had made frequent appearances in the nineteenth century due to French influence in the city, which began with a colony of exiles during the Napoleonic era. It was further encouraged by dance masters of other backgrounds, chiefly Italian and Russian. Eventually, American-born teachers began to assert a presence as they opened studios in the city for dance training. Not until 1909, however, did the first American school of ballet come into being; it was formed by the New York Metropolitan Opera, borrowing from European traditions as well as engaging European dancers for the development of its programs. The form of ballet brought to New York had originated in Renaissance Italy; it was imported to the seventeenth-century court of Louis XIV by Catherine de Medici, whereupon the French developed the standards for ballet technique. French ballet masters of that era were so much in vogue they danced their way into Molière's plays. Terpsichore's baton was subsequently passed to Russia but eventually the center of gravity shifted after World War II to New York, where experiments in dance were spiritedly afoot.

Ballet was gaining ground as well in other American cities where American-born choreographers were successfully opening regional companies. They added to the luster of the New York scene with their visiting performances. In the latter half of the twentieth century, dance horizons were wondrously expanded in the city by the arrival of Russian performers defecting from the Soviet Union. Meanwhile, no dance personality had become as central to the ballet landscape of the city as the choreographer George Balanchine, a native of Saint Petersburg, who had arrived in the 1930s. His innovative concepts revolutionized classical dance and riveted the eyes of the world on New York. As the millennium was ushered in, the city could boast a whole cluster of ballet companies of world-class standing; they were indebted for a good part of their repertory not only to the virtuosity of Balanchine but to that of many American choreographers, particularly Balanchine's contemporary Jerome Robbins. An exacting artist who left his legendary imprint on many Broadway musicals, Robbins broadened the world of classical ballet with an essentially American idiom.

In the sphere of formalized dance that had abandoned the "en pointe" technique, a burst of activity was led by the American choreographers Katharine Dunham, Pearl Primus, Merce Cunningham, Martha Graham, Alvin Ailey, and Twyla Tharp. Through their dance companies and their studios, they launched entirely new dance phrases and invigorated their work with political, racial, and ethnic themes. The seductive worlds of the ballet and modern dance could not obscure, however, the pleasures of ballroom dancing

FIGURE 12.15
Ballet Rehearsal at the Met, 1900.
English assemblies and French dancing
masters helped shape New York's terpsi-
chorean profile. The first American school
of ballet was formed in 1909 by the
Metropolitan Opera, leaning on European
choreographers and traditions for its dance
conceptions. Here a group of ballerinas
rehearses for an operatic performance.

and folk gambols as they were practiced in all the boroughs by the city's mul-
tiethnic population. Perhaps there were now fewer who could execute the ca-
pers demanded by the ziganka, the saltarello, the cacucha, the rigadoon, or the
hornpipe but some basic idioms were being nicely refined at century's end
and exposed to the glare of the spotlight: Irish clog dancing, black hoofing,
and the Argentine tango. All were honored by major productions staged with-
in the embrace of the Great White Way.

CHAPTER THIRTEEN

COMMUNICATION AS ART AND AS INDUSTRY

Literature, Newspapers, Printing, and Publishing

Thomas Gage of His Majesty's armed forces was fuming. "It must give every well-wisher to his Country the greatest Pain and Anxiety to see the Public Papers crammed with Treason," he wrote with an agitated quill to the colonial governor of New York in August 1765. "Every Lye that Malice can invent . . . to sow Dissention and create Animosities between Great-Britain and the Colonys . . . is done with Impunity," he hurried on, "and without any Notice taken of the Printers, Publishers or authors of these seditious Papers." It was the year of the Stamp Act and tempers on both sides of the political fence were boiling. As a promoter of the infamous tax measure, Governor Cadwallader Colden found himself targeted by an angry mob who relieved him of his prized carriage and, after parading effigies of the devil and of Colden himself in it, dramatically burned all three in flames near the fort. The *New-York Weekly Post-Boy* carried an extensive account of the affair, noting that earlier on that day of November 1, 1765, the dissenters had composed threatening papers that were "stuck up all over the Town, some of them in a good Stile."

The *Post-Boy*'s comment on style, an aside almost lost in the focus of the political account, is of significance in confirming that New York's earliest literati were polemicists rather than novelists, poets, or playwrights. This was as true for militant Tories as for those promoting independence. Their well-crafted sentiments appeared in essays, newspapers, documents, private papers, and on sheets "stuck up all over the Town." No doubt Thomas Gage would have much preferred the diverting kind of literature that was making the rounds among his peers in Georgian England: Tobias Smollett's *Peregrine Pickle*, Henry Fielding's *Tom Jones,* and Laurence Sterne's *Tristam Shandy* constituted some of the latest fiction then in circulation. But literary talent of that sort had not yet evolved in New York. No one in either the Dutch or English colonial periods had flirted with the muse of writing by devising plots and inventing characters.

There were, to be sure, minor versifiers, diarists, belletrists, and chroniclers whose responses to the New World date from the seventeenth-century period of Dutch settlement. Peter Stuyvesant himself wielded some colorful prose in the lengthy reports he submitted to Holland. When writing in 1649 to defend his administrative posture, he assured his directors that he was not "impregnated with any sinister motive, passion or favor" and embellished his screed with a Latin quote from Justinian. Jacob Steendam, a clerk of the Dutch

. . . Printing, and Publishing

West India company, preferred the medium of verse in communicating with Holland. In the first published poem on record (1659) relating to Manhattan, Steendam addressed the mother country's neglect of the colony, lamenting that it had been "From her care so quickly weaned." Stuyvesant and Steendam were certainly less talented than the Dutch chronicler Adriaen van der Donck whose documentary account in 1655 of life in the New World is lightened by an aptness for felicitous phrasing. "The air in the New Netherlands is so dry, sweet and healthy," he writes, "that we need not wish that it were otherwise."

When the sweet air of the New Netherlands was taken over by order of Charles II in 1664, no great poetic breezes were swept in with the conquering English fleet. Much time was taken up with the drafting of colonial laws, which according to the first English governor, Richard Nicolls, required "great tryalls and exercise of patience," as well as "divers condescensions and alterations." Perhaps the 1670 chronicle of the English settler Daniel Denton comes closest to fiction with its sustained exaggerations in depicting newly named New York. "The Natives tell us of Glittering Stones, Diamonds or Pearl in the one [area]," he writes, "and the Dutch hath boasted of Gold and Silver in the other."

No makers of literature followed on Denton's heightened prose who could give hints of the extraordinary literary legacy that England had amassed in successive epochs honoring the English tongue: the Chaucerian, the Renaissance, the Elizabethan, and the Jacobean. Rather than a piling on of lyrical tomes, a certain boorishness was the salient trait of England's transatlantic colony, known more for its strides in trade than in refinement of thought. The town's small colonial elite, who represented intellect as well as power and wealth, looked to London and Edinburgh for literature and enlightenment. Abigail Franks, who socialized with the Livingstons, the Bayards, the Schuylers, the Morrises, and the Delanceys, was typical of this privileged cluster of families as the member of a very small, affluent Jewish community. She avidly read the journals, books, and periodicals sent to her from London and particularly enjoyed the *Gentleman's Magazine,* which kept her up to date and informed. Mrs. Franks's erudition allowed her to quote from Shakespeare in her letters, and in one of them, penned to her son in England in 1733, she acknowledges "ye Catalogue of books" and admits that "I could with Vast Pleasure Imploy three hours of the 24 from my Family Affairs to be diping in a good Author: And relinquish Every other Gaity." She grumbled about the ignorance she encountered in the Manhattan colony and took epistolary refuge in calling the ladies of her synagogue "a stupid set of people."

Polemicists and essayists of the Georgian period made enduring contributions to New York's culture in various fields. Before being burned in effigy, Cadwallader Colden wrote a significant number of scientific treatises, while a small group of intellectuals ambitiously formed a club in 1745 called the Society for Encouraging Useful Knowledge. It never did become an overseas counterpart to the Royal Society as hoped, but it did pave the way for a series of short-lived, literary journals, some of them with telling names: The *In-*

FIGURE 13.1 *Portrait of Thomas Gage, 1779.*
New York's earliest literati were polemicists
rather than poets, playwrights, or novelists.
This was as true for militant Tories like
Sir Thomas Gage as for those promoting
independence. It infuriated Gage that
"Printers, Publishers or authors of . . .
seditious Papers" could act with impunity.
Many of these papers were declared by the
press to be "in a good stile."

dependent *Reflector* (1752), the *Occasional Reverberator* (1753), the *Plebean* (1754),
the *Instructor* (1755), and *John Englishmen* (1755). Of these brief New York ex-
periments, often having political overtones, perhaps the *Independent Reflector*
approached the brilliance of the *American Magazine and Historical Chronicle*
(1757) published in Philadelphia. A small but intensely religious voice was
heard in Queens, during the decade of Thomas Gage's fulminations, when the
work of Jupiter Hammon, a slave, was published in 1760; he was the first
American black poet to appear in print. "God's tender mercy brought thee
here / Tost o'er the raging main," wrote Hammon in a poem addressed to
Phillis Wheatley, a fellow writer in Boston who was to garner more fame in
the centuries to come than did her Queens contemporary.

. . . Printing, and Publishing

FIGURE 13.2 *New-York Gazette: And the Weekly Mercury, 1783.* Newspapers and printers had yet to stamp the colony of New York with any distinction in communications as decades of English rule wore on. Boston and Philadelphia had taken the lead. The *New-York Gazette,* printed in 1725 by Hugh Gaine, was the first of four weekly papers to serve the Manhattan area. Only one of the four held non-Tory views.

Like all those disposed to independence from England, Hammon and the family of his master were forced to flee when the revolution erupted. Hammon was not, in any case, leaving behind a lucrative literary market; no such market existed in New York either then or for the rest of the eighteenth century. To be sure. A small coterie of city dwellers such as Elihu Hubbard-Smith, Anthony Bleecker, William Dunlap, John Wells, William Johnson, Samuel Mitchell, Edward Miller, and William Woolsey did make notable attempts, following the Revolution, to promote literary discussion; they were primarily business and professional men who sought enlightenment through mutual instruction. Still, by 1789, there was no local man of letters who could be called on to lend a touch of literary grace to George Washington's inaugural festivities. When the writer Charles Brockden Brown moved to New York from his native Philadelphia at century's close, he lamented that there existed no "set or class of persons, denominated authors." Brown, whose writing tended toward Gothic romances and the doctrines of William Godwin, became the first novelist to earn a modest income in New York through the exercise of his quill. In his work, he championed women's rights. His novel, *Wieland; or, The Transformation* (1798) was followed by other novels, short stories, and criticism, little of which is remembered today.

A decade later, Washington Irving launched a writing career that would bring him substantial fame as well as money. He contributed satirical essays and poems to the literary forum he named *Salmagundi,* described by the Englishman John Lambert in 1808 as a "little work [that] has been deservedly a great favourite with the public. It possesses more of the broad humour of Rabelais and Swift, than the elegant morality of Addison and Steele." Irving's attachment to his native city was the springboard for his first major work, a satirical narrative called *A History of New York from the Beginning of the World to the End of the Dutch Dynasty* (1809). The author laced his narrative with as much fiction as fact, and sprinkled it with frequent digressions prompted, he explains, not by "an unusual spirit of egotism, but merely that the reader may for once have an idea how an author thinks and feels while he is writing." Among the several documentary sources for his history was that of Adriaen van der Donck, a writer he admired. Shaping his writing persona under the pen name Diedrich Knickerbocker, the energetic Irving gathered a productive circle of "Knickerbockers" around him in the city he called Gotham. Like himself, they were gentlemen litterateurs: James Fenimore Cooper, William Dunlap, Fritz-Green Halleck, William Cullen Bryant, Samuel F. B. Morse, Charles Wiley, and James Kent. They swelled the printer's craft with their turnout of novels, poetry, essays, and plays and constituted New York's first "literary set." Cooper created the earliest sea novel in 1821 when he published *The Spy.* William Cullen Bryant enjoyed sustained popularity as poet and editor during the antebellum decades. Through the camaraderie of the Knickerbocker group criticism of prose and poetry got under way, serving to set up literary standards and providing a vehicle for close contact with writing trends abroad.

The Newspaper Stand

FIGURE 13.3 *The Newspaper Stand, ca. 1840.* The French aristocrat Alexis de Tocqueville admired the American press on his visit to the New World, declaring that "the only authors whom I acknowledge . . . are the journalists." Among the increasing newspapers in circulation in the city, the *Herald* (1835) and the *Tribune* (1841) became indisputably the two most influential.

The role of professional critic was spiritedly taken up by Edgar Allan Poe, better known for his short stories and moodily rhyming poems: "The skies they were ashen and sober / The leaves they were crisped and sere- / . . . It was night in the lonesome October / Of my most immemorial year" (*Ulalume,* 1847). Well versed in the writings of the European critic-philosophers Samuel Coleridge and Friedrich Schelling, Poe saw criticism as a science concerned with the principles of writing, less concerned with its content. His was a typical belief of the Romantic era, that a poem deserves to be called a poem "only inasmuch as it excites, by elevating the soul." When the Bostonian Margaret Fuller found New York more to her liking, she, together with Poe, became the leading critics of the early Victorian period. Fuller discoursed with equal facility on the status of American literature—she admired Irving, Cooper, and Charles Brockden Brown among others—and on the status of women; her *Woman in the Nineteenth Century* is one of the rewarding staples of feminist writing. Poe, nonetheless, gave it a highly censorious critique in his *Broadway Journal.*

An equally renowned union of Boston and New York sensibilities was registered in the mutual admiration of the writers Nathaniel Hawthorne and

. . . Printing, and Publishing

THE BROADWAY JOURNAL.

VOL. I. NO. 10.　　　NEW YORK, SATURDAY, MARCH 8, 1845.　　　Published at

Three Dollars per Annum.
Single Copies, 6 1-4 Cents.

C. F. BRIGGS, EDGAR A. POE, H. C. WATSON, EDITORS.

153 BROADWAY, by
JOHN BISCO.

Truth, whether in or out of fashion, is the measure of knowledge and the business of the understanding; whatsoever is beside that, however authorised by consent or recommended by variety, is nothing but ignorance, or something worse.
 LOCKE.

REVIEWS.

WOMAN IN THE NINETEENTH CENTURY.
(Second Notice.)

THE great defect of Miss Fuller's book is a want of distinctness. We can easily discover that her chief concern is to help remove the evils which afflict society; but we cannot discover any hints of the means by which they may be removed. She is sufficiently learned, sufficiently vigorous, and sufficiently earnest, but not sufficiently plain and direct. We have too much of the Scandinavian mythology and the Greek tragedy, and too little of what the book professes to deal with—woman in the nineteenth century. The most direct writing is on a topic that no virtuous woman can treat justly, because she must of necessity be imperfectly informed; it is exceedingly painful to read a portion of her work, which we feel must have been painfully produced; and though we cannot but respect her for her courage in printing it, we regret that she should have felt herself bound to do so, since no good can possibly result from it. There are a thousand existing evils in society which a woman may freely censure, and a thousand topics of pervading interest which she may freely discuss, with profit to her sex, without verging towards those that the innocent had better not know the existence of. We wish that Miss Fuller had loosened the fibula of her arrows, and let them fly at the practices which are, indeed, the direct causes of the lewdness which she deplores, instead of treating of the lewdness itself, which she can only know by hearsay, and of course but imperfectly comprehend.

The only way in which any good can be rendered to society, is by making woman more womanly and man more manly. To make sailors of women and milliners of men, is to have imperfect sailors and imperfect milliners. The advocates of woman's rights who are for putting men and women on a level, point to France as a proof that women are capable of performing all the duties of men; but they would hardly be willing to accept of the morals or the politics of France, which they must do if they adopt her practices. The difference between the sexes in this country is all in favor of the women: the law of courtesy grants them every thing, and the law of the land gives them more than they could ask. The privilege of voting is one which they could not exercise if it were granted, and it is the only privilege that is withheld from them. No change can bring them any good, or at least no greater privileges than what they enjoy at present. Men labor for little else than to make women happy; the cream of every enjoyment is skimmed for their express use, while the sour milk is drank by their lords; the instincts of the mass can be trusted more safely than the speculations of any individual. Men and women fall naturally into their proper spheres when let alone, and there can be no

need of any violent revolutions to displace them from their true positions. The restraints which Miss Fuller complains of as hindering women from becoming blacksmiths, sailors, and soldiers, are the restraints which Nature has imposed, and which can never be overcome. As we have already said, the mind of woman is not endowed with the elements of command, because she cannot originate. There are no other restraints to her doing so, but her own weaknesses. Miss Fuller glories in the "triumphs of female authorship"; but we know of no woman who can claim the merit of originality. And we have no peculiar "signs of the times" in any work which has appeared from a woman's hand. In the Arts, where the creative faculties are tested, women have done nothing. Drawing and painting are considered a necessary part of every woman's education, but the world has produced no famous woman-artist of any kind; yet their way of life peculiarly fits them for artistic employment. There are no restraints upon woman in any civilised country, to prevent her becoming an architect; yet we have never heard of but one architectural work, and that a very recent one, produced by a female. All women are instructed in the rudiments of music, yet we have no female composers. The employments of women are distinct from those of men, and the more perfect that society becomes, the more distinct they will grow. Therefore, instead of its being a cause of complaint that women are compelled to be women, it should be hailed as a sign, indeed, of the incoming of better times.

We believe that Miss Fuller admits the truth of our argument in the following passage, although we are not sure that we comprehend her meaning:

"The especial genius of woman I believe to be electrical in movement, imitative in function, spiritual in tendency. She excels not so easily in classification, or recreation, as in an instinctive seizure of causes, and a simple breathing out of what she receives that has the singleness of life, rather than the selecting and energizing of art."

Among all the "signs of the times" which Miss Fuller takes note of, there is none so encouraging as the following:

"A woman of excellent sense said it might seem childish, but to her one of the most favorable signs of the times was, that ladies had been persuaded to give up corsets."

It is a most favorable sign indeed, and the next generation of men will be all the better for it. But we should be glad to see the candy saloons and worsted warehouses of Broadway disappear along with the corset stores.

Miss Fuller has a great passion for heroines. Among all the females that she has selected for emulation, not one has been taken from the pure feminine creations of Walter Scott. To combat a postulate of Spinoza, she has extracted a long poem from W. E. Channing, a character of a woman from the tragedy of Festus, and a monstrosity—Mother Perpetua, from Eugene Sue. We see no need of a resort to fiction, while there are Catherines, Elizabeths, and Isabellas in abundance.

There are many admirable little episodes in the book, which ever and anon appear, like springs of sweet water

FIGURE 13.4 *Review of Margaret Fuller's Book by Edgar Allan Poe, 1845.*
When Edgar Allan Poe became an editor of the *Broadway Journal,* a review appeared of Margaret Fuller's feminist tract *A Woman in the Nineteenth Century.* The condescending 1845 critique held that "men and women fall naturally into their proper spheres . . . and there can be no need . . . to displace them from their true positions."

FIGURE 13.5
"The New Colossus" by Emma Lazarus, 1883. A native New Yorker, the poet Emma Lazarus attracted the attention of literary critics with her early poems. The well-known lines from her sonnet "New Colossus"—Give me your tired, your poor—reflect the intense compassion that led her to fight for the oppressed. The lines are inscribed on the pedestal of the Statue of Liberty.

FIGURE 13.6
Portrait of the Aging Walt Whitman, 1887. Victorian critics were unprepared for the sensuous and subjective voice of Walt Whitman. Ralph Waldo Emerson hailed him as "half alligator, half song thrush" and his work as a "mixture of the Bhagavad-Gita and the *New York Herald.*" The bard linked himself wholly with the city in poetry of unmatched ardor and color.

Herman Melville who were among the great pre–Civil War voices. Melville felt that the New Englander possessed a mind equal to his own, describing him as a "man of a deep and noble nature" whose profound intellect "drops into the universe like a plummet." A native of Manhattan, Melville lived near the Battery, as had Jacob Steendam a century earlier, and was forever afterward attracted to the mysteries of the sea. Melville's first book, *Typee* (1846), is a marine adventure story as are four subsequent novels. *Moby Dick* (1851), the landmark epic novel that Melville dedicated to Hawthorne, opens with a scene set in the author's familiar Battery neighborhood: "Go from Corlears Hook to Coenties Slip, and from thence, by Whitehall, northward," his narrator declares. "What do you see? . . . Crowds pacing straight for the water." Time and again, the settings in Melville's large corpus of novels, poems, tales, essays, and criticism draw on a familiarity with the New York environment as in *Pierre, or the Ambiguities* (1852). In his "Bartleby the Scrivener" (1853), a short story with Dickensian overtones, the deterioration of Bartleby takes place within the precincts of Wall Street.

"I celebrate myself, and sing myself," declares Walt Whitman in his *Song of Myself* (1855) to the astonishment of mid-nineteenth century critics, unprepared for so sensuous and subjective a voice. Ralph Waldo Emerson thought of the poet as "half alligator, half song thrush" and his work as a "mixture of the Bhagavad-Gita and the *New York Herald.*" Born in Brooklyn, Whitman wrote passionately about every aspect of life in New York, identifying himself with the city in tones unmatched in ardor or color. The poems gathered in the nine editions of *Leaves of Grass* (1855, first edition) heralded a talent powerful enough to draw the spotlight still farther away from the literary world of New England where a remarkable chorus of philosophers, poets, novelists, abolitionists, naturalists, transcendentalists, historians, and independent divines had for long held American readers of the nineteenth century in thrall. The nation's foremost literary scene as developed by Whitman and his contemporaries now belonged to Gotham. As writers, they identified themselves with a democratic, humanistic, and cosmopolitan "Young America," opposed to the elitism of the earlier Knickerbockers and to the theologically tinged morality of New England's literati. They underscored the secularism and cosmopolitanism that were forever after to distinguish New York's literary profile.

Side by side with the impassioned writings of Whitman were nineteenth-century books of scant merit featuring the seamier side of urban life that held the attention of an ever-expanding reading public. They became increasingly numerous as the century wore on, as did the novels of popular writers such as Sylvanus Cobb, who turned out hundreds of novelettes and innumerable short stories, all of them with adventure and morality tailored to Victorian acceptance. "In over a hundred short stories . . . never an impure line," declared the *New York Ledger* at one point in commenting on the author's early output. Cobb was a contemporary of Horatio Alger, a Harvard-educated, Unitarian minister who moved from New England to New York and who conceived

The New Colossus.

Not like the brazen giant of Greek fame,
With conquering limbs astride from land to land;
Here at our sea-washed, sunset-gates shall stand
A mighty woman with a torch, whose flame
Is the imprisoned lightning, and her name
Mother of Exiles. From her beacon-hand
Glows world-wide welcome; her mild eyes
 command
The air-bridged harbor that twin-cities frame.

"Keep, ancient lands, your storied pomp!" cries she
With silent lips. "Give me your tired, your poor,
Your huddled masses yearning to breathe free,
The wretched refuse of your teeming shore,
Send these, the homeless, tempest-tost to me,
I lift my lamp beside the golden door!"

Emma Lazarus.

November 2nd 1883.

Walt Whitman
Sept: '87

well over a hundred tales for boys. Most of them, written in the last quarter of the century, leaned toward the perseverance-triumphs-over-obstacles formula; they sold millions of copies for long after he died.

Watching over the buildup of native literature in these post–Civil War decades was William Dean Howells, the supreme arbiter of taste and the doyen of American letters. Howells garnered wide audiences in New England and New York with his fiction, his essays, and his insistence on literary polish and perfection of style. A fundamental dictum of his was that art must serve morality. Writing in the foremost periodicals of the day, Howells represented the voice of the new realism, a reaction to the Sylvanus Cobb type of popular romance as well as a departure from his own earlier novels of manners. In considering Howells's prose, Mark Twain, a Missourian who sojourned often in New York and wrote about the city, found it stylistically "a continual delight and astonishment. . . . He is, in my belief, without peer in the English-speaking world." It is no surprise, then, that with the defection of Howells from Boston in the 1880s, the center of literary gravity was fixed firmly in New York. In 1890 the erstwhile Bostonian published *A Hazard of New Fortunes,* his first novel placed in Manhattan.

The new realism was championed by Henry James and Edith Wharton, lyrical voices of the Gilded Age, a term coined by Twain. Both native New Yorkers, James and Wharton moved within elitist circles and used the conflicting standards of high society as grist for their realist fiction. Many of their novels stay close to the New York scene, where the manners, the dress, and the concerns of the rich are sharply, and often ironically, delineated. Both were supreme professionals, writing poetry, criticism, and travel pieces beyond their tales of fiction, and advancing the genre of the short story. Two of Wharton's masterpieces with New York settings are *The House of Mirth* (1905), which centers on the story of a Manhattan girl whose misplaced values lead to tragedy, and *The Age of Innocence* (1920) in which the author attacks unyielding standards in high society. Wharton was strongly influenced in her work by the older Henry James whose contemplation of social mores rises above the ordinary novel of manners. It was James who introduced psychological realism as a pervasive element in fiction; *The Portrait of a Lady* (1881) is considered a choice example of this new aesthetic direction.

James and Wharton were joined, as major voices, by turn-of-the-century writers such as Theodore Dreiser, Stephen Crane, and others who found a theme for their fiction in the pathos of life as it concerned mostly the urban middle class. Crane's *Maggie: A Girl of the Streets* (1893) is actually couched in tenement surroundings, but the heroine's descent and ultimate death bear a close relationship to Dreiser's Hurstwood in *Sister Carrie* (1900), as well as to Wharton's Lily in *The House of Mirth.* City dwellers who decline into lethargy, indifference, or self-destruction became one of the leading motifs of the novels of naturalism, an aesthetic that had been launched some time earlier with the appearance of Emile Zola's *L'Assommoir* (The Dram Shop). This powerful 1876 epic of a proletarian family ruined by poverty and drink, and

Zola's sequential novels featuring the same family, strongly affected the craft of fiction in New York and elsewhere.

As the city slipped into the Roaring Twenties, new voices, new themes, and new styles enlivened the torrents of pages issued as novels or as shorter pieces in pioneering literary magazines. With the widening network of the city's printing and publishing worlds lending support, the rank of Gotham as the nation's leading literary center took on increasing weight. Native talent engaged in the writing of plays, prose, and poetry was joined by the pencraft of others attracted to New York from all parts of the country. A fair number made their way to Greenwich Village, a west side neighborhood of narrow streets and colonial charm that attracted Edna St. Vincent Millay, Eugene O'Neill, Walter Lippmann, John Dos Passos, Hart Crane, e. e. cummings, Edmund Wilson, Willa Cather, John O'Hara, and many other writers of equal or lesser stature. It was a teeming seedbed of avant-garde ideas in literature, politics, and behavior that the eager Olive Brand from Salt Lake City, a character in Dreiser's *Gallery of Women* (1929), found seductive. "Oh, what a girl was Olive," wails the disapproving husband in the story, "before ever she had been tainted with the virus of these radicals! . . . They had turned her head . . . [these] Greenwich Village ne'er do wells, pseudo and disgraced artists and poets . . . an unholy and disgraceful crew." Out of this Greenwich Village tapestry of wits came some enduring masterpieces.

Literary voices that contributed to the chorus of the 1920s streamed also from two of New York's ethnic neighborhoods: Harlem and the Lower East Side. An unprecedented wave of creativity took hold in the uptown black community, which spiraled into an era known as the Harlem Renaissance. Countee Cullen, Langston Hughes, Nella Larsen, Zora Neale Hurston, Arna Bontemps, Rudolph Fisher, and Jean Toomer were among those who brought their talents to bear on the issue of black identity both in terms of the written page and in terms of the intellectual camaraderie that was engendered. Most writers of the time were not natives of the city but their combined voice registered a strong ethnic presence and focused world attention on this New York neighborhood. Black and white talents were intertwined, and publishers became receptive to the new black voices. In 1928 Claude McKay's *Home to Harlem* made the bestseller list. Perhaps the most lyrical recorder of the Renaissance in black prose, poetry, and drama was Langston Hughes whose *Big Sea* (1940) re-creates the euphoria that allowed black artists to make their mark. "It was a period when every season there was at least one hit play on Broadway acted by a Negro cast," Hughes writes, "and when books by Negro authors were being published with much greater frequency and much more publicity than ever before or since n history."

In an ethnic neighborhood of New York on the lower east side that received the influx of East European Jews from the 1880s to the 1920s, still other literary voices were heard. To serve these new makers of literature, a cluster of periodicals and newspapers surfaced. Almost exclusively, journalism was to provide the chrysalis for the flowering of the Yiddish literature they created

because books were too expensive to produce and equally too expensive to buy. The *Jewish Daily Forward* and the *Day* were particularly strong vehicles in promoting the creative pieces of writers capable of a fine, colloquial flow. East European authors whose work appeared in newspaper serialization shaped the Yiddish dialect into a literary tongue replete with richness and individuality. Mokter Sforim Mendele, I. N. Peretz, and Sholem Aleichem largely led the way with their talents in a journalistic world that thrived on an intimate relationship with its readership. Peretz described their work as "a literature of the moment, topical, unable to get out of the Polish or Lithuanian *shtetl*." But they did get out: into the homes, the streets, the factories, and sweatshops of east side immigrant workers who were quick to respond to the thematic allusions in what was essentially an organic literature.

Adjustment to the teeming life of New York provided endless themes. Abraham Cahan, long the editor of the *Jewish Daily Forward,* conceived his powerful *Rise of David Levinsky* (1917) with the city as background, as did Anzia Yezierska in her *Salome of the Tenements* (1922). Probably the most popular Yiddish writer in the era of the 1920s was Sholem Asch whose later novels *The Mother* (1930) and *East River* (1946) were devoted to Jewish life in the city. Isaac Bashevis Singer caught the imagination of a still-wider public beginning in the 1930s and did so until well after the Holocaust, with most of his work translated into English. While rooted in an East European shtetl past, Singer's tales marked the gradual secularization of ethnic materials by moving toward Western literary norms. "Yiddish literature," lamented the critic Irving Howe, "was unhappily compressed into a few fervent decades."

Jewish writers, black writers, and writers of the most varied backgrounds were welcomed by the *New Yorker,* a magazine founded in 1925 that came to be applauded for its trenchant journalistic prose and new voices in fiction. Dorothy Parker, Robert Benchley, Alexander Woollcott, and E. B. White were among the early writers attached to the weekly magazine who were influential in shaping its profile. Lillian Hellman, Willa Cather, Ralph Ellison, Jack Kerouac, Norman Mailer, James Baldwin, Mary McCarthy, William Styron, Truman Capote, James Jones, Irwin Shaw, Allen Ginsberg, Jason Epstein, Saul Bellow, John Updike, John Cheever, Susan Sontag, and dozens more appeared at one time or another in its pages or had their work reviewed there. They represent seven decades of literati with highly individual writing styles.

A foremost spokesman for the Beat Generation of the 1950s was Allen Ginsberg, whose volume of poetry entitled *Howl* (1956) became popular on university campuses as did J. D. Salinger's *Catcher in the Rye* (1951); they enjoyed a wide general audience as well. In that decade, Ralph Ellison published his *Invisible Man* (1952) in which he combined realism, folk story, mythology, and surrealism—a veritable fugue of narrative techniques. *Herzog* (1964) by Saul Bellow, the story of a neurotic Jewish intellectual, was a best seller in the 1960s as was Bernard Malmud's *The Fixer* (1967), centered on a Jew falsely accused of murder. In the following decade Norman Mailer and Tom Wolfe aired a new aesthetic with their introduction of fictive journalism. Publication

of E. L. Doctorow's *Ragtime* (1975), a fusion of fact and fiction, harked back in approach, though not in style, to Washington Irving's satirical *History of New York*. John Updike began to enjoy widespread popularity beginning in the 1970s with themes that embrace American middle-class mannerisms, particularly in his Rabbit series of novels. His prodigious output of poetry, criticism, short stories, and novels offers a writing style that would have pleased William Dean Howells.

And what style characterizes the generation of New York writers facing the twenty-first century who clutch their ballpoints or, attendant upon the muse, stare into computer screens that have replaced the quill, the fountain pen, the pencil, and the typewriter? One of the trends is toward the novel of consciousness or confessionalism. Such a tale or poem deconstructs experience to offer a personal vision often charged with raw emotionalism, forays into psychoanalysis, violence, sexual explicitness, and rarified subtleties. Confessionalism extends beyond novels into the current vogue for memoirs that are perhaps in more demand than confessional novels. Their popularity reflects the recent opening up of the category of literature to writing other than fiction. Another strong writing trend is toward feminist themes as exemplified by Susan Brownmiller in prose, Adrienne Rich in poetry, and Wendy Wasserstein in drama. The mystery genre continues to provide excellent escape literature as do chronicles of travel.

Still, these trends are several among many. What continues to define the New York literary tradition is the secularism and cosmopolitanism that had taken hold in the nineteenth century. In separating Gotham's literary persona from that of more provincial New England, the twentieth-century critic Edmund Wilson wrote that "New Yorkers, all facing, as it were, in the direction of the mouth of the Hudson, have more easily passed out into the larger world, and the great city in which they have all sojourned has been cosmopolitan and always changing." An economic link, as well as cosmopolitanism, unifies writers who move in and out of the city's precincts. Ever alert to the commercial dimensions of culture, Gotham has established itself as the foremost marketplace where determined authors from all regions of the country seek to have their work published, marketed, and sold. New York is, in the words of Walt Whitman, "the main spring, the pinnacle, the extremity, the no more beyond" of the American publishing world.

Newspapers and printers had yet to stamp the colony of New York with any distinction in communications as decades of English rule wore on. True, the Dutch had left no heritage to build on when they surrendered New Amsterdam in 1664; there was not even so much as a printing press, despite Holland's extraordinary publishing lead in seventeenth-century Europe. The first colonial hand press finally made its appearance in 1693, long after presses were operating in Boston and Philadelphia. Benjamin Franklin's busy press in Philadelphia was to create a precedent when it brought out the first novel published in America, an edition of Samuel Richardson's *Pamela* (1740). It was issued not

FIGURE 13.7
Herald Square and the Herald Building, 1899.
When the *New York Herald* moved to new quarters in 1893 at Broadway and Thirty-fourth Street, that intersection came to be known as Herald Square. Press rooms were visible to the public through the plateglass windows of the splendid building inspired by Italian Renaissance motifs. Nearby, a beguiling young woman stops to buy a *Herald* from a newsboy.

FIGURE 13.8 *Mr. Eustace Tilley, 1925.*
Writers of the most varied backgrounds were welcomed by the *New Yorker,* a literary magazine founded in 1925 that came to be applauded for its trenchant journalism and new voices in fiction. Cartoons also became a strong feature. The ultraeffete image of Eustace Tilley created by the artist Rea Irvin remains its ever-popular logo.

long after its critically acclaimed appearance in London because Franklin knew that everyone with any pretensions to literary interests was reading *Pamela.* When New York's presses became active, the city could at last claim four weekly newspapers, all established before the mid-eighteenth century: The *New-York Gazette* (1725), the *New-York Weekly Journal* (1735), the *New-York Weekly Post-Boy* (1743), and the *New-York Evening Post* (1744). Three of the four were Tory in sentiment.

The *New-York Weekly Journal,* "containing the freshest Advices, Foreign, and Domestick" soon found itself at the center of a storm for its non-Tory views. Its publisher, John Peter Zenger, was hauled into prison in 1734 for allowing his paper to contain "many Things tending to Sedition and Faction, to bring His Majesty's Government into Contempt, and to disturb the Peace thereof." Four of its issues were ordered to be "burnt by the Hands of the Common Hangman, or Whipper, near the Pillory in this City." The publisher endured a year of incarceration for seditious libels during which time Anna Catherine Zenger ably carried on publication of her husband's paper. Zenger was fortunate in having the venerable Andrew Hamilton, a highly respected lawyer, plead his case in the colonial court. "I agree with Mr. Attorney, that Government is a sacred Thing," Hamilton conceded at the outset, "but I differ from him when he would insinuate, that the just Complaints of a Number of Men, who suffer under a bad Administration, is libelling that Administration." This is "not the cause of a poor Printer," Hamilton argued; "it is the Cause of Liberty." The jury returned a verdict of not guilty, a landmark decision attained by New York for the colonies in the cause of a free press.

Following independence, newspapers rapidly multiplied. By 1800 there were five daily papers in addition to several weeklies; by midcentury the number of dailies had doubled. Of these, the *New York Herald* (1835) under James Gordon Bennett and the *New York Tribune* (1841) under Horace Greeley were the most influential. Earlier in the century when Alexis de Tocqueville published his views of America, he felt the country had "properly speaking, no literature." But the French aristocrat did admire the press. "The only authors whom I acknowledge as American," he wrote, "are the journalists." He certainly would have included Margaret Fuller in that pronouncement. Fuller's engagement as columnist by the *Tribune* heightened the value of the paper; it also registered a hopeful place in journalism to be attained by women.

News-gathering in Fuller's day was managed by pony express, pigeons, railroads, and steamboats, putting Manhattan at a considerable advantage since it was both a railroad hub and seaport. In 1846, a year that saw the introduction of the steam press and the Hoe rotary press, Fuller wondered if the recent invention of the electric telegraph would allow journalists to place a more pronounced emphasis on analysis rather than on news-gathering since she believed, somewhat like Tocqueville, that "the most important part of our literature . . . lies in the journals which . . . form at present the only efficient instrument for the general education of the people." When the *New York Times* was launched in 1851, it began with the advantage of telegraphic facilities.

A new dimension in presenting the news came with the advent of illustrations. *Frank Leslie's Illustrated Newspaper* (1855) and *Harper's Weekly* (1857) pioneered in this coupling of engravings and text, made possible by the compatibility of typeface and woodblocks in the printing rack. One of the most talented of those employed by *Harper's* in the nineteenth century was Winslow Homer, whose engraved drawings for that weekly are highly prized. Photography soon advanced enough to serve the reporting of the Civil War, while in 1888 it served the cause of the poor when the *New York Sun,* under the able direction of Charles A. Dana, published the shocking slum scenes photographed by Jacob Riis. Like other major papers, the *Sun* carried not only illustrated news but the fiction of top-flight writers. Turning to Mark Twain, Dana declared in May 1884 that "I have got Henry James and Bret Harte and I must have you."

As the nineteenth century came to a close, New York's multiple newspapers, journals, and magazines thrilled to the invention of Marconi's wireless telegraph. News could now be reported "forty miles away without the use of wires," exulted the *New York Herald* in its October 1, 1899, issue, declaring it "a feat unparalleled in the history of journalism." That world of journalism continued to expand mightily as waves of immigrants swelled the reading public and as magazines like *Time* (1923) and *Newsweek* (1933) offered spirited digests of the week's happenings. The combined total of dailies and weeklies climbed to well over two hundred following World War I, including papers of nineteenth-century origin printed in the outer boroughs such as the *Brooklyn Daily Eagle* (1841); it had been edited for two years by Walt Whitman and lasted well over a century. In the tally of notable papers was the *Wall Street Journal* (1889), which had begun modestly some decades earlier as a bulletin monitoring stock activity. Picture magazines, headed by *Life* (1936), also increased in circulation following the First World War; they garnered wide audiences as they swelled the arena of photojournalism in which women attained conspicuous roles. Jessie Tarbox Beals had led the way in 1900; now Margaret Bourke-White and Berenice Abbott achieved fame with their stunning photo-realism.

Newspapers, magazines, the printing trade, photography, and book publishing extensively widened the city's economic base as they gathered force in the arena of communications. Further, New York's multiple papers earned the distinction of serving not only English-speaking readers but ethnic populations of an impressive range of tongues: Arabic, Carpatho-Rusyn, Chinese, Croatian, Czech, French, German, Greek, Hebrew, Hungarian, Italian, Korean, Polish, Russian, Serbian, Slovak, Slovenian, Spanish, Ukrainian, and Yiddish. Foreign-language papers were less affected during the spiraling curve downward, which began in the 1960s, in New York's giant newspaper industry. It was about then that television presented itself as an innovative and effective communications agent. Because there was nothing in print technology to rival TV's instantaneous reporting from a point thousands of miles away, the city's major English-language dailies steadily dropped in number by the

onset of the twenty-first century to as low a count as four: the *Times*, the *Post*, *Newsday*, and the *Daily News*.

What is perhaps noteworthy about the count of four is that it matches the number of eighteenth-century weeklies with which New York began to assemble its spectacular communications history. The current paucity of major newspapers in communications-driven New York, with its concomitant lack of competition in presenting the general news to a city numbering millions of readers, has in no way diminished the indispensable coverage offered by its number one paper, the *New York Times*. Here, detailed reporting and analysis, in all fields of major and minor concerns by journalists assigned to far-flung areas of the globe, continues to mark the *Times* as a paper of national and international rank. It has also, in the last decade or so, conspicuously stepped up its boroughwide coverage of the city's happenings and concerns. With its specially focused sections and Sunday supplement, the *Times* functions as a reliable recorder both of New York's and the nation's daily history. "Like the Yankees, the Stock Exchange and other institutions bearing the New York name," declared Mayor Rudolph Giuliani in a 1996 tribute to the paper, "the *Times* helps to define the city and enhance its reputation around the world."

Book publishing in New York, which would become one of the city's ranking communications industries, got off to a remarkably slow start. It did not escape the notice of Benjamin Franklin, the most resourceful of colonial printers. Visiting the city from Philadelphia in 1723, he wondered how residents managed with such a meager offering of books: those "who lov'd Reading were oblig'd to send for their Books from England," he remarked with a certain tinge of hauteur. Not for long would this be true. When colonial New York set about building the first blocks of its future book publishing empire, it turned to a brash solution: piracy. Of the city's earliest colonial publishers—William Bradford, Hugh Gaine, and James Rivington—it was Rivington who first began pirating popular foreign books for his press. William Bradford's imprint on the title page of the *Citty Laws* flagged his royal connection as the colony's official printer: "At New-York, Printed and Sold by William Bradford, Printer to their Majesties, King William and queen Mary, 1694." Hugh Gaine, an Irishman and merchant, specialized in almanacs and books for children.

Colonial publications were initially of a theological, legal, scientific, or documentary nature. A pioneering volume on native Americans by Cadwallader Colden entitled *The History of the Five Indian Nations* was "Printed and sold by William Bradford in New-York, 1727." When the same book was issued in London twenty years later, antipathy to Indian themes and names rendered the English edition lamentably altered. More Manhattan printer-publishers joined the initial three. One of the most enterprising among them was James Parker, a protégé of Benjamin Franklin. In 1745 George Berkeley's *Abstract from Dr. Berkley's* [sic] *Treatise on Tar-Water* bore the imprint "New-York, Printed and sold by J. Parker."

. . . Printing, and Publishing

FIGURE 13.9
Portrait of Edna St. Vincent Millay, ca. 1928.
The young Edna St. Vincent Millay brought
to the Greenwich Village literary scene a
refreshingly new voice and a Pulitzer Prize
(1923) for her *Ballad of a Harp-Weaver.*
Popular among the Village crowd, Millay
supported liberal causes and was among
those arrested in 1927 for their protest of
the Sacco-Vanzetti indictment.

Following the Revolution, New York's book-printing industry began to
pick up momentum. Already in 1807, the English chronicler John Lambert
noted the lucrative aspects of the book trade, remarking that "the booksellers
and printers of New York are numerous, and in general men of property." A
distinct factor in widening the market for New York's booksellers and print-
ers was the success of the Erie Canal. Harper and Brothers, followed in pro-
ductivity by John Wiley; Appleton; Dodd, Mead; and Putnam, turned out
books with titles in virtually all fields. The canal enabled Harper's, founded in
1817, to undersell local publishers of school and religious books in Ohio. For

FIGURE 13.12 *Sketch of Truman Capote by Andy Warhol, ca. 1954.*
FIGURE 13.12 *Sketch of Truman Capote by Andy Warhol, ca. 1954.*
Truman Capote and Andy Warhol were both trendsetters in the 1950s to 1970s, capturing a large following—the first in the world of literature, the second in art— among the New York public. Warhol's sketch of Capote is one of the many he drew of celebrities. Beyond strong creative talent, the two had in common a blatant narcissism.

tions in turning out the printed word—following on the technological leaps of color printing and computer-generated editions—are sure to be dazzling in time to come.

But what of the publishing world itself? A startlingly high number of book firms and magazines have been subjected to a dizzying pattern of mergers, buyouts, and takeovers. Some of the oldest and most respected of New York's publishing houses have been bought, in the 1990s, by European firms, media industries, and American conglomerates in which time-honored publishing (a love of the book) is not the core business. Profit making is, or as the *New York Times* of March 26, 1998 declared, "the book business is now a business of bookkeeping." Small independent book firms and university presses stand ready to guard the turf but genuine concern has been aroused for the survival of what may be termed the poetic principle: it propels the publishing of a book for the sake of its literary worth alone. Fostering literature based on this principle has given dignity and pride to New York's publishing world and garnered for its authors a whole gamut of prestigious awards.

Perhaps parallels can be drawn with the fifteenth century when the cherished world of illuminated manuscripts was brought to a halt by the Gutenberg press in a triumph of technology over aesthetics. Will the poetic principle be ground to a minimum in the face of the profit principle? That is yet to be seen. A new chapter in publishing awaits as the twenty-first century gets under way.

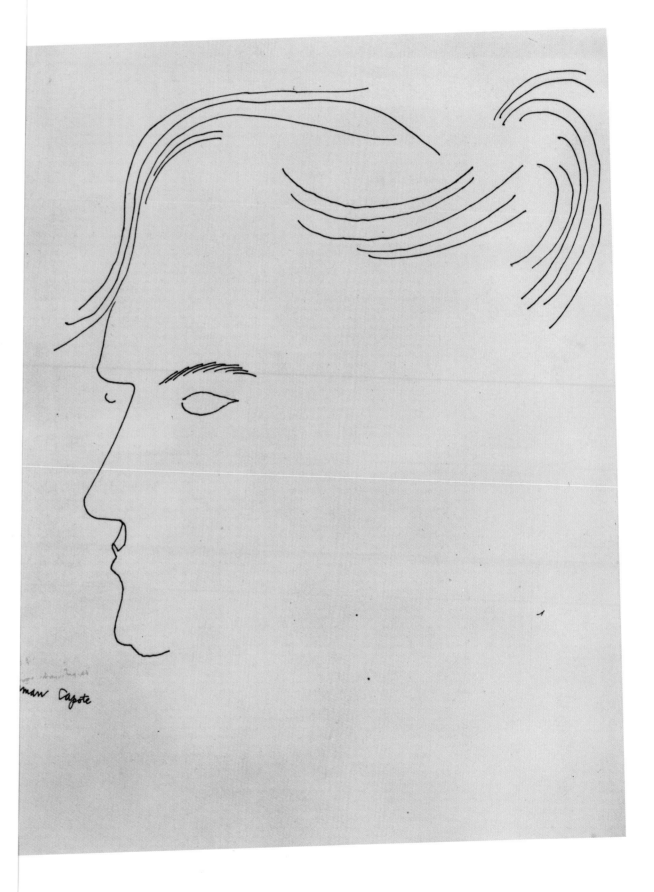

FIGURE 13.10
Olive Brand in a Greenwich Village Cafe, 1929.
"Oh, what a girl was Olive before ever
she had been tainted with the virus of these
radicals! . . . [these] Greenwich Village ne'er
do wells . . . an unholy and disgraceful
crew." So laments her husband in Theodore
Dreiser's fictional story *A Gallery of Women*.
Artist Betty Petschek offers a glimpse of
Olive at a Village cafe.

many literary and other titles, American firms, particularly Harper's, pirated
English editions with impunity, protected by a nineteenth-century copyright
law that favored only American authors. Not unrelated to piracy was an im-
pudent question posed in the January 1820 issue of the *Edinburgh Review*: "In
the four quarters of the globe," a columnist asked, "who reads an American
book?" Outrage was registered in the commercial and literary quarters of
Gotham, yet it was true that the country's cultural life was still derivative. It
was equally true that pirated editions of the classics, and of works by contem-
porary foreign writers, were cheaper to buy. One of those writers was the au-
thor of *Oliver Twist*.

New York's publishing world was considerably unsettled in 1842 when
young Charles Dickens, flushed with success, visited the city. The twenty-nine-
year-old Dickens had five published novels to his credit, and all of them were
pirated. Though this gave him an English-reading public on the New World

side of the Atlantic, it robbed him of revenue: the United States was still declining to make a reciprocal copyright agreement with Great Britain. During his visit Dickens had hoped to enlist Gotham's publishing world on his side but was instead viciously opposed. "I have never been so shocked and disgusted," fumed the novelist in writing to an American friend, "as I have been . . . in reference to the International Copyright question . . . [with] scores of your newspapers attacking me in such terms of vagabond scurrility as they would denounce no murderer with." Not for another century would the matter of international copyright be resolved.

During the Victorian decades, New York firmly established itself as the publishing center of the nation with a vibrant support system of printers, printmakers, advertising agencies, photography laboratories, paper suppliers, job offices, and numerous bookstores firmly in place. And in 1853 Harper and Brothers rendered the vexing question of the *Edinburgh Review* quite redundant: in that year the firm published more than seven hundred books of which nearly four hundred were by American authors. Could the authoritative *Review* now dare claim that no one in England was reading an American book? To register the economic impact of the burgeoning book industry, the name of Printing House Square was given to the crossroads of Park Row and Nassau Street where the newspaper, publishing, and printing industries were concentrated in the post–Civil War years. Already, paperback editions had become a regular feature, and in the 1870s *Publishers Weekly* and the *Library Journal* made a much-needed appearance to serve the publishing world through reviews and news of the trade. Before the century was out, Columbia University Press, the first of several university presses to be located in the city, was established.

The importance to metropolitan New York of a critical journal was recognized by Henry Seidel Canby who launched the *Saturday Review of Literature* in 1924. Its service to book publishing was reflected in a circulation of nearly six hundred thousand, which it reached before eventually disappearing. Critical journals such as the *New Republic* (1914), the *Columbia Journalism Review* (1921), and the *New York Review of Books* (1963) have added luster in the twentieth century to the numerous journals that monitor print news, enlist prominent reviewers, or serve as important media for book advertising. These and all areas of the publishing world continue to open up opportunities for women as editors, owners, sales and marketing executives, publishers, and literary agents. Blanche Knopf had early on established high standards, in the firm of Alfred A. Knopf (1915), with regard to the quality of fiction offerings and book design. Barbara Epstein pioneered in forming the *New York Review of Books,* while several women editors—among them Elisabeth Sifton, Helen Wolff, Nan Talese, and Margaret McElderry—have carried their own imprint on books published by their firms. The book trade today is part of a dense world of words created not only by books but also by the electronic highways of the World Wide Web, microwave transmissions, television, satellites, and digitalized newsprint. In the face of such a communications deluge, innova-

SPORTS FOR ALL SEASONS AND ALL FANS

Take Me Out to the Ball Game

Take me out to the ball game, Take me out with the crowd
Buy me some peanuts and cracker jacks, I don't care if I never go back
For it's root, root, root for the home team
If they don't win it's a shame
For it's one, two, three strikes you're out at the old ball game.

There were no handouts of peanuts or Cracker Jack but plenty of ball-playing in colonial Manhattan. Varieties of this pastime were imported across the Atlantic by the Dutch during the steady transfer of their seventeenth-century culture to the New World. Not baseball, of course; that was a much later creation. Still, rudiments of the future Yankees team play were foreshadowed in colonial games where balls were thrown, kicked, and chased or just as often whacked with a mallet, a club, a racket, or a pared-down stick. Dutch burghers of Manhattan delighted in games of bowls, skittles, kolf, paille-maille, old cat, stool-ball, round-ball, and ninepins, which they played within the narrow confines of the fledgling settlement or in nearby open spaces. Invariably, players positioned themselves not far from the sight of a tavern where athletic exer-

FIGURE 14.1

James, Duke of York, Playing Tennis, 1641.
Tennis dates from the Renaissance but
was only imported to the New World in
the late nineteenth century. The first lawn
court was constructed in 1874 on grounds
in Staten Island. Here the eight-year-old
James, Duke of York, after whom New York
was named, plays tennis to a captive court
audience with decidedly restrained pleasure.

tions were punctuated with a welcoming drink. Kolf was played by both men
and women with a hooked club that was sometimes faced with metal. Since
it was also played on ice, it appears to have been the forerunner more of hock-
ey than of golf, a sport that was already being developed in Scotland. When
Dutch women took up the game of kolf, they used a racket with netting to
drive the horsehair-filled ball, suggesting early features of tennis.

New World natives of Manhattan had their own versions of ball-playing,
and rolling the hoop as well. But their athletic prowess came into far more
conspicuous profile when engaged in hunting or fishing. Here techniques of
the bow and arrow that natives had superbly honed were passed on to their
colonial invaders, along with the arts of spearing fish and of canoeing. To be
sure, Indians engaged themselves in these activities out of necessity rather than
sport, yet neither their skills nor a natural pride in performance were thereby
diminished. Nor could their athletic leanings ever earn the label of idleness
that was often assigned to the behavior of early New Amsterdam settlers who
sought diversion in countering the rigors of frontier life. Colonial administra-
tors steeped in moral rectitude frowned on an indulgence in sports, an atti-
tude that was admittedly harder to sustain in the lusty seaport atmosphere of
Manhattan than in either New England or the South. Popular Dutch games
such as "clubbing the cat," in which players baited a feline cooped up in a bar-
rel, or "pulling the goose," wherein the fowl's neck was fatally wrung, were
considered among the diversionary events that, because they stifled feelings of
humanity, were unfriendly to morals. This was deemed especially true when
bets were taken, as they frequently were.

As a deeply religious Calvinist, Peter Stuyvesant, on his arrival as governor,
scanned the seventeenth-century sporting scene with a suspicious eye, con-
vinced that too much recreation would lead to mischief and "kindle the anger
of God." He looked for possible occasions to ban sports and to deny any mer-
rymaking considered to be of a corrupting order. Early in 1654 he forbade
"certain farmers' servants to ride the goose of Bacchus at Shrove-tide" because
it was deemed "censurable for subjects and neighbors to celebrate such pagan
and popish feasts and to practise such evil customs in this country, even
though they may be tolerated and looked at through the fingers in some
places in Fatherland." On another occasion, in the fall of 1659, the high-mind-
ed governor set aside October fifteenth as a day of general fasting and prayer
lest, as he feared, the heavens would visit wrath on the settlers because of "dila-
toriness in God's service, blaspheming His holy name, desecrating the Sabbath,
drunkenness, lasciviousness, whoredom, hate, envy, lies, fraud, luxury, abuse of
God's gifts, and many other iniquities." He spelled out the terms of the fast-
ing: "We interdict and forbid, during divine service on the day aforesaid, all
exercise and games of tennis, ball-playing, hunting, fishing, ploughing and
sowing, and, moreover, all other unlawful practices, such as dice [and] drunk-
enness on pain of . . . corporeal correction."

The fun-loving Dutch nevertheless pursued their sports and did so with far
fewer restrictions than were imposed in other colonies. Winter offered the de-

THE HIGH BORNE PRINCE IAMES DVKE OF YORKE.
borne October = the 13. 1633.

FIGURE 14.2

Kolf Player by Rembrandt, 1654.

The game of kolf was played enthusiastically by the Dutch in the seventeenth century and brought to New Amsterdam. It became the basis for ice hockey rather than golf. Colonial rulers of New Amsterdam, particularly Peter Stuyvesant, frowned on too much recreation through games lest they lead to corruption and "kindle the anger of God."

lights of sleighing and ice-skating of which all Dutch people were fond. Sleighing on snow-laden roads also served as a form of transportation; ice-skating took place on the several frozen surfaces that dotted the lower reaches of Manhattan. The largest of these was the Collect Pond, a picturesque reservoir located in the neighborhood surrounding today's Foley Square. Racing of a primitive sort was devised by New Amsterdam carters who liked driving their wagons or carts at a gallop, something absolutely prohibited, however, within the narrow confines of the town as being too dangerous to the movement of pedestrians. Drivers were ordered to walk alongside their oxen or horses; if found sitting or standing on their carri-ers, heavy fines were imposed along with suspended use of the vehicle for six weeks.

A lively expansion in the range of seventeenth-century sports was to accompany the subsequent wave of colonial rule in Manhattan when the English supplanted the Dutch in 1664 and held sovereign sway until the close of the Revolution. During their tenure, the English steadily imported elements of their cherished sports practices in which the prominent features were ball

and horse. The first royal governor, Richard Nicolls, undoubtedly an accomplished equestrian like all members of the Duke of York's household, offered a silver cup for a horse race to be held every spring and fall in the western stretches of "Yorkshire," the name he gave to Long Island. His declared motive in 1665 was "not so much for the divertissement of youth as for encouraging the bettering of the breed of horses which through great neglect has been impaired." Good horses were needed for mounted troops, a point not lost on the duke's appointee who, having been commanded "to See that ye Publick Peace and Safety, bee diligently attended," was ever fearful "of the Enemyes approach." Beyond defense and recreation, a good horse was an appealing alternative to walking or riding in bumpy coaches as a way of getting about in Manhattan and the adjoining colonial territories.

Nicolls's successor as governor, Richard Lovelace, continued to promote annual races in the Hempstead area of Long Island. Here, on the farming stretches of the island was discovered a level of very fine grass, known first as the Salisbury Plains and then as Newmarket, considered ideally suited to an equestrian run. It was glowingly described by the chronicler Daniel Denton in 1670 as a course "where you find neither stick nor stone to hinder the Horse heels or endanger them in their Races, and [where] once a year the best Horses are brought hither and the Swiftest rewarded with a silver Cup." Races on this grassy stretch soon became widely known along the Atlantic coast, indicating that the romance of the turf, kindled in medieval England, had taken firm root among the inhabitants of the newly named New York colony. From that time on, racetracks steadily proliferated.

English traditions had a profound influence in shaping most athletic and recreational practices in the eighteenth century. A wide offering now enlivened the scene in the ever-expanding and prospering New York seaport: archery, bowling, hawking, bull and bear baiting, cockfighting, cricket, fishing, fowling, fox-hunting, golf, gouging, hawking, shooting, sleighing, swimming, wrestling, and yachting. With the importation of handsome sleighs, sleigh-riding became an absolute passion in winter. "They are not so strict in keeping Sabbath as in Boston and other places where I had been," noted the Boston visitor Sarah Kemble Knight in 1704. "Their Diversions in the Winter is Riding Sleys about three or four Miles out of Town. . . . I believe we mett 50 or 60 slays that day—they fly with great swiftness, and some are so furious that they'le turn out of the path for none but a Loaden cart."

Water sports were a natural to the sea-encircled town, as they were in England. The East River made a splendid staging area for all sorts of sloops and boats as documented in the panorama of New York of 1717, engraved in London, where the yacht of colonel Lewis Morris takes its place among the featured watercraft. Rowing along Manhattan's other shore became popular, too. A typical race would send boats up the Hudson to Hoboken, and then back to the Battery flagstaff. East River ferries carried racing enthusiasts to the tracks of Long Island even though there were several accommodations for racing, by the mid-eighteenth century, in Manhattan itself. One such track

Take Me Out to the Ball Game

was located on the estate of Sir Peter Warren in Greenwich Village, then well outside of town; another was situated to the north in the Harlem area. Still, most eyes were fixed on the favored turf described by Daniel Denton in 1670, which could now accommodate an astonishing number of steeds. A "great Horse race" run on Hempstead Plains "engaged the attention of so many of this City," claimed the *New-York Weekly Post-Boy* of June 4, 1750, "that upwards of 70 Chairs and Chaises were carried over the [Brooklyn] Ferry from hence the Day before; besides a far great[er] number of Horses; and it was thought that the number of Horses on the Plains at the Race, far exceeded a Thousand."

Games that hinted of extended leisure hours inevitably made their way to the New York colony in deference to the increasing number of the English upper class making up the population. Golf was apparently introduced quite early; an inventory of the belongings of Governor William Burnet, who had arrived to take charge in 1720, included "nine gouff clubs, one iron ditto, and seven dozen balls." Where it was that Burnet managed to devise a fairway is not recorded but open sites were hardly a problem. Ball-playing of a less elaborate order than golf, as well as hunting, fishing, rowing, and a few other diversions, had certainly been well known to Manhattan natives and to the Dutch, but they had fed into the cultural life of the then sparsely populated island either as necessities or as intimate folk play. Now, the very whacking of a ball often took on a sophisticated dimension as English rules of play were applied not only to the ritual of golf but also to a whole cluster of games. In addition to rules, a hierarchy entered the sporting world as well, whereby certain athletic diversions such as hawking, golf, and yachting were reserved for the elite of the colony as was true in the mother country.

The impact of English sporting practices did not vanish with the close of the Revolution and the accompanying exit of royal governors. Rules for athletics that had been set in the colonial era were for the most part honored, and sporting periodicals published across the Atlantic continued to be eagerly read. By then, too, English sporting prints had come to fascinate the public, particularly New Yorkers, who enjoyed seeing them reproduced in the overseas periodicals to which they subscribed and who could afford to buy individual engravings and aquatints to hang on the walls of their homes. When New York's incipient printing and publishing houses of the early 1800s began to amass a readership for local sports news, periodicals like the *New York Sporting Magazine and Annals of the American and English Turf* (1833) rolled off the press. Much of the contents of its early issues comprised extracts from English periodicals, and commentaries came chiefly from the pens of English writers. The editor made no secret of the fact that he would keep the policy and design of his publication close to the model set by the *English Sporting Magazine,* a highly respected overseas publication. Other sports journals that appeared in the early decades of the new republic were invariably based on models set by the English press.

FIGURE 14.3 *Dr. Rich's Institute for Physical Education, ca. 1850.*

Following the routing of the Dutch, in 1664, English athletic traditions had a profound influence in shaping sports and recreational practices. The very whacking of a ball often took on a sophisticated dimension as English rules of play were applied that lasted into the postcolonial era. Well-stocked gyms for men were another heritage from England.

Editorials on sporting events were by this time becoming increasingly frequent in the nonspecialized daily papers. Boxing and wrestling, initially viewed on this side of the Atlantic in a highly unfavorable light, came in for sharp criticism. "We are grieved to find the pernicious customs which disgrace the populace of Europe creeping among us," snorted the *New-York Spectator* of July 15, 1823, characterizing these sports as "scenes of riot, brutality and systematic violation of order and decency, where customs must be acquired which will not bear repetition." It was an Englishman by the name of William Fuller, nonetheless, who managed by his gentlemanly demeanor to make sparring attractive to Americans during the same decade. Fuller maintained a gymnasium in the city; his 1826 advertisement in the *New-York Evening Post* offered instruction in the "manly science of self-defence, whereby gentlemen, after a few lessons will be enabled to chastise those who may offer violence." The *Post* registered its approval of Fuller's curriculum in which gymnastics accompanied the sparring lessons because these exercises gave "vigor to the human frame."

Take Me Out to the Ball Game

An athletic exhibition sparking no controversy was held in the winter of 1821, reminding the increasing numbers of sports-attuned New Yorkers that North American natives had continued to hold their own in displays of skill. "An Esquimaux Indian in his Seal skin canoe . . . pushed off from the Battery bridge and . . . propelled his boat with astonishing rapidity, running by and beating several four oared boats with ease," reported the *New-York Evening Post* of February 3, 1821, adding that he showed a similar prowess in spearing placed targets. "There were upwards of ten thousand people," estimated the paper, "to witness his extraordinary feats." Crowds even larger than that were making the pilgrimage to the future borough of Queens in sustained fascination with events of the turf that had been launched in colonial days. "I went over in the barouche," recorded former mayor Philip Hone in his diary for May 11, 1842, only to find that "the difficulty of getting on and off the course with a carriage are scarcely compensated by any pleasure to be derived from the amusement. . . . The tens of thousands of the sovereign people who wished to see this race made their arrangements by the railroad to go by the South Ferry, but the number were so great that the locomotives refused to draw." A riot thereupon ensued as a horde of irate ticket holders responded volubly to the new and exasperating dilemma caused by steam transportation.

With the refinement of game rules, as well as with an increase in facilities and the formation of sporting clubs, more and more adherents were attracted to individual sports and to athletic happenings. Clubs were a throwback to English practices, with the difference that, as waves of nineteenth-century immigrants expanded New York's population, clubs often took on an ethnic character. This was so for the multiple reasons of language, identification with mother country traditions, a sense of nationalist pride, and a bonding of kindred spirits that was undeniably helpful in adjusting to an already bewildering, heterogenous city. Early clubs included an East River Fishing Club formed by the Irish, the Saint Andrew Curling Club initiated by the Scots, the Saint George Cricket Club formed by the English, and a number of athletic groups organized by German immigrants termed *Turnverein,* or gymnastic societies.

Polo, yachting, equestrian hunts, and racing had their own exclusive, upper-class followers. In the summer of 1844, wealthy Philip Hone noted with snobbish approval the presence of "a gay, saucy-looking squadron of schooner yachts lying off the Battery . . . owned by gentlemen of fortune and enterprise. Crowds of people, especially of the fairer sort," he wrote in his diary, "go down to witness this mimic display of maritime glory; and some of the most favored of our belles and nice young men about town are invited to pleasant parties by the jack tars." A decidedly new chapter was added, following the Civil War, to the equally bewitching saga of the turf when the wealthy New York sportsman Leonard Walter Jerome put his considerable resources behind the formation of the American Jockey Club in 1866; he fostered the opening of the thoroughbred racetrack in the area of the Bronx now known

as Jerome Park. It was a splendid course with a clubhouse that was thoroughly luxurious. Here the Belmont Stakes were inaugurated, lasting until 1890, while the vast track itself (230 acres, 93 hectares) operated until a decade later, when it made way for a reservoir.

The recreational game that appealed to all ethnic groups of the later half of the nineteenth century was baseball. How could it have been otherwise? Here was a game based on camaraderie and teamwork that prodded the zest of the amateur, rewarded the skill of the talented, and raised its heroes to exalted status. It could be played on rustic lots or a formal diamond, and it could switch from an anonymous local scene thrilling youngsters to a grand spectacle eventually mesmerizing thousands. Early equipment was minimal: a ball and a bat. Origins of the game are admittedly moot but more than one kind of colonial ball-playing—cricket and the game of rounders in particular—contributed to its formation. Yet as a malleable construct that adapted neither rules nor rituals from European sources, it was developed and refined in stages on native soil. Different versions of the game held sway until the rules formulated by the New York Knickerbocker Club in 1846 eventually prevailed. Then it was that the four-base diamond was established with ninety-foot base paths, nine-man teams, and players batting in rotation.

Civil War soldiers of the North and South who learned baseball helped to popularize it throughout the country; by the last quarter of the century, a sizable number of teams had been formed. No other sport was to acquire such a widespread following. "The fascination of the game has seized upon the American people, irrespective of age, sex, or other condition," proclaimed *Harper's Magazine* in 1886. Clearly, the game had taken a strong hold on participants and spectators alike and was, by this time, considered an athletic diversion that was quintessentially American. Mark Twain was led to believe that baseball had become "the very symbol, the outward and visible expression of the drive and push and rush and struggle of the raging, tearing, booming nineteenth century." Perhaps, but baseball has its quiet moments, too, with the large green diamond offering a pastoral oasis from crowded city streets. With its contrasts of speed and long pauses, together with the drama of making it to home plate, the game has sparked a variety of reflective remarks. "Baseball is about going home, and how hard it is to get there and how driven is our need," philosophized the twentieth-century scholar A. Bartlett Giamatti. "The journey must always start once more, the bat an oar over the shoulder, until there is an end to all journeying."

As baseball swelled in practice and popularity, the Knickerbocker rules were subject to steady revision. In 1881 the distance between pitcher and batter had increased from forty-five to fifty feet; three years later, overhand pitching was legalized, while at the end of that decade a further tinkering of the rules set the pitching distance to the present-day length of sixty feet, six inches. That year, too, the formula of four balls and three strikes came to define the now thoroughly American game immortalized by Jack Norworth in his 1908 lyrics: "For it's one, two, three strikes, you're out, at the old ball game."

Take Me Out to the Ball Game

Unlike baseball, the associated team games of basketball and football were not urban inventions. Still, New Yorkers embraced these sports, which came to be identified more with the population of colleges and schools than with city-based teams. "The high fever of inter-university football," declared the Englishman Arnold Bennett visiting in 1912, "struck me as . . . [an] authentic phenomenon." Gotham's romance with basketball accelerated in the 1930s when the teams associated with New York University, the City College of New York, and Saint John's University brought the game to an all-time popularity. A low point came in 1951 with the so-called point-shaving scandal, which imputed malpractices to City College's championship team members. But the game's glamour was eventually restored and passionately embraced by youngsters on school grounds, at home, and in gymnasiums all over the boroughs. Juvenile players in the city have contributed conspicuously to the makeup of many winning professional teams.

Football's gear and configuration make it a game that requires some basic training, but it is nonetheless a team sport avidly monitored by the young and the populace at large. High school football has added immeasurably to the educational ambience of teenagers in New York and their team plays often are covered in the Gotham newspapers. Before the advent of television broadcasts, Saturday afternoons in the fall were invariably set aside to watch the matches of visiting college teams programmed in Columbia University's Baker Field and elsewhere in the boroughs. When colorful rivalries between prominent teams such as Notre Dame and Columbia, Army and Navy, or Princeton and Yale were staged in New York, they became a high point of the Thanksgiving holidays. As much pageantry as combat attended each game, with cheerleaders, mascots, marching bands, and pep rallies adding to the exuberance of the spectacle.

What all three athletic pursuits—basketball, football, and baseball—had in common was their contribution toward the blurring of social status. They tended to diminish the ideological and economic differences among the various ethnic communities; at the same time they could reinforce ethnic solidarity. New York City youths learned these games informally in neighborhood lots or on school grounds where they crossed ethnic boundaries and gave their allegiance to shared heroes. Baseball in particular became an Americanizing ritual for the children of immigrants, serving as a common language by which elements of American culture were passed on from generation to generation. In time, all three games turned the axis of the athletic world from one governed by participants to one dominated by spectators.

Boxing and wrestling were, from the start, spectator sports. Even when reviled during Victorian days as blood sports that were socially unredeeming, boxing and wrestling had no trouble drawing crowds. Boxing with gloved hands and strict supervision had difficulties, nonetheless, coming into its own with the dawn of the twentieth century, associated as it was with an unruly audience; this was especially true before boxing events shifted in direction from a show of brute strength to finesse of technique. With boxing's legaliza-

tion in 1920, the city firmly took hold of its role as the nation's boxing capital. Both these sports were among the few that entertained no barriers with regard to color or race.

Facilities to accommodate the burgeoning world of sports became ever more elaborate: playing fields and arenas mushroomed in the varying territories of the five boroughs. Queens, of course, had taken the colonial lead with its seventeenth-century racetracks, while the Bronx and Staten Island followed up with track runs during the course of the next two centuries. An enclosed baseball park—the first ever—was a Civil War diamond of 1862 in Brooklyn's Union Grounds; a second diamond was marked out in Brooklyn's Capitoline Grounds two years later. In the same decade, boxing was dignified with a proper venue: an indoor facility opened in 1879 in the heart of post–Civil War Manhattan that featured sparring as its main attraction. It was the city's first Madison Square Garden, located at the crossroads of Broadway, Madison Avenue, and Twenty-sixth Streets. Here, John L. Sullivan defended the title of heavyweight champion in 1882 and was subsequently to remark: "I have done much to elevate and bring boxing before the public to a degree that had not been known . . . previous to my ascending this ladder of fame."

Success of the Garden's enterprises led to the commission for a second and more elaborate facility, designed by the beaux arts master Stanford White. Lavishly decorated in terra cotta, the building featured a tower for which the financing had given great difficulties but the architect prevailed. "White's instinct concerning the indispensability of the Tower was correct," notes the architecture critic David Garrard Lowe, "for it made Madison Square Garden, like Richard Upjohn's Trinity Church before it and William Van Alen's Chrysler Building after it, one of those structures which cut into the skyline of New York with an unmistakable silhouette." Jack Dempsey became the darling of the boxing fans in the vast amphitheater, a happy fate not shared by the architect, who was murdered in 1906 on the premises of his stunning creation. Soon after the First World War, a third Madison Square Garden opened at Fiftieth Street and Eighth Avenue, bearing its original name despite the change in location. The fourth and present home of the Garden is a vast circular complex atop the tracks of Pennsylvania Station. It has nearly one hundred box suites that call for exceedingly high rentals and a cable television network that uniquely serves the Garden in the broadcast of the many major games played there.

Four outdoor playing fields racked up legends as colorful as those accruing to the four incarnations of Madison Square Garden. The Polo Grounds (1891) in upper Manhattan and Ebbets Fields (1913) in Brooklyn garnered local followings that were intimately tied to the success of the home teams— the Giants and the Dodgers—who played there. Borough residents developed fierce attachments to the stadiums in their midst and the sports personalities associated with them; they exercised a role as central to community

life as the Colosseum created for the populace of ancient Rome in a.d. 80 (and still standing as lasting testimony to its cultural importance). The strong association with place continued to be true after the opening of the country's most famous baseball arena, Yankee Stadium (1923) in the Bronx as the home of the New York Yankees. With a capacity of more than sixty-six thousand, it acquired an aura that proved to be seductive to fans and players alike. Babe Ruth needed just three words to describe it: "Some ball yard!" Ted Williams talked of "the bigness of it. . . . It takes at least one series to get accustomed to the stadium and even then you're not sure." Mickey Mantle was wont to wax more poetic: "There was a great dark mystery about it when I first came here from Oklahoma," he declared. "I still get goose pimples just walking inside it." When Shea Stadium opened in Queens in 1964, it was neither as large nor as prone to creating legends. Shea overflowed its capacity of fifty-five thousand seats not with a sporting event but with a rock concert given by the Beatles a year after its opening. Joining the major venues that give great pride to the city are the Louis Armstrong Stadium (1972) and the Arthur Ashe Stadium (1997) located in Flushing Meadows, where they are both part of the National Tennis Center. The U.S. Open Tennis Tournament played there is equal to Wimbledon in worldwide interest.

By the time the earliest of these large playing fields came into existence, a totally new kind of facility was racking up audiences that went far beyond the capacity of the largest stadium. This was radio. Broadcasts of athletic events, at the very hour they were unfolding on the field, became an explosive factor in expanding the play-by-play knowledge of games and, with no ticket required, in enlarging the circle of devotees for individual events. The first athletic event to be aired was the 1899 race for the America's Cup in New York harbor, broadcast by the inventor Guglielmo Marconi himself in the same year he introduced wireless telegraphy. Sports broadcasters became an entrenched part of the sports scene as they helped to make heroes out of succeeding waves of talented players. But if radio proved to be revolutionary in sports history, television was to overshadow—though not replace—radio in expanding still further the number of fans any single game could command and in reinforcing the importance of sports to cultural life.

Inevitably, radio and television offered vibrant competition to the print reporting of athletic events without, however, noticeably reducing the number of subscribers to the sports pages of the city's newspapers. During the summer of 1886 one of the city's leading dailies, the *New York Tribune,* announced that it "was compelled to devote more than 500 columns of its valuable space [to sports] . . . assigning to the collection and presentation of this class of news many of the best observers and writers in its service." Print coverage since then has continued to be vital. Most daily or weekly papers carry a column, if not several pages; the *New York Times* carries a weekly section in addition to daily reporting and maintains a large staff of journalists who are experts in various athletic practices. All those reporting—on radio, on television, and in print—keep lively pace with the burgeoning of sports events, and some

Take Me Out to the Ball Game

FIGURE 14.5 *Polo Grounds, 1895.*
Appealing to all ethnic groups in the
post–Civil War years was the game of base-
ball. Here was a sport based on camaraderie
and teamwork that prodded the zest of
amateurs who could play it on rustic lots.
To watch the game at the grand Polo
Grounds, a stadium opened in 1891 near
157th Street in Manhattan, was an
incomparable thrill.

FIGURE 14.6 *Stag at Sharkey's, ca. 1930.* Reviled during Victorian days as blood sports that were socially unredeeming, boxing and wrestling had no trouble nevertheless drawing crowds. They were among the few sports that ignored barriers with regard to color or race. The artist George Bellows matches the physical brutality of prizefighting with the unsavory pleasure of the onlooking crowd.

among them manage, as did Red Barber, Mel Allen, and Don Dunphy, to develop a following as loyal as that accorded a player. Reflective essays on competitive sports often appear in the *New Yorker,* and there are, in addition, a whole batch of periodicals catering to individual sports, led by the comprehensive *Sports Illustrated* (1954) and its offshoots, one of which is *Sports Illustrated for Kids* (1989).

Though the coverage of sports is generally relegated to the back section of a daily, happenings in sports more than occasionally dominate the front page as they did on October 30, 1999 when the New York Yankees capped the World Series championship for the third time in four years. Not many twentieth-century sports headlines were of such major significance as one in 1947 announcing that an athlete named John Roosevelt (Jackie) Robinson had been signed on as a member of the Brooklyn Dodgers baseball team. Robinson had by then an impressive sports record behind him but faced little chance

Take Me Out to the Ball Game

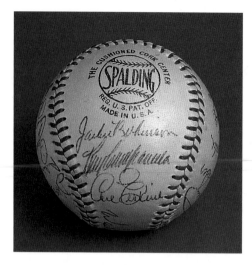

of entering a major league as an African American. The young player's subsequent career with the Brooklyn Dodgers proved to be stunning. His performance on the field and his ability to handle the pressures of his role became an inspiration to all who fought bigotry, Arthur Ashe, a black tennis champion, later declared, adding that "Robinson was ever-quick to pay homage to Louis as his forerunner." Some years earlier, Joe Louis, the black boxing champion, had been widely hailed for defending his world title against Max Schmeling at Yankee Stadium. But his was not a competition as hampered by racial barriers as baseball. Progress in the desegregation of sports had meanwhile remained exasperatingly slow for African Americans, particularly in team games, so that Robinson's newly won status signaled a turning point. Still, the wondrous achievements of subsequent players such as Don Newcombe, Roy Campanella, Elston Howard, Willie Mays, and Henry Aaron did not mean the end of racial tensions on the playing fields or off. The climb in the realm of sports management is still uphill.

Women had been meanwhile fighting for *their* place on winning teams. Tennis appeared to be an easy point of entry since the game had been introduced in 1874 to the United States from Bermuda by Mary Ewing Outerbridge. Her initiative led to the construction of the first lawn court on the grounds of the Staten Island Cricket and Baseball Club. Women certainly went on to make their mark at the net, but when the powerful West Side Tennis Club, formed in 1892 with headquarters on Central Park West, moved to Forest Hills at the outbreak of World War I, it continued to remain an all-male preserve. Distaff players of exceptional rank finally broke the barrier; Althea Gibson, a Wimbledon winner and world champion, did so in 1957. Her triumph was heightened by the fact that she was also the first black player to gain admission. Golf and swimming were among the other competitive sports deemed sedate enough for female participation but certainly not track, field, or basketball. Because women nonetheless persisted, they have come in recent decades to distinguish themselves in all these events. Jackie Joyner-Kersee has dazzled modern audiences with the records she set as a pentathlete.

As New Yorkers witnessed the gradual falling away of gender and racial barriers in the ranks of the premillennium world of sports, they became witness as well to that same world being marked by two conspicuous evolutions: increasing professionalism and rampant commercialization. A whole new set of personalities was accordingly introduced that became connected with sports competitions: organizers, promoters, managers, and others who operate with all the force of a big business enterprise. They conduct sports-related affairs in corridors far removed from the playing field. By contrast, street recreation in the city's boroughs has managed to preserve some of the intimacy and color associated with colonial games. Gutters and sidewalks are chalked off, as of yore, for boxball, stoopball, stickball, punchball, hopscotch, and other games, involving both girls and boys, that spawn future athletes. Many school youngsters enjoy the facilities provided by the city, particularly Downing Stadium on Randall's Island and an athletic complex known as Asphalt Green at Nineti-

FIGURE 14.9 *A Columbia University Professor Runs the Marathon, 1988.*
Jogging and running are sports that beckon a wide variety of city dwellers. Following the first New York City Marathon in 1970, multitudes have joined in this annual foot-race traversing all five boroughs. Champions and amateurs alike experience a heady thrill in finishing the twenty-six-mile course, as did Istuán Deák, who logged a total of six marathon runs.

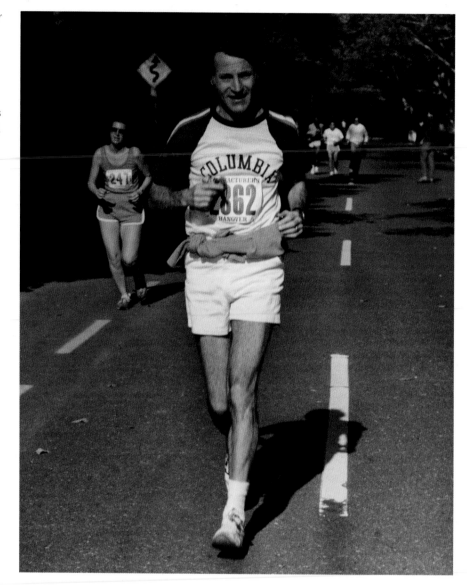

eth Street and FDR Drive. School yards remain centers of local basketball rivalries, and Little Leagues, which began to appear in the 1970s, fill the void left by the waning of some street sports caused by the increase in traffic, loss of empty lots, and rising street crime.

Generations of youngsters in the school yards and the neighborhood lots of the city's boroughs had not far to look for inspiration. Some of the greatest athletes of all times were playing in their very midst: baseball heroes Babe Ruth and Joe DiMaggio, Sid Luckman of Columbia football, Joe Namath of the New York Jets (football), Walt Frazier of the Knicks (basketball), Joe Louis and Jack Dempsey of boxing fame, and a score of others whose names continue to spark a floodburst of admiration. Given the city's special attachment to baseball, perhaps Joe DiMaggio—whose skill at bat became legendary throughout the entire country—can be singled out as a favorite among fa-

FIGURE 14.10
Savoring the Beaches of New York, 1989.
Gotham's felicitous placement by Neptune
offers its residents any number of water
sports. The coast of Manhattan provides
for fishing and boating pleasures while
Brooklyn, Queens and Staten Island boast
miles of ocean waterfront for swimming and
sunbathing. Sandy beaches along the Sound
are to be found in the Bronx. Gotham
bathing beauty pauses for the camera before
plunging into the waters of the Atlantic.

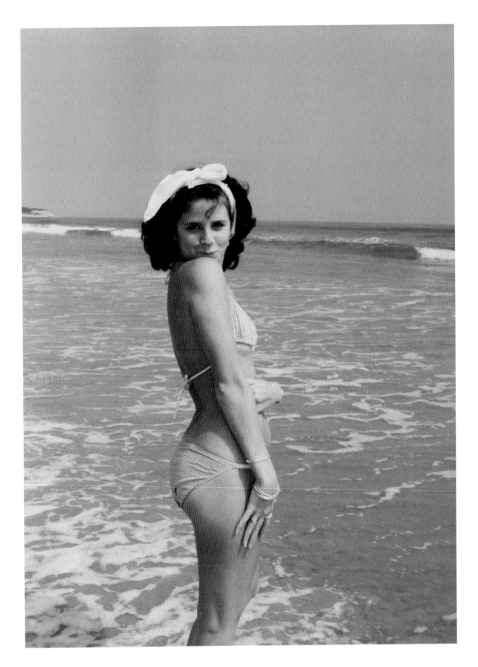

vorites. "No other sustained performance in the history of baseball," writes Michael Seidel, scholar and baseball chronicler, "builds with the drama and explodes with the energy of Joe DiMaggio's 56-game consecutive hitting streak launched . . . in New York on May 15, 1941." It earned DiMaggio untold popularity. Attachments of this intensity among borough fans were not able, however, to contain the runaway commercialism operating right in their midst. Two of the most popular local teams—the Dodgers and the Giants—went to the highest bidders on the West Coast in 1958: the Dodgers to Los Angeles, the Giants to San Francisco. Never had there been a more passionate identity between community and sport as was displayed by borough fans for the two

Take Me Out to the Ball Game

teams. Although the New York Mets were created to replace them, something had been irretrievably lost. The wooing of players from one team to another and the steady renegotiation of contracts in favor of the highest bidder have become elements in modern sports that erode local pride.

As though in a dramatic counterswing to the commercialization of sports, to blockbuster, spectator-centered events, to increasing professionalism, and to the sedentary pleasures offered by television, millions of New Yorkers have turned the spotlight on themselves in the last two decades. In an embrace of a new cult of fitness, they have once again turned to individual athletics. To accommodate the new trend, an impressive network of gymnasiums and fitness centers have opened up throughout the five boroughs, augmented by health spas, indoor ball courts, tennis bubbles, a host of instructive periodicals, and television fitness programs. Personal trainers are at the ready for those who can afford them, while exercise machines of every technological wizardry have invaded cramped apartments, basements, and the more spacious health clubs. The current rage in individual sports, whether conducted inside or out, centers on aerobics, weight lifting, power walking, in-line skating, bicycling (stationary or otherwise), jogging, and running. New York City's popular annual marathon, organized in 1(62 and coursing through all five boroughs, attracts more would-be entrants than can be accommodated. Those with equal energy but a tad more daring have taken to adventure sports. Facilities have opened up at century's end in the large Sports Center at Chelsea Piers, and locales elsewhere in the city, for parasailing, rock climbing, mountain biking, kayaking, outrigger canoeing, and surfing. Is this not bold affirmation that New York's geographic terrain denies her no recreational possibilities?

To all this lust-for-life activity, public health officials lend an approving and guiding eye, though they are aware the call to fitness was long ago sounded. In September 1860 the influential *Harper's Weekly* warned urbanites that passive onlooking of athletic events would produce "pulmonary men and women . . . childless wives . . . dyspeptic men . . . puny forms, and . . . bloodless cheeks." It sounded as startling then as it does now. Puny forms? Bloodless cheeks? They are decidedly not images appealing to active New Yorkers facing the new millennium. Gothamites may prefer to eschew extravertical wall climbing, trail biking, or parasailing, but this is not to say they depend exclusively on Nordic tracks or gym pads for the healthy lungs and rosy cheeks advocated by *Harper's*. Right in their midst is an incomparable outdoor sports field devised for their well-being and recreation: Central Park.

An alphabetical inventory of the sports or recreations that can be enjoyed in the wondrous oasis of Central Park (a few are for children only) reaches to a surprising number: baseball, bicycling, bird-watching, boating, bowling, coasting, croquet, fishing, football, handball, hockey, horseback riding, horseshoe pitching, ice-skating, jogging, model yachting, paddle tennis, pony riding, rock climbing, roller-blading, shuffleboard, skiing, soccer, softball, swimming, tennis, and wading. Triathalons are held here, too. Then there are thirty tennis courts, eight baseball diamonds, and acres of poetic vistas for the in-

halation of great draughts of space. All this was the vision of the park's creators, Calvert Vaux and Frederick Law Olmsted. To the northwest of the spacious wonderland they created is the recently completed Riverbank State Park serving the Harlem community. The twenty-eight acres of recreational space flanking the Hudson north of 125th Street boast swimming pools, picnic areas, and facilities for track and basketball.

New Yorkers facing the new millennium are fortunate, as are sports enthusiasts the world over, in adding the World Soccer Cup, the Wimbledon finals, the Goodwill Games, and the Olympics to their roster of sports pleasures. All these events are televised from different sites worldwide in a magnificent global reach that would certainly win the applause of that visionary New Yorker Walt Whitman, who witnessed the birth of baseball in his Civil War rounds. The poet would surely have gloried in the twentieth-century bonding of sports lovers across geographical boundaries. His own world, he declared in his "Song of the Open Road," knew no limits: "I inhale great draughts of space / The east and the west are mine, and the / north and the south are mine."

NOTES

CHAPTER 1. A MULTIPLE BIRTH

1. "Nowadays . . ." in More, *Utopia*, p. 32.
2. Verrazzano log quotes in Ramusio, *Navigationi et viaggi*, vol. 3, p. 350 et seq.
8. Henry Hudson log quotes in Cumming, Skelton, and Quinn, *The Discovery of North America*, pp. 289–90.
9. "By craft or fraud . . ." in Stokes, *New York Past and Present*, pp. xv–xvi.
11. "They all drink here . . ." in Stokes, *Iconography*, vol. 4, p. 149.
11. "After the laudable customs . . ." in Stokes, *Iconography*, vol. 1, p. 38.
11. "To stand guard . . ." in Stokes, *Iconography*, vol. 1, p. 70.
13. "Country has arrived . . ." in Van Rensselaer, *History*, vol. 1, p. 296.
13. "Great talk of the Dutch . . ." in Pepys, *Diary and Correspondence*, vol. 2, p. 93.
13. "All the news . . ." in Pepys, *Diary and Correspondence*, vol. 2, p. 162.
13. "I thought fitt . . ." in Stokes, *Iconography*, vol. 4, p. 240.
14. "I had much rather . . ." in New-York Historical Society, *Commemoration*, p. 34.
14. "Liberty of their Consciences . . ." in Stokes, *Iconography*, vol. 1, p. 113.
14. "Praying that God . . ." in Jameson, *Original Narratives*, p. 466.
14. "With so gentle . . . Cedar on Lebanon" in Stokes, *Iconography*, vol. 1, p. 114.
14. "Now begins New Netherland . . ." caption to the 1717 Burgis view of New York in Deák, *Picturing America*. vol. 1, p. 44.
14. "Fforme and Ceremony . . ." in *History of the State of New York*, vol. 1, pp. 602–4.
17. "This entire Province . . ." in Stokes, *Iconography*, vol. 4, p. 291.
17. "I cannot delay . . ." in Stokes, *Iconography*, vol. 4, p. 303.
17. "The fruits natural . . ." in Denton, *A Brief Description of New York*, pp. 3–4.
21. "The number of inhabitants . . ." in Miller, *New York Considered and Improved*, p. 40.
21. "The people of New York . . ." in Hamilton, *Gentleman's Progress*, p. 88.
22. "Trade of this city . . ." caption to the 1717 Burgis view of New York in Deák, *Picturing America*, p. 44.
22. "Discovered this Country . . ." caption to the 1717 Burgis view of New York in Deák, *Picturing America*, p. 44.
24. "New York is the chief . . ." in Sweetser and Ford, *How to Know New York City*, p. 5.
24. "My city's fit and noble . . ." in Whitman, *Complete Poetry*, p. 425.

CHAPTER 2. A MULTIRELIGIOUS DESTINY

28. "In most people of what Sect . . ." in Still, *Mirror for Gotham*, p. 24.
30. "Godless rascals . . ." and "For as we have here Papists . . ." in G. Smith, *Religion and Trade*, p. 213.
30. "Infest New Netherland" in Van Rensselaer, *History*, vol. 1, p. 449.
30. "A new and unheard of abominable heresy . . ." in G. Smith, *Religion and Trade*, p. 220.
31. "Shut your eyes . . ." in G. Smith, *Religion and Trade*, p. 220.
31. "Give noe disturbance . . ." in Dix, ed., *History of the Parish of Trinity Church*, p. 63.
31. "Abt 20 churches . . . upon those people" in Dix, ed., *History of the Parish of Trinity Church*, p. 52.
31. "Here bee not many . . ." in Stokes, *Iconography*, vol. 4, p. 342.
31. "Generaly of a turbulent . . ." in Stokes, *Iconography*, vol. 4, p. 342.
31. "Ministers have been . . ." in Stokes, *Iconography*, vol. 4, p. 315.
33. "The Dutch and ffrench Ministers . . ." in Stokes, *Iconography*, vol. 4, p. 330.
33. "The Great Church . . ." in Dix, ed., *History of the Parish of Trinity Church*, p. 64.
33. "Are the Lutheran Church . . ." in Still, *Mirror for Gotham*, p. 17.
33. "That the organ . . ." in Dix, ed., *History of the Parish of Trinity Church*, p. 223.
33. "There be a Crown and Cherub . . ." in Dix, ed., *History of the Parish of Trinity Church*, p. 225.
34. "Have three English churches . . ." in Still, *Mirror for Gotham*, pp. 34–5.
38. "Are buildings of simplicity, quality . . ." in Huxtable, *The Architecture of New York*, p. 20.
38. "The 103rd place of worship . . ." in Stokes, *Iconography*, vol. 5, pp. 1673–4.

38. "Sunday is vigorously observed . . ." in Pachter and Wein, eds., *Abroad in America*, p. 59.

41. "One sees neither domes . . ." in Pachter and Wein, eds., *Abroad in America*, p. 55.

41. "We'll need plenty of time . . ." in *Saint Patrick's Cathedral*, p. 14.

41. "Probably be a combination . . ." in Strong, *Diary*, vol. 2, p. 310.

41. "Irish element is acquiring . . ." in Forster, *Life of Charles Dickens*, vol. 2, p. 413.

41. "The bowl has been going round . . ." in Jameson, *Original Narratives*, vol. 8, p. 327.

44. "He should not only know . . ." in Stokes, *Iconography*, vol. 4, p. 114.

44. "Or else some other place . . ." in Kilpatrick, *Dutch Schools of New Netherland*, p. 60.

44. "Sufficient meat drinke . . ." in Seybolt, *Apprenticeship*, pp. 88–9.

45. "This Province should have been . . ." in Kammen, *Colonial New York*, p. 249.

45. "On one of the finest situations . . ." in Bridenbaugh, "Patrick M'Robert's Tour," pp. 139–40.

47. "Going without his Academical Habit . . ." in Humphrey, *From King's College to Columbia*, p. 206.

47. "Let it be our ambition . . ." in Campbell, *The Life and Writings of DeWitt Clinton*, p. 206.

47. "Was expected to assume a vital . . ." in Bender, *New York Intellect*, p. 91.

49. "They will influence elections . . ." in Brace, *Dangerous Classes*, vol. 1, p. 96.

49. "Sixty-five libraries at one stroke . . ." in Carnegie, letter of March 12, 1901.

53. "Very existence is an obscure fact . . ." in Thomas, "Mid-Nineteenth Century Life," p. 19.

CHAPTER 3. SEAFARING SPLENDOR

55. "Look at the crowds . . . attract them thither" in Melville, *Moby Dick*, p. 2.

59. "Rundlet of sugar . . ." and "[We] must remain your debtors . . ." in Stokes, *Iconography*, vol. 4, p. 70.

59. "Attained to a very poor . . ." in Stokes, *Iconography*, vol. 4, p. 117.

60. "Very wicked and spiteful words . . ." and "in a new country, with only . . ." in Stokes, *Iconography*, vol. 4, p. 118.

60. "For when the ships of New Netherland ride . . ." in Stokes, *Iconography*, vol. 4, p. 129.

60. "In the midwaye betwixt Boston . . . excellent harbour" in Stokes, *Iconography*, vol. 4, pp. 107–8.

62. "There are about nine or ten three Mast Vessels . . ." in Stokes, *Iconography*, vol. 4, p. 342.

63. "The Chinese were kind . . ." in Lee, *The Letters of Richard Henry Lee*, vol. 2, p. 366.

65. "So devastating were the effects . . ." in Lambert, *Travels*, vol. 2, p. 65.

65. "The engrossing topic . . ." in Hone, *Diary*, vol. 1, p. 217.

67. "One of the prettiest and most rakish looking . . . East River" in *New York Herald*, May 1, 1844.

70. "This is done with the trunks . . ." in Crèvecoeur, *Sketches of Eighteenth-Century America*, p. 748.

72. "Than a giraffe could be persuaded . . ." in Dickens, *American Notes*, vol. 1, pp. 1–2.

75. "Build me straight, O worthy . . ." in Longfellow, "The Building of the Ship," *Favorite Poems*, pp. 325–35.

76. "Nowhere outside the national capital . . ." in Albion, *The Rise of New York Port*, p. 213.

80. "I am with you / you men . . ." in Whitman, "Crossing Brooklyn Ferry," *Complete Poetry*, p. 148.

CHAPTER 4. MERCHANT PRINCES

83. "The crowning city [of Tyre] . . . a mart of nations" in Isaiah 23.

83. "7246 beaver skins . . ." in Stokes, *Iconography*, vol. 4, p. 67.

84. "A Pier for the convenience . . . for three years" in Stokes, *Iconography*, vol. 4, p. 110.

84. "No wampum except that strung . . ." in Stokes, *Iconography*, vol. 4, p. 120.

87. "Since the yeare 1647 . . . with an excellent harbour" in Stokes, *Iconography*, vol. 4, pp. 107–8.

87. "Fitt tyme and Place . . . frequent that Exchange," in Stokes, *Iconography*, vol. 4, p. 275.

88. "A Whiping post is erected . . ." in Stokes, *Iconography*, vol. 4, p. 314.

90. "In the genteelest Taste . . ." in Stokes, *Iconography*, vol. 4, p. 751.

92. Jefferson quote in Porter, *John Jacob Astor*, vol. 1, p. 168.

94. Melville quote in McCall, *The Silence of Bartleby*, p. 156.

94. "There is nothing in Paris or London . . ." in Hone, *Diary*, vol. 2, p. 772.

94. "He is, I suppose, next to the President . . ." in Borrett, *Letters from Canada*, p. 288.

CHAPTER 5. PEOPLING NEW YORK

107. "O My America! My new-found-land . . ." in Donne, *The Complete Poetry of John Donne*, pp. 55–8.

107. "We saw the land much populated . . ." in Ramusio, *Navigationi et Viaggi*, vol. 3, p. 350 et seq.

108. Henry Hudson log quotes in Cumming, Skelton, and Quinn, *The Discovery of North America*, pp. 289–90.

108. "Our people . . . bought the island Manhattes . . ." in Stokes, *Iconography*, vol. 4, p. 67.

109. "Whether they cannot . . . unrighteousness beginnings . . ." in Stokes, *New York Past and Present*, p. xv.
"Sometimes manifest themselves with arrows, like enemies . . ." in Jameson, *Original Narratives*, p. 67.

109. "The colony began to advance bravely and to live in friendship . . ." in Jameson, *Original Narratives*, p. 78.

109. "The natives are well set in their limbs . . ." in van der Donck, *A Description*, p. 22.

109. "It is somewhat strange that among . . . without blemish" in Jameson, *Original Narratives,* p. 72.

110. "The women are the most skilful stargazers . . . as to us" in Jameson, *Original Narratives,* p. 69.

110. "The Indians are naturally taciturn . . . female connections" in Skinner, *Indians of Greater New York,* p. 40.

112. "We authorized Maryn Andriessen . . ." in Innes, *New Amsterdam and Its People,* p. 23.

112. "Had winked at this infraction . . ." and "Before great Mischiefs overtake your Subjects . . ." in O'Callaghan, trans., *A Brief and True Narrative of the Hostile Conduct,* p. 17.

112. "To say something of the Indians . . ." in Denton, *A Brief Description of New York,* p. 45.

115. "Great is our disgrace . . ." in van der Donck, *Vertoogh van Nieu Nederland,* p. 49.

115. "This liberty then [of coexistence] . . . abuse" in Jameson, *Original Narratives,* p. 273.

115. "On the island of Manhate, and its environs . . ." in Jameson, *Original Narratives,* p. 259.

116. "I [believe] for these 7 years last past . . ." in Stokes, *Iconography,* vol. 4, p. 342.

116. "Daggers Durks Tucks in Canes, Pockett Pistolls . . ." in Stokes, *Iconography,* vol. 4, p. 334.

116. "Our chiefest unhappyness . . ." in Stokes, *Iconography,* vol. 4, p. 375.

119. "Composed of inhabitants from all the countries . . ." in Cooper, *America and the Americans,* vol. 1, p. 181.

119. "The language we heard spoken was different . . ." in Still, *Mirror for Gotham,* p. 106.

121. "The goods and chattel of the Irish . . ." and "The Germans were generally ruddy . . ." in Bishop, *The Englishwoman in America,* p. 380.

121. "A free Emigrant Office . . ." in Handlin, *A Pictorial History of Immigration,* p. 100.

125. "The riot was a savage one. . ." in Duvergier de Hauranne, *Huit mois,* p. 26.

125. "Turning point in the history of the Jews" in Howe, *World of Our Fathers,* p. 5.

125. "That somewhere in this teeming hive . . ." in Riis, *The Making of an American,* p. 35.

127. "New Netherland would by Slave Labor . . ." in O'Callaghan, *Voyages of the Slavers,* pp. xx–xi.

127. "We have resolved not only that slaves shall . . ." in O'Callaghan, *Voyages of the Slavers,* pp. xv.

127. "It is by negroes that I find my chievest Profitt . . ." in Goodfriend, *Before the Melting Pot,* p. 113.

128. "The Late Hellish Attempt of [your] Slaves . . ." in Stokes, *Iconography,* vol. 4, p. 475.

128. "Ever since the negroe conspiracy . . ." in Hamilton, *Gentleman's Progress,* p. 88.

131. "One striking feature consists in the number of blacks . . ." in Fearon, *Sketches of America,* p. 9.

131. "Not even in Philadelphia . . ." in Trollope, *Domestic Manners of the Americans,* p. 259.

131. "Some Harlemites thought the race millennium had come . . ." in Lewis, ed., *The Portable Harlem Renaissance Reader,* p. 80.

133. "We have tomorrow / Bright before us . . ." in Lewis, *When Harlem Was in Vogue,* p. 118.

CHAPTER 6. CITY OF CONTRASTS

135. "Tell her . . . that when John Jacob Astor was skinning rabbits . . ." in Ross, *Ladies of the Press,* p. 86.

135. "As a perpetual inheritance for ever . . ." in Jameson, *Original Narratives,* pp. 90–6.

136. "Reserve the island of the Manhattes . . ." in Jameson, *Original Narratives,* p. 90
"This capital is adorned with so many noble . . ." in Abbott, *Peter Stuyvesant,* p. 277.

137. "The English go very fashionable . . ." in Knight, *The Private Journal of a Journey,* p. 69.

137. "Fashionable parties were generally . . ." in Irving, *A History of New York,* p. 161.

139. "As New England excepting some Families . . ." in Dixon, *The Saga of American Society,* p. 58.

139. "Will it not be more Magnificent . . ." in T. Smith, *The City of New York,* p. 161.

139. "The splendor of wealth . . ." in Brissot de Warville, *New Travels in the United States,* pp. 140–1.

140. "The little nets that hung from his silk . . ." in Moreau de St. Méry, *Voyages aux Etats Unis,* p. 143.

143. "No hostess ever apologizes . . ." in Sherwood, *Manners and Social Usages,* p. 458.

143. "In planning a dinner . . ." in McAllister, *Society as I Have Found it,* p. 257.

146. "Well fashioned people . . ." in Jameson, *Original Narratives,* p. 72.

146. "Flying reports about asylums . . ." in van der Donck, *Vertoogh van Nieu Nederland,* p. 32.

146. "If you consider . . ." in Brodhead, *Documents,* vol. 1, p. 556.

146. "A certain bouwery situate . . ." in Stokes, *Iconography,* vol. 4, p. 157.

147. "There is not yet any Provision made . . ." in Stokes, *Iconography,* vol. 4, p. 537.

147. "Fetters, Gives [gyves or chains], Shackles . . ." in Stokes, *Iconography,* vol. 4, p. 545.

148. "Employed in spinning of wool . . ." in Stokes, *Iconography,* vol. 4, p. 545.

148. "There are Fifty Thousand people . . ." in Spann, *The New Metropolis,* p. 75.

152. "No one can walk the length of Broadway . . ." in Strong, *Diary,* vol. 2, p. 57.

153. "The neglect of the poor . . ." in Brace, *Dangerous Classes,* p. 322.

153. "Where dogs would howl to lie . . ." in Dickens, *American Notes,* vol. 1, p. 215.

153. "This cannot end here . . ." in Hone, *Diary,* vol. 2, p. 360.

154. "Their very number make one stand aghast" in Riis, *How the Other Half Lives*, p. 118.

161. "American social science can do better . . ." in Moynihan, ed., *On Understanding Poverty*, p. 34.

CHAPTER 7. BROADWAY

163. "I lead a very dull life . . ." in Stokes, *Iconography*, vol. 4, p. 1256.

165. "A cloacina of all the depravities . . ." in Jefferson, *Jeffersonian Cyclopedia*, vol. 2, p. 634.

166. "In the yeares 1641 & 1642 . . ." in Duncan, *Travels through Part of the United States and Canada*, vol. 1, pp. 29–31.

166. "According to our opinion . . ." in Stokes, *Iconography*, vol. 4, p. 208.

166. "The Principal Street is a noble . . ." in Pownall, *Topographical Description*, pp. 43–4.

169. "There is not in any city in the world . . ." in La Rochefoucauld-Liancourt, *Travels through the United States of North America*, vol. 2, p. 456.

169. "Some of the most picturesque . . ." in Poe, *Doings of Gotham*, pp. 25–6.

171. "The street is excavated to a depth . . ." in Hone, *Diary*, vol. 1, pp. 177–8.

171. "Beyond doubt, the most richly filled . . ." in Poe, *Doings of Gotham*, pp. 25–6.

172. "From Eighth Street down, the men are earning it . . ." in Jacobs, *The Death and Life of Great American Cities*, p. 247.

172. "Pink satin, bonnets & feather . . ." in Still, *Mirror for Gotham*, p. 87.

172. "In a morning saunter up Broadway . . ." in Kemble, *Journal*, vol. 1, p. 55.

172. "Heaven save the ladies . . ." in Dickens, *American Notes*, vol. 1, p. 194.

174. "The best-dressed woman . . ." in Wharton, *A Backward Glance*, p. 20.

174. "Broadway, with the soldiers marching . . ." in Whitman, "Give Me the Splendid Silent Sun," *Complete Poetry*, pp. 287–8.

174. "I notice more building this season . . ." in Strong, *Diary*, vol. 4, pp. 207, 211.

178. "Will Broadway reach all the way to Albany . . ." in Jenkins, *The Greatest Street in the World*, p. 236.

180. "I know not whether . . ." in James, *Washington Square*, p. 19.

180. "Cursed with its universal . . ." in Wharton, *A Backward Glance*, p. 54.

183. "I was struck by the illuminated . . ." in Honour, *The New Golden Land*, p. 260.

183. "A heavy-handedness of form . . ." in Goldberger, *The City Observed*, p. 197.

CHAPTER 8. BROOKLYN AND STATEN ISLAND

Brooklyn

187. "What do your Lordships . . ." in Stokes, *Iconography*, vol. 4, p. 153.

187. "In a tempest, or when the Windmill . . ." in Stokes, *Iconography*, vol. 4, p. 151.

190. "On Tuesday last [27 August] we got . . ." and "In respect to the attack . . ." in Deák, *Picturing America*, vol. 1, p. 101.

193. "We were doused with a wave . . ." in Moreau de St. Méry, *Voyage aux Etats Unis*, p. 145.

193. "Thousands of people from New York . . ." in Moreau de St. Méry, *Voyage aux Etats Unis*, p. 190.

194. "This is the city and I am one . . ." in Whitman, "Song of Myself," *Complete Poetry*, p. 73.

194. "Of course be necessary . . ." in Olmsted, *The Years of Olmsted*, p. 357.

194. "My only mortal entanglement" in Lancaster, *Prospect Park Handbook*, foreword.

196. "And thee, across the harbor . . ." in Crane, *The Bridge*, p. 1.

199. "Political sewage of Europe" in Hammack, *Power and Society*, p. 211.

199. "Our Brooklyn is so lovely . . ." in Hammack, *Power and Society*, p. 212.

199. "American customs and institutions . . ." in Hammack, *Power and Society*, p. 211.

199. "They are going to Coney Island . . ." in Schwartz, *In Dreams Begin Responsibilities*, p. 4.

199. "I had been in America . . ." in Singer, "A Day in Coney Island," *New Yorker*, July 31, 1971, p. 33.

200. "It was futile . . ." in Heller, *Now and Then*, p. 51.

200. "Brooklyn of ample hills . . ." in Whitman, "Crossing Brooklyn Ferry," *Complete Poetry*, p. 149.

200. "A comfortable and complacent duenna" in McCullers, *The Mortgaged Heart*, p. 217.

200. "I live in Brooklyn . . ." in Capote, *The Dogs Bark*, p. 131.

200. "Though borough it may be . . ." in Tierney, "What if Brooklyn Hadn't Surrendered?" *New York Times Magazine*, December 28, 1997, p. 48.

Staten Island

202. "A return to the domination of Great Britain . . ." in D. Smith, *Staten Island: Gateway to New York*, p. 80.

202. "On 5th January . . ." in Jameson, *Original Narratives*, p. 202.

204. "Thus, I lost the beginning . . ." in Jameson, *Original Narratives*, p. 211.

204. "A great many of the trees . . ." in Hamilton, *Gentleman's Progress*, p. 39.

204. "The house had been the habitation . . ." in D. Smith, *Staten Island, Gateway to New York*, p. 80.

207. "Mr. Gibbons-Sir . . ." in Lane, *Commodore Vanderbilt*, p. 36.

208. "We had a fine drive . . ." in Stuart, *Three Years in North America*, vol. 1, pp. 403–4.

208. "The apricots growing . . ." in Thoreau, *Familiar Letters*, p. 84.

208. "My life is like a stroll . . ." in Salt, *Life of Henry David Thoreau*, p. 34.

208. "An asylum . . . for the purpose . . ." in B. Shepherd, *Sailors' Snug Harbor*, p. 15

208. "The orderly and palatial buildings . . ." in B. Shepherd, *Sailors' Snug Harbor,* p. 81.

208. "Breakfast on plovers' eggs . . ." in B. Shepherd, *Sailors' Snug Harbor,* p. 29.

212. "Progressive public spirit" in Sachs, *Made on Staten Island,* p. 67.

CHAPTER 9. THE BRONX AND QUEENS

The Bronx

217. "Situate on the mainland . . ." in Stokes, *Iconography,* vol. 4, p. 90.

218. "That after the Christians have multiplied . . ." in van der Donck, *A Description,* p. 72.

220. "The said manor . . ." in Jenkins, *The Story of the Bronx,* p. 3

221. "These were the days when my heart . . ." in Poe, *Collected Works,* vol. 1, p. 411.

221. "Apologized for not having a pet raven" in Poe, *Collected Works,* vol. 1, p. 410.

226. "Enjoyed the advantage of central heating . . ." in Bennett, *Your United States,* p. 188.

226. "This dining room is a paradise . . ." in Clemens, *My Father Mark Twain,* p. 228.

226. "Read Sholom Aleichem . . ." in Pachter and Wein, eds., *Abroad in America,* p. 273.

226. "With all sorts of conveniences that we Europeans . . ." in Trotsky, *My Life,* p. 271.

228. "All the time we hung around . . ." in Doctorow, *Billy Bathgate,* p. 22.

229. "I wrote these lines . . ." in Nash, "Geographical Reflection," *I Wouldn't Have Missed It,* p. 8.

Queens

231. "The instigation of divers Persons. . ." in Denton, *A Brief Description of New York,* p. 17.

231. "On the west [of Long Island]. . ." in Denton, *A Brief Description of New York,* pp. 41–3.

231. "Spacious Medows or Marches . . ." in Denton, *A Brief Description of New York,* p. 44.

231. "Once a year the best horses . . ." in Denton, *A Brief Description of New York,* pp. 44–5.

232. "Come you, Phillis, now aspire . . ." in Wegelin, *Jupiter Hammon,* p. 33.

232. "The forepart of yᵉ Day there was . . ." in Stokes, *Iconography,* vol. 5, p. 1007.

232. "Borough of Queens has so many advantages . . ." in Queens (Borough) Chamber of Commerce, p. 13.

235. "As my train emerged . . ." in Fitzgerald, *The Great Gatsby,* p. 89.

235. "The Borough of Queens not only had . . ." in Queens (Borough) Chamber of Commerce, p. 13.

235. "The city seen from the Queensboro . . ." in Fitzgerald, *The Great Gatsby,* p. 55.

CHAPTER 10. POLITICIANS FOR ALL SEASONS

Stuyvesant

243. "Probity and experience" in Brodhead, *Documents,* vol. 1, p. 178.

243. "We have remarked the insolence . . ." in W. Shepherd, *The Story of New Amsterdam,* p. 73.

244. "New Alehouses, Taverns . . ." and "more honorable trades . . ." in Stokes, *Iconography,* vol. 4, p. 114.

244. "Not only to maintain the trade . . ." in Brodhead, *Documents,* vol. 1, p. 178.

244. "I have more power here than the Company . . ." in Brodhead, *Documents,* vol. 1, p. 212.

244. "To inflict as much injury . . ." in Brodhead, *Documents,* vol. 1, p. 178.

244. "All private Yachts . . ." in Stokes, *Iconography,* vol. 4, p. 110.

244. "To ordain and establish a reasonable Excise and impost . . ." in Stokes, *Iconography,* vol. 4, p. 111.

247. "Every male person . . ." in Stokes, *Iconography,* vol. 4, p. 112.

247. "We were not less rejoiced to hear . . ." in Stokes, *Iconography,* vol. 4, p. 111.

247. "From God and the Company . . ." in W. Shepherd, *The Story of New Amsterdam,* pp. 118, 78.

Dongan

249. "A very hard thing upon mee . . ." in Kammen, *Colonial New York,* p. 75.

254. "Ordered to give and Cofirme to this Citty . . ." in Stokes, *Iconography,* vol. 4, p. 324.

254. "Fforme and Method Ffor yᵉ Weal . . ." in Stokes, *Iconography,* vol. 4, p. 327.

255. "For that he nott haveing the feare of God . . ." in Stokes, *Iconography,* vol. 4, p. 327.

255. "On the Lord's Day or att Any other tyme . . . to Excuse the Same" in Stokes, *Iconography,* vol. 4, p. 328.

255. "The most prevailing opinion . . ." and "A more equal ballance . . ." in Stokes, *Iconography,* vol. 4, p. 342.

257. "You are to declare our Will and pleasure . . ." in Phelan, *Thomas Dongan,* p. 91.

Wood

258. "Great energy, ambition, and . . ." in Strong, *Diary,* vol. 2, p. 350.

261. "People said he was to be their rowdy's man . . ." in *New York Herald,* March, 31, 1855.

261. "It is especially gratifying in a great city . . ." in Hutchinson, *A Model Mayor,* p. vii.

261. "Proven beyond the possibility . . ." and "no rogue ever resided . . ." in Ingraham, *A Biography of Fernando Wood,* 3.

264. "How long, O Fernando Wood . . ." in Strong, *Diary,* vol. 2, p. 371.

La Guardia

267. "We will transmit this city . . ." speech in Box 2485, New York City Municipal Archives, January 1, 1934.

269. "Wear your rubbers, Mr. La Guardia . . ." in Elliott, *Little Flower,* p. 208.

269. "Not only out of debt . . ." in Kessner, *Fiorello H. La Guardia,* p. 271.

273. "My dear Chief . . ." in Kessner, *Fiorello H. La Guardia,* p. 542.

CHAPTER 11. TRIUMPHS OF ARCHITECTURE AND URBAN ENGINEERING

275. "Buildings lift New York toward the sky . . ." in Faÿ, *The American Experiment,* pp. 190–1.

275. "Skyscrapers use / Their full height . . ." in Rowse, *The Poet Auden,* p. 67.

275. "The Director and Koopman [agent] live together . . ." in Jameson, *Original Narratives,* p. 83.

276. "New from the ground . . ." in Bullivant, "A Journall," p. 55 et seq.

276. "Since it came into the hands of the English . . ." in Pownall, *Topographical Description,* p. 43.

276. "Whither his Excellency [Sir Charles Hardy, the governor] . . ." in Stokes, *Iconography,* vol. 4, p. 683.

276. "Many of the private houses in New York . . ." and "Of the public buildings there . . ." in Weld, *Travels through the States of North America,* p. 153.

280. "As she does nothing for us . . ." in Carstensen and Gildemeister, *New York Crystal Palace,* p. 47.

280. "Mostly in the Venetian style . . ." in Carstensen and Gildemeister, *New York Crystal Palace,* p. 49.

281. "Are essential elements of our urban memory . . ." comment by David Garrard Lowe in conversation with the author, May 4, 1998.

281. "Architecture is the greatest profession!" in Dain, *The New York Public Library,* p. 169.

285. "They loom more user friendly . . ." comment by Sanford Malter in conversation with the author, January 14, 1999.

287. "A fort has been staked out . . ." in Jameson, *Original Narratives,* p. 83.

287. "All Merchants and other that Shall at any time come . . ." in Stokes, *Iconography,* vol. 4, p. 309.

287. "Having undertaken a great worke . . ." in Stokes, *Iconography,* vol. 4, p. 310.

287. "Soe far as every Inhabitants house . . ." in Stokes, *Iconography,* vol. 4, p. 309.

287. "Ye building of A Bridg att . . ." in Stokes, *Iconography,* vol. 4, p. 378.

288. "A good and convenient draw bridg . . ." in Stokes, *Iconography,* vol. 4, p. 378.

288. "A thousand Ships may ride here . . ." in Stokes, *Iconography,* vol. 4, p. 342.

288. "Streets are Nasty and unregarded . . ." in Bullivant, "A Journall," p. 55 et seq.

288. "Those large arms of the sea . . ." in Olmsted, *Forty Years of Landscape Architecture,* p. 20.

288. "Triumph of cubism" in Trotsky, *My Life,* p. 270.

293. "To this we should add a further source . . ." in Asa Greene, *A Glance at New York,* p. 180.

293. "Nothing is talked of or thought of in New York . . ." in Hone, *Diary,* vol. 2, p. 624.

294. "In the greater part of the Park . . ." in Olmsted, *The Papers of Frederick Law Olmsted,* p. 107.

294. "Among beautiful and useful things . . ." in Triborough Bridge and Tunnel Authority, "Spanning the Narrows," p. 4.

294. "Finally became a sort of engineer by association . . ." in Moses, *Public Works,* p. 159.

297. "The only works of art which America . . ." in Alexandrian, *Marcel Duchamp,* p. 57.

300. "Proud ornament[s] of the city . . ." in Fulda, *Amerikanische Eindrucke,* p. 47.

300. "The railway and its equipment . . ." in Cudahy, *Under the Sidewalks of New York,* p. 17.

CHAPTER 12. PAINTING, THEATER, MUSIC, AND DANCE

303. "Drawe to lief [life] one of each kinde of thing . . ." in Hulton, *America, 1585,* p. 9.

305. "The Gentry of this place . . ." in Copley, *Letters and Papers,* p. 174.

307. "In the arts of designing and drawing . . ." in Deák, *Picturing America,* vol. 1, p. 131.

307. "His exertions in his profession . . ." in Dunlap, *History of the Rise and Progress of the Arts,* vol. 2, p. 88.

307. "I believe . . . that it is of the greatest importance . . ." in Howat, *The Hudson River and Its Painters,* p. 33.

308. "I studied the work of the masters . . ." and "I am deeply moved by the great works . . ." in Weinberg et al., *American Impressionism and Realism,* p. 42.

309. "The more I get about, the more I feel that . . ." in Adams, *Walt Kuhn, Painter,* p. 48.

310. "The strength of contemporary American art . . ." in Rosenberg, "A French Point of View," 11.

310. "By my troth, I am not nervous . . . by damning me" in Kemble, *Journal,* p. 61.

310. "Such an exhibition of female powers . . ." in Hone, *Diary,* vol. 1, p. 63.

311. "Rapidly improved within the last twenty years . . ." in Lambert, *Travels,* vol. 2, p. 55.

311. "Of all the new pieces . . ." in Lambert, *Travels,* vol. 2, p. 59.

312. "In dress, manners, appearance or habits . . ." in Fearon, *Sketches of America,* p. 86.

312. "To see the parterre filled with lightermen . . ." in Sagra, *Cinco meses,* p. 63.

312. "The barbarous and brutal practice . . ." in Bryant, *Power for Sanity,* p. 59.

314. "There are nearly twice as many . . ." in Bennett, *Your United States,* p. 137.

314. "Every member of the audience . . ." in Bennett, *Your United States,* p. 138.

315. "His comeing here and Returning . . ." in Dix, ed., *History of the Parish of Trinity Church,* p. 228.

315. "They having at this time no organist . . ." in Hamilton, *Gentleman's Progress,* p. 45.

318. "A tollerable *concerto* of musick . . ." in Hamilton, *Gentleman's Progress,* p. 48.

318. "Went to *La Traviata* . . ." in Strong, *Diary,* vol. 2, p. 313.

318. "The public had the luck . . ." in Handlin, *This Was America,* p. 345.

320. "So solemnly, so well, and so like me . . ." in Harlow, *Andrew Carnegie,* p. 124.

320. "The scenery and the legs are everything . . ." in Still, *Mirror for Gotham,* p. 176.

324. "He hath been of loose carriage here . . ." in Stokes, *Iconography,* vol. 4, p. 341.

324. "They are said to excel those of every city . . ." in Lambert, *Travels,* vol. 2, p. 99.

327. "Pish this is nothing . . ." in Thackeray, *Letters and Private Papers,* vol. 3, p. 261.

CHAPTER 13. COMMUNICATION AS ART AND AS INDUSTRY

331. "It must give every well-wisher . . ." in Stokes, *Iconography,* vol. 4, p. 749.

331. "Stuck up all over the Town . . ." in *New-York Weekly Post-Boy,* November 7, 1765.

331. "Impregnated with any sinister motive . . ." in Brodhead, *Documents,* vol. 1, pp. 322–3.

332. "The air in the New Netherlands is so dry . . ." in van der Donck, *Description,* p. 60.

332. "Great tryalls and exercise of patience . . ." in Stokes, *Iconography,* vol. 4, p. 252.

332. "Ye Catalogue of Books . . ." in Franks, *The Lee Max Friedman Collection,* p. 15.

333. "God's tender mercy . . ." in O'Neale, *Jupiter Hammon,* p. 75.

334. "Set or class of persons . . ." in Candidus, "On American Literature," p. 340.

334. "Little work [that] has been deservedly . . ." in Lambert, *Travels,* vol. 2, p. 98.

334. "An unusual spirit of egotism . . ." in Irving, *A History of New-York,* p. 28.

335. "The skies they were ashen and sober . . ." in Poe, "Ulalume," *Poetical Works,* p. 25.

337. "Man of a deep and noble nature . . ." and "drops into the universe . . ." in *Melville and Hawthorne,* pp. 66–67.

337. "Go from Corlears Hook to Coenties Slip . . ." in Melville, *Moby Dick,* p. 2.

338. "In over a hundred short stories . . ." in Cobb, *The Magnificent Partnership,* p. 40.

340. "A continual delight and astonishment . . ." in Pattee, *A History of American Literature,* p. 217.

341. "Oh, what a girl was Olive . . ." in Dreiser, *A Gallery of Women,* vol. 1, p. 99.

341. "It was a period when every season . . ." in Hughes, *The Big Sea,* p. 228.

342. "A literature of the moment . . ." in Howe, *World of Our Fathers,* p. 26.

342. "Yiddish literature was unhappily compressed . . ." in Howe, *World of Our Fathers,* p. 507.

343. "New Yorkers, all facing, as it were . . ." in Wilson, *Classics and Commercials,* p. 424.

343. "The main spring, the pinnacle . . ." in Rubin and Brown, eds., *Walt Whitman of the New York "Aurora,"* p. 19.

345. "Many Things tending to Sedition and Faction . . ." and "Burnt by the Hands . . ." in Rutherford, *John Peter Zenger,* p. 42.

345. "I agree with Mr. Attorney . . ." in Rutherford, *John Peter Zenger,* p. 74.

345. "Properly speaking, no literature . . ." in Tocqueville, *Democracy in America,* vol. 2, p. 58.

345. "That most important part of our literature . . ." in Fuller, *The Writings of Margaret Fuller,* p. 370.

346. "I have got Henry James and Bret Harte . . ." in Twain, *Mark Twain-Howells Letters,* vol. 2, p. 490.

346. "Forty miles away without the use of wires . . ." in *New York Herald,* October 1, 1899.

347. "Like the Yankees, the Stock Exchange and other institutions . . ." in *New York Times,* August 19, 1996.

347. "Who lov'd Reading were oblig'd to send . . ." in Kammen, *Colonial New York,* p. 270.

349. "The booksellers and printers of New York are numerous . . ." in Lambert, *Travels,* vol. 2, p. 79.

349. "In the four quarters of the globe . . ." in Leary, *American Literature,* p. 4.

350. "I have never been so shocked and disgusted . . ." in Pachter and Wein, eds., *Abroad in America,* p. 86.

CHAPTER 14. SPORTS FOR ALL SEASONS AND ALL FANS

356. "Certain farmers' servants to ride the goose . . ." in Singleton, *Dutch New York,* p. 294.

356. "Dilatoriness in God's service . . ." and "We interdict and forbid . . ." in Brodhead, *Documents,* vol. 2, pp. 78–9.

359. "Not so much for the divertissement of youth . . ." in Earle, *Colonial Days in Old New York,* p. 218.

359. "To See that ye Publick Peace . . ." in Stokes, *Iconography,* vol. 4, p. 256.

359. "Where you find neither stick nor stone . . ." in Denton, *A Brief Description of New York,* pp. 44–5.

359. "They are not so strict . . ." in Knight, *The Private Journal of a Journey,* pp. 70–1.

360. "Engaged the attention of so many . . ." in *New-York Weekly Post-Boy,* June 4, 1750.

361. "We are grieved to find the pernicious customs . . ." in *New York Spectator,* July 15, 1823.

361. "Manly science of self-defence . . ." in *New-York Evening Post,* November 27, 1826.

361. "Vigor to the human frame" in *New-York Evening Post,* June 24, 1830.

362. "An Esquimaux Indian in his Seal . . ." and "There were upwards . . ." in *New-York Evening Post,* February 3, 1821.

362. "I went over in the barouche . . ." in Hone, *Diary,* vol. 2, pp. 600–1.

362. "A gay, saucy-looking squadron . . ." in Hone, *Diary,* vol. 2, p. 709.

363. "The fascination of the game has seized . . ." in Giamatti, *A Great and Glorious Game,* p. 52.

363. "The very symbol, the outward and visible expression . . ." in Seymour, *Baseball,* vol. 1, p. 345.

363. "Baseball is about going home . . ." in Giamatti, *A Great and Glorious Game,* pp. 30–1.

364. "The high fever of inter-university football . . ." in Bennett, *Your United States,* p. 129.

365. "I have done much to elevate . . ." in Wignall, *The Story of Boxing,* p. 209.

365. "White's instinct concerning the indispensability . . ." in Lowe, *Stanford White's New York,* p. 142.

367. "Some ball yard!" "The bigness of it . . ." and "There was a great dark mystery . . ." in Robinson and Jennison, *Yankee Stadium,* pp. 29, 82, 83.

367. "Was compelled to devote . . ." in H. Hall, *The Tribune Book of Open-Air Sports,* p. iii.

370. "Robinson was ever-quick to pay homage . . ." in Ashe, *A Hard Road to Glory,* p. 11.

373. "No other sustained performance . . ." in Seidel, *Streak,* p. xi.

"I inhale great draughts of space . . ." in Whitman, "Song of the Open Road," *Complete Poetry,* p. 139.

BIBLIOGRAPHY

Abbott, Lyman. *Henry Ward Beecher: A Sketch of His Career.* Hartford, Conn.: American Publishing, 1887.

Adams, Philip Rhys. *Walt Kuhn, Painter: His Life and Work.* Columbus: Ohio State University Press, 1978.

Albion, Robert Greenhalgh. *The Rise of New York Port [1815-1860].* With the collaboration of Jessie Barnes Pope. Hamden, Conn.: Archon Books, 1961.

Alexandrian, Sarane. *Marcel Duchamp.* Trans. Alice Sachs. New York: Crown Publishers, 1977.

Allen, Frederick Lewis. *The Lords of Creation.* New York: Harper and Brothers, 1955.

———. *Only Yesterday: An Informal History of the 1920s.* New York: Harper and Brothers, 1981.

Allen, Oliver. *New York New York: A History of the World's Most Exhilarating and Challenging City.* New York: Atheneum Press, 1990.

Amory, Cleveland. *Who Killed Society?* New York: Harper and Brothers, 1960.

Andrews, Wayne. *Mr. Morgan and His Architect.* New York: Pierpont Morgan Library, 1957.

Archdeacon, Thomas. *New York City, 1664–1710: Conquest and Change.* Ithaca: Cornell University Press, 1976.

Armstrong, Margaret. *Fanny Kemble: A Passionate Victorian.* New York: Macmillan, 1938.

Asbury, Herbert. *The Gangs of New York: An Informal History of the Underworld.* New York: Old Town Books, 1989.

Ashe, Arthur. *A Hard Road to Glory: A History of the African-American Athlete.* New York: Warner Books, 1988.

Ashton, Dore. *The New York School: A Cultural Reckoning.* New York: Viking Press, 1973.

Asimov, Isaac. *In Memory Yet Green: The Autobiography of Isaac Asimov, 1920–1954.* New York: Doubleday, 1979.

Auchincloss, Louis. *Edith Wharton: A Woman in Her Time.* New York: Viking Press, 1971.

———. *The Vanderbilt Era: Profiles of a Gilded Age.* New York: Charles Scribner's Sons, 1989.

———, ed. *The Hone and Strong Diaries of Old Manhattan.* New York: Abbeville Press, 1989.

Baily, Francis. *Journal of a Tour in Unsettled Parts of North America.* London: Baily Brothers, 1856.

Barrett, Walter. *The Old Merchants of New York City.* 5 vols. New York: Worthington, 1863.

Batterberry, Michael, and Ariane Batterberry. *On the Town in New York: From 1776 to the Present.* New York: Charles Scribner's Sons, 1973.

Beach, Moses Yale, ed. *The Wealth and Biography of the Wealthy Citizens of the City of New York.* New York: Published at the Sun Office, 1855.

Beard, Rick, ed. *On Being Homeless: Historical Perspectives.* New York: Museum of the City of New York, 1987.

Beaver, Patrick. *The Crystal Palace: A Portrait of Victorian Enterprise.* Chichester, Sussex: Phillimore, 1977.

Beebe, Lucius. *The Big Spenders.* New York: Doubleday, 1966.

Bender, Marilyn. *The Beautiful People.* New York: Coward-McCann, 1967.

Bender, Thomas. *New York Intellect: A History of Intellectual Life in New York City, from 1750 to the Beginning of Our Own Time.* New York, Alfred A. Knopf, 1987.

———. *Toward an Urban Vision: Ideas and Institutions in Nineteenth-Century America.* Lexington: University Press of Kentucky, 1975.

Bennett, Arnold. *Your United States: Impressions of a First Visit.* New York and London: Harper and Brothers, 1912.

Berenholtz, Richard. *Manhattan Architecture.* New York: Prentice-Hall Press, 1988.

Bettmann, Otto L. *The Bettmann Archive Picture History of the World.* New York: Random House, 1978.

Bishop, Isabella Lucy Bird. *The Englishwoman in America.* London: John Murray, 1856.

Blackburn, Roderic H., and Ruth Piwonka. *Remembrance of Patria: Dutch Arts and Culture in Colonial America, 1609–1776.* Albany, N.Y.: Albany Institute of History and Art, 1988.

Blanchard, Claude. *Voilà l'Amérique.* Paris: Editions Baudinière, 1931.

Bloom, Nathan. *Housing in New York City.* New York: First National City Bank, 1970.

Bolton, Reginald Pelham. *The Bombardment of New York.* New York: Baker and Taylor, 1915.

Bonomi, Patricia U. *A Factious People: Politics and Society in Colonial New York.* New York: Columbia University Press, 1971.

Borrett, George T. *Letters from Canada and the United States.* London: J. E. Adlard, 1865.

Brace, Charles Loring. *Dangerous Classes of New York, and Twenty Years' Work among Them.* Vols. 1 and 2. New York: Wynkoop and Hallenbeck, 1872.

———. *The Life of Charles Loring Brace, Chiefly Told in His Own Letters.* New York: Charles Scribner's Sons, 1894.

Bridenbaugh, Carl. *Cities in the Wilderness: The First Century of Urban Life in America, 1625–1742.* New York: Ronald Press, 1938.

———. "Patrick M'Robert's Tour through Part of the North Provinces of America." *Pennsylvania Magazine of History and Biography* 59 (April 1935): 134–80.

Brissot de Warville, J. P. *New Travels in the United States of America. Performed in 1788.* New York: T. and J. Swords, 1792.

Brodhead, John Romeyn. *Documents Relative to the Colonial History of the State of New York: Procured in Holland, England and France.* Vols. 1 and 2. Albany: Weed, Parsons, 1856.

Browder, Clifford. *The Money Game in Old New York: Daniel Drew and His Times.* Lexington: University Press of Kentucky, 1986.

Brown, Lloyd A. *The Story of Maps.* New York: Dover Publications, 1949.

Brown, T. Allston. *A History of the New York Stage from the First Performance in 1732 to 1901.* 3 vols. New York: Dodd, Mead, 1903.

Browne, Junius Henri. *The Great Metropolis: A Mirror of New York, New York:* 1869. Reprint, New York: Arno Press, 1975.

Bryant, William Cullen. *Power for Sanity: Selected Editorials of William Cullen Bryant, 1829–1861.* Compiled and annotated by William Cullen Bryant II. New York: Fordham University Press, 1994.

Bryce, James. *The American Commonwealth.* 3 vols. London: Macmillan, 1888.

Buckingham, James Silk. *America: Historical, Statistical, and Descriptive.* 3 vols. London: Fisher, Son, and Company, 1841.

Bullivant, Dr. Benjamin. "A Journall with observations on my travail from Boston in N.E. to N.Y. New-Jersies and Philadelphia in Pensilvania. A.D. 1697." Ed. Wayne Andrews as "A Glance at New York in 1697: The Travel Diary of Dr. Benjamin Bullivant." *New-York Historical Society Quarterly* 40 (January 1956): 55–73.

Burr, Aaron. *Political Correspondence and Public Papers of Aaron Burr.* Ed. Mary-Jo Kline. Princeton: Princeton University Press, 1983.

Burrows, Edwin G., and Mike Wallace. *Gotham: A History of New York City to 1898.* New York: Oxford University Press, 1999.

Bush, Clive. *The Dream of Reason: American Consciousness and Cultural Achievement from Independence to the Civil War.* London: Edward Arnold, 1977.

Cahan, Abraham. *The Rise of David Levinsky.* New York: Harper and Brothers, 1917.

Campbell, William W. *The Life and Writings of DeWitt Clinton.* New York: Baker and Scribner, 1849.

Candidus [Charles Brockden Brown]. "On American Literature." *Monthly Magazine and American Review* 1 (August 1799): 340.

Canfield, Cass. *The Incredible Pierpont Morgan: Financier and Art Collector.* New York: Harper and Row, 1974.

Capote, Truman. *The Dogs Bark: Public People and Private Places.* New York: Random House, 1973.

Carnegie, Andrew. Letter to the Director of the New York Public Library, March 12, 1901. Archives of the New York Public Library.

Caro, Robert. *The Power Broker: Robert Moses and the Fall of New York.* New York: Alfred A. Knopf, 1974.

Carstensen, George, and Charles Gildmeister. *New York Crystal Palace.* New York: Riker, Thorne, 1854.

Chernow, Ron. *The House of Morgan: An American Banking Dynasty and the Rise of Finance.* New York: Atlantic Monthly Press, 1990.

Cheyney, Edward Potts. *European Background of American History, 1300–1600.* New York: Harper and Brothers, 1904.

Chiapelli, Fredi, ed. *First Images of America: The Impact of the New World on the Old.* Vols. 1 and 2. Berkeley: University of California Press, 1976.

Christoph, Peter R., ed. *The Dongan Papers, 1683-1688.* Syracuse, N.Y.: Syracuse University Press, 1993.

Clemens, Clara. *My Father, Mark Twain.* New York: Harper and Brothers, 1931.

Clemens, Samuel. *Mark Twain's Autobiography.* Ed. Albert Bigelow Paine. New York: Harper and Brothers, 1924.

Cobb, Stanwood. *The Magnificent Partnership.* New York: Vintage Press, 1954.

Cole, William, ed. *New York: A Literary Companion.* Wainscott, N.Y.: Pushcart Press, 1992.

Commager, Henry Steele. *The American Mind: An Interpretation of American Thought and Character since the 1880s.* New Haven: Yale University Press, 1950.

———, ed. *Living Ideas in America.* New York: Harper and Brothers, 1951.

Condit, Carl W. *The Port of New York: A History of the Rail and Terminal System from the Beginnings to the Pennsylvania Station.* Chicago: University of Chicago Press, 1980.

Condon, Thomas J. *New York Beginnings: The Commercial Origins of New Netherland.* New York: New York University Press, 1968.

Cooke, Hope. *Seeing New York: History Walks for Armchair and Footloose Travelers.* Philadelphia: Temple University Press, 1995.

Cooper, James Fenimore. *America and the Americans: Notions Picked Up by a Travelling Bachelor.* 2 vols. London: Published for H. Colburn by R. Bentley, 1836.

———. *Ned Myers: Or, A Life before the Mast.* New York: Stringer and Townsend, 1850.

Copley, John Singleton. *Letters and Papers of John Singleton Copley and Henry Pelham, 1739–1776.* Boston: Massachusetts Historical Society, 1914.

Countryman, Edward. *A People in Revolution: The American Revolution and Political Society in New York, 1760–1790.* Baltimore: Johns Hopkins University Press, 1981.

Crane, Hart. *The Bridge.* New York: Liveright, 1970.

———. *The Poems of Hart Crane.* Ed. Marc Simon. New York: Liveright, 1986.

Cray, Robert E. *Paupers and Poor Relief in New York City and Its Burial Environs, 1700–1830.* Philadelphia: Temple University Press, 1988.

Crèvecoeur, Michel-Guillaume-Jean de. *Sketches of Eighteenth-Century America.* New York: B. Blom, 1972.

Crouthamel, James L. *Bennett's New York Herald and the Rise of the Popular Press.* Syracuse, N.Y.: Syracuse University Press, 1989.

Cudahy, Brian J. *Under the Sidewalks of New York: The Story of the Great-*

est Subway System in the World. Brattleboro, Vt.: Stephen Greene Press, 1979.

Cumming, William P., R. A. Skelton, and David B. Quinn. *The Discovery of North America.* London: Elek Books, 1971.

Dain, Phyllis. *The New York Public Library: History of Its Founding and Early Years.* New York: New York Public Library, 1972.

Davidson, Marshall B. *New York: A Pictorial History.* New York: Charles Scribner's Sons, 1977.

Deák, Gloria Gilda. *Kennedy Galleries' Profiles of American Artists.* New York: Kennedy Galleries, 1984.

———. *Picturing America, 1497–1899: Prints, Maps, and Drawings Bearing on the New World Discoveries and on the Development of the Territory That Is Now the United States.* 2 vols. Princeton: Princeton University Press, 1988.

Denton, Daniel. *A Brief Description of New York Formerly Called New Netherlands.* Cleveland: Burrows Brothers, 1902.

Devorkin, Joseph. *Great Merchants of Early New York: "The Ladies Mile."* New York: Society of the Architecture of the City, 1987.

Diamonstein, Barbarlee. *American Architecture Now.* New York: Rizzoli Press, 1980.

Dicey, Edward. *Six Months in the Federal States.* London: Macmillan, 1863.

Dickens, Charles. *American Notes for General Circulation.* Vols. 1 and 2. London: Chapman and Hall, 1842.

Dix, Morgan, ed. *A History of the Parish of Trinity Church in the City of New York.* New York: Putnam, 1898.

Doctorow, E. L. *Billy Bathgate.* New York: Random House, 1989.

Doezema, Marianne. *George Bellows and Urban America.* New Haven: Yale University Press, 1992.

Dolkart, Andrew. *Guide to New York City Landmarks.* Washington, D.C.: Preservation Press, 1992.

Domett, H. W. *A History of the Bank of New York, 1784–1884.* New York: G. P. Putnam's Sons, 1884.

Donne, John. *The Complete Poetry of John Donne.* With an introduction, notes, and variants by John T. Shawcross. New York: New York University Press, 1967.

Dreiser, Theodore. *The Color of a Great City.* New York: Boni and Liveright, 1923.

———. *A Gallery of Women.* Vols. 1 and 2. New York: Horace Liveright, 1929.

Duncan, John M. *Travels through Part of the United States and Canada in 1818 and 1819.* Glasgow: University Press, 1823.

Dunlap, William. *History of the New Netherlands, Province of New York, and State of New York, to the Adoption of the Federal Constitution.* Vols. 1 and 2. New York: Carter and Thorp, 1839–40.

———. *History of the Rise and Progress of the Arts of Design in the United States.* Vols. 1 and 2. New York: George F. Scott, 1834.

Duvergier de Hauranne, Ernest. *Huit mois en Amérique: Lettres et notes de voyage, 1864–1865* (Eight months in America: Letters and travel notes). Paris: Library Internationale, 1866.

Dwight, Theodore. *Sketches of Scenery and Manners in the United States.* New York: A. T. Goodrich, 1829.

———. *Things As They Are: Or, Notes of a Traveller through Some of the Middle and Northern States.* New York: Harper and Brothers, 1834.

Earle, Alice Morse. *Colonial Days in Old New York.* New York: Charles Scribner's Sons, 1896.

Edminston, Susan, and Linda D. Cirino. *Literary New York: A History and Guide.* Boston: Houghton Mifflin, 1976.

Elias, Stephen N. *Alexander T. Stewart: The Forgotten Merchant Prince.* Westport, Conn.: Praeger, 1992.

Elliott, Lawrence. *Little Flower: The Life and Times of Fiorello La Guardia.* New York: Morrow, 1983.

Ellis, Edward R. *The Epic of New York City.* New York: Old Town Books, 1966.

Encyclopedia of New York City. Ed. Kenneth T. Jackson. New York: Yale University Press and the New-York Historical Society, 1995.

Entrikin, J. Nicholas. *The Betweeness of Place: Towards a Geography of Modernity.* London: Macmillan Education, 1991.

Ernst, Robert. *Immigrant Life in New York City, 1825–1863.* New York: King's Crown Press, Columbia University, 1989.

Faÿ, Bernard. *The American Experiment.* New York: Harcourt, Brace, 1929.

Fearon, Henry Bradshaw. *Sketches of America: A Narrative of a Journey of Five Thousand Miles through the Eastern and Western States of America.* London: Longman, Hurst, Rees, Orme, and Brown, 1819.

Fee, Elizabeth, and Steven H. Corey. *Garbage! The History of Politics and Trash in New York City.* New York: New York Public Library, 1994.

Fernow, Berthold. *New York in the Revolution: Documents Relating to the Colonial History of the State of New York.* 1887. Reprint, Cottonport, La.: Polyanthos, 1972.

Fitzgerald, F. Scott. *The Great Gatsby.* New York: Cambridge University Press, 1991.

Flexner, James Thomas. *America's Old Masters.* New York: Doubleday, 1980.

———. *John Singleton Copley.* New York: Fordham University Press, 1993.

Forbes, John Douglas. *J. P. Morgan Jr., 1867–1943.* Charlottesville: University Press of Virginia, 1981.

Ford, Ford Madox. *New York Is Not America.* New York: Albert and Charles Boni, 1927.

Forster, John. *The Life of Charles Dickens.* 2 vols. New York: Charles Scribner's Sons, 1899.

Franks, Abigail. *The Lee Max Friedman Collection of American Jewish Colonial Correspondence: Letters of the Franks Family, 1733-1748.* Ed. Leo Hershkowitz and Isidore S. Meuer. Waltham, Mass.: American Jewish Historical Society, 1968.

Fulda, Ludwig. *Amerikanische Eindrucke.* Stuttgart and Berlin: J. G. Cotta, 1914.

Fuller, Margaret. *Margaret Fuller's New York Journalism.* Knoxville: University of Tennessee Press, 1995.

———. *The Writings of Margaret Fuller.* Ed. Mason Wade. New York: Viking Press, 1941.

Furer, Howard. *New York: A Chronological and Documentary History, 1574–1970.* Dobbs Ferry, N.Y.: Oceana Publications, 1974.

Gawne, Eleanor Jerner. *Fabrics for Clothing.* Peoria, Ill.: Charles A. Bennett, 1973.

Gerdts, William H., et al. *Ten American Painters.* New York: Spanierman Gallery, 1990.

Giamatti, A. Bartlett. *A Great and Glorious Game: Baseball Writings of A. Bartlett Giamatti.* Ed. Kenneth Robson. Chapel Hill, N.C.: Algonquin Books, 1998.

Goldberger, Paul. *The City Observed: New York, a Guide to the Architecture of Manhattan.* New York: Random House, 1979.

Goodale, Katherine. *Behind the Scenes with Edwin Booth.* Boston and New York: Houghton Mifflin, 1931.

Goodfriend, Joyce D. *Before the Melting Pot: Society and Culture in Colonial New York City, 1664-1730.* Princeton: Princeton University Press, 1992.

Grafton, John. *New York in the Nineteenth Century: Three Hundred and Twenty-One Engravings from* Harper's Weekly *and Other Contemporary Sources.* New York: Dover Publications, 1977.

Greeley, Horace. *The Autobiography of Horace Greeley, or Publications of a Busy Life.* New York: E. B. Treat, 1872.

Greene, Asa. *A Glance at New York.* New York: A. Greene, 1837.

Haks, Donald, and Marie Christine van der Sman. *Dutch Society in the Age of Vermeer.* The Hague: The Hague Historical Museum, 1996.

Hale, Sarah. *Woman's Record; or Sketches of All Distinguished Women from the Creation to A.D. 1854.* New York: Harper and Brothers, 1855.

Hall, Henry, ed. *The Tribune Book of Open-Air Sports.* New York: Tribune Association, 1887.

Hall, Max, ed. *Made in New York: Case Studies in Metropolitan Manufacturing.* Cambridge, Mass.: Harvard University Press, 1959.

Hamilton, Alexander. *Gentleman's Progress: The Itinerarium of Dr. Alexander Hamilton, 1774.* Ed. Carl Bridenbaugh. Chapel Hill: University of North Carolina Press, 1948.

Hammack, David. *Power and Society: Greater New York at the Turn of the Century.* New York: Russell Sage Foundation, 1982.

Handlin, Oscar. *A Pictorial History of Immigration.* New York: Crown Publishers, 1973.

———. *Statue of Liberty.* New York: Newsweek Book Division, 1971.

———. *This Was America: True Accounts of People and Places, Manners and Customs, As Recorded by European Travelers to the Western Shore in the Eighteenth, Nineteenth, and Twentieth Centuries.* Cambridge, Mass.: Harvard University Press, 1949.

Hardie, James. *The Description of the City of New York: Containing Its Population, Institutions, Commerce, Manufactures, Public Buildings, Courts of Justice, Places of Amusement, etc.* New York: Samuel Marks, 1827.

Harding, Walter. *The Days of Henry Thoreau: A Biography.* New York: Dover Publications, 1982.

Harlow, Alvin F. *Andrew Carnegie.* New York: J. Messner, 1953.

Harris, Bill. *The History of New York City.* New York: Portland House, 1989.

Harris, Leon. *Merchant Princes: An Intimate History of Jewish Families Who Built Great Department Stores.* New York: Harper and Row, 1979.

Hart, Simon. *The Prehistory of the New Netherland Company.* Amsterdam: City of Amsterdam Press, 1959.

Hartshorne, Richard. *Perspective on the Nature of Geography.* Chicago: Rand McNally, 1959.

Haswell, Charles H. *Reminiscences of an Octogenarian of the City of New York.* New York: Harper and Brothers, 1896.

Hatton, Joseph. *Henry Irving's Impressions of America, Narrated in a Series of Sketches, Chronicles, and Conversations.* London: Sampson Low, Marston, Searle, and Rivington, 1884.

Heller, Joseph. *Now and Then: From Coney Island to Here.* New York: Alfred A. Knopf, 1998.

Henderson, Mary. *The City and the Theatre: New York Playhouses from Bowling Green to Times Square.* Clifton, N.J.: James T. White, 1973.

Henry, O. *The Best Short Stories of O. Henry.* New York: Modern Library, 1945.

Hill, Frederick Trevor. *The Story of a Street: A Narrative History of Wall Street from 1664 to 1908.* New York: Harper and Brothers, 1908.

Holmes, Isaac. *An Account of the United States of America, Derived from Actual Observation, During a Residence of Four Years in that Republic, Including Original Communications.* London: Caxton Press, 1823.

Homberger, Eric. *Scenes from the Life of a City: Corruption and Conscience in Old New York.* New York: Alfred Knopf, 1994.

Homberger, Eric, and Alice Hudson. *The Historical Atlas of New York City: A Visual Celebration of Nearly Four Hundred Years of New York City's History.* New York: Henry Holt, 1994.

Hone, Philip. *The Diary of Philip Hone, 1828–1851.* 2 vols. Ed. Allan Nevins. New York: Dodd, Mead, 1927.

Honour, Hugh. *The New Golden Land: European Images of America from the Discoveries to the Present Time.* New York: Pantheon Books, 1975.

Honyman, Robert. *Colonial Panorama, 1775: Dr. Robert Honyman's Journal for March and April.* Ed. Philip Padelford. San Marino: Huntington Library, 1939.

Hood, Clifton. *722 Miles: The Building of the Subways and How They Transformed New York.* New York: Simon and Schuster, 1993.

Hoover, Edgar M., and Raymond Vernon. *Anatomy of a Metropolis: The Changing Distribution of People and Jobs within the New York Metropolitan Region.* Cambridge, Mass.: Harvard University Press, 1959.

Houghton, George W. *The Coaches of Colonial New York.* New York: Hub Publishing, 1890.

Howat, John. *The Hudson River and Its Painters.* New York: Penguin Books, 1978.

Howe, Irving. *World of Our Fathers.* New York: Harcourt, Brace Jovanovich, 1976.

Howells, William Dean. *A Hazard of New Fortunes.* New York: Boni and Liveright, 1889.

Hughes, Langston. *The Big Sea: An Autobiography.* New York: Alfred A. Knopf, 1945.

Hulton, Paul. *America, 1585: The Complete Drawings of John White.* Chapel Hill: University of North Carolina Press and British Museum Publications, 1984.

Humphrey, David C. *From King's College to Columbia, 1746–1800.* New York: Columbia University Press, 1976.

Hungerford, Edward. *The Williamsburg Bridge.* Brooklyn: Eagle Press, 1903.

Hutchins, Edward H. *Poe: A Critical Study.* Cambridge, Mass.: Harvard University Press, Belknap Press, 1957.

Hutchinson, E. *A Model Mayor: Early Life, Congressional Career, and Triumphant Municipal Administration of Hon. Fernando Wood.* New York: American Family Publication, 1855.

Huxtable, Ada Louise. *Architecture, Anyone?* New York: Random House, 1986.

———. *The Architecture of New York: Classic New York, Georgian Gentility to Greek Elegance.* New York: Doubleday, 1964.

———. *Goodbye History, Hello Hamburger: An Anthology of Architectural Delights and Disasters.* Washington, D.C.: Preservation Press, 1980.

Ingraham, Abijah. *A Biography of Fernando Wood: A History of the Forgeries, Perjuries, and Other Crimes of Our "Model" Mayor.* New York: N.p., 1856.

Innes, J. H. *New Amsterdam and Its People.* New York: Charles Scribner's Sons, 1902.

Irving, Washington. *Astoria, or Enterprise Beyond the Rocky Mountains.* Paris: Beaudry's European Library, 1836.

———. *A History of New-York from the Beginning of the World to the End of the Dutch Dynasty by Friedrich Knickerbocker.* New York: George P. Putnam, 1850.

Isbouts, Jean-Pierre. *Carrère and Hastings, Architects to an Era.* Leiden: Rijksuniversiteit, 1980.

Jackson, Kenneth T. *Cities in American History.* New York: Alfred A. Knopf, 1972.

Jacobs, Jane. *The Death and Life of Great American Cities.* New York: Random House, 1961.

Jaher, Frederic Cople. *The Rich, the Wellborn, and the Powerful: Elites and Upper Classes in History.* Chicago: University of Illinois Press, 1973.

———. *The Urban Establishment: Upper Strata in Boston, New York, Charleston, Chicago, and Los Angeles.* Chicago: University of Illinois Press, 1982.

James, Henry. *The American Scene.* Bloomington: Indiana University Press, 1968.

———. *Washington Square.* New York: Doric Books, 1950.

Jameson, J. Franklin, ed. *Original Narratives of Early American History: Narratives of New Netherland, 1609–1664.* Vol. 8. New York: Charles Scribner's Sons, 1909.

Jardine, Lisa. *Worldly Goods.* London: Macmillan, 1996.

Jefferson, Thomas. *The Jeffersonian Cyclopedia: A Comprehensive Collection of the Views of Thomas Jefferson.* 2 vols. Ed. John P. Foley. New York: Russell and Russell, 1967.

Jenkins, Stephen. *The Greatest Street in the World: The Story of Broadway, Old and New, from the Bowling Green to Albany.* New York: G. P. Putnam's Sons, 1911.

———. *The Story of the Bronx from the Purchase Made by the Dutch from the Indians in 1639 to the Present Day.* New York: G. P. Putnam's Sons, 1912.

Jones, Howard Mumford. *O Strange World: American Culture, the Formative Years.* New York: Viking Press, 1964.

Joseph, Marjory L. *Introductory Textile Science.* New York: Holt, Rinehart and Winston, 1986.

Kalm, Peter. *Peter Kalm's Travels to North America.* Vols. 1, 2, and 13. New York: Wilson-Erickson, 1937.

Kammen, Michael. *Colonial New York: A History.* New York: Scribner, 1975.

Katz, Michael. *In the Shadow of the Poorhouse: A Social History of Welfare in America.* New York: Basic Books, 1986.

Kemble, Frances Anne Butler. *Journal of a Residence in America.* Brussels: Ad. Wahlen, Bookseller, 1835.

Kessner, Thomas. *Fiorello H. La Guardia and the Making of Modern New York.* New York: McGraw-Hill, 1989.

Keys, Alice Mapelsden. *Cadwallader Colden: A Representative Eighteenth-Century Official.* New York: Columbia University Press, 1906.

Kilpatrick, William Heard. *The Dutch Schools of New Netherland and Colonial New York.* Washington, D.C.: Government Printing Office, 1912.

Klayman, Richard. *America Abandoned: John Singleton Copley's American Years, 1738–1774, An Interpretive History.* Lanham, Md.: University Press of America, 1983.

Klein, Michael M., ed. *New York: The Centennial Years, 1676–1976.* Port Washington, N.Y.: Kennikat Press, 1976.

Knight, Sarah Kemble. *The Private Journal of a Journey from Boston to New York in the Year 1704.* Albany: Frank H. Little, 1704.

Koolhaas, Rem. *Delirious New York: A Retroactive Manifesto for Manhattan.* New York: Oxford University Press, 1978.

Kouwenhoven, John A. *Adventures of America, 1857–1900: A Pictorial Record from Harper's Weekly.* New York and London: Harper and Brothers, 1938.

———. *Half a Truth Is Better Than One.* Chicago: University of Chicago Press, 1982.

Krinsky, Carol Herselle. *Gordon Bunshaft of Skidmore, Owings, and Merrill: New York, Architectural History Foundation.* Cambridge, Mass.: MIT Press, 1988.

Lamb, Martha J., and Mrs. Burton Harrison. *History of the City of New York: Its Origin, Rise, and Progress.* Vols. 1–3. New York: A. S. Barnes, 1896.

Lambert, John. *Travels through Canada and the United States of North America in the Years 1806, 1807, 1808.* Vols. 1 and 2. London: C. Cradock and W. Joy, 1814.

Lancaster, Clay. *Prospect Park Handbook.* Foreword by Marianne Moore. New York: Greensward Foundation, 1988.

Landau, Sarah Bradford, and Carl W. Condit. *Rise of the New York Skyscraper, 1865–1913.* New Haven: Yale University Press, 1996.

Lane, Wheaton Joshua. *Commodore Vanderbilt: An Epic of the Steam Age.* New York: Alfred A. Knopf, 1942.

Lankevich, George J., and Howard B. Furer. *A Brief History of New York City.* Port Washington, N.Y.: Associated Faculty Press, 1983.

La Rochefoucauld-Liancourt, François-Alexandre Frédéric, duc de. *Travels through the United States of North America, the Country of the*

Bibliography

Iroquois, and Upper Canada in the Years 1795, 1796, and 1797. 2 vols. London: T. Davison, 1799.

Leary, Lewis. *American Literature: A Study and Research Guide.* New York: St. Martin's Press, 1976.

Lee, Richard Henry. *The Letters of Richard Henry Lee.* Vols. 1 and 2. Ed. James Curtis Ballagh. New York: Da Capo Press, 1970.

Lessard, Suzannah. *The Architect of Desire: Beauty and Danger in the Stanford White Family.* New York: Dial Press, 1996.

Lewis, David Levering. *When Harlem Was in Vogue.* New York: Alfred A. Knopf, 1981.

———, ed. *The Portable Harlem Renaissance Reader.* New York: Viking Press, 1994.

Lincoln, Abraham. *United States Lincoln Sesquicentennial Commission: Lincoln Day by Day, a Chronology, 1809–1865.* 3 vols. Washington, D.C.: Lincoln Sesquicentennial Commission, 1960.

Lockwood, Charles. *Bricks and Brownstones: The New York Row House, 1783–1929, an Architectural and Social History.* New York: McGraw-Hill, 1972.

———. *Manhattan Moves Uptown: An Illustrated History.* Boston: Houghton Mifflin, 1976.

Longfellow, Henry Wadsworth. *Favorite Poems.* New York: Doubleday, 1967.

Lowe, David. *Stanford White's New York.* New York: Doubleday, 1992.

Lyman, Susan Elizabeth. *The Story of New York.* New York: Crown, 1964.

Mackay, Donald A. *The Building of Manhattan.* New York: Harper and Row, 1987.

Malone, Dumas. *Jefferson and His Time.* 6 vols. Boston: Little, Brown, 1948–81.

Martineau, Harriet. *Society in America.* Vols. 1–3. London: Saunders and Otley, 1837.

Mayer, Martin. *The Builders: Houses, People, Neighborhoods, Government, Money.* New York: W. W. Norton, 1978.

McAllister, Ward. *Society As I Have Found It.* New York: Cassell, 1890.

McCall, Dan. *The Silence of Bartleby.* Ithaca, N.Y.: Cornell University Press, 1989.

McCullers, Carson. *The Mortgaged Heart.* Boston: Houghton Mifflin, 1971.

McCullough, David. *The Great Bridge.* New York: Simon and Schuster, 1972.

McKean, John. *Crystal Palace: Joseph Paxton and Charles Fox.* London: Phaidon Press, 1994.

Melville, Herman. *Moby Dick.* New York: Modern Library, 1944.

———. *Pierre.* New York: HarperCollins, 1995.

Melville and Hawthorne in the Berkshires: A Symposium. Kent, Ohio: Kent State University Press, 1968.

Miller, Arthur. *Death of a Salesman.* New York: Penguin Books, 1976.

Miller, Edwin Haviland. *Walt Whitman's "Song of Myself": A Mosaic of Interpretations.* Iowa City: University of Iowa Press, 1989.

Miller, Samuel. *A Brief Retrospective of the Eighteenth Century.* 3 vols. London: Reprinted for J. Johnson, 1805.

Miller, The Reverend John. *A Description of the Province and City of New York, with Plans of the City and Several Ports As They Existed in the Year 1695.* London: Thomas Rodd, 1893.

———. *New York Considered and Improved, 1695.* Cleveland: Burrows Brothers, 1903.

Mills, C. Wright. *The Power Elite.* New York: Oxford University Press, 1956.

Mohl, Raymond A. *Poverty in New York, 1783–1825.* New York: Oxford University Press, 1971.

Molière, Jean Baptiste Poquelin. *Le bourgeois gentilhomme: Comédie-Ballet.* Paris: Didier, 1968.

Monthly Magazine and American Review. Vols. 1–3 (April 1799–December 1800).

Moore, Margaret. *End of the Road for Ladies' Mile?* New York: Drive to Protect Ladies' Mile District, with the cooperation of the Municipal Art Society and the Historic Districts Council, 1986.

Moore, Marianne. *Collected Poems.* New York: Macmillan, 1951.

More, Thomas. *Utopia.* London: Folio Society, 1972.

Moreau de St. Méry, Médéric-Louis-Elie. *Voyage aux Etats Unis de l'Amérique, 1793–1798.* New Haven: Yale University Press, 1913.

Morris, Jan. *Manhattan '45.* New York: Oxford University Press, 1987.

Morris, Lewis. *The Papers of Lewis Morris.* 3 vols. Ed. Eugene Sheridan. Newark: New Jersey Historical Society, 1991.

Morris, Lloyd. *Incredible New York: High Life and Low Life of the Last Hundred Years.* New York: Random House, 1951.

Moses, Robert. *Long Island Studies Conference: Robert Moses, Single-Minded Genius.* Ed. Joann P. Krieg. Interlaken, N.Y.: Heart of the Lakes, 1989.

———. *Public Works: A Dangerous Trade.* New York: McGraw-Hill, 1970.

Moynihan, Daniel P., ed. *On Understanding Poverty: Perspectives from the Social Sciences.* New York: Basic Books, 1969.

Nash, Gary. *The Urban Crucible: The Northern Seaports and the Origins of the American Revolution.* Cambridge, Mass.: Harvard University Press, 1986.

Nash, Ogden. *Funniest Verses of Ogden Nash.* New York: Hallmark Editions, 1968.

———. *I Wouldn't Have Missed It: Selected Poems of Ogden Nash.* Selected by Linell Smith and Isabel Eberstadt. Introduction by Archibald MacLeish. Boston: Little, Brown, 1975.

Nevins, Allan. *American Social History as Recorded By British Travellers.* New York: Henry Holt, 1923.

Nevins, Allan, and John A. Krout, eds. *The Greater City, New York, 1898–1948.* Westport, Conn.: Greenwood Press, 1948.

Nevins, Deborah, ed. *Grand Central Terminal: City within the City.* New York: Municipal Art Society, 1982.

New York City Bicentennial Corporation. *An Historical Portrait: New York City, 1776–1976.* New York: Manhattan Post Card Publishing, 1976.

New York City Guide. Prepared by the Works Progress Administration. New York: Random House, 1939.

New-York Historical Society. *Commemoration of the Conquest of New Netherland on Its Two Hundredth Anniversary by the New-York Historical Society.* New York: New-York Historical Society, 1864.

O'Callaghan, E. B. *The Documentary History of the State of New York.* 4 vols. Albany, N.Y.: Weed, Parsons, 1850–1.

———. *History of New Netherland: Or, New York Under the Dutch.* Vols. 1 and 2. New York: D. Appleton, 1846.

———. *Voyages of the Slavers* St. John *and* Arms of Amsterdam, *1659, 1663.* Albany, N.Y.: J. Munsell, 1867.

———, trans. *A Brief and True Narrative of the Hostile Conduct of the Barbarous Natives towards the Dutch Nation.* Albany, N.Y.: J. Munsell, 1863.

Olmsted, Frederick Law. *Forty Years of Landscape Architecture: Central Park.* Ed. Frederick Law Olmsted Jr. and Theodora Kimball. Cambridge, Mass.: MIT Press, 1973.

———. *The Papers of Frederick Law Olmsted.* Vol. 3. Baltimore: Johns Hopkins University Press, 1983.

———. *The Years of Olmsted, Vaux, and Company, 1865–1874.* Vol. 6. Baltimore: Johns Hopkins University Press, 1992.

O'Neale, Sondra A. *Jupiter Hammon and the Biblical Beginnings of African-American Literature.* Metuchen, N.J.: Scarecrow Press, 1993.

Ostow, Miriam, and Anna B. Dutka. *Work and Welfare in New York City.* Baltimore: Johns Hopkins University Press, 1975.

Pachter, Marc, and Frances Wein, eds. *Abroad in America: Visitors to the New Nation, 1776-1914.* Reading, Mass.: National Portrait Gallery and Addison-Wesley, 1976.

Pattee, Fred Lewis. *A History of American Literature since 1870.* New York: Century, 1915.

Patterson, Jerry E. *The City of New York: A History Illustrated from the Collections of the Museum of the City of New York.* New York: Harry N. Abrams, 1978.

Pepys, Samuel. *Diary and Correspondence.* Vols. 1–4. London: Bell and Daldy, 1867.

Phelan, Thomas P. *Thomas Dongan: Colonial Governor of New York, 1683-1688.* New York: P. J. Kenedy and Sons, 1933.

Pinkerton, John. *A General Collection of the Best and Most Interesting Voyages and Travels in All Parts of the World.* Vols. 12 and 13. London: Longman, Hurst, Rees, Orms, and Brown, 1812.

Plowden, David. *Bridges: The Spans of North America.* New York: Viking Press, 1974.

Plunz, Richard. *A History of Housing in New York City: Dwelling Type and Social Change in the American Metropolis.* New York: Columbia University Press, 1990.

Poe, Edgar Allan. *Collected Works of Edgar Allan Poe.* Ed. Thomas Ollive Mabbott. Cambridge, Mass.: Harvard University Press, Belknap Press, 1969.

———. *Doings of Gotham.* Pottsville, Penn.: Jacob R. Spannuth, 1929.

———. *The Poetical Works of Edgar Allan Poe, with a Notice of His Life and Genius by James Hannay.* London: Addey, 1853.

Pomerantz, Sidney I. *New York, an American City, 1783–1803: A Study of Urban Life.* Port Washington, N.Y.: Ira J. Friedman, 1965.

Porter, Kenneth Wiggins. *John Jacob Astor, Business Man.* 2 vols. Cambridge, Mass.: Harvard University Press, 1931.

Pownall, Thomas. *A Topographical Description of the Dominions of the United States of America, 1776.* Ed. Louis Mulkearn. Pittsburgh: University of Pittsburgh Press, 1949.

Pye, Michael. *The Biography of New York.* London: Sinclair-Stevenson, 1991.

Queens (Borough) Chamber of Commerce. *Queens Borough: Being a Descriptive and Illustrated Book of the Borough of Queens, City of Greater New York.* Brooklyn: Brooklyn Eagle Press, 1914.

Raesly, Ellis Lawrence. *Portrait of New Netherland.* New York: Columbia University Press, 1945.

Ramusio, Giovanni Battista. *Navigationi et viaggi* [Venice, 1563–1696]. Vols. 1–3. Amsterdam: Theatrum Orbis Terrarum, 1963.

Reed, Henry Hope, and Sophia Duckworth. *Central Park: A History and a Guide.* New York: Clarkson N. Potter, 1972.

Renwick, James. *Life of DeWitt Clinton.* New York: Harper and Brothers, 1859.

Reynolds, Donald M. *The Architecture of New York City: Histories and Views of Important Structures, Sites, and Symbols.* New York: Macmillan, 1984.

Richardson, Edgar P. *American Art: A Narrative and Critical Catalogue.* San Francisco: Fine Arts Museums of San Francisco, 1976.

———. *American Paintings and Related Pictures in the Henry Francis Du Pont Winterthur Museum.* Charlottesville: University Press of Virginia, 1986.

———. *Painting in America, from 1502 to the Present.* New York: Thomas Y. Crowell, 1965.

Riis, Jacob. *How the Other Half Lives: Studies among the Tenements of New York.* Cambridge, Mass.: Harvard University Press, Belknap Press, 1970.

———. *The Making of an American.* New York: Grosset and Dunlap, 1909.

Robinson, Ray, and Christopher Jennison. *Yankee Stadium: Seventy-five Years of Drama, Glamour, and Glory.* New York: Penguin Putnam, 1998.

Rosenberg, Pierre. "A French Point of View." In Theodore E. Stebbins Jr., Carol Troyen, and Trevor J. Fairbrother, *A New World: Masterpieces of American Painting, 1760-1910.* Boston: Museum of Fine Arts, 1983.

Ross, Ishbel. *Ladies of the Press: The Story of Women in Journalism by an Insider.* New York: Harper and Brothers, 1936.

Rothman, David, and Sheila Rothman, eds. *On Their Own: The Poor in Modern America.* Reading, Mass.: Addison-Wesley, 1972.

Rothschild, Nan A. *New York City Neighborhoods: The Eighteenth Century.* New York: Academic Press, 1990.

Rowse, A. L. *The Poet Auden: A Personal Memoir.* London: Methuen, 1987.

Rubin, Joseph J., and Charles H. Brown, eds. *Walt Whitman of the New York "Aurora."* State College: Pennsylvania State University Press, 1950.

Rubin, Joseph Jay. *The Historic Whitman.* University Park: Pennsylvania State University Press, 1973.

Russell, William Howard. *My Diary North and South.* Philadelphia: Temple University Press, 1988.

Rutherford, Livingston. *John Peter Zenger: His Press, His Trial, and a Bibliography of Zenger Imprints.* New York: Dodd, Mead, 1904.

Sachs, Charles L. *Made on Staten Island: Agriculture, Industry, and Suburban Living in the City.* Richmondtown, Staten Island: Staten Island Historical Society, 1988.

Sagra, Ramon De La. *Cinco meses en los Estados-Unidos de la America del Norte* (Five months in the United States of North America). Paris: Pablo Renouard, 1836.

Saint Patrick's Cathedral, the 100th Year. New York: Saint Patrick's Cathedral, [1979?].

Salt, Henry Stephens. *Life of Henry David Thoreau.* Urbana: University of Illinois Press, 1993.

Sanders, Ronald. *The Lower East Side: A Guide to Its Jewish Past in Ninety-nine New Photographs.* New York: Dover Publications, 1979.

Schwartz, Delmore. *In Dreams Begin Responsibilities and Other Stories.* New York: New Directions, 1978.

Scoville, Joseph Alfred. *The Old Merchants of New York City.* Vols. 1–4. New York: Carleton, 1866.

Seidel, Michael. *Streak: Joe DiMaggio and the Summer of '41.* New York: McGraw-Hill, 1988.

Severini, Lois. *The Architecture of Finance: Early Wall Street.* Ann Arbor, Mich.: UMI Research Press, 1983.

Seybolt, Robert Francis. *Apprenticeship and Apprenticeship Education in Colonial New England and New York.* New York: Columbia University Press, 1917.

Seymour, Harold. *Baseball.* Vols. 1–3. New York: Oxford University Press, 1960–90.

Shepherd, Barnett. *Sailors' Snug Harbor, 1801–1976.* New York: Snug Harbor Cultural Center in association with Staten Island Institute of Arts and Sciences, 1979.

Shepherd, William R. *The Story of New Amsterdam.* New York: Alfred A. Knopf, 1917.

Sherwood, Mary Elizabeth. *Manners and Social Usages.* New York: Harper and Brothers, 1897.

Silver, Nathan. *Lost New York.* New York: Houghton Mifflin, 1967.

Singleton, Esther. *Dutch New York.* New York: Dodd, Mead, 1909.

———. *Social New York Under the Georges, 1774–1776.* New York: D. Appleton, 1902.

Skinner, Alanson. *The Indians of Greater New York.* Cedar Rapids, Iowa: Torch Press, 1915.

Smith, Dorothy Valentine. *Staten Island, Gateway to New York.* Philadelphia: Chilton Book Company, 1970.

Smith, George I. *Religion and Trade in New Netherland: Dutch Origins and American Development.* Ithaca: Cornell University Press, 1993.

Smith, Thomas E.V. *The City of New York in the Year of Washington's Inauguration, 1789.* New York: Anson D. F. Randolph, 1889.

Solomon, Alan. *Painting in New York, 1944 to 1969.* Pasadena: Pasadena Art Museum, 1970.

Spann, Edward K. *Ideals and Politics: New York Intellectuals and Liberal Democracy, 1820–1880.* Albany: State University of New York Press, 1972.

———. *The New Metropolis: New York City, 1840–1857.* New York: Columbia University Press, 1981.

Stansell, Christine. *City of Women: Sex and Class in New York, 1789–1860.* New York: Alfred A. Knopf, 1986.

Stebbins, Theodore E., Jr., Carol Troyen, and Trevor J. Fairbrother. *A New World: Masterpieces of American Painting, 1760-1910.* Boston: Museum of Fine Arts, 1983.

Still, Bayard. *Mirror for Gotham: New York as Seen by Contemporaries from Dutch Days to the Present.* New York: New York University Press, 1956.

Stokes, I. N. Phelps. *The Iconography of Manhattan Island, 1498–1909.* 6 vols. New York: Robert H. Dodd, 1915–36.

———. *New York Past and Present, 1524–1939.* New York: Privately printed, 1939.

Strong, George Templeton. *The Diary of George Templeton Strong, 1835–1876.* Vols. 1–4. Ed. Allan Nevins and Milton Halsey Thomas. New York: Macmillan, 1952.

Stuart, James. *Three Years in North America.* Vols. 1 and 2. Edinburgh: Robert Cadell, 1833.

Sweetser, M. F., and Simeon Ford. *How to Know New York City: A Serviceable and Trustworthy Guide.* New York: Press of J. J. Little, 1895.

Tauranac, John, and Christopher Little. *Elegant New York: The Builders and the Buildings, 1885–1915.* New York: Abbeville Press, 1985.

Thackeray, William Makepeace. *The Letters and Private Papers of William Makepeace Thackeray.* 4 vols. Ed. Gordon N. Ray. Cambridge, Mass.: Harvard University Press, 1946.

Thomas, Milton Halsey. "Mid-Nineteenth Century Life in New York." *New-York Historical Society Quarterly* 37 (January 1953): 5–39.

Thoreau, Henry David. *Familiar Letters of Henry David Thoreau.* Ed. F. B. Sanborn. Boston: Houghton, Mifflin, 1894.

Thornwell, Emily. *The Lady's Guide to Perfect Gentility.* New York: Derby and Jackson, 1860.

Tobler, Emanuel. *The Changing Face of Poverty: Trends in New York City's Population in Poverty, 1960–1990.* New York: Community Service Society of New York, 1984.

Tocqueville, Alexis de. *Democracy in America.* Vols. 1 and 2. New York: Henry G. Langley, 1845.

Trager, Philip. *New York.* Middletown, Conn.: Wesleyan University Press, 1980.

Triborough Bridge and Tunnel Authority. *Triborough Bridge and Tunnel Authority Facilities.* New York: Triborough Bridge and Tunnel Authority, 1973.

Trollope, Frances. *Domestic Manners of the Americans.* London: Folio Society, 1974.

Trotsky, Leon. *My Life: An Attempt at an Autobiography.* New York: Charles Scribner's Sons, 1930.

Trow, George W. S. *My Pilgrim's Progress: Media Studies, 1950–1998.* New York: Pantheon Books, 1999.

Twain, Mark. *Mark Twain-Howells Letters: The Correspondence of Samuel L. Clemens and William D. Howells, 1872-1910.* Ed. Henry Nash Smith and William H. Gibson, with the assistance of Fred-

eric Anderson. Cambridge, Mass.: Harvard University Press, Belknap Press, 1960.

Twain, Mark, and Charles Dudley Warner. *The Gilded Age: A Tale of Today* [1873]. New York: Oxford University Press, 1996.

Valentine, David T., ed. *Manual of the Corporation of the City of New York.* 29 vols. New York: J. W. Bell and Others, 1841–70.

Vanderbilt, Arthur T. *Fortune's Children: The Fall of the House of Vanderbilt.* New York: William Morrow, 1989.

van der Donck, Adriaen. *A Description of the New Netherlands* [1665]. Syracuse, N.Y.: Syracuse University Press, 1968.

———. *Vertoogh van Nieu Nederland* (Remonstrance of New Netherland). Albany, N.Y.: Weed, Parsons, 1856.

Van Rensselaer, Mrs. Schuyler. *History of the City of New York in the Seventeenth Century.* Vols. 1 and 2. New York: Macmillan, 1909.

Wallock, Leonard. *New York: Culture Capital of the World, 1940–1965.* New York: Rizzoli International Publications, 1988.

Ward, David. *Poverty, Ethnicity, and the American City, 1840–1925.* Cambridge: Cambridge University Press, 1989.

Wecter, Dixon. *The Saga of American Society: A Record of Social Aspiration, 1607–1937.* New York: Charles Scribner's Sons, 1937.

Wegelin, Oscar. *Jupiter Hammon, American Negro Poet: Selections from His Writings and a Bibliography.* Freeport, N.Y.: Books for Libraries Press, 1970.

Weinberg, H. Barbara, Doreen Bolger, and David Park Curry. *American Impressionism and Realism: The Painting of Modern Life, 1885–1915.* New York: Metropolitan Museum of Art. Distributed by Harry N. Abrams, 1994.

Weld, Isaac. *Travels through the States of North America and the Provinces of Upper and Lower Canada, During the Years 1795, 1796, 1797.* London: Printed for John Stackdale, 1799.

Wharton, Edith. *A Backward Glance.* New York: D. Appleton-Century, 1934.

———. *The House of Mirth.* London: Folio Society, 1990.

———. *Old New York.* London: Virago Press, 1985.

Whibley, Charles. *American Sketches.* Edinburgh and London: William Blackwood and Sons, 1908.

Whiffen, Marcus, ed. *The Architect and the City: Papers from the AIA-ACSA Teacher Seminar.* Cranbrook Academy of Art, June 11–12, 1962.

White, E. B. *Here Is New York.* New York: Harper and Brothers, 1949.

Whitman, Walt. *Complete Poetry and Selected Prose and Letters.* London: Nonesuch Press, 1971.

Wieman, Clark. *The Age of New York City Infrastructure: Water Supply, Wastewater Disposal, Bridges, Transit, Streets.* New York: Cooper Union for the Advancement of Science and Art, 1991.

Wignall, Trevor C. *The Story of Boxing.* London: Hutchinson, 1923.

Willis, Carol. *Form Follows Finance. Skyscrapers and Skylines in New York and Chicago.* New York: Princeton Architectural Press, 1995.

Wilmerding, John. *American Light: The Luminist Movement, 1850–1875, Paintings, Drawings, Photographs.* Princeton, N.J.: Princeton University Press in collaboration with the National Gallery of Art in Washington, D.C., 1989.

Wilson, Edmund. *Classics and Commercials: A Literary Chronicle of the Forties.* New York: Farrar, Straus, 1958.

Wilson, Richard Guy. *McKim, Mead, and White, Architects.* New York: Rozzoli International Publications, 1983.

Wilson, Rufus Rockwell. *New York, Old and New: Its Story, Streets, and Landmarks.* Vols. 1 and 2. Philadelphia: J. B. Lippincott, 1902.

Wortley, Lady Emmeline Stuart. *Travels in the United States, Etc. during 1849 and 1850.* Paris: Baudry's European Library, 1854.

Yellowitz, Irwin, ed. *Essays in the History of New York City: A Memorial to Sidney Pomerantz.* Port Washington, N.Y.: National University Publications, 1978.

Yezierska, Anzia. *Salome of the Tenements.* Urbana: University of Illinois Press, 1995.

Yochelson, Bonnie. *Berenice Abbott: Changing New York.* New York: Museum of the City of New York, 1997.

PICTURE CREDITS

Engraver: Amos Doolittle

Print Collection, Miriam and Ira D. Wallach Division of Art, Prints, and Photographs, New York Public Library, Astor, Lenox, and Tilden Foundations

FIGURE 2.1 *Portrait of the Drapers' Guild, 1662*

Etching. 9¹¹⁄₁₆ × 14⁴⁄₁₆; 242 × 364 mm.

Artist: Rembrandt Harmensz van Rijn

Etcher: Leopold Flameng

Issued: 1876

Print Collection, Miriam and Ira D. Wallach Division of Art, Prints, and Photographs, New York Public Library, Astor, Lenox, and Tilden Foundations

FIGURE 2.2 *Captain Webb Preaching Methodism in New York, 1768*

Engraving. 4⁶⁄₁₆ × 6⅛ inches; 114 × 156 mm.

Artist and Engraver: Anonymous

Print Collection, Miriam and Ira D. Wallach Division of Art, Prints, and Photographs, New York Public Library, Astor, Lenox, and Tilden Foundations

FIGURE 2.3 *Trinity Church, ca. 1790*

Watercolor. 5.2 × 7.5 inches; 128 × 186 mm.

Artist: Unknown

Museum of the City of New York, Gift of Stephen C. Clark in memory of his father, Alfred Corning Clark

35.408.102

FIGURE 2.4 *B'nai Jeshurun Synagogue, ca. 1830*

Colored lithograph. 11 × 9.1 inches; 275 × 228 mm.

Artist: Alexander Jackson Davis

Lithographer: Anthony Imbert

Museum of the City of New York, J. Clarence Davies Collection

29.100.1611

FIGURE 2.5 *Night-Fall, St. Thomas Church, Broadway, New York, ca. 1835*

Watercolor. 13⅝ × 8⁵⁄₁₆ inches; 341 × 208 mm.

Artist: George Harvey

Museum of the City of New York, Bequest of Mrs. J. Insley Blair in memory of Mr. and Mrs. J. Insley Blair

52.100.11

FIGURE 2.6 *The Beecher Trial in Brooklyn, 1875*

Wood engraving. 7½ × 10½; 190 × 266 mm.

Artist: J. N. Hyde

Frank Leslie's Illustrated Newspaper, April 17, 1875

From J. Grafton, New York in the Nineteenth Century, Dover, 1977

FIGURE 2.7 *Saint Mark's Church: Skywriting Spiral, 1937*

Photograph

Photographer: Berenice Abbott

Museum of the City of New York, Gift of the Federal Art Project, Work Projects Administration

Abbott no. 214

FIGURE 2.8 *A South East View of the City of New York in America, ca. 1763*

Engraving. 21½ × 28 inches; 538 × 700 mm.

Artist: Thomas Howdell

Engraver: P. Canot

Museum of the City of New York, Gift of Miss Edith Allen Clark, given in memory of her brother, P. A. Clark

51.48.2

FIGURE 2.9 *Night School in the Seventh Avenue Lodging House (Children's Aid Society), 1890*

Photograph

Photographer: Jacob A. Riis

Museum of the City of New York, Jacob A. Riis Collection

90.13.4.173

FIGURE 2.10 *East Side Public School, ca. 1890*

Photograph

Photographer: Jacob A. Riis

Museum of the City of New York, Jacob A. Riis Collection

Riis no. 250

FIGURE 2.11 *Virginia Day Nursery, 1906*

Photograph

Photographer: Percy Byron

Museum of the City of New York, Byron Collection

93.1.1.17279

FIGURE 2.12 *Women's Swim Team, Columbia University, 1999*

Photograph

Photographer: Specter Kozinn

Columbia Spectator, January 21, 1999

FIGURE 3.1 *Man-of-War and Galleys, ca. 1550*

Engraving. 8¹⁰⁄₁₆ × 11⁴⁄₁₆ inches; 217 × 285 mm.

Artist: Peter Breughel

Engraver: F. Huys

Print Collection, Miriam and Ira D. Wallach Division of Art, Prints, and Photographs, New York Public Library, Astor, Lenox, and Tilden Foundations

FIGURE 3.2 *Winter Scene on Frozen Canal in the Netherlands, ca. 1620*

Oil on wood. 14½ × 25¼ inches; 368 × 650 mm.

Artist: Hendrick Avecamp

Los Angeles County Museum

FIGURE 3.3 *Canal in Broad Street, 1659*

Wood engraving. 3³⁄₁₆ × 3⁷⁄₁₆ inches; 80 × 87 mm.

Issued: ca. 1820

Artist and Engraver: Unknown

Emmet Collection, Miriam and Ira D. Wallach Division of Art, Prints, and Photographs, New York Public Library, Astor, Lenox, and Tilden Foundations

FIGURE 3.4 *View of Fort George with the City of New York from the Southwest (the Carwitham View of New York), ca. 1731–6*

Colored copper engraving. 20 × 15½ inches; 500 × 388 mm.

Artist: prob. William Burgia

Engraver: John Carwitham

Museum of the City of New York, Bequest of Mrs. J. Insley Blair in memory of Mr. and Mrs. J. Insley Blair

52.100.30

FIGURE 3.5 *Castle Garden at the Battery, ca. 1840*

Colored lithograph. 12¼ × 8¾ inches; 307 × 219 mm.

Lithographer: D. W. Lewis
Museum of the City of New York, Gift of Mrs. Rodman Gilder
in memory of her husband, Rodman Gilder
55.62.24

FIGURE 3.6 *The Steamer "Hartford" Bound for California, Feb. 20, 1849*
Watercolor. 25½ × 38½ inches; 637 × 963 mm.
Artist: Joseph B. Smith
Museum of the City of New York, Bequest of Mrs. J. Insley
Blair in memory of Mr. and Mrs. J. Insley Blair
52.100.3

FIGURE 3.7 *Erie Railway Company's Steam Ferry Boat "Pavonia,"
ca. 1850*
Colored lithograph. 11.5 × 23.8 inches; 288 × 595 mm.
Lithographer and publisher: Endicott and Company
Museum of the City of New York, J. Clarence Davies Collection
34.100.261

FIGURE 3.8 *Yachting in New York Harbor, ca. 1850*
Oil on canvas. 19 × 15 inches; 475 × 375 mm.
Artist: James E. Buttersworth
Museum of the City of New York, Anonymous Gift
51.222.2

FIGURE 3.9 *Bay of New York Taken from the Battery, 1851*
Colored lithograph. 25 × 46 inches; 625 × 1,150 mm.
Drawn from nature by J. Bornet
Figures by E. Valois
Drawn on stone by E. Valois
Publisher: D. McClellan
Museum of the City of New York, Bequest of Mrs. J. Insley
Blair in memory of Mr. and Mrs. J. Insley Blair
52.100.25

FIGURE 3.10 *Clipper Ship "Eagle" Sailing Out of New York, ca. 1855*
Oil on canvas. 20¼ × 30⅛ inches; 515 × 768 mm.
Artist: James E. Butterworth
South Street Seaport Museum

FIGURE 3.11 *Steerage Passengers ("SS Pennland" of the Red Star Line),
1893*
Photograph
Photographer: Percy Byron
Museum of the City of New York, Byron Collection
93.1.1.18432

FIGURE 3.12 *The Schooner "Theoline," 1936*
Photograph
Photographer: Berenice Abbott
Museum of the City of New York, Gift of the Federal Art
Project, Work Projects Administration
Abbott no. 109

FIGURE 3.13 *Rope Store, Peerless Equipment Company, 1936*
Photograph
Photographer: Berenice Abbott
Museum of the City of New York, Gift of the Federal Art
Project, Work Projects Administration
Abbott no. 68

FIGURE 4.1 *View of Tyre by the River Sidon, ca. 1650*
Etching. 5⅞ × 8¹¹⁄₁₆ inches; 150 × 216 mm.
Artist: I. Peeters
Engraver: Wenceslaus Hollar
Print Collection, Miriam and Ira D. Wallach Division of Art,
Prints, and Photographs, New York Public Library, Astor, Lenox,
and Tilden Foundations

FIGURE 4.2 *Section of the City Wall, 1653*
Wood engraving. 2¹¹⁄₁₆ × 3¹¹⁄₁₆ inches; 64 × 83 mm.
Engraver: Anonymous
Issued: ca. 1820
Emmet Collection, Miriam and Ira D. Wallach Division of Art,
Prints, and Photographs, New York Public Library, Astor, Lenox,
and Tilden Foundations

FIGURE 4.3 *Gezicht van de Beurs te Amsterdam (Interior of the Stock
Exchange in Amsterdam), ca. 1770*
Engraving. 11 × 15¼ inches; 280 × 387 mm.
Artist: H. Schoute
Print Collection, Miriam and Ira D. Wallach Division of Art,
Prints, and Photographs, New York Public Library, Astor, Lenox,
and Tilden Foundations

FIGURE 4.4 *Wall Street, West from Hanover Street, 1790*
Chromolithograph. 27.9 × 17.11 inches; 698 × 428 mm.
Artist: Jennie Brownscombe
Issued: 19th century
Museum of the City of New York, J. Clarence Davies
Collection
29.100.2335

FIGURE 4.5 *Portrait of John Jacob Astor, ca. 1802*
Painting. 17 × 15 inches; 430 × 381 mm.
Artist: Anonymous
Manuscripts and Archives Division, New York Public Library,
Astor, Lenox, and Tilden Foundations

FIGURE 4.6 *Leonard Bond's Hat Ware-House, ca. 1828*
Watercolor drawing. 9.1 × 7.6 inches; 227 × 190 mm.
Artist: Alexander Jackson Davis
Museum of the City of New York, Gift of Joseph B. Davis
35.257.1

FIGURE 4.7 *Interior of the New York Merchants' Exchange, 1830*
Etching with engraving. 3⁹⁄₁₆ × 2¾ inches; 88 × 68 mm.
Artist: Charles Burton
Engraver: H. Fossette
I. N. Phelps Stokes Collection, Miriam and Ira D. Wallach
Division of Art, Prints, and Photographs, New York Public
Library, Astor, Lenox, and Tilden Foundations

FIGURE 4.8 *Merchants' Exchange, 1837*
Colored lithograph. 22 × 15¼ inches; 550 × 382 mm.
Artist: C. G. Warner
Printed and published by J. H. Bufford's Lithograph Establishment
Museum of the City of New York, New York Stock
Exchange Fund
38.299.8

FIGURE 4.9 *Bartleby, the Scrivener of Wall Street, 1853*
India ink on paper. 7¼ × 5½ inches; 184 × 140 mm.
Artist: Thomas Wesley Peck
Executed: 1999
Collection of the artist

FIGURE 4.10 *Grand Ball at the Academy of Music for the Prince of Wales, 1860*
Wood engraving. 8 × 7 inches; 201 × 176 mm.
Newspaper illustration in *Frank Leslie's Illustrated Newspaper*, October 27, 1860
Museum of the City of New York

FIGURE 4.11 *Portrait of J. Pierpont Morgan, 1902*
Photograph
Photographer: Pach Brothers
Museum of the City of New York

FIGURE 4.12 *Portrait of John D. Rockefeller Sr., 1903*
Oil on canvas. 40½ × 31½ inches; 1,012 × 788 mm.
Artist: Arthur Ferraris
Museum of the City of New York, Gift of Mrs. Alta Rockefeller Prentice
62.204.1

FIGURE 5.1 *Portrayal of New World Indians, 1493*
Woodcut. 4 3/8 × 2⅞ inches; 112 × 71 mm.
Anonymous (published with the letter of Christopher Columbus)
Rare Books Division, New York Public Library, Astor, Lenox, and Tilden Foundations

FIGURE 5.2 *View of New Amsterdam (the Hartgers View), ca. 1626–8*
Copper engraving. 4¾ × 3¼ inches; 119 × 81 mm.
Artist: Possibly Kryn Frederycks
Issued: 1651
Museum of the City of New York, J. Clarence Davies Collection
29.100.792

FIGURE 5.3 *The Restituto New World Map and View of New Amsterdam, ca. 1673*
Colored engraving. 18½ × 21½ inches; 466 × 541 mm.
Cartographer and publisher: Carolus Allardt
Museum of the City of New York, J. Clarence Davies Collection
29.100.2199

FIGURE 5.4 *Notice of Runaway Slaves, 1763*
Newspaper announcement posted by William Bull
New-York Gazette; or, the *Weekly Post-Boy*, October 27, 1763
General Research Division, New York Public Library, Astor, Lenox, and Tilden Foundations

FIGURE 5.5 *Miniature of James Duane (1733–97), ca. 1784*
Miniature oil on ivory.
Artist: James Ramage
Museum of the City of New York, Gift of Mrs. Elon H. Hooker
39.207

FIGURE 5.6 *Bill of Sale for a Slave, September 3, 1785*
Document (handbill)
Museum of the City of New York, Gift of Mrs. Newbold Morris
34.86.2

FIGURE 5.7 *Corner of Warren and Greenwich Streets. Drawn in January, during the Snow, 1809*
Watercolor. 7¾ × 13½ inches; 194 × 338 mm.
Artist: Baroness Hyde de Neuville
Museum of the City of New York, Bequest of Mrs. J. Insley Blair in memory of Mr. and Mrs. J. Insley Blair
52.100.6

FIGURE 5.8 *The Boots Cleaner, ca. 1840; the Root Beer Seller, ca. 1840; the Butter and Milkman, ca. 1840; the Oyster Stand of Patrick Bryant, ca. 1840; the Butcher, ca. 1840*
Watercolors. Each 10¼ × 14 inches: 256 × 350 mm.
Artist: Nicolino Calyo
Museum of the City of New York, Gift of Mrs. Francis P. Garvan in memory of Francis P. Garvan
55.6.1; 55.6.8; 55.6.10; 55.6.16; 55.6.22

FIGURE 5.9 *Rioters Chasing Negro Women and Children through Vacant Lots in Lexington Avenue, 1863*
Wood engraving. 2½ × 3¼ inches; 63 × 82 mm.
Artist: Anonymous [from *Harper's Weekly*, July 21, 1863]
Museum of the City of New York

FIGURE 5.10 *View from Castle Garden, 1881*
Watercolor. 13½ × 19½ inches; 338 × 488 mm.
Artist: Hughson Hawley
Museum of the City of New York, Bequest of Riesa Friedman
71.62.1

FIGURE 5.11 *Street Arabs at Night, ca. 1890*
Photograph
Photographer: Jacob A. Riis
Museum of the City of New York, Jacob A. Riis Collection
90.13.4.126

FIGURE 5.12 *Immigration Building, Ellis Island, 1938*
Photograph
Photographer: Berenice Abbott
Museum of the City of New York, Gift of the Federal Art Project, Work Projects Administration
Abbott no. L-12

FIGURE 5.13 *Ellis Island (Man Reading Newspaper), ca. 1950*
Photograph
Photographer: Erika Stone
Museum of the City of New York, Gift of Erika Stone
96.173.6

FIGURE 6.1 *The New Dutch Church, Corner of Nassau and Crown (Liberty) Streets, ca. 1731*
Copper engraving. 13¾ × 9¾ inches; 344 × 244 mm.
Engraver: William Burgis
Museum of the City of New York, Gift of James Garretson
55.249.1

FIGURE 6.2 *Robert Ray (1759–82), 1771*
Oil on canvas. 30 × 25½ inches; 763 × 648 mm.
Artist: John Durand
Museum of the City of New York, Bequest of Gherardi Davis
41.304.1

FIGURE 6.3 *The Walton House, ca. 1780*
Drawing in ink. 4⁹⁄₁₆ × 6⅛ inches; 110 × 155 mm.
Artist: [Abram S. Hosier?]
Print Collection, Miriam and Ira D. Wallach Division of Art,
Prints, and Photographs, New York Public Library, Astor, Lenox,
and Tilden Foundations

FIGURE 6.4 *Philip Hone (1780–1851), 1820*
Oil on canvas. 29½ × 24 inches; 738 × 600 mm.
Attributed to John Wesley Jarvis
Museum of the City of New York, Gift of Mr. Henry W. Munroe
85.205.1

FIGURE 6.5 *Fashionable Turnouts in New York, 1868*
Colored lithograph. 18¾ × 28¾ inches; 469 × 719 mm.
Artist: Thomas Worth
Published by: Currier and Ives
Museum of the City of New York, J. Clarence Davies Collection
29.100.2480

FIGURE 6.6 *Tenement on Mulberry Street, 1879*
Wood engraving. 10½ × 7¼ inches; 266 × 183 mm.
Artist: William A. Rogers
Harper's Weekly, April 5, 1879
From J. Grafton, *New York in the Nineteenth Century, Dover, 1977*

FIGURE 6.7 *Black and Tan Dive in Broome Street near Wooster Street,
ca. 1890*
Photograph
Photographer: Jacob A. Riis
Museum of the City of New York, Jacob A. Riis Collection
Riis no. 163

FIGURE 6.8 *Notorious Five Points Neighborhood, ca. 1886*
Watercolor. 10 × 14 inches; 250 × 357 mm.
Artist: Charles Witham
Museum of the City of New York, Gift of William Seymour
39.134.3

FIGURE 6.9 *The Tombs Prison (Halls of Justice), 1896*
Watercolor. 42 × 29¼ inches; 745 × 1,068 mm.
Artist: Charles Broughton
Museum of the City of New York, Gift of the late Mrs. Charles
Broughton through Mrs. Ross K. Boore
51.47

FIGURE 6.10 *Sweatshop in Hester Street Tenement, ca. 1890*
Photograph
Photographer: Jacob A. Riis
Museum of the City of New York, Jacob A. Riis Collection
Riis no. 149

FIGURE 6.11 *Breadline—No One Has Starved, 1932*
Etching. 6½ × 11⅞ inches; 165 × 282 mm.
Artist: Reginald Marsh
Susan Sheehan Gallery

FIGURE 6.12 *Number 6, the Bowery, 1944*
Chinese ink drawing with watercolor. 40½ × 26 5/8 inches;
1,030 × 676 mm.
Artist: Reginald Marsh

Museum of the City of New York, Gift of Reginald Marsh
53.107.2

FIGURE 6.13 *Stoopball in East Harlem, 1953*
Photograph
Photographer: Sanford Malter
Collection of the photographer

FIGURE 7.1 *The Castello Plan, 1660*
Redraft of the original plan by John Wolcott Adams for
I. N. Phelps Stokes
Drawing in ink: 19.14 × 13.3 inches; 479 × 333 mm.
Original artist: Jacques Cortelyou
Museum of the City of New York, J. Clarence Davies Collection
29.100.709

FIGURE 7.2 *Broadway from Bowling Green, ca. 1834*
Aquatint. 13.6 × 9.5 inches; 304 × 241 mm.
Artist: William J. Bennett
Museum of the City of New York, J. Clarence Davies Collection
29.100.2275

FIGURE 7.3 *City Hall and Park View, 1835*
Oil on copper. 17 × 21 inches; 340 × 525 mm.
Artist: Anonymous, after William Bartlett
Museum of the City of New York, Bequest of Mrs. J. Insley
Blair in memory of Mr. and Mrs. J. Insley Blair
52.100I5

FIGURE 7.4 *Broadway and Rector Street, ca. 1850*
Watercolor. 14.5 × 20.75 inches; 379 × 531 mm.
Artist: John William Hill
Museum of the City of New York, Gift of Forsyth Wickes
38.19

FIGURE 7.5 *Broadway at Ann Street, Barnum Museum, 1855*
Colored lithograph. 21⁸⁄₁₆ × 30⁸⁄₁₆ inches; 545 × 775 mm.
Artist: Unknown
Museum of the City of New York, Harry T. Peters Collection
57.300.582

FIGURE 7.6 *Rainy Late Afternoon, Union Square, 1890*
Oil on canvas. 28 × 36 inches; 713 × 963 mm.
Artist: Childe Hassam
Museum of the City of New York, Gift of Miss Mary
Whitney Bangs
69.121.1

FIGURE 7.7 *Madison Square Park, 1898*
Photograph
Photographer: Joseph Byron
Museum of the City of New York, Byron Collection

FIGURE 7.8 *Wanamaker's, Fourth Avenue and East Ninth Street, 1936*
Photograph
Photographer: Berenice Abbott
Museum of the City of New York, Gift of the Federal Art
Project, Work Projects Administration
Abbott no. 74

FIGURE 7.9 *Broadway to the Battery, 1938*
Photograph

Photographer: Berenice Abbott
Museum of the City of New York, Gift of the Federal Art
Project, Work Projects Administration
Abbott no. L-6

FIGURE 7.10 *Broadway Boogie-Woogie, 1942–43*
Oil on canvas. 23 × 23 inches; 585 × 585 mm.
Artist: Piet Mondrian
Museum of Modern Art

FIGURE 8.1 *Ferry House in Brooklyn [detail from the Burgis view],
ca. 1717*
Engraving: Area of detail 5½ × 13 inches; 138 × 330 mm.
Artist: William Burgis
Engraver: John Harris
I. N. Phelps Stokes Collection, Miriam and Ira D. Wallach
Division of Art, Prints, and Photographs, New York Public
Library, Astor, Lenox, and Tilden Foundations

FIGURE 8.2 *New York from Heights near Brooklyn, 1820–3*
Aquatint. 15.7 × 24.1 inches; 393 × 603 mm.
Artist: William G. Wall
Engraver: John Hill
Museum of the City of New York, J. Clarence Davies Collection
29.100.2164

FIGURE 8.3 *Brooklyn from the Foot of Wall Street in 1825*
Watercolor. 7.7 × 17 inches; 186 × 431 mm.
Artist: Abram Hosier, 1896, after Peter Maverick, 1825
Museum of the City of New York, J. Clarence Davies Collection
29.100.3540

FIGURE 8.4 *The Ferry at Brooklyn, 1830*
Gouache. 10.75 × 17 inches; 269 × 425 mm.
Artist: Unknown
Museum of the City of New York, J. Clarence Davies Collection
34.100.39

FIGURE 8.5 *City Hall of Brooklyn, 1850*
Colored lithograph. 11 × 14 inches; 275 × 350 mm.
Artist: C. Autenrieth
Publisher: Henry Hoff
Museum of the City of New York, Bequest of Mrs. J. Insley
Blair in memory of Mr. and Mrs. J. Insley Blair
52.100.23 S

FIGURE 8.6 *Bird's-Eye View of Great New York and Brooklyn Bridge,
1883*
Colored lithograph. 15.4 × 24.8 inches; 387 × 625 mm.
Artist: Unknown
Publisher: A. Major
Museum of the City of New York, J. Clarence Davies Collection
29.100.1752

FIGURE 8.7 *Tennis in Prospect Park, 1885*
Wood engraving. 5⅜ × 7 inches; 135 × 177 mm.
Artist: T. de Thulstrup
Harper's Weekly, July 11, 1885
From J. Grafton, New York in the Nineteenth Century, Dover,
1977

FIGURE 8.8 *The Boardwalk, Coney Island, ca. 1897*
Photograph
Photographer: Joseph Byron
Museum of the City of New York, Byron Collection

FIGURE 8.9 *Brooklyn Skyline, 1925*
Oil on canvas. 21 × 25 inches; 534 × 636 mm.
Artist: Glenn O. Coleman
Hollis Taggart Galleries
Photograph courtesy Owings-Dewey Fine Art

FIGURE 8.10 *Flotilla Approaching Staten Island, July 12, 1776*
Watercolor. 18¾ × 11½ inches; 476 × 291 mm.
Artist: Archibald Robertson
Spencer Collection, New York Public Library, Astor, Lenox, and
Tilden Foundations

FIGURE 8.11 *New York Quarantine, Staten Island, 1833*
Aquatint. 30½ × 24 inches; 763 × 600 mm.
Artist and engraver: William James Bennett
Publisher: Parker and Company, and Lewis P. Clover
Museum of the City of New York, Bequest of Mrs. J. Insley
Blair in memory of Mr. and Mrs. J. Insley Blair
52.100.26

FIGURE 8.12 *Clipper Ship* Sweepstakes, *ca. 1853*
Oil on canvas. 32 × 54 inches; 813 × 1,373 mm.
Artist: Fitz Hugh Lane
Museum of the City of New York, Bequest of Theodore E. Blake
M50.5

FIGURE 8.13 *The Narrows Ferry Schedule, 1897*
Printed handbill
Museum of the City of New York, Gift of Henry A. Ahearns
42.288

FIGURE 8.14 *The Boardwalk at Midland Beach, Staten Island, 1898*
Photograph
Photographer: Adolph Wittemann
Museum of the City of New York, Leonard Hassam Bogart
Collection

FIGURE 8.15 *Sailors' Snug Harbor, Livingston, Staten Island, 1899*
Photograph
Photographer: Joseph Byron
Museum of the City of New York, Byron Collection
93.1.1.14135

FIGURE 8.16 *Hope Avenue, No. 139, Staten Island, Richmond, 1937*
Photograph
Photographer: Berenice Abbott
Museum of the City of New York, Gift of the Federal Art
Project, Work Projects Administration
Abbott no. 270

FIGURE 8.17 *Chinese Scholar's Garden, 1999*
Photograph
Photographer: Yangming Chu
Staten Island Botanical Garden Archives

FIGURE 9.1 *Treaty between the Indians and the Dutch with Jonas
Bronck at Spuyten Duyvil Creek, 1642*

Oil on canvas. 41 × 60 inches; 1,040 × 1,525 mm.
Artist: Edwin Willard Deming
Issued: 19th century
Museum of the City of New York, Gift of Rita and
Murray Hartstein
96.13.3

FIGURE 9.2 *Woodruff Stables in the Bronx, 1861*
Oil on canvas. 24¼ × 40 inches; 616 × 1,017 mm.
Artist: Johannes E. Oertel
Museum of the City of New York, Gift of Harris Fahnestock
34.340

FIGURE 9.3 *Construction of the Grand Concourse in the Bronx, 1892*
Watercolor. 18½ × 24 inches; 470 × 610 mm.
Artist: Louis A. Risse
Museum of the City of New York, Gift of Mrs. F. L. Bunnell
69.111.2

FIGURE 9.4 *Country Store Interior, 2533 Sage Place, Spuyten Duyvil, Bronx, 1935*
Photograph
Photographer: Berenice Abbott
Museum of the City of New York, Gift of the Federal Art
Project, Work Projects Administration
Abbott no. 12

FIGURE 9.5 *The Bronx Zoo, 1936*
Oil on canvas. 15 × 20 inches; 375 × 500 mm.
Artist: Vincent La Gambina
Museum of the City of New York, Gift of the artist
88.10.2

FIGURE 9.6 *Van Cortlandt Park, 1944*
Oil on canvas. 20 × 23⅞ inches; 508 × 608 mm.
Artist: Vincent La Gambina
Museum of the City of New York, Gift of Grace
La Gambina
92.40.3

FIGURE 9.7 *Bowne House in Flushing, Queens, 1661*
Photograph (19th century)
Photographer: Unknown
Museum of the City of New York

FIGURE 9.8 *Steinway and Sons Piano Factory in Long Island City, Queens, 1902*
Photograph
Photographer: Joseph Byron
Museum of the City of New York, Byron Collection
93.1.1.2138

FIGURE 9.9 *Engineer's Sketch of the Queensboro Bridge, 1908*
Drawing in ink on paper. 4¼ × 7½ inches; 109 × 190 mm.
Artist (engineer): William H. Burr
Redraft (architect): Sanford Malter
General Research Division, New York Public Library, Astor,
Lenox, and Tilden Foundations

FIGURE 9.10 *Northern Boulevard, Flushing, Queens, 1923*
Photograph

Photographer: Unknown
Museum of the City of New York

FIGURE 9.11 *Triborough Bridge, East 125th Street Approach, 1937*
Photograph
Photographer: Berenice Abbott
Museum of the City of New York, Gift of the Federal Art
Project, Work Projects Administration
Abbott no. 233

FIGURE 9.12 *Trylon and Perisphere, New York World's Fair, 1939*
Photograph
Photographer: Unknown
Museum of the City of New York, Gift of New York World's
Fair 1939, Inc.

FIGURE 9.13 *Tennis Champion Pancho Gonzales in Forest Hills, 1959*
Photograph
Photographer: John I. Dennison
Collection of the author

FIGURE 10.1 *The City of New Amsterdam Located on the Island of Manhattan in New Netherland, ca. 1650*
Watercolor. 12.6 × 21.2 inches; 315 × 635 mm.
Artist: Probably Augustine Heerman
Austrian National Library, Map Department

FIGURE 10.2 *The Governor's House and the Church in the Fort, ca. 1650*
Wood engraving. 3⁵⁄₁₆ × 2¹⁵⁄₁₆ inches; 90 × 70 mm.
Engraver: Anonymous
Issued: ca. 1820
Emmet Collection, Miriam and Ira D. Wallach Division of Art,
Prints, and Photographs, New York Public Library, Astor, Lenox,
and Tilden Foundations

FIGURE 10.3 *Property Deed for Bouwerie No. 1, 1651*
Manuscript on parchment. 12½ × 8 inches; 310 × 203 mm.
Museum of the City of New York, Gift of Stuyvesant Fish
35.431.1

FIGURE 10.4 *Portrait of Peter Stuyvesant, ca. 1660*
Oil on wood panel. 22½ × 17½ inches; 573 × 450 mm.
Artist: [Henri Couturier?]
New-York Historical Society

FIGURE 10.5 *Deed Signed by Peter Stuyvesant, May 15, 1664*
Manuscript on parchment. 12½ × 8 inches; 315 × 203 mm.
Museum of the City of New York, Gift of DeLancey Kountze
33.307

FIGURE 10.6 *Stadthuys of New York on Pearl Street, Corner of Coenties Slip, 1679*
Watercolor. 12.875 × 10.25 inches; 322 × 256 mm.
Artist: Jaspar Danckaerts
Redraft: Louis Oram
Issued: 19th century
Museum of the City of New York, J. Clarence Davies Collection
29.100.1634

FIGURE 10.7 *Portrait of the Duke of York, ca. 1682*
Engraving. 5¹⁵⁄₁₆ × 9⁹⁄₁₆ inches; 136 × 239 mm.
Engraver: Anonymous

Print Collection, Miriam and Ira D. Wallach Division of Art, Prints, and Photographs, New York Public Library, Astor, Lenox, and Tilden Foundations

FIGURE 10.8 *Portrait of Thomas Dongan, ca. 1666*
Oil on linen. 45¾ × 34½ inches; 1,144 × 875 mm.
Artist: Anonymous
New-York Historical Society

FIGURE 10.9 *Seal of the City of New York, 1686*
Painted plaster cast
Museum of the City of New York 31.191 A

FIGURE 10.10 *Fernando Wood, ca. 1856*
Engraving. 10¼ × 6¾ inches; 256 × 169 mm.
Engraver: J. C. Buttre after daguerreotype by M. B. Brady
Museum of the City of New York, Gift of the City of New York, Department of Parks
50.212.7

FIGURE 10.11 *"Wall Street, Half Past Two, October 13, 1857," 1857*
Oil painting. 50 × 39½ inches; 1,270 × 1,054 mm.
Artists: James H Cafferty and Charles G. Rosenberg
Museum of the City of New York, Gift of the Hon. Irwin Untermyer
40.54

FIGURE 10.12 *Reception of Prince of Wales at Castle Garden by the Mayor of the City of New York and Common Council, October 11, 1860*
Wood engraving. 5.2 × 8.3 inches; 130 × 208 mm.
Artist: Unknown
Frank Leslie's Illustrated Weekly, October 11, 1860
Museum of the City of New York

FIGURE 10.13 *To the Victor Belongs the Spoils, 1871*
Engraving. 8 × 6 inches; 200 × 150 mm.
Artist: Thomas Nast
Museum of the City of New York

FIGURE 10.14 *Fulton Fish Market Dock, 1934*
Watercolor. 13¾ × 11½ inches; 344 × 288 mm.
Artist: Anthony Velonis
Museum of the City of New York, Gift of Anthony Velonis
91.93.5

FIGURE 10.15 *The End of an Epoch, 1938*
Oil on canvas. 21 × 25½ inches; 525 × 638 mm.
Artist: Maurice Kish
Museum of the City of New York, Gift of Maurice Kish
73.35

FIGURE 10.16 *Portrait of Fiorello La Guardia, 1939*
Photographer: Unknown
Print Collection, Miriam and Ira D. Wallach Division of Art, Prints, and Photographs, New York Public Library, Astor, Lenox, and Tilden Foundations

FIGURE 10.17 *Portrait of Robert Moses, 1978*
Oil painting. 60 × 48 inches; 1,526 × 1,221 mm.
Artist: Kurt Delbanco
Museum of the City of New York, Gift of Romie Shapiro
80.51

FIGURE 11.1 *Interior of a Dutch Home, ca. 1658*
Oil on canvas. 25½ × 23½ inches; 650 × 605 mm.
Artist: Pieter de Hooch
Rijksmuseum, Amsterdam

FIGURE 11.2 *Trinity Church [detail from the Burgis View], ca. 1717*
Engraving (full dimensions): 20⁵⁄₁₆ × 20⅛ inches; 516 × 511 mm.
Artist: William Burgis
Engraver: John Harris
I. N. Phelps Stokes Collection, Miriam and Ira D. Wallach Division of Art, Prints, and Photographs, New York Public Library, Astor, Lenox, and Tilden Foundations

FIGURE 11.3 *City Hall and Park View, 1835*
Oil on copper. 17 × 21 inches; 425 × 525 mm.
Artist: Anonymous, after William Bartlett
Museum of the City of New York, Bequest of Mrs. J. Insley Blair in memory of Mr. and Mrs. J. Insley Blair
52.100.15

FIGURE 11.4 *Woolworth Building, 1913*
Etching and drypoint. 13 × 10½ inches; 330 × 267 mm.
Artist: John Marin
Susan Sheehan Gallery

FIGURE 11.5 *Winter Afternoon in New York, 1916*
Oil on canvas. 19 × 23 inches; 475 × 575 mm.
Artist: Childe Hassam
Museum of the City of New York, Bequest of Mrs. Giles Whiting
71.120.107

FIGURE 11.6 *View of the Chrysler Building, ca. 1933*
Oil painting. 39¾ × 25 inches; 1,012 × 637 mm.
Artist: Rachel Hartley
Museum of the City of New York, Robert R. Preato Collection
91.76.18

FIGURE 11.7 *The Commissioners' Plan of 1811*
Engraving. 22¾ × 89½ inches; 569 × 2,238 mm.
Artist: William Bridges, after John Randel Jr.
Museum of the City of New York, J. Clarence Davies Collection
29.100.2730

FIGURE 11.8 *Manhattan Company Receiving Reservoir, 1825*
Watercolor. 10 × 16 inches; 250 × 400 mm.
Artist: G. P. Hall
Museum of the City of New York, J. Clarence Davies Collection
29.100.1579

FIGURE 11.9 *Gapstow Bridge, ca. 1890*
Watercolor. 4⅝ × 7¾ inches; 115 × 195 mm.
Artist: J. M. Slaney
Museum of the City of New York, J. Clarence Davies Collection
89.4.1

FIGURE 11.10 *Laying Cable for the Broadway Surface Railroad at Union Square, 1890*
Gouache on paper. 20 × 30 inches; 500 × 750 mm.
Artist: Hughson Hawley
Museum of the City of New York, Gift of Colonel

Thomas Crimmins
42.323.104

FIGURE 11.11 *Manhattan Bridge, Looking Up, 1936*
Photograph
Photographer: Berenice Abbott
Museum of the City of New York, Gift of the Federal Art
Project, Work Projects Administration
Abbott no. 173

FIGURE 11.12 *The Connectors, 1934*
Etching. 13 × 9⅞ inches; 331 × 253 mm.
Artist: James E. Allen
Susan Sheehan Gallery

FIGURE 12.1 *Native Rendering of an Atlantic Seaboard Turtle,
ca. 1585*
India ink on paper. 5½ × 4½; 140 × 114 mm.
Redraft after native petroglyph
Artist: Thomas Wesley Peck
Collection of the artist

FIGURE 12.2 *Common Box Tortoise, 1585*
Watercolor. 5⅝ × 7¾; 144 × 197 mm.
Artist: John White
British Museum, London

FIGURE 12.3 *Grace Mears Levy (Mrs. Moses Levy), ca. 1720–8*
Oil on canvas. 42½ × 33½ inches; 1,063 × 838 mm.
Artist: Attributed to Gerardus Duyckinck
Museum of the City of New York, Bequest of Alphonse
H. Kursheedt
36.343.2

FIGURE 12.4 *John Street Theatre Handbill, 1785*
Handbill. 17 × 11 inches; 425 × 275 mm.
Museum of the City of New York, Gift of J. F. Mulrein
31.141.1

FIGURE 12.5 *Sarah Bernhardt in Her Suite at the Hoffman House, 1896*
Photograph
Photographer: Percy C. Byron
Museum of the City of New York, Byron Collection

FIGURE 12.6 *John Barrymore as Hamlet, 1922*
Oil painting. 43 × 53½ inches; 1,075 × 1,338 mm.
Artist: James Montgomery Flagg
Museum of the City of New York, Gift of James
Montgomery Flagg
46.214.1

FIGURE 12.7 *Harris Theater on Broadway, 1940*
Watercolor. 27 × 40.375 inches; 675 × 1,009 mm.
Artist: Reginald Marsh
Museum of the City of New York, Gift of Reginald Marsh
53.107.3

FIGURE 12.8 *Palmo's Opera House, ca. 1847*
Engraving. 7½ × 7½ inches; 188 × 188 mm.
Artist: Unknown
Museum of the City of New York, J. Clarence Davies Collection
29.100.854

FIGURE 12.9 *Academy of Music, 1854*
Stereographic view
Photographer: Unknown
Museum of the City of New York, Gift of Mrs. Levinia A. Pape
34.5.6

FIGURE 12.10 *Niblo's Garden Playbill for The Black Crook, September
12, 1866*
Playbill. 9¼ × 5¾ inches; 231 × 144 mm.
Museum of the City of New York, Anonymous Gift
42.471

FIGURE 12.11 *German Street Band, 1879*
Wood Engraving. 4¾ × 6¼ inches; 118 × 158 mm.
Artist: J. G. Brown
Harper's Weekly, April 26, 1879
From J. Grafton, New York in the Nineteenth Century,
Dover, 1977

FIGURE 12.12 *Dance in a Dutch Inn, ca. 1652*
Etching. 9⁸⁄₁₆ × 12⁵⁄₁₆ inches; 240 × 317 mm.
Artist and engraver: Adriaen van Ostade
Print Collection, Miriam and Ira D. Wallach Division of Art,
Prints, and Photographs, New York Public Library, Astor, Lenox,
and Tilden Foundations

FIGURE 12.13 *The Grecian Bend, 1868*
Lithograph (sheet music cover)
Artist: Unknown
Written by W. H. Lingard
Published by William A. Pond and Company
Museum of the City of New York
49.405.5C

FIGURE 12.14 *Telephone Waltzes, ca. 1883*
Lithograph (sheet music cover)
Music by August Hellmann
Published by Hitchcock's Music Store
Museum of the City of New York
49.405.3

FIGURE 12.15 *Ballet Rehearsal at the Metropolitan Opera House,
September 1900*
Photograph
Photographer: Joseph Byron
Museum of the City of New York, Byron Collection

FIGURE 13.1 *Portrait of General Thomas Gage, 1779*
Mezzotint. 4²⁄₆ × 3⁷⁄₁₆ inches; 109 × 85 mm.
Artist: Anonymous
Issued: 19th century
Print Collection, Miriam and Ira D. Wallach Division of Art,
Prints, and Photographs, New York Public Library, Astor, Lenox,
and Tilden Foundations

FIGURE 13.2 *The New-York Gazette: And the Weekly Mercury, March
17, 1783*
Newspaper
Printed by Hugh Gaine at his Book-Store and Printing Office
at the Bible and Crows, Hanover Square, New York

Museum of the City of New York, J. Clarence Davies
Collection
34.100.1.1.118 B

FIGURE 13.3 *The Newspaper Stand, ca. 1840*
Watercolor. 14 × 10¼ inches; 350 × 256 mm.
Artist: Nicolino Calyo
Museum of the City of New York, Gift of Mrs Francis P.
Garvan in memory of Francis P. Garvan
55.6.3

FIGURE 13.4 *Critique of Margaret Fuller, 1845*
Review in the *Broadway Journal*, March 8, 1845
Henry W. and Albert A. Berg Collection of English and
American Literature, New York Public Library, Astor, Lenox,
and Tilden Foundations

FIGURE 13.5 *"The New Colossus," 1883*
Manuscript
Poem by Emma Lazarus
Museum of the City of New York, Gift of George S. Hellman
36.319

FIGURE 13.6 *Walt Whitman, 1887*
Photograph
Photographer: George C. Cox
Museum of the City of New York, Gift of Mr. Clarence
Clough Buel
40.146

FIGURE 13.7 *Herald Square and the New York Herald Building, 1899*
Oil on canvas. 15⅞ × 11⅞ inches; 405 × 302 mm.
Artist: Herman N. Hyneman
Eno Collection, Miriam and Ira D. Wallach Division of Art,
Prints, and Photographs, New York Public Library, Astor, Lenox,
and Tilden Foundations

FIGURE 13.8 *Eustace Tilley, 1925*
Drawing. 2 × 3 inches; 50 × 75 mm.
Artist: Rea Irvin
Museum of the City of New York, Gift of George S. Hellman
67.100.73

FIGURE 13.9 *Portrait of Edna St. Vincent Millay, ca. 1928*
Photographer: Carl van Vechten
Henry W. and Albert A. Berg Collection of English and
American Literature, New York Public Library, Astor, Lenox,
and Tilden Foundations

FIGURE 13.10 *Olive Brand in a Greenwich Village Cafe, 1929*
India ink on paper. 7½ × 9 inches; 191 × 228 mm.
Artist: Betty J. Petschek
Executed: 1999
Collection of the artist

FIGURE 13.11 *Times Square, 1940*
Oil on canvas. 24 × 20 inches; 600 × 500 mm.
Artist: Stokely Webster
Museum of the City of New York, Gift of Stokely Webster
75.40

FIGURE 13.12 *Sketch of Truman Capote, ca. 1954*
Ink on paper. 16¾ × 13¾ inches; 426 × 349 mm.
Artist: Andy Warhol
Susan Sheehan Gallery

FIGURE 14.1 *James, Duke of York, Playing Tennis, 1641*
Engraving. 7½ × 5⅛ inches; 187 × 126 mm.
Artist and engraver: Matthias Merian, the Younger
British Museum, London

FIGURE 14.2 *Kolf Player in the Netherlands, 1654*
Etching. 3⁵⁄₁₆ × 5⁵⁄₁₆ inches; 115 × 137 mm.
Artist: Rembrandt Harmensz van Rijn
Print Collection, Miriam and Ira D. Wallach Division of Art,
Prints, and Photographs, New York Public Library, Astor, Lenox,
and Tilden Foundations

FIGURE 14.3 *Dr. Rich's Institute for Physical Education, ca. 1850*
Colored lithograph. 19.12 × 11.8 inches; 478 × 295 mm.
Published by William Endicott and Company
Museum of the City of New York, J. Clarence Davies Collection
29.100.2583

FIGURE 14.4 *Madison Square Garden, ca. 1895*
Watercolor. 24 × 17½ inches; 600 × 437.5 mm.
Artist: W. Louis Sonntag Jr.
Museum of the City of New York, Gift of Mrs. Frederick
A. Moore
49.14

FIGURE 14.5 *Crowd at the Polo Grounds, 1895*
Colored print. 10.1 × 7.8 inches; 253 × 195 mm.
Artist: Jay Hambidge
Printer: The Truth Company
Museum of the City of New York, Gift of Mrs. Giles Whiting

FIGURE 14.6 *Stag at Sharkey's, ca. 1930*
Lithograph. 18¾ × 7⅞ inches; 476 × 201 mm.
Artist: George Bellows
Susan Sheehan Gallery

FIGURE 14.7 *"Out at Home," ca. 1935*
Silkscreen. 10 × 8 inches; 253 × 203 mm.
Artist: Fletcher Martin
Photograph: Gift of Midtown Galleries, Museum of the City
of New York

FIGURE 14.8 *Signed Baseball of the 1955 World Champion Brooklyn
Dodgers*
Museum of the City of New York
55.349.2

FIGURE 14.9 *A Columbia University Professor Joins the Marathon, 1988*
Photograph
Photographer: Éva Peck
Collection of the photographer

FIGURE 14.10 *Savoring the Beaches of Gotham, 1989*
Photograph
Photographer: Anonymous
Collection of the author

INDEX

Index

This book was set in 10/14 Bembo, licensed from Monotype/Adobe, a facsimile of a typeface cut in 1495 by Francesco Griffo (1450–1518) for the Venetian printer Aldus Manutius (1450–1515). The face was named for Pietro Bembo, the author of the small treatise *De Ætna,* in which it first appeared. The companion italic is based on the handwriting of the Venetian scribe Giovanni Tagliente from the 1520s. The present-day version of Bembo was first introduced by the Monotype Corporation in 1929, under Stanley Morison's supervision. Serene and versatile, it is a typeface of classical beauty and high legibility.

This book was designed by Linda Secondari.
Composed at Columbia University Press by William Meyers.